Artmaking in the Age of
Global Capitalism

Artmaking in the Age of Global Capitalism

Visual Practices, Philosophy, Politics

Jan Bryant

EDINBURGH
University Press

Edinburgh University Press is one of the leading university presses in the UK. We publish academic books and journals in our selected subject areas across the humanities and social sciences, combining cutting-edge scholarship with high editorial and production values to produce academic works of lasting importance. For more information visit our website: edinburghuniversitypress.com

Edinburgh University Press Ltd
The Tun – Holyrood Road, 12(2f) Jackson's Entry, Edinburgh EH8 8PJ

First published in hardback by Edinburgh University Press 2019

Typeset in 11/13 Bembo by
IDSUK (DataConnection) Ltd, and
printed and bound by CPI Group (UK) Ltd,
Croydon, CR0 4YY

A CIP record for this book is available from the British Library

ISBN 978 1 4744 5694 4 (hardback)
ISBN 978 1 4744 5695 1 (paperback)
ISBN 978 1 4744 5696 8 (webready PDF)
ISBN 978 1 4744 5697 5 (epub)

Contents

List of Figures

Acknowledgements

Acknowledgment of Country

This book was written and researched on the traditional lands of the Wurund-jeri and Boon Wurrung people of the Kulin Nations who are the recognised custodians of this land. I pay my respects to their ancestors and acknowledge the strong and ongoing Aboriginal and Torres Strait Islander peoples' con-nection to material and artistic practices on these lands for more than 60,000 years. In recognition that the land was never ceded under the terms of a treaty, I support the work of the Wurundjeri Tribe Land and Compensation Cultural Heritage Council in reaching an agreement currently being negotiated with the Victorian State Government of Australia.

In the spirit of voice, treaty and truth, an announcement known as the Uluru Statement which spoke of the importance of hearing first peoples' voices in legislative decisions was delivered by Aboriginal and Torres Strait Islander delegates on 26 May 2017. I urge the government to recognise the momentum of popular support that is gathering for the Statement across all sectors of the nation and to acknowledge that the mood for reconciliation cannot be destroyed.

And thanks to . . .

The support of all the artists and curators involved in this project, and the gen-erosity of my readers, Emily Beausoleil, Angela Dimitrakaki Carol Macdonald, Justin Clemens, Melissa Deerson, Gwynne Porter, Fiona Macdonald, Helen Hughes, Deborah Ostrow, Tara Mcdowell and Octavia Bryant. And for the ongoing support from my very much-loved friends and family.

Introduction: The Gift of Being Disgusted

Artmaking in the Age of Global Capitalism: Visual Practices, Philosophy, Politics looks at the strategies visual artists and filmmakers are using to criticise the social and economic conditions shaping our historical moment, and in the process, how the world is being positively re-imagined today through their work. With this objective in mind, attention is paid to the legacies, both theoretical and material, that help us to understand how we got to this point in history. And, thus, this book locates its concerns at the intersection of practice and theory, while working through a range of methods, historical encounters and philosophical approaches. The challenge is to be able to identify the potential of a work's political-aesthetic, to determine whether it has found a way to critically intervene into the conditions of the *Dispositif* (Apparatus), or whether it is merely accommodating the continuation of current conditions.[1] It is to isolate, in other words, the mere semblance of political affect from a quality that is more rapacious, scratchy and disruptive.

As we continue to slumber under the weight of a concerned, yet impotent 'left', I recall that as early as 1928, Walter Benjamin offered advice to the poet whose resignation had become heavy and whose critical observations had fallen into habit: 'to be in routine means to have sacrificed one's idiosyncrasies, to have forfeited the gift of being disgusted.'[2] To accept Benjamin's call today means that scrutiny of current conditions and their effects needs to become an urgent and ongoing undertaking. It is to reject, finally, the figure of the syphon-like, distanced artist-commentator who presents the world's inequalities in cleaned-up form to an educated art audience, and for whom the ethical implications of speaking for the other continue to be poorly acknowledged.

The kind of artwork under discussion is not the same as political activism.[3] Jacques Rancière, who threads his way through this book, catches the sense of this in the following way:

> The problem . . . is that the adaptation of expression to subject matter is a principle of the representative tradition that the aesthetic regime of art has called into question. That means that there is no criterion for establishing a correspondence between aesthetic virtue and political virtue.[4]

Recognising the need for the visual arts to respond to its own disciplinary traditions and histories, Rancière is acknowledging the diminished viability of adopting representational methods, describing the aesthetic regime as a weave of 'perception, affection and thought'.[5]

The political is formulated here as both dispute and polemic, and thus takes a route via a prefatory consideration of Carl Schmitt's theory of politics as conflict and 'antagonism' – his friend/enemy dyad – before returning to Rancière's concept of dissensus.[6] This consideration of the differences between Schmittian conflict and Rancièrian dissensus takes place via Andrew Benjamin's conceptualising of time and tradition as a way to position artmaking and writing in the plenitude of the present. Since art is constituted on its relation to the past, this is particularly apposite. For artists and filmmakers to positively re-imagine the way the world might be conditioned means negotiating the way history and contemporaneity together influence the formal and conceptual aspects of their work.

As Schmitt wrote, 'All political concepts, images, and terms have a polemical meaning. They are focused on a specific conflict and are bound to a concrete situation ... the result ... is a friend-enemy grouping.'[7] Schmitt's grouping is not raised as metaphor, but as a concrete, existential relation. 'The distinction of friend and enemy denotes the utmost degree of intensity of a union or separation, of an association or dissociation. It can exist theoretically and practically, without having simultaneously to draw upon all those moral, aesthetic, economic or other distinctions.'[8] In his formulation of the political, Schmitt revealed a division between 'politics' and 'the political' or *la politique* from *le politique*, understood as the dividing of the ontic from the ontological.[9] As Oliver Marchart notes, this splitting identifies an 'unbridgeable chasm' between politics and the political: nonetheless, 'by splitting politics from within something essential is released.'[10] In theorising the differing demands of this ontological/ontic division within the broader category of politics, Schmitt identifies the point where conflict becomes visible under adversarial conditions, the moment when conflictual energy is at its most potent. Roberto Esposito encapsulates this as 'the temporal hiatus that, by means of tension, links possibility and reality, past and present, origin and contemporaneousness – the contemporary feature of the origin and the originary feature of the contemporary.'[11]

This is a useful entry into Andrew Benjamin's discussion on the specificity of thinking the political (its philosophical presentation). Thus, I would like to bracket momentarily the political necessity of conflict between adversaries for Schmitt, to think instead about time and conflict at the time of making, as Andrew Benjamin conceives of it. For Benjamin, conflict emerges in relation to the present through an entanglement with the demands of tradition, presence and need, 'since it is the differences given at the level of this interplay that mark the primordiality of conflict.'[12]

Articulated as need, the response can be formulated as a specific stand in relation to a particular repetition. Repetition here is the reiteration of the already given. Need exists in relation to the gift and yet the gift, what is taken to have been given, is itself determined by need.[13]

This need to respond to tradition is more than a reciprocal demand already existing in the structure of the gift, it is also for Andrew Benjamin the recognition of a 'philosophical concern staged in time'.[14] Time becomes a determining factor for philosophy's formulations, but not as simple presents 'that would reduce the present to a mere moment in chronological time. More exactly: they define the present by invoking and holding to different formulations of the time of writing.'[15] The temporal unfolding of tradition or history is also applicable to the way artists invoke and respond to present conditions. Since such a conception frames the terms around which artists are considered for this book, I will pick up on Andrew Benjamin's proposition in Part III, particularly in relation to an incomplete present and the possibility of unshackling hope from utopian or theological thinking.

In a search for films and artworks that respond in rupturing ways to the conditions of our historical moment, *Artmaking in the Age of Global Capitalism* relies upon Jacques Rancière's 'politics of the aesthetic' as stabilising ground.

The dream of a suitable political work of art is in fact the dream of disrupting the relationship between the visible, and the sayable, and the thinkable without having to use the terms of a message as a vehicle. It is the dream of an art that would transmit meanings in the form of a rupture with the very logic of meaningful situations.[16]

Politics arises in Rancière's thinking as *dissensus* or disagreement. He differs from Schmitt, however, on two pertinent points. First, Rancière does not see dissensus as conflict between an enemy and a friend, since these radical opponents would need to have been neutralised first, but as 'a perturbation of the normal relation between sense and sense';[17] and second, as defined in *The Politics of Aesthetics*, he does not strictly separate politics from the political, although, 'The political *is* the terrain upon which the verification of equality confronts the established order of identification and classification'.[18] Furthermore, as 'the opposition between sense and sense is not an opposition between the sensible and the intelligible, political dissensus is not the appearance or the form that would be the manifestation of an underlying social and economic process.'[19] This is posed as a struggle for emancipation played out on the aesthetic plane via interventions that disturb the 'police order', a phrase that Rancière uses as a catch-all for the mechanisms that order and distribute how we see and speak at any moment.[20] 'The distribution of the visible itself is part of the configuration of domination and subjection.'[21]

Dissensus or disagreement about what can and cannot be sensed in the aesthetic realm at any historical moment is found in the 'distribution of the sensible' where divisions open up within the common. Divisions enable individuals or groups to form new perceptual conditions, to be recognised and heard. At his most concrete, Rancière writes:

> The way in which, by drawing lines, arranging words, or distributing surfaces, one also designs divisions of communal space. It is the way in which, by assembling words, or forms, people define not merely various forms of art, but certain configurations of what can be seen and what can be thought.[22]

What interests Rancière 'more than politics or art is the way the boundaries defining certain practices as artistic or political are drawn and redrawn.'[23] If this objective appears reactive, then it is quickly followed by a positive/active claim to free creative making and thinking from the imposition of history's 'proscriptions [and] declarations of powerlessness on the present.'[24]

If we are to fulfil the demands thus posed, in particular the determination to identify art and film works that are able to upset present configurations of what can be thought and seen, then this implies taking a political stance, to paraphrase Rancière, a polemical view of what ideas are and do.[25] Building polemical garrisons from which to lead and direct the readers is a point Rancière established in his early texts on Louis Althusser, who remained within Idealist modes of thinking for Rancière, and who was closer to the explicator than the materialist. Rancière's work on Joseph Jacotot, the nineteenth century teacher who promoted the equality of all intelligences, flowed from the momentum to separate himself from Althusser's influence. And this is what *Artmaking in the Age of Global Capitalism* shares most closely with Rancière, a concern to protect a materialist approach for understanding visual practices, while pursuing a practical application of political theory and philosophy to the work of filmmakers and artists. In doing so, the book tries to attend as closely as possible to a method that is expertly and lightly pursued by T. J. Clark who insists on working out from the work itself, from 'the specificity of picturing'.[26]

Acknowledging that Rancière has a formulation of ethics and morality (discussed in Chapter 8) that does not align with my own, I depart from his work momentarily to note that a concern of this book is to consider the political resonances that proliferate as makers and their works come into contact with others and with communities. In refusing to separate artists from their work, my aim is not to personalise the criticism, but to recognise that a relation to the world, to others, is a quality that inheres in the work as a method of the practice itself. In other words, there is an ethics of practice that

disavows the autonomy of art as an act or an object separated from its making or context. Simon Critchley has articulated this as a need flowing from disappointment for 'a theory of ethical experience and subjectivity that will lead to an infinitely demanding ethics of commitment and politics of resistance.'[27] It is related to an interest framed by Emily Beausoleil as a practical ethics that plays out in daily interactions of 'receptivity and responsiveness,' and thus arises from the urgency to respond to the political pressures of the present.[28]

Artmaking in the Age of Global Capitalism is divided into three parts. As a way to better understand the recent past and its impact on the present, Part I explores the political and economic forces that began changing the social realities from the 1970s onwards, with reference to various theoretical and philosophical responses to these shifts. It places particular focus on the divisions that occurred in what were once a set of discourses loosely united under the umbrella of Marxist Leftism, before detailing the coexistent hardening of neoliberal economics and the impact this had on artists and their practices. Part II digs down into these divisions to detail clashes between supposed compatriots, writers, theorists and artists. They form material examples for the divisions outlined in Part I, which turned, eventually, into a crisis on the old left about how to respond to contemporary capitalism. The examples may seem arbitrary. As a way to avoid the assumption that a full picture of the past is realisable, a universalising point of view is eschewed and the seemingly random nature of the chosen examples is an inevitable result of working at the level of the detail, rather than 'the whole'. Instead, it is hoped that the reader will assemble the pieces to form a picture of the kinds of diverse pressures that split the Left last century, and which, in turn, effected the way art and filmmakers approach a political aesthetic today.

Part III offers four extended essays on practices that respond critically to contemporary political and economic conditions. They are artworks that avoid resorting to habitual methods, and are also at the forefront, I will be arguing, in tying the impact of the work and its making to an ethical relation with audiences and collaborators. The first two chapters, one on Frances Barrett's performance, *Curator* (2015) and the second on Claire Denis's film, *L'Intrus* (2004), operate as companion pieces. The second touches on how the political implications of borders and hospitality (care) are embedded in the film's treatment, particularly the narrative structure. Denis's political position is determined by a certain questioning of historical forms of patriarchy. The first essay considers how the boundaries traversed by Barrett, the politics of the work, springs from ethical questions, as she embroils her 'actors' in 'real-life' responsibilities of care. It is this dimension that propels her political–aesthetics and her queer/feminism. Not only do both works demonstrate the inextricable links between politics and ethics, and politics and aesthetics, but do so through the artists' feminist positioning.

Moving the discussion into a deeper examination of the inter-connectedness of politics and aesthetics, Chapter 10 explores the political-aesthetics of contemporary painting. It opens with a consideration of Jean Paulhan's theories of rhetoric (*cliché*) and terror as a way to understand the heavy burden of history that painting bears. Because such a burden may be generalised as a burden of imagery itself, this chapter digs into the 'painterly' as something belonging specifically to the painting medium. It then moves onto an extended consideration of fashion, as aesthetic flux (Benjamin, Simmel, Agamben), suggesting that regardless of the insistence that aesthetics cannot be separated from the political, the amalgam may split at the surface in a way that befuddles political intent, as the fashionable aesthetic overwhelms critical reception.

To conclude this section, a consideration of how a political-aesthetics forms in Angela Brennan's painting is first argued through questions of mimesis (Lacoue-Labarthe) and then judgement and criticality (Deleuzian tradition), contesting claims that we have passed into a post-critical era this century, to propose instead that to judge is a question of ethics and not a question of history.

Chapter 11 changes direction by looking at an artist who works with communities affected by geo-political crises. How political events are expressed as a political-aesthetics is introduced through three works by the Northern Irish/New Zealand artist, Alex Monteith. She works with a range of communities, using various filmic modes, within the flow of 'real' world actions. Considered are two works made in Northern Ireland, *Chapter and Verse* (2004) and *Shadow V* (2017), both of which deal with The Troubles in poetic ways. The third is a large work in progress, *Murihiku Coastal Incursions* (2014–). It draws upon wide circles of collaboration with local Māori over how to process artefacts that were taken wholesale from a remote region in Aotearoa in the 1970s by an Australian archaeologist, without consultation with Iwi. The objects had been left in boxes, unrecorded, in a New Zealand university archive ever since. All three projects touch on questions of colonialism, but each is visualised differently, working out of the logic of the works' differing concepts. This chapter includes a look at *Trade Item* (2018), a series of works by Sarah Munro that use decolonising tactics.

Part I

Still Deep in the Bones of the Bourgeoisie

Still Deep in the Bones of the Bourgeoisie: Introduction

In 1928, Walter Benjamin derided his fellow Berliners, the 'left-radical intelligentsia', saying they were wholly lost.[1] He accused, in particular, the writer, Erich Kästner, of having fallen into routine, which was also the source, he surmised, of Kästner's heavy heartedness.[2] Criticising the writer for protecting the interests of his own class, or what Benjamin defined as the 'middle strata – agents, journalists, heads of departments', he charged Kästner with both a hatred towards 'the petit-bourgeoisie' and a noticeable abandonment of 'any striking power against the big bourgeoisie'. The left intelligentsia, Benjamin concluded, 'had little to do with the labour movement', and more to do with 'cliques and fashions', turning revolutionary reflexes 'into objects of distraction . . . supplied for consumption.'[3] 'The clowning of despair' is the phrase Benjamin used to describe self-interest dressed as radical left concern.[4]

Such posturing continues to be a common feature of many contemporary art events, with a picture of the globally pitched art industry, particularly that of government-backed events and large state-run museums, manifesting from an amalgam of wealth, elitism and spectacle-tourism. Targeted at our consumerist, individuated impulses, the biennale model is indicative of the large, state-supported art event that relies on attracting global audiences to boost cities' tourist numbers. At the 56th Venice Biennale (2015), the British artist, Isaac Julian, sponsored by Rolls-Royce, directed live readings of Marx's entire *Capital*. It was a programme suggested by Okwui Enwezor, the Biennale's Visual Arts Director, as part of his broadly pitched theme of 'politics'. In response, Laura Cumming, writing for the *Guardian* reported,

> No doubt Julian can live with the preposterous contradictions involved. But the double act is emblematic of this 56th edition of the world's grandest art event, which is nothing if not explicitly critical of capitalism, consumerism and filthy lucre, while relying upon them all for its very lifeblood.[5]

Rachel Withers of *The Conversation* called the 2015 Venice Biennale, 'The Arsenale full of guns and stripped of hope.'[6] Such events frequently operate with the mystification that content will override context, but on the contrary,

context quickly turned against any attempt of artists to shatter the police order (as Jacques Rancière calls the distribution of the aesthetic regime at any moment), turning such complicity into a sour and shallow irony. To borrow again from Benjamin, it turns 'yawning emptiness into a celebration', digging historic contradictions of privilege and inequality further into contention.[7] The reification of Marxist theory as performance during the Venice Biennale was not only a low point in the cynical emptying of 'meaning', treating politics as 'décor' for the event, it also illuminated the continuing contradictions that arise from atomised environments where wealth and the suckling of class interests coalesce with tourist dollars and public funding.

A year before the Venice event, the realities that flow from a consideration of art funding became an issue during the launch of the 19th Sydney Biennale, directed by Juliana Engberg. Initially three artists, with another six quickly following,[8] withdrew their work as a protest against the event's connection to Transfield Holdings, one of the Biennale's sponsors, but also a private company recently engaged by the Australian Government to manage its highly contentious offshore immigration detention centres.[9] Contributing artists who did not join the boycott were placed in a difficult moral position. Some claimed that they would protest from within the event, and others said that this was untenable. Within days, Transfield's Chairman, Luca Belgiorno-Nettis, who was also Head of the Biennale, resigned and the board removed Transfield's sponsorship.[10] The Communications Minister, Malcom Turnbull, who was soon to become Prime Minister of Australia (2015–2018), had close and long personal connections with Belgiorno-Nettis, denouncing the artists' actions, while also clearly revealing his Government's attitude to the civil role of art. On national radio, he claimed that the artists demonstrated, 'sheer vicious ingratitude'.[11] It was a moment of clarity for artists, a reminder that a chasm of misunderstanding about art and its forms frequently exists between a patron class and artists working on the ground, within their own communities. This was further emphasised during a radio interview with Belgiorno-Nettis, when he said:

> Most of the other artists were in the show and were still in the show, *acting as artists*. Those artists who stepped out of the show should keep out of the show, if they decided to cast their lot with the activists they can stay there.[12]

The massive breach in differing perceptions between artists and patrons seemed to have caught the Government by surprise. Turnbull announced that the artists' actions might put an end to the Biennale altogether.

> Really, this is disastrous … I hope the Biennale can survive, but I think the artists who have done this have potentially driven a stake, not through the asylum seeker policy, I can assure you of that, but through the Biennale.[13]

The Biennale went ahead. And the opponents of the protesting artists took advantage of a glaring hole in their logic. Substantial funding for the event came from all tiers of government, but especially the Federal Government through the Australia Council for the Arts. So why snip off Transfield from a protest against the Government's dispersion of monies to objectionable companies and practices? Surely, only the complete boycotting of all government-funded events and the refusal to accept government grants of any kind is the logical extension of a protest against offshore detention. As a counterpoint, Alana Lentin and Javed de Costa, writing at the time for the *Guardian*, insisted that 'these arguments . . . purposefully misunderstand the point of the boycott and deny the power of this crucial step towards disrupting the private supply chain on which Australia's cruel "deterrent" policy depends.'[14] Judged as the only 'effective' contemporary tactic left to them, the group protesting the Sydney Biennale modelled their actions on the Israeli Boycotts, Divestments and Sanctions (BDS) movement.[15] And yet, nearly twenty years into the Post-Tampa era (the Tampa Affair represents the first significant refugee boat incident manipulated to appeal to a populist anti-immigration vote[16]), nothing has changed in the ruling governments' (centre-left and centre-right parties) rigid approaches towards refugees arriving in Australia without visas, neither the severity of the conditions, nor the failure to protect the well-being of those it imprisons via the privatisation of its primary duty of care. 'While secrecy was central, with little information publicly released',[17] the freelance journalist, Antony Loewenstein reported after a visit to Christmas Island (one of the sites of offshore detention in the Indian Ocean) that, 'serious allegations of rape, abuse, and violence were commonplace at the centre, one Australian officer labelling the facility a "horrendous chicken pen". Guards locked asylum seekers in solitary confinement for days on end, without communication.'[18] Nonetheless, the Biennale boycotts attracted widespread coverage in the popular media, and, after a visit to Christmas Island, Lowenstein concluded that at least the public was able to be exposed to 'a healthy debate' about mandatory, offshore imprisonment during the time of the boycott.[19]

However, it now seems as though those few weeks of protest had never happened, with two Biennales having since gone ahead without the slightest tremor of dissension or protest against the Government's offshore detention policy. What the protests did produce, momentarily, was a crack in the protective carapace of the Biennale model, within which 'dissent' is encouraged (permitted), but also very much contained.

1

Benjamin's Challenge for the Twenty-first Century

The purpose in outlining this case is to offer an example that might materialise the political 'texture' of advanced western economies today, a brief consideration at least of the kind of 'heavy-handed' counter-attacks used by governments to quell oppositional voices. The aim is to move a little closer to taking up Benjamin's prescient challenge, his insistence that critical responses should be reformulated on the specificity of contemporary conditions.[1]

As elsewhere in the world, Australia has a history of artists protesting over local issues, from the French nuclear tests in the Pacific (1973) to protecting old forests (2003). After the 1976, Sydney Biennale, which inexplicably was held every three years, artists criticised what they perceived as an event that was, according to Helen Grace, 'inaccessible to artists ... poorly run and largely unaccountable', and this was in spite of the Biennale's significant public funding.[2] In the years between the second and third Biennales, the actions of local artists included successfully lobbying the directors and organising a publication or anti-catalogue that they handed out at the 1979 opening, titled *White Elephant or Red Herring*, to replace the official catalogue.[3] However, by 2014 a very different economic and political climate was in play, and the Biennale boycotts against both offshore detention and the privatisation of prisons seemed to receive more brutal retaliation than it had in the past. As with a wound bared to the world, it was a rare moment in revealing the reality of inter-connected forms of 'power and consent', to adopt Rancière's terms,[4] for while the Biennale protests demonstrated a momentary burst of defiance, what followed were draconian backlashes, some official and others less open to empirical verification. First, the announcement that arts funding would be drastically slashed. The conservative Murdoch broadsheet, *The Australian*, quoting a commissioned report on arts funding, concluded that the cuts were payback for the 2014 protests.[5] Its journalist, Matthew Westwood, surmised that the boycotts were an 'attack on the Coalition Government and on neo-liberal values.'[6] Inferring that the protestors were solely driven by 'ideology', he ignored the moral implications of prison conditions and the atrocities that flow from them. The fallout continued into 2016:

The consequences of former federal arts minister Senator George Brandis' ideologically driven raid on the Australia Council last year have finally been revealed today. And, as predicted, it's a blood bath. Sixty-two arts organisations have been cut from the Australia Council's four-year funding program today as it was forced by the Turnbull government to accommodate the cuts Brandis made when he took one-hundred million dollars of its money to fund his own ill-conceived National Program for Excellence in the Arts (now Catalyst).[7]

This played into the current tendency for debates – from climate change to human rights – to divide along purely ideological lines. One proposition is to consider this through the 'silent revolution' thesis, outlined by Ronald F. Inglehart and Pippa Norris (political scientists who research populism): 'We argue that the classic economic Left–Right cleavage in party competition is overlaid today by a new Cultural cleavage dividing Populists from Cosmopolitan Liberalism.'[8] The 'silent revolution' is the term given to progressive, 'value-changing' developments that occurred in affluent societies as a post-war generation came to voting age in the 1970s. Reaction to 'progressive tides of cultural change' has amassed a seemingly 'angry and resentful counter-revolutionary backlash.'[9] Evidence reveals that this reactionary force is especially located,[10]

> among the older generation, white men, and less educated sectors, who sense decline and actively reject the rising tide of progressive values, resent the displacement of familiar traditional norms, and provide a pool of supporters potentially vulnerable to populist appeals.[11]

It is in such an environment of economic and cultural division that more insidious retaliations for speaking out were incubated. In off-the-record interviews with artists, it was claimed that an ongoing shunning of artists who participated in the protests continue to be in force from members of the local patron/dealer/exhibiting community, despite several years having now passed.

Accompanying the cuts in arts funding and the supposed shunning of artists was a noticeable intensification in the Government's lack of transparency, for what followed was even less public access to information about offshore prisons, with now only a trickling of stories seeping through an otherwise solid wall of secrecy. If a mark of our time is the control of information to the public about sensitive government actions ('embedding' journalists in frontline wars comes to mind), then in 2017, the Australian Government attempted to install even harsher forms of control by proposing amendments to the 2015 Australian Border Force Act (ABF). The ABF already represented an aggressive retitling

of the Act from 'border protection' to 'border force', but it now threatened present and past employees of detention centres with two years' imprisonment if they 'told-tales' about the realities of the private, offshore prisons.[12] Making doctors, nurses, social workers, teachers, lawyers, and guards criminally liable, Minister, Peter Dutton,[13] said it was 'to stop the unauthorised disclosure of information that could harm the national or public interest.'[14] Fearing it would be defeated by a legal High Court challenge, the proposal was eventually withdrawn. However, what the mooting of such a proposal represented in the first instance, in its objective to strengthen even further forms of state control and secrecy, was the confidence (the gall) with which the Government moved on its incremental reduction of citizens' rights that we have seen replicated around the world this century. And it comes with seeming obliviousness or a lack of care for the way each act accumulatively corrodes citizens' trust in 'democratic' processes. As Inglehart and Norris conclude, the texture of contemporary politics is woven 'by anti-immigrant attitudes, mistrust of global and national governance, support for authoritarian values, and left-right ideological self-placement.'[15]

The fear that we were moving into a new period of authoritarianism was suggested by Nicos Poulantzas as early as 1970, opening his historical materialist text on fascism and dictatorship with the prescient question: 'What purpose can there be in a study of fascism at this moment in time?'

> I believe that the urgency of the problem makes such a study a political necessity. Until very recently the question of fascism and the other forms of dictatorship seemed to be relegated to historical oblivion, the concern of academic historiography alone. It is now becoming increasingly clear that imperialism is passing through a major world-wide crisis, which is only just beginning but which already reaches into the imperialist heartlands themselves. In the light of the sharpness of class struggle in the period we have now entered (and which stretches far into the future), the question of the exceptional State (*Etat d'exception*), and so of fascism, is therefore posed once more just as the question of the revolution itself is back on the agenda.[16]

In an interview with Christian Salmon, Judith Butler discusses how Donald Trump is the incarnation of a new form of fascism.

> What you have described are the mid twentieth-century forms of European fascism. With Trump, we have a different situation, but one which I would still call fascist . . . he acts as if he has the sole power to

decide foreign policy, to decide who goes to jail, to decide who will be deported, which trade agreements will be honoured, which foreign policy will be broken and made ... No one is sure he has read the constitution or even cares about it. That arrogant indifference is what attracts people to him. And that is a fascist phenomenon. If he puts deeds to words, then we have a fascist government.[17]

By early 2018, the situation had become so urgent that Madeleine Albright had weighed into these fears, publishing *Fascism: A Warning*. It is a clear and pointed criticism of the current US President and his methods, but she is also concerned with the confidence that Donald Trump's 'voice' is giving to autocratic leaders around the world.

Why 'per freedom-house' is democracy now under assault and in retreat? Why are many people in positions of power seeking to under-mine public confidence in elections, the courts, the media, and on the fundamental question of earth's future, science? Why have such dan-gerous splits been allowed to develop between rich and poor, urban and rural, those with a higher education and those without. Why has the United States, at least temporarily, abdicated its leadership in world affairs. And why, this far into the 21st century are we once again talk-ing about fascism. One reason, frankly, is Donald Trump. If we think of fascism as a wound from the past that had almost healed, putting Trump in the Whitehouse was like ripping off the bandage and picking at the wound and picking at the scab.[18]

The context for Albright's book is her childhood experience of twentieth-century European fascism, and thus, she forms, along with Foucault, Deleuze, Derrida et al., a valuable generation of first-hand witnesses. It makes their writings vital resources for those hoping to effectively and critically respond to contemporary conditions, at the level of political-aesthetics. As Foucault reminded readers last century in the foreword to Deleuze and Guattari's *Anti-Oedipus*,

the major enemy, the strategic adversary is fascism ... And not only historical fascism, the fascism of Hitler and Mussolini, which was able to mobilize and use the desire of the masses so effectively but also the fascism in us all, in our heads and in our everyday behaviour, the fascism that causes us to love power, to desire the very thing that dominates and exploits us.[19]

An important adjunct to this is Marina Valverde's point:

> One of Foucault's greatest insights was that the activity of governing others incited and presupposed a parallel system of self-rule; this general point ... demonstrates that the persistence of illiberal practices of moral governance is indicative not of a failure to complete the liberal project but rather of a seldom noticed but irreducible despotism in the heart of the paradigmatic liberal subject's relation to himself.[20]

To put these observations in association with Rancière: if

> the essence of the police ... is not repression but rather a certain distribution of the sensible that precludes the emergence of politics [then] there are nonetheless better and worse forms of police, depending on the extent to which the established order remains open to breaches in its 'natural' logic.[21]

Analysed with nuanced and careful attention, this would make concentration on the breaches a crucial focus for those wanting to shift the police order in this moment of greater opacity. And thus, in the next section, I am considering breaches as points of vulnerability in communities themselves, while drawing a line (albeit a chalky one) between activism and the concerns of *Artmaking in the Age of Global Capitalism*.

2

A Community of Sense

I recall a distinction made in the Introduction about thinking through a political-aesthetics for our time that is skewed differently to activism. Going into some detail about the official reaction to the Biennale boycotts was to ask how an engaged critical politics might operate in today's global art environment, with governments holding increasing sway over public funding of the arts. Nonetheless, in separating art and activism, it should not be taken that I am also casting a position in support of Transfield Holdings Chairman, Luca Belgiorno-Nettis, when he claimed that *artists should act as artists*. The atomisation of a person's labour in this way is wholly rejected as a controlling mechanism that holds and limits the possibility for resistance. Activism can be a productive component of an artist's wider practice, as it is part of Alex Monteith's, one of the artists covered in this book, just as activism might borrow from art as part of a conscious performance of resistance, as Howard Caygill reminds us of the Mexican Zapatista Army of National Liberation (1994–).[1]

While Monteith separates her exhibition practice from her activism (working on the latter as part of a collective known as Local Time), other artists work within communities and with activist methods as an integral part of their practices. In the work of the Cuban artist, Tania Bruguera, for instance, activism and art practice are indistinguishable. Her work encompasses such things as establishing political organisations, as with the Partido del Pueblo Migrante or the Migrant People's Party (MPP) (2006–2015). She describes the medium of the work as 'the Implementation of a new form of mass political organisation and creation of other forms of political representation' and the material as 'Immigration policies established by countries receiving large waves of immigration, immigrants, local and federal politicians, public presentations, performances, installations, art, activism.'[2] Another tactic Bruguera uses is to 'repurpose' terms, such as *arte útil*, conceptualising art as a tool of transformation, out of which global collectives are then established.

> *Arte útil* roughly translates into English as 'useful art', but it goes further, suggesting art as a tool or device. *Arte útil* draws on artistic thinking to imagine, create, and implement tactics that change how we act in society.

This work methodology transforms social affect into political effectiveness through realisable utopias. Instead of focusing on production, *arte útil* generates a process of social implementation. The 'usefulness' in *arte útil* is not about problem solving to improve the efficiency of the system, but about creating an altogether new system via a-legal loopholes. *Arte útil* shifts from production to a process of social implementation.[3]

It is apposite to note that Bruguera adopts the language and logic of artmaking by forming political actions out of mediums and materials. Considering that artworks are produced, for Rancière, out of the 'sensible fabric of experience', from which a critical restructuring of forms and approaches is then possible,[4] the ground for Bruguera is a language and aesthetic form that she shares (is legible) with the communities within which she produces work. Before this could have taken place, radical opponents (those who cannot share the other's say-able or see-able) have already been neutralised, as outlined through Rancière in the Introduction.[5] The constitution of a community has different beginnings to the aesthetic regime as a grouping of bodies that come before politics:

Politics comes afterwards, as the invention of a form of community that suspends the evidence of other forms by insinuating new relationships between meanings, between meanings and bodies, between bodies and the modes of identification, between places and destination. Its practice consists of calling into question existing communitarian alliances and introducing new relations of 'communities' between terms, relations that put the not-common in common much as poetic figures transform the supposed adequation of subjects and properties. That's where the 'between' finds its meaning . . . This between is not originally between subjects. It is between identities, and the roles they can assume; between the places they are assigned, and those they occupy illicitly.[6]

When Rancière discusses how a community is structured, he differs from Jean-Luc Nancy in not speaking about loss in the wake of the collapse of communism and communitarianism last century.[7] Rancière also distinguishes his conception of community from those presuming singular relations or cohesive groupings: 'I don't treat "the people" as a unifying concept. A form of subjectivation defines a figure of the people that is itself made from the tension between many peoples.'[8] 'Subjectivation', as procedures of government that turn individuals into subjects, builds on Foucault's use of the term, to include a person's politicisation, or more precisely their identification of radicalised equality through the example of a 'wrong'. Subjectivation is central to Rancière's concept of political dissensus.[9] Rancière writes:

We have had powerful figures of subjectivation, as for example the revolutionary people and the proletariat. But these figures, inhabited by homonymy, have themselves always been traversed by contradiction. There have always been many peoples in 'the people' and many kinds of proletariat in 'the proletariat'. Identification and disidentification have never stopped intermixing their reasons, and figures of subjectivation are always in danger of falling back into identitarian substantialisation.[10]

The recognition that communities are constituted by diverse and contradictory figures is not meant to also suggest that art communities (makers, activists, patrons, curators and other workers, critics and visitors) are limited in the impact they have on controlling and containing the aesthetic regime. Rather, it is to acknowledge that, as with the contested space of aesthetics, spaces within communities exist as breaches opening and closing between identities. 'Politics exists in specific communities of sense. It exists as a dissensual supplement to the other forms of human gathering, as a polemical redistribution of objects and subjects, places and identities, spaces and times, visibilities and meanings.'[11] Groups agree at certain places and times on what constitutes an art community, but this is contingent upon an ongoing process of dissensus and transformation, subjectivation and dis-identification.

Coexistent with a search for theories to explain changing social groupings, such as how to define a community, as well as a growing push for prosecuting identity interests, the 1970s saw a return to a form of *laissez-faire* economics. Western governments, and their financial arms, The World Bank and the International Monetary Fund (IMF), began directing flows of capital on the condition that certain monetary policies were implemented by states (such that global flows would be ensured) and if nations sought to borrow funds it might come with radical conditions of austerity.[12] I am thinking in particular of the Latin American Debt Crisis of the late 1970s and early 1980s, when Brazil, Mexico and Argentina, whose borrowings far outstripped earnings, were unable to service their debts, opening up to a forced intervention by the IMF that insisted on market deregulation, open free trade and austerity programmes. This was the first crisis that clearly demonstrated the brutal and rapid social costs of what was first described in the 1980s as 'dry economics' but which became widely known this century as 'neoliberalism'. The longer view will show how the grip it held on how global economics was handled led to a further re-entrenchment of class inequalities, as exponential gaps opened up between the wealthy (now dubbed the 'one percent'[13]) and the poor.

Antonio Negri and Michael Hardt have called this 'Empire':

> The construction of the paths and limits of these new global flows
> has been accompanied by a transformation of the dominant productive
> processes themselves, with the result that the role of industrial factory
> labour has been reduced and priority given to communicative, coop-
> erative, and affective labour.[14]

A return of employment uncertainties due to increased casualisation, the
withering of organised unionism, reduced state regulation and a ballooning
perception that institutions, such as banks and governments have failed us –
these are a few albeit crucial outcomes. Ronald F. Inglehart and Pippa Norris
outline the causes and effects with a little more detail:

> There is overwhelming evidence of powerful trends toward greater
> income and wealth inequality in the West, based on the rise of the
> knowledge economy, technological automation, and the collapse of man-
> ufacturing industry, global flows of labour, goods, peoples, and capital
> (especially the inflow of migrants and refugees), the erosion of organized
> labour, shrinking welfare safety-nets, and neo-liberal austerity policies.[15]

As these conditions are being spoken about with an intensifying sense of
urgency and greater impending danger, the term itself – neoliberalism – is
coming under a barrage of attacks from supporters and critics. It is too broad
and applied too universally, critics claim, to adequately capture the nuances
entwined in the causes and effects of current economic conditions.[16] However,
while the term is criticised for its imprecision and lack of clarity, nothing has
emerged at this time to replace it. Hence, I have retreated into an even more
generic term, 'global capitalism' to describe the era, but have retained neoliberal
at times to identify the pressure that market-thinking has imposed on visual
makers' practices across a large proportion of the world.

Has it always felt this way – the individual navigating her way through the
interests and complexities of power and capital, while trying to avoid being
corrupted by it? Does each age feel itself more brutally affected by capitalism
than the one that preceded it?[17] Perhaps the only difference is the presentation
of a new version of a related set of problems. In trying to come to terms with
contemporary art's approach to politics, I found myself returning repeatedly
to those two decades of the twentieth century, the 1960s and 1970s, when
social, cultural and political conditions seemed to be changing underfoot in
a quicksandy kind of way. This was touched on a little earlier with reference
to the fear of Nicos Poulantzas that fascism was returning as early as 1970.

The need to understand this moment in history led me back to some intellectual antecedents that disclosed the kinds of tensions that were gathering force at the time. In particular, the need to understand how the negative conditions being produced by contemporary capitalism might be effectively countered through art and filmmaking.

To ask how art might participate in critically responding to these effects, therefore, is to also confront criticisms that the figure of the artist is embroiled in 'neoliberal' ways, most obviously as they negotiate their ways through the contemporary art industry and its ties to private and government funding channels. We are all in some way shaped by global capitalism and this book is an attempt to ask how it might be critically questioned as a moving forwards, rather than a folding back into habitual responses that tend to neutralise political tensions. I will pose at this point the following premise: for artists to benefit from contemporary state and private funding channels means to operate with a 'know-all irony', in Benjamin's words. It means lowering an opaque haze over the objectionable parts of a sponsor's activities.[18] But this is a messy position for those working within contemporary global art networks – the desire to respond in meaningful ways to issues of inequality, while also acknowledging that it comes from a position of relative privilege, and potential speciousness. (Privilege is understood here as the freedom of self-distributed labour and the independence to pursue a fairly high level of independent thought, but one limited by the conditions of contemporary economic systems.) To defend contemporary art's potential to form a critical political aesthetic that might shift ways of thinking, saying and seeing, then I think it is important to understand the conditions – aesthetic, political, social and economic – that have brought us to this historical moment, as well as some relevant philosophical and political theories that have interpreted these conditions.

3

Crisis on the Left

When the 2015 Venice Biennale performed readings of *Capital* as part of its curated programme, Marxism had become 'fashionable' again after being 'out of favour' for several decades. It had become fashionable in a commodified way at Venice, but now in the afterlife of the Global Financial Crisis (GFC) of 2007–8, with another show of capitalism's resilience, Marx had also returned for serious re-interpretation for the twenty-first century. In a paper presentation, delivered in 2018, Antonio Negri proposed three reasons why we should 'start again with Marx'.[1] 'The first reason is political. Marx's materialism helps us to demystify all progressive and consensual notions of capitalist development, and affirm, in opposition to them, its antagonistic character.'[2] The second is Marxist critique: 'Marx carries forward his critique of capitalism in a historical ontology that is construed and always renewed by class struggle. Critique takes on the standpoint of the oppressed working class and puts it in motion.'[3] As with all returns, Marxism carries an entanglement of past debates that have metastasised throughout its body. It was what Negri calls 'Marxist dogmatism', which, as a founding member of *Potere Operaio* (Worker's Power, 1967–73), was the force against which part of the movement pushed to incorporate concerns of marginalised identities and foreign workers.[4] The third reason for the urgency of Marx today is the struggle for 'the realm of the commons' and its 'reappropriation on behalf of the workers and citizens.' This includes 'the common goods of nature . . . a defence from the chemical and destructive invasion of the *bios* of the earth, struggles for the reappropriation of life and environmental struggles in general.'[5] This is Negri's urgent need to rethink current conditions under Marxist terms. He proposes that capitalism fled the factories as retaliation for the rise of radical movements and the power of unions in 1960s. Yes, it was a flight, if not an attack, if one is to recall Margaret Thatcher's brutal suppression of the miners and other workers' strikes in the early 1980s, but only from the position of advanced capitalist economies. As manufacturing moved exponentially through these years into the factories of so-called 'developing' nations, the workers who produce most of our commodities continue to suffer from ineffective representation (unionism), unsafe conditions, long hours and low wages.

The bewilderment, the confusion, the necessity to rethink the logic of revolution intensified following the effective suppression of the May 1968 uprisings. It was a decisive achievement by the French State that negotiated with the trade unions to end the strikes.[6] André Gorz encapsulated the kinds of debates that arose over what he called the 'category proletarian', delivered with censorial sarcasm:

> It is of little importance to know what proletarians themselves think they are, and it matters little what they *believe* they are doing or expecting. All that matters is what they *are*. Even if their present behaviour is a little mystified and their current desires somewhat at odds with their historical role, sooner or later essence will out and reason will triumph over mystification. In other words, the being of the proletariat transcends the proletarians. It is a sort of transcendental guarantee that proletarians will ultimately conform to the class lines.[7]

For Jacques Rancière,

> things were thrown brutally into relief [after 1968] ... no 'Marxist' discourse could continue to get by on the mere affirmation of its own rigour [because] the Althusserian theoretical presuppositions prevent us from understanding the political meaning of the student revolt.[8]

It was from within such an atmosphere that Rancière was led to not only reject the writings of his teacher and mentor, Louis Althusser, but to charge him with idealism, a problem Marx had focused on overcoming in the nineteenth century: 'There, where the "need for philosophy" was shorthand for a political demand, Althusser acts as if philosophy itself was the object of the demand, as if philosophy itself was politics.'[9] In a search for a more 'materialist'-materialism that might also resist the elitist pose of explication, Rancière took a very different turn, publishing in 1969, *Le maître Ignorant (The Ignorant Schoolmaster)*, 'a revolution in teaching from a chance experiment' which he subtitled 'five lessons in intellectual emancipation.'[10]

It was not only about who speaks for whom that saw Marxism came under criticism after 1968.[11] What had become particularly niggly, and from within the left itself, were questions about the cogency of laying the revolutionary subject over the figure of the proletariat. Étienne Balibar has pointed out that proletariat was described by Friedrich Engels in *Condition of the Working Class in England* (1844):

> In short, they are all those now called (from an old Roman word) proletarians, which the Industrial Revolution created in huge numbers, crowding them into its cities and plunging them into poverty,

and who have now begun to shake the bourgeois order by their strikes, their 'combinations', their insurrections. They are, so to speak, *the people of the people (le people du peuble)*, its most authentic fraction and the pre-figurement of its future.[12]

The problem of the category proletariat for theorists after 1968 is summarised by Jean-Philippe Deranty: 'The question of whether or not this identity underlies a history of emancipation becomes irrelevant in view of the overriding practical, political consequence of such reduction. In the end, the proletarians are unable to free themselves by themselves.'[13] This passage comes from an article on Rancière, in which Deranty also notes Rancière's shift in focus to 'the workers who transgressed and subverted the order of things, by claiming the right to be poets, playwrights, philosophers and so on, that is, the right to have a meaningful voice beyond the constraints of their social destiny.'[14]

By 1990, as identity politics gained greater momentum, Robert Young, whose work emerged from within the discipline of post-colonial studies (a term replaced today with the verb 'decolonising' practices) issued an indictment against the whole Marxist project:

> So as long as gender and race can be satisfactorily subordinated to class then Marxism does not need refuting, and history can be reasserted as the single narrative of the Third International ... Marxism's inability to deal with the political interventions of other oppositional groups has meant that its History can no longer claim to subsume all processes of change. The straightforward oppositional structure of capital and class does not necessarily work anymore: if we think in terms of Hegel's master/slave dialectic, then rather than the working class being the obvious universal subject-victim, many others are also oppressed: particularly women, black people, and all other so-called ethnic and minority groups.[15]

At the same time as the 'proletariat' failed to materialise as a united body in the revolutionary struggle, sectionalised agitators with diverse demands grew in forceful opposition to totalising theories (in particular, decolonising subjects, feminists, non-normative identities, sexuality and physical ability, and so on), a shift that is labelled in political science circles as 'postmaterialism'.[16] Two decades later, Phillip Rothwell reiterates these concerns, writing,

> In the realm of political action ... asking women and sexual minorities to subsume their needs and aspirations to the workers' or independence movement's revolution often leads to the replication of oppressive hierarchies and the reinforcement of a reactionary or colonizing status quo.[17]

There also appeared to be an unpreparedness for some on the left to account for the effects of changing economic and social conditions last century, or rather a reluctance to move away from dialectical thinking. Alongside, there was tendency by others to criticise Marxist approaches to critical theory, or any approach that was seen to be totalising or universalising.[18] Consistent with their push to rethink the logic of the political against totalising systems, Gilles Deleuze and Felix Guattari, in their first collaborative text, *Anti-Oedipus: Capitalism and Schizophrenia* wrote:

> We no longer believe in a primordial totality that once existed, or in a final totality that awaits us at some future date. We no longer believe in the dull grey outlines of a dreary, colourless dialectic of evolution, aimed at forming a harmonious whole out of heterogeneous bits by rounding off their edges. We believe only in totalities that are peripheral. And if we discover such a totality alongside various separate parts, it is a whole *of* these particular parts but does not totalise them; it is a unity *of* all of these particular parts but does not unify them; rather, it is added to them as a new part fabricated separately.[19]

My excising of this paragraph from a large body of work is misleading, for it infers that Deleuze and Guattari were dismissing Marx altogether rather than for its Hegelian tendencies. Marx's insistence on bringing the material from the immaterial to reconcile the division between abstract thought and worldly action, described by Vincent Descombes as the search for a concrete philosophy,'[20] played a significant role in post-war French political theory. It was particularly pertinent to Jean-Paul Sartre who compensated for the a-politicism of his existential metaphysics by adopting a Marxist critique of contemporary events, publishing articles through the political journal, *Les Temps Modern*, which he co-founded in 1945.[21] Especially engaging were his public debates in support of various decolonising forces against French rule.[22] Nonetheless, neither Deleuze nor Guattari were friends of the phenomenological tradition into which Sartre's existentialism fell, and their route to politics took a decisively different turn. (Deleuze claimed that his interest in politics was incited only after the events of May 1968 and his meeting with Guattari.)

In a panel discussion on 'Deleuzian Politics?' Peter Hallward criticises Deleuze and Guattari's version of Marxism, writing,

> if you think about the usual, conventional way of using Marx, in someone like Sartre for instance [he was] one of the last philosophers who was able to talk meaningfully about politics in a way that exceeded the limits of academic philosophy.[23]

Such a view tends to fix Marxism, albeit inadvertently, as an orthodoxy rather than a living, discursive field, leaving the problem of the revolutionary subject, coupled with the question of who has agency to speak for whom, as unresolved problems for contemporary discourse. Another panel member, Nicholas Thoburn responded,

> whilst they declared themselves to be Marxists they also problematise Marxism quite regularly, as a narrative of development and as a potentially constraining identity-form. Nonetheless, what seems to me really clear is that *Anti-Oedipus*, at least, is completely traversed by Marx and Marxism.[24]

Pressed against the legacy of left scholarship and the changing economic conditions of the latter decades of the century, it would be more useful to see their criticism of totalities not as a rejection of Marx but as a search for new thinking that might account for the resilience of capitalism.

> Felix Guattari and I have remained Marxists, in our two different ways, perhaps, but both of us. You see, we think any political philosophy must turn on the analysis of capitalism and the ways it has developed. What we find most interesting in Marx is his analysis of capitalism as an immanent system that's constantly overcoming its own limitations, and then coming up against them once more in a broader form, because its fundamental limit is capital itself.[25]

At the time of writing *Anti-Oedipus*, May '68 would have still been a raw reminder of the way counter-insurgencies against capitalism had been defeated with acuity through the centuries. Thoburn touched, I believe, on the crux of Deleuze and Guattari's predicament:

> One gets the sense that the foregrounding of Marxian concerns through an emphasis on capitalism has emerged to suit a time of political impasse. It is as if after the deterritorialising joys of '68 (a time when Guattari said he 'had the impression sometimes of walking on the ceiling') and the early English-language reception of Deleuze and Guattari's work, our more sombre times require a recognition of the increasing isomorphism of processes of complexity and difference to capitalist productivity.[26]

To rebuke the widespread perception that May '68 was a failure, in a 1990 interview with Antonio Negri, Deleuze surmised that 1968 'was a demonstration, an irruption, of a becoming in its pure state . . . To say revolutions are bad is to confuse two different things, the way revolutions turn out historically and

people's revolutionary becoming.'[27] This was the conclusion drawn by those who had boycotted the 2014 Sydney Biennale. According to one of the artists involved, it was a shaking up of the existing order, part of an ongoing process, a becoming that would build greater awareness over time.[28]

Although coming from a different perspective, the collaborative work of Deleuze and Guattari should be added to that of Michel Foucault, in particular his lectures on bio-politics that were directed to thinking through and against the dominant forms of power at the time.[29] Foucault had revealed that increasingly insidious forms of disciplinary control had been developing since Europe had evolved from centralised, sovereign rule to the entrenchment of bourgeois capitalism,[30] and this was applicable to western states in general.[31] Perhaps this might be considered one of greatest points of tension for critical theory in this period, for while the analyses of Deleuze, Guattari and Foucault seemed intent on forming new ways of thinking about systems of contemporary power, what seemed to stick to them, sometimes quite virulently, were accusations that they were in support of the very system of power they were analysing.

The criticism that Foucault had turned against Marxism is nonetheless uncontroversial. In the late 1970s, Foucault supported *nouvelle Philosophie* (the New Philosophers), in particular, André Glucksmann, a disaffected member of a European Mao-spontaneity group, Gauche prolétarienne. Glucksmann now insisted that Marxism inevitably ends in the Gulag.[32] (There is conjecture by some commentators that this was the probable cause of his rift with Deleuze around this time.)[33] As a return to *laissez-faire* economics gained momentum, Foucault's support was perceived at the time as his slippage into conservative politics, and an abandonment in the fight to overcome class divisions and inequities. For there seems little doubt that conservative forces leapt onto this new phase in French political thought. Peter Dews cites a *Time Magazine* cover story of September 1977, titled 'Marx is Dead', where the author writes, 'the discovery (at long last!) of a group of young, handsome and militantly anti-Marxist French intellectuals'. Dews notes that such reporting was typical of a crude conflation of the human rights ideology of the US President, Jimmy Carter, and *nouvelle Philosophie*.[34]

Criticisms about Foucault have not dissipated with time, and his work on bio-politics continues to attract negative criticism. In a recent text, Daniel Zamora does acknowledge that Foucault was always supportive of excluded groups; that is, groups not benefiting from modern employment. However, Zamora criticises Foucault for pushing a 'broad conception of identity' to replace the problem of exploitation. 'As the concept of "social class" disappeared from philosophical analysis, the struggle against capitalism was gradually being replaced by a struggle against normalisation of behaviours and identities imposed on subjects, as well as Marxism and "social statism".'[35]

On the other hand, Antonio Negri remembers the atmosphere in Europe at the time by relating his personal response to the political mood in Italy.

> The overlap between my reading of Foucault and a period of my work when I tried to summarise a lengthy 'revisionist' interpretation of Marx. This revision was not at all a rejection of Marx, as was often the case at the end of the 1970s.[36]

Negri was trying to find a way to overcome the pragmatism of the Italian Communist Party and the Unions, a move they called 'the historic compromise', as they joined with right-leaning forces.[37] Negri touches on the rawest point in what emerged as a problem for the Left at this time, how to conceptualise the 'neoliberal' subject. With Foucault, we could say: 'the Human being is not characterized by a certain relation to truth, but he possesses, as belonging properly to him, a truth both offered and hidden.'[38] I labour this point, only to try to immerse my thinking, as much as possible, in the times themselves, to try to understand, in other words, the kind of joyful, future positing that Foucault's new thinking must have had on Negri and other progressive thinkers at the time.

However, by returning to these debates today is also to see that the attacks against Marxism through the latter decades of last century, such as Young's, were often heavy hammers against more subtle filiations of thought. In his critical review of Marxist philosophy, Étienne Balibar argues:

> Marx was not led by his theoretical activity towards a unified system, but to an at least potential plurality of doctrines which has left his readers and successors in something of a quandary. Similarly, it did not lead him to a uniform discourse, but to a permanent oscillation between 'falling short of' and 'going beyond' philosophy.[39]

At the core of Marx's analysis of capital is an approach, Balibar continues, that is better described as an 'open totality', meaning that

> not only is there no distinction to be made between 'philosophical' and 'historical' or 'economic' works, but that division would be the surest way to fail to understand anything of the critical relation in which Marx stands to the whole philosophical tradition, and of the revolutionary effect he has had upon it.[40]

In the following section, I want to touch on the form and impact of the dominant, global economic system of our time and how it impacts art practices.

4

'Efficient Market Ideology'

Artmaking in the Age of Global Capitalism is asking how art can function as a critical political aesthetic today, in particular how it might shift ways of thinking, saying and seeing. Although controversial, since it has failed to meet its promise, the dominant economic system is still driven by the 'efficient market ideology', which is another way of insisting that as long as the very rich are looked after, wealth will trickle down to the greater populace.[1] One reason to look back to the 1970s is to try to understand why analyses of these nascent conditions seemed to bifurcate in these years. There were those who worked with the texture of intensifying global capitalism, while developing new forms of resistance; while others seemed to insist on maintaining class segmentation in defence of a more 'orthodox' Marxist approach. In the creative disciplines (art, architecture and cinema), the uptake of French philosophy – particularly that of Barthes, Foucault, Derrida, and later Deleuze and Guattari – was widespread in the latter decades of last century, accompanied by disdain in certain circles (justified or not) for Marxist totalities (as outlined earlier). If the tag of 'neoliberal' sticks to certain philosophers during this period (Foucault and Deleuze were the chosen examples), then it also attaches to the figure of the artist who acts from within an industry largely determined by global economics. 'To act' in this sense implies finding ways to disrupt the smooth flow of the 'police order' (as shorthand for the hegemonic management of the aesthetic regime). It is only with acknowledgement of this milieu, which is supported by multiple public and private economic interests, that it is possible for artists to productively resituate their tactics, to move, in other words, from conceptualising to acting, from developing a suitable critical method that might shake up the political-aesthetic.

When Guy Debord published *The Society of the Spectacle* in 1967, it was the culmination of ideas that had been fermenting for more than a decade in the pages of *Potlatch* (1953–7) and *The Situationist Internationale* (1958–72), radical art journals that explored different ideas about the effects of capitalism on art and the psyche. Under capitalism, as Marx had postulated, our immediate orbit has been fractured by the wealth of society being calculated by commodity-producing capital.[2] However, by giving shape to current forms of

alienation, the spectacle theory was a way to pull together, under a single con-cept, the diverse causes and effects of post-second World-War capitalism, to update Marx, in other words, for a new age. According to the situationists, the spectacle is 'separation perfected',[3] the 'concrete inversion of life and, as such, the autonomous movement of non-life.'[4] It perverts life by supplanting truth with falsehoods, reality with image, and action with passivity, and it operates in a very specific way. Out of reach but necessarily perceptible, there exists a sense of 'reality as the unity of life' – 'reality' positioned on the periphery of our understanding, if you like – which provides the complement for the sense of loss or alienation that we experience in our daily lives.[5]

In 1967, Debord believed that the spectacle incorporated, two forms: dif-fuse, representing monopoly capitalism; and concentrated, representing state bureaucracy. He believed that the diffuse form of the spectacle, as both a goal and an outcome of the dominant mode of production and its associated abun-dance of commodities, was already reaching into all areas of life and governing almost all time spent outside the production process. The concentrated form, a model for totalitarian governments, supported by police violence and punitive disciplinary methods, was sustained by the relentless imposition of one version of the 'good', mercilessly enforced.

Today we are in the midst of a further intensification of the effects of a radical capitalist ideology. Its ancestors are liberalism (an insistence on small government and low taxes) and classical economics (a form of economic theory that confines its interests to questions of labour and capital).[6] The job of government, under these terms, is to protect property and to allow capital to flow freely with minimal or preferably no regulation. This form of *laissez-faire* economics thrived in the nineteenth century, producing negative conditions out of which organised labour movements were able to flourish. Throughout the twentieth century, in advanced capitalist countries, there were moments when organised labour enjoyed sympathetic support from government, with accompanying strong welfare systems.

However, by the 1970s, forces of opposition railed against this type of gov-ernment. The centre of influence for conservative governments, their theoretical justification for deregulating markets and labour across the globe and privatising state-owned facilities and services, was the Chicago School of Economics, more particularly, the economist, Milton Friedman and his colleagues. In contradis-tinction was the proposition underlying Keynesian economics that governments *should* intervene with spending to avert depressions (an example would be the projects, known as The New Deal, instituted by the Roosevelt administration in 1933 to alleviate the effects of the Great Depression). The Chicago School, however, pushed for supply-side economics and the withdrawal of regulatory barriers. At the heart of support for free-market policy was an abiding belief that markets are rational, efficient and just, and also operate in uniform ways.

By the time Debord came to write 'Préface à la quatrième edition Italienne de *La Société du Spectacle*' (Italian Preface) in 1979, he perceived that the domin-ion of both forms of the spectacle, the diffuse and concentrated had intensified, with the sham 'getting thicker, descending to the fabrication of the most trivial things, like a sticky fog which accumulates at the ground level of all daily life.'[7]

Although still pursuing a regulatory-free system, neo-classic economics, promoted by the Chicago School, rejected the idea that governments should not interfere with capital. On the contrary, the state should actively pursue opportunities that would *ensure* capital flows freely, without regulatory inter-ference. This represents a marked shift from a more hands-off role for econom-ics to one that busies itself in all areas of society, justified by a theory that the market is ultimately fair. This trickle-down ideology has proven over time to erode a strong middle class and widen the disparity between the very wealthy and the poor. As Thomas E. Janoski notes, other economists rejected the effi-cient market hypothesis, which reached its peak of influence 'in the 1990s up until 2008', arguing that on the contrary, the market produces inequality. 'There are three main issues that social scientists contest about neo-classical views of markets', Janoski writes, 'inequality, instability and residualisation or overreach.'[8]

The last point of criticism, the overreach of economics, is particularly pertinent for the arts and humanities. Working out of Theodore Schultz's 'return-on-investment' research,[9] one of neoliberal's leading Chicago School theorists, Gary Becker, student of Milton Friedman, argued for a 'human capi-tal' factor to be applied to areas of society that had previously been considered beyond economic interest, such as education. In Becker's highly influential *Human Capital*, he argues for a quantifiable return for training and educa-tion based on a return on investment outlay.[10] Such a proposition will end up becoming the global norm, extending this rationale into all areas of society. David Harvey points out, 'If markets do not exist (in areas such as land, water, education, health care, social security, or environmental pollution) then they must be created by state action if necessary.'[11] I would extend this to museums and the arts, or to borrow neoliberal language, forms of 'cultural capital'. As Fred Block observed, seeing the value in human endeavours only if they satisfy an economic return, reduces human activity to an exchange of commodities, and the idea of capital to a purely quantitative measure.[12]

By 1988, in his *Commentaires sur la société du spectacle*, Debord concluded that the spectacle, now imposed worldwide, had finally integrated into a form simultaneously diffuse and concentrated. 'When the spectacle was concen-trated, the greater part of surrounding society escaped it; when diffuse, a small part; today, no part. The spectacle has spread itself to the point where it now permeates all reality.'[13] The general victory of the diffuse form now dominated the character of the integrated form. Thus, the distinct forms of spectacular

power that had once existed between state bureaucracy and monopoly capitalism were now imperceptible, reaching rapidly across the globe. The diffuse form, which ultimately came to overpower the world, had always been the more seductive, and thus, the more savage in the way it encroached into all regions of the physical and behavioural character of society. This is the systemic structure of capitalism itself, a total system, which nonetheless produces fragmentation (alienation).[14] Debord was clear to stress that the spectacle is a false means of unity, merely an illusion of unity.

One objective in the situationists' development of the spectacle theory was to find a way to understand how the energy of resistance (in whatever form it takes) ends up being absorbed by the market, a process they called 'recuperation'. It is what Deleuze and Guattari describe as capitalism overcoming its own limitations that subsequently bolsters the system making it all the more resilient. Working within a Marxist tradition, the concept of recuperation owed its critical form to György Lukács' 'reification' theory, reached through his analysis of Marx's concept of commodity fetishism.[15] However, where Lukács had focused on commodity relations, Debord pushed this further to suggest that commodities, despite their reifying nature, constitute only part of the story. Capital today, he surmised, is mediated via images, or, put differently, the spectacle is capital accumulated to such a point that it has become image. Debord's inherent Platonism situates images in a secondary order to 'truth' or 'reality', and thus he conceives of contemporary conditions as being corrupted by images coming from every aspect of life to merge into a common stream. This single, spectacular, image-commodity-world says nothing more than 'What appears is good, what is good appears'.[16]

By the late 1950s, art was considered by the situationists to be impossibly embroiled in the capitalist system, necessarily both a cause and an outcome of the spectacle. By 1962, the process by which ideas and artworks are recuperated, to be sold back as commodities, led the Debordian faction of the situationists to give up art altogether and all practising artists were expelled from the group.[17] Instead, they turn to the streets with the ambitious objective to re-imagine architecture and the built form. In 1963, the four remaining situationists, the Parisian faction, wrote:

> It is striking that of the twenty-eight members of the Situationist International whom we have had to exclude so far, twenty-three personally had a socially recognised and increasingly profitable role as artists; they were known as artists in spite of their membership in the SI. But as such they were tending to reinforce the position of our enemies, who want to invent a 'situationist' so as to finish with us by integrating us into the spectacle as just one more doomsday aesthetic.[18]

To give up art as the only 'logical' way to avoid being consumed by the system represents the most extreme reaction to the market at the time. Through the 1950s to the 1970s, there were many other methods being tested around the world that would attempt to remove art from the interests of the market. The Happenings of Allan Kaprow and Carolee Schneemann, mail art, New York's conceptual artists, performance art, The Art & Language Group, the Japanese Gutai, the German, New York and Australian Fluxus artists, the French *Nouveaux Realistes*, and the Italian Arte Povera (to suggest a random sprinkling only) proved the least effective at resisting recuperation. Each group would fail the logic of the situationists' spectacle theory. By 1975, Ian Burn, a member of The Art & Language Group, was accusing his community of artists of internalising 'an intensely capitalistic mode of production' within 'endless market expansion' and the 'idea of an endlessly innovative avant-gardist growth'.

> While it may once have seemed an exaggeration of economic determinism to regard works of art as 'merely' commodities in an economic exchange, it is now pretty plain that our entire lives have become so extensively constituted in these terms that we cannot any longer pretend otherwise ... The inside story of this is that there is no 'radical theory' in the arts today, and there can be none while the present state of affairs prevails. That also explains something about the extreme poverty of 'critical theory', since a critical theory which sets itself the task of revealing the various forms of conflict and exploitation needs to be informed by some (prospect of) radical theory, something which denies the current ideology and economic class values embodied in modern art ... In this light, most of the chatter about 'plurality' in the contemporary scene comes over as so much liberal claptrap.[19]

For Burn, it meant returning home in 1977, whereupon he established *The Artworkers Union, Australia* (1979–92),[20] organising affiliations with other creative industry unions, such as the Media, Entertainment and Arts Alliance Union (MEAA), and writing for union magazines.[21] Organising artists around issues of art labour is one form of resistance to global capitalism that continues today.[22]

Writing in this century, both David Harvey and Frédéric Lordon echo Debord in their analyses of contemporary global economics. Harvey wrote:

> Neoliberalism has, in short, become hegemonic as a mode of discourse. It has pervasive effects on ways of thought to the point where it has become incorporated into the common-sense way many of us interpret, live in, and understand the world ... [effecting] divisions of labour, social relations, welfare provisions, technological mixes, ways of life and thought, reproductive activities, attachments to the land and habits of the heart.[23]

And in the opening of *Willing Slaves of Capital*, Frédéric Lordon describes capitalism as a 'repulsive spectacle' that 'tramples the main tenet of the very body of thought that it flaunts'. Capitalism, he writes, 'keeps making itself contentious'.[24]

Artmaking in the Age of Global Capitalism is asking how art can function as a critical political-aesthetic today; how it might shift ways of thinking, saying and seeing. Looking back to the 1970s demonstrated that the texture of intensifying effects of global capitalism fractured the left. If the criticism of neoliberalism stuck to certain philosophers during this period, then it is also attached to the figure of the artist who acts from within an industry largely determined by global, neoliberal economics. It is a situation where even the public sector is likely to be financially supported by private interests, and where government funding for museums is often tied to visitor numbers and other quantitative data measures. Before moving from conceptualising to acting, from developing a suitable critical method to shaking up the political-aesthetic, for artists to productively resituate their tactics, then perhaps this is the ground that must first be acknowledged. There will always be limitations. And while this is premised on thinking productively about a changed future, none of us are beyond the reach of the global economic-political system, nor innocent in helping advance its interests. We modify our idiosyncrasies, our innate impulses, to survive in whatever economic and social environment we find ourselves.

Modification is not necessarily a conscious act, as Catherine Malabou has shown, for 'Our brain is plastic, and we do not know it.'[25] Such plasticity affects artists, filmmakers and writers in the complicated process of adapting/mollifying the brain to the most highly valued identity of the neoliberal's armoury: 'the entrepreneur'. The entrepreneur is the ideal figure, independent, self-motivated, creative, can turnover ideas quickly and productively, knows how to generate funding, is financially self-reliant, and importantly, epitomises the one for whom the onerous burden of work has been removed.[26] Massimo Cacciari outlines how 'the artist' has enjoyed throughout modernity a certain level of 'freedom' within the realm of labour:

> As a reaffirmation of the artist's function of effective emancipation-liberation from the pure relations of exchange dominant in the metropolis; art is conceived of as an expression of a de-alienated work-time and hence as a full expression of freedom itself. And this image of de-alienated labour and freedom is secured in the product through the 'absolute' distinction between use-value and exchange value and the subsequent transformation of use-value by artistic creativity. Handcraft labour represents, in one way or another, the language of this creativity, its necessary technique of

application. The quality implicit in use value ceases to reflect a condition of the entire capitalist mode of production and becomes as it were the remnant of a vanished form of labour, nostalgically rending towards its re-actualization – memory and duration.[27]

If we think of artists as those who through their craft enjoy a form of de-alienated labour, then these two figures, the artist and the entrepreneur, begin to coalesce. Frédéric Lordon extends this point to a contemporary, neoliberal workforce:

> [Artists], this very rare, isolated tribe, this limit-point of employment, has been turned into a general model for the overall project of neoliberal normalization. Is not the artist the very emblem of 'free will', and the unreserved commitment of the self? More to the point, is not the artist the proof *par excellence* that the second correlates with the first? For artistic productivity arises from the alliance between the artist's specific skills and the condition of coinciding with one's desire. And this is precisely the ideal formula which the neoliberal enterprise would like to reproduce on a large scale, evidently with the provision that each employee's 'own desire' must be aligned with the desire of the enterprise.[28]

I would add a qualification, therefore, the consumerist, individuated impulses that shape our expectations of art probably should be placed in the context of neoliberal's subject-modifying effects. In the face of the so-named 'precarity' of today's labour conditions, the privilege of the artist may continue to fall on the side of de-alienated labour, but the reality of survival means finding one's way between the polarities of adapting/resigning to market demands or taking up the insecurity of casual and part-time employment in whatever field is available. Against the pan-endemic of the effects of global capitalism, it takes ongoing vigilance and brutal self-reflection to test the soundness of one's creative output. It means checking too that we are not instrumentalising our friends and colleagues in pursuit of our own ambitions and desires.

Part II

Encounters from the Twentieth Century

Encounters from the Twentieth Century: Introduction

In his recent study on 'theories of emancipation', Razmig Keucheyan opens with the following words: 'In the beginning was defeat. Anyone who wishes to understand the nature of critical thinking must start from this fact.'[1] The student uprisings in Paris in May '68 are frequently cited for the widespread disappointments, failures, and senses of betrayal that the events induced in the Left, and for the chasm opened up between the desires of intellectuals and those of the proletariat.[2] Described by those writing at the time as a moment of exuberance, violence and festivity, the riots spread from the students to the workers, engulfing Paris and beyond over several weeks.[3] France, as one observer wrote, was 'poised between exhilaration and fear'.[4] In the midst of all the excitement it was inconceivable that anything could possibly be the same again. The Event was an insurrection (a defence!). In Alain Touraine's analysis, it was a battle against the forms of alienation and domination that had been wreaked by advanced capitalism. And it was fought in both the symbolic and the 'real' spaces of Paris. The 'night of the barricades' (the students' occupation of the Latin Quarter on 9 and 10 May) was 'one moment in "May" around which all myth-hallowed liberating potential centres.'[5]

It was in this mood that Angelo Quattrocchi wrote in his 'tale' of May 1968; 'Revolutions are the ecstasy of history: the moment when social reality and social dream fuse (the act of love).'[6] The handling of the event by the State proved to be a turning point in the 'crisis', for it rallied previously unimagined public support for the students. Quattrocchi remarked: 'The ruling society mustn't be caught in the act of murdering its own children.'[7] And although the barricades had been erected without plan and the cobblestones had been thrown with little purpose, these acts worked immediately on French consciousness, raising images of former uprisings, especially that of the Commune in 1871. Moreover, slogans written originally by the Communards had found their way once again onto the walls of Paris nearly 100 years later, releasing the same expectations: 'Run forward Comrade, the old world is behind you.'[8] 'The barricade [in 1871] was a technique; in May '68, it was a sign, at once a throwback to the nineteenth-century and conclusively modern.'[9]

May 1968 had not been an uprising led (or even understood) by traditional, left forces, such as the influential French Communist Party that had somehow been superciliously blinded by the idea of the transcendent proletariat, or the unions that ended up negotiating with the conservative President, Charles de Gaulle, for higher wages. Importantly, as André Gorz stressed, in a spirit resonant of Guy Debord, the internal contradictions of capitalism had not been solved or overcome, 'they had never been more spectacular'.[10]

What had been left behind was a conceptual chasm, with no other agents of transformation capable of filling it. Some had mooted youth as the next revolutionary subject. But this was logically incoherent, not a group at all, connected only through media-commodity images that had been altered by the interests of the market and then projected back onto them. From the 1950s onwards, youth had been one of the preferred targets of the commodity market, and it had been easily and successfully named and seduced, frequently under the image of 'rebelliousness'. As such it would prove itself to be too compliant, multivalent, diffuse and without purpose. Far from replacing the ideal of class politics, youth as a generalised category was at the vanguard of a momentous shift that was taking place; modernity was not only in the process of turning away from the paradigm of production to consumption, but also from collectivism to identity politics. As it became clear in a post-analysis of the events of '68, to believe in Marx's proletarian class as the bearer of the revolutionary project had been placed under enormous strain.

And thus, with positions now blurred, I am reminded of the hostile reception of Theodor Adorno's posthumously published, non-materialist *Ästhetische Theorie* (1970) by the New German Left. When Adorno, as Peter Uwe Hohendahl writes, 'presented modernism and the avant-garde as the only viable response to the increasing brutality of advanced capitalism,'[11] it was used to support what was judged as a conservative position. '[Adorno's] renewed claim that, in the final analysis, only the authentic work of art over-comes the stultifying atmosphere of the cultural industry met with disbelief and outspoken disapproval.'[12] Adorno's critics judged his late work to be 'irrelevant for the Marxist project'.[13]

Encounters, such as those between Adorno and the German New Left (or between Foucault and his detractors) and those that follow are fragmentary moments in pursuit of an intentionally, non-totalising approach to history. The aim is to reveal past fractures in the left to avoid restaging meta-histories of past activity. It is a tactic to avoid historicism, in Benjamin's terms, since repeating or staging a canonical line of political art, as foreground to the contemporary, would carry with it the same problems of marginalisation and exclusion that flowed from historical discourses in the past. An example is Peter Osborne's philosophy of contemporary art, *Anywhere or not at all*, that

re-treads the same old ground of predominantly male artists from last century, reinscribing the idea that these are the 'master-works' of the period.[14] Alternatively, one could enact a crude form of deconstruction by restaging another art-historical narrative, with the presumption that this might contest the canon, while actually only replacing one narrative with another.

Artmaking in the Age of Global Capitalism is intent on avoiding either of these options, and so the next section draws upon three particular encounters between thinkers or artists from the second half of the twentieth century that disclose fissures in what continues problematically to be called Leftist thinking, particularly over the role of Marxism. The first of these is between Pier Paolo Pasolini (1922–75) and Italo Calvino (1923–85) who 'fell out' over whether obscurity or directness is the more prescient political method; the second is an explication of Henri Lefebvre's (1901–91) concept of the 'everyday', which he developed via a Hegelian-Marxist methodology, and the retort that came from Maurice Blanchot (1907–2003) as he slowly unravelled Lefebvre's revolutionary promise. The third comprises an analysis of the early work of the Neue Slowenische Kunst (1984–) who made art in response to the effects of a devolving communist state, and yet, in a western context of free-market capitalism, the results of such methods seemed indistinguishable from work that supports the expansion of a neoliberal agenda.

The three examples are thereby quite idiosyncratic. To believe that exceptions will be discoverable in the details of an (in)accessible and remote past is to also believe in an historical-materialist-Walter-Benjaminian kind of way that a form of truth (this ideal) also resides there. While discussion of divisions in leftist thinking were introduced earlier, the next section digs down into the detail of such divisions by exploring specific encounters from recent history. I am proposing this as the ground for understanding the evolution of contemporary political-aesthetics, without the demand to restage another history. Thus, the examples are not meant to fold one into the other but to stand, if the reader so wishes, as separate narratives that build to a larger picture. If May '68 is used as a symbolic marker to identify an inherent crisis in the way society was being interpreted, then I offer these encounters as rumblings on either side of that event.

5

Encounter One: Pier Paolo Pasolini and Italo Calvino

> *A lowering morning in July,*
> *A taste of ashes fills the air;*
> *A smell of sweating wood stains the hearth.*
> *Drowned flowers.*

> (*Lines*, Arthur Rimbaud[1])

It is a sad moment for Pier Paolo Pasolini, Marxist, lover (but also victim) of the *stracci*,[2] poet, filmmaker, essayist ... It is 1964, he is forty-two, and he believes (painfully) that the political resolve of the Left is fraying as it becomes progressively ensnared in the complications of language.[3] He begins to rail against those he once admired but whose expression of politics had become a matter of deflection (of implication), rather than an act of clarity. He concludes that power and social conditions are not being placed under close and ongoing scrutiny (the author, Italo Calvino, is his most prescient target) but floating in a much lighter air, more ambiguous, and perhaps more cynical.

> *If now the analogic survives*
> *and Logic is out of style*
> *(and I with it:)*
> *there's no call for my poetry.*[4]

The quote is a portion of a stanza from *A Desperate Vitality* (1964), excised from this larger whole, which itself is both whole and diverse and broken. Sadness about his times (and his own place in it) runs through the poem in the way knobby bits of a spine push against skin.

> *Neo-capitalism has won, I'm out on the street /*
> *as a poet [sob] /*
> *as a citizen [another sob] /.*

A notion to return to Pasolini had been sitting vaguely in the background of my thoughts for a while now, but such a 'return' was not to be a digging into

the factual documents of his life, in the method of the archivist, for instance, but an attempt to syphon atmospheric and sensible affects from his politics. My hope had been to transform such affects into energy capable of redressing my own political melancholia, without simply returning to old and tired divisions. I began reading *A Desperate Vitality* naïvely, therefore, not expecting to find the contradictions of my own desires so clearly challenged by Pasolini.

This poem, this 'cinematic' poem, attempts to summon in words the effect of watching a Godard film, only to use this same device as a method for criticising Godard's style and intent, and thus his politics.[5]

> *As in a film by Godard:*
> *Beneath that unique sun that steadily bled,*
> *The canal of Fiumicino's Port*
> > *– a motorboat returning unnoticed*
> > *– Neapolitan sailors in their woollen rags*
> > *– A highway accident with only a small crowd around. . .*
>
> *– As in a film by Godard*
> *Rediscovered romanticism contained*
> *in cynical neo-capitalism, and cruelty –*
> *at the wheel*
> *On the road to Fiumicino*
> *And there's the castle (sweet*
> *mystery for the French screenwriter,*
> *in the troubled, infinite, secular sun,*
> *this papal beast, with its battlements,*
> *on the hedges and vine rows of the ugly*
> *countryside of peasant serfs) . . .*

Godard's films of the 1960s – his *mise-en-scène* (sun, the Mediterranean sports cars, camerawork, montage), his writers (Alberto Moravia), his actors (Jean-Paul Belmondo) – all become signs for the deepening effects of post-war capitalism, or what Pasolini dubs 'neo-capitalism'.[6]

> *Belmondo, a cat that never dies,*
> *'at the wheel of his Alfa Romeo'*
> *in the logic of narcissistic montage,*
> *detaches himself from time, and inserts*
> *Himself:*
> *into images that have nothing to do with*
> *the boredom of the progressing hours . . .*
> *the slow dying glitter of the afternoon.*

In his attack against the 'unreality' of spectacle, Pasolini points in particular to the absence of boredom that marks the duration of everyday reality. As meaning is wholly suffocated by style, he also aims to unmask a maker's political perspective (Godard et al.). Boredom is, after all, at the threshold of great deeds, as Walter Benjamin observed, and spectacle the great pacifier.[7] And yet, Pasolini's poem is not so much a critique of current conditions (in politics, in filmmaking, in art), as it is an obituary to his own political worldview.

> *Death lies not /*
> *in being unable to communicate /*
> *but in the failure to continue to be understood.*[9]

To be out of step with the world is a death *worse* than death, and Pasolini identifies 'neo-capitalism' as the corrosive element that is quickly dissipating the resolve of his own political view. What now threatens the Left comes from within the very logic of leftist thinking, rather than the usual divisions and expulsions that had marked leftist movements through the twentieth century (Pasolini himself was expelled from the Italian Communist Party for homosexuality).[8] From the backwards glance of the twenty-first century, this early/ish rumbling of the crisis of the Left is no longer surprising . . . 'At the beginning of the sixties, something was cracking, and [Calvino] and I were on either two sides of the crack.'[9]

Pasolini's essay on Calvino is disarming: on one hand, he considers Calvino's 'metallic writing [to be] almost pristine, but light, incredibly light': but on the other, he believes his old friend has freed literature from its 'function' and 'duties', so that it has become 'an abandoned mine where Calvino goes to withdraw whatever treasure he wants'. In particular, he takes 'the techniques of ambiguity', both in the 'classic sense', as a device 'of infinite fading', but also in the way he uses ambiguity as 'an echo in the valley of grottoes that resounds here and there but always with the same sound.'[10]

Calvino responds:

> What you mean is that it is you who have moved far away: not just with cinema, which is the thing that is furthest from the mental rhythms of a bookworm . . . but because also your use of words has shifted to communicating a presence traumatically as though projecting it onto big screens: a mode of rapid intervention on the present that I ruled out from the start.[11]

'Being present', as Calvino comments in his letter to Pasolini, may exude a 'great sensation of being alive, but this is the life in the world of effects, not in the world of slow reasoning and reflection.'[12] In a letter to Mario Socrate and Vanna Gentili, agreeing with their phrase, 'The problem is that one cannot totally identify with any movement', he added, 'The only difference is that you

are living this condition actively, being in the middle of it, whereas for me now the only possibility is the position of the spectator at a distance.'[13]

By 1970, therefore, Calvino *believed* himself to be a spectator of politics. He had resigned from the Communist Party in 1957, and was now placing literature at the centre of his activities, explaining in the letter to Socrate and Gentili, 'If one moves then from politics to literature, this sense of *not belonging* becomes even more absolute.'[14] Calvino had also given up on realism as a literary style and had moved in 1967 to Paris, joining with the *Ouvroir de littérature potentielle* (Oulipo) in 1968.[15] Oulipo consisted of writers and mathematicians who were using scientific methods to understand the organising principles of language, treating their meetings as laboratories for new and audacious literary ideas, and viewing themselves not as writers, but as technicians.[16] Calvino also formed a close association with Roland Barthes, echoing in his writing Barthes's 'death of the author' thesis and the concept of intertextuality.[17] Literature was generated by investigations into the structures of language systems, the recognition of voids forming between text and world, and the pressure of differing forms of perception that thrust meaning into regressive chasms (a device 'of infinite fading', as Pasolini called it[18]). Calvino had become a proponent of structuralism and post-structuralism at the peak of their influences.[19]

In contrast, as Jonathan Galassi writes, 'Pasolini's immersion in the crisis of the actual became ever more despairingly radical.'[20] He accuses both Calvino and Francesco Leonetti of '"systematizing the sign systems/and goodnight to the dialects" – that is, for taking an anthropological detached approach to the working of class with whom Pasolini passionately identified.'[21] Some commentators believe that Pasolini's fears have again materialised in contemporary Italy. For example, Alessia Ricciardi blames Italy's left for Silvio Berlusconi's move from media owner to Prime Minister in 1994, bringing about Forza Italia's 'monopolistic grip on the means of social organization'.[22] The decisive shifts in Italian politics and culture revealed that: 'the anthropological mutation of the country that Pasolini decried in its incipient form in the mid-1970s had become by the end of the 1980s a *fait accompli*.'[23] It is what Ricciardi calls, 'the squandering of [the left's] cultural capital'.[24]

Ah! Such loyalty dividing ways, these differing, yet equally convincing positions. There is great appreciation for Calvino's analogising and distancing methods, but also, more recently, for Pasolini's political resolve, which means that he, like an annoying mosquito around the legs of perceived power, was certain to whom his sting should be directed. And yet, what divides these figures also unifies them, particularly in their shared insistence on poetics, even if the continuing aporia that falls between action and reflection remains unresolved.

6

Encounter Two: Lefebvre and Blanchot

Man [*sic*] must be everyday or he will not be at all.[1]

Henri Lefebvre spent much of his intellectual life devising ways to rid contemporary existence of the effects of alienation, focusing particularly on a Marxist interpretation of the 'The everyday'. 'The substance of everyday life – "human raw material" in its simplicity and richness – pierces through all alienation', he wrote, 'and establishes "disalienation".' Publishing major texts on the everyday from 1947 (written just after The Liberation, as he pointedly notes[2]) until 1968,[3] the expansion of the notion of alienation from the realm of work into everyday life, and especially into leisure activities, was Lefebvre's major contribution to Marxist thought.[4] What constitutes 'the everyday' for Lefebvre was explained in these terms: the everyday is 'in a sense residual, defined by "what is left over" after all distinct, superior, specialised, structured activities have been singled out by analysis.'[5] When Lefebvre refers to the everyday he is referring to a part of life that is distinct from work, outside public life, outside the university, the law, and outside the reach of consumerism.

Aligning with similar objectives to György Lukács,[6] Lefebvre's theoretical explications aimed to 'reconcile Marxism and philosophy and to endow Marxism with philosophical status.'[7] As with Lukács, Lefebvre had constructed a philosophy that moved from ontology to Marxism, built around a theory of alienation: and as with Lukács' reification thesis, Lefebvre considered mystification, or the obscuring of capitalist conditions, as the largest barrier to revolutionary change.[8] This meant a return to Hegel, particularly to Hegel's dialectical (and teleological) method of *aufgehoben*, which, having no equivalent in French or English, is often translated as sublation. *Aufgehoben* insists upon a double movement to both abolish thought (to cancel it) and to raise it to a higher level (to preserve it): or rather, this method puts in play the continual supercession of an old reality by a newer one that is both higher and more profound. Lefebvre also wanted to establish Marxism as critical theory, that is, as both philosophy and supercession of philosophy.[9]

The everyday, for Lefebvre,

> is a philosophical concept that cannot be understood outside of philosophy ... [It] neither belongs to nor reflects everyday life ... but points to its possible redemption in philosophical terms, directed towards the non-philosophical ... as a 'self-surpassing'.[10]

Guided by dialectical materialism and the concrete resolution of the fundamental contradictions that characterise bourgeois society, the end of history would be reached in the form of un-alienated utopia.

Marxism, Lefebvre argued, 'is a doctrine about thought in movement and about movement in things, and they [Marxists] immobilise it.' They 'have lost sight of its dynamic, living character' and are 'bogged down in literal exegeses which add nothing to Marxist thought.'[11] (Lefebvre's attempt to reinvigorate Marxism, will lead to his eventual expulsion from the French Communist Party.[12])

Conditions were such during this period that it seemed necessary to update Marx's position on alienation. As Mark Poster has pointed out, Marx's 'goal of universality was arrested by the non-intelligibility of daily life', for even Marx, by isolating alienation in industrial production, had under-estimated both the fragmenting character and intensity of alienation.[13] And it also meant that the 'illusions to come' would be concentrated in production, missing the reach of capitalism into all areas of life.[14] Thus, by 1968, Lefebvre reinterpreted Marx's idea of production 'to acquire [for it] a more forceful and a wider significance'. It would now consist of spiritual production or creations (including social time and space), material production (the making of things) and the self-production of human beings in the process of their historical self-development, which involves the production of social relations as well as the re-production of each of these categories.[15] This was Lefebvre's *poiesis* and *praxis*, which did not take place in the so-called higher spheres of scholarship, state or culture, but in everyday life and accounted for the many-faceted phenomena that affect objects and beings. It was a method for combining the experiential and creative aspects of human activity, as well as the instrumental.[16]

Henri Lefebvre and the situationists

Lefebvre's belief in the possibility of transforming everyday life aligned with the concerns of the Situationist International (1957–74),[17] and for a brief, yet productive moment, before malicious disagreements permanently divided them, Lefebvre collaborated with this younger group.[18] Along with Lefebvre, and consistent with Marxist praxis, the situationists believed that the everyday had to be lived and not simply thought or theorised. This was 'a period of major breakthroughs in the domination of nature', they wrote, which carried with

it no 'corresponding increase in the real possibilities of everyday life'.[19] Guy Debord, the leading voice of the group, claimed in 1961 that an interest in the everyday emanated from one's own recognition that it is both 'unbearable misery' and the location of 'real possibilities'.

> All the desires that have been frustrated by the functioning of social life were focused there, and not at all in the specialised activities or distractions. That is, awareness of the profound richness and energy abandoned in the everyday life is inseparable from awareness of the poverty of the dominant organization of this life. Only the perceptible existence of this untapped richness leads to the contrasting definition of everyday life as poverty and as prison, and then, in the same movement, to the negation of the problem.[20]

In a conference convened by Lefebvre in 1961, Debord issued, via tape recording, the following entreaty:

> if we regard everyday life as the frontier between the dominated and the un-dominated sectors of life, and thus as the terrain of risk and uncertainty, it would be necessary to replace the present ghetto with a constantly moving frontier; to work ceaselessly toward the organization of new chances.[21]

This was not only a plea to critically appreciate the way the market was encroaching into aspects of life, but it also insisted upon discovering (inducing) a space that is capable of generating limitless movement, while remaining open to chance and spontaneity. Contemporary life may be relentlessly alienating, and seamlessly so, but it also conceals certain possibilities, such as moods or atmospheres that if activated could lead to a fuller (less alienated) existence. This would be a positive and active life, a life given over to play and poetry, rather than commerce and spectacularised leisure.

In the end, Debord and the situationists repudiated Lefebvre's description of the everyday, as 'whatever remains after one has eliminated all specialised activities'; a view Debord insisted was taken up in 'blind faith' by sociologists.[22] He asked how such activities were to be defined or isolated in a realm that had already been colonised by spectacular relations (leisure, of course, was a favourite target) and which, by 'osmosis', shared characteristics with specialised activities, such that in a sense we are never inside or outside of everyday life.[23]

By 1968, Lefebvre had modified his original and much broader concept to incorporate the concerns raised by the situationists:

> Considered in the specialisation and their technicality, superior activi-
> ties leave a 'technical vacuum' between one another, which is filled up
> by everyday life. Everyday life is profoundly related to all activities, and
> encompasses them with all their differences and their conflicts; it is their
> meeting place, their bond, their common ground.[24]

It meant, however, being at once inside and outside of daily life, to form
positions without boundaries or hierarchy, to unite in the plenitude of ful-
some being. Furthermore, since revolution for the situationists demanded the
individual's fulfilment of ever-changing desire, then this would also imply that
notions of identity bolted to class alone were beginning to slip away from
them, although perhaps not altogether consciously. Despite this, as a funda-
mental demand of their political philosophy, the situationists remained within
totalising systems of thought, retaining the image of the transcendent prole-
tariat who was to carry the revolutionary promise for us all.

Maurice Blanchot and the unravelling of the everyday

In 1959, the philosopher, Maurice Blanchot, published a response (a kind of
homage with a backhand slap) to Lefebvre's 'everyday', agreeing that it takes
us back to existence, to what is most important, to the spontaneity as it is
lived.[25] However, Blanchot insisted that in the everyday the individual is in
a state of 'human anonymity', held in its movement without knowing it: 'we
have no name, little personal reality, scarcely a face, just as we have no social
determination to sustain or enclose us.'[26] Thus, we move through this moment
of not 'knowing', prior to identity, gender or class in an unconscious state that
is also open extemporaneously to the flux and flow of 'existence'. Working
through Lefebvre, Blanchot concentrated in particular on both the conceptual
fragility of the everyday *and* its 'impossibility' as a space of political action.
In a critical departure from Lefebvre, Blanchot writes:

> The everyday escapes. This is its definition. We cannot help but miss it
> if we seek it through knowledge, for it belongs to a region where there
> is still nothing to know, just as it is prior to all relation insofar as it has
> always already been said, even while remaining unformulated, that is to
> say, not yet information.[27]

Since, everyday existence never had to be created, everyday people are the
most atheist of people, such that 'no god whatsoever could stand in relation' to
them. This is how the person in 'the street escapes all authority, whether it be

political, moral or religious'.[28] Held in the movement of the everyday we have little personal reality and 'scarcely a face', and no 'social determination'. It is in such ways that the everyday escapes.

> Why does the everyday escape? Because it is without subject. When I live the everyday, it is anyone, anyone whatsoever, who does so, and this any-one is properly speaking, neither me, nor properly speaking, the other; he is neither the one nor the other, and he is the one and the other in their interchangeable presence, their annulled irreciprocity – yet without there being an 'I' and an 'alter ego' able to give rise to a dialectical recognition.[29]

A characteristic of the everyday is the recognition that conscious thought makes the everyday vanish, an observation that Debord came close to when he announced that 'disinterested observation is even less possible here than any-where else'.[30] The everyday is wholly occupying and absorbing, and thus, with neither conscious thought nor contemplation possible, it is without aesthetic judgement, political perspective or social formation. Accordingly, 'The every-day breaks down structures and undoes forms, even while ceaselessly regath-ering itself behind the form whose ruin it has insensibly brought about.'[31] It contests truth and thus the world of the Law, Government, the University, the sensible and the rational, of depths and meditations, for it designates 'a region or a level of speech where the determinations true or false, like the opposition yes and no, do not apply – it being before what affirms it and yet incessantly reconstituting itself beyond all that negates it.'[32]

The Turin Horse

In *The Turin Horse* (2011),[33] Béla Tarr asks his audience to feel the full weight of life.[34] And from the opening extended shot of a coachman trudging along under grey expanses of sky in a cart pulled by his maltreated horse, we become exhausted by Tarr's long, extended shots, his slow music and its emphasis on a single base chord, endlessly repeated, and in the background the sound of a relentless moaning gale.[35] The land is barren. And when he reaches his dirt-floor house, we see a single tree in the visible distance that designates his daughter's furthest point from her dismal habitat.[36]

Tarr saves the heaviest of life's heaviness, though, for his subjects' daily domestic routine. These scenes – with a little salt to flavour it, the single boiled potato, pulled apart by hand, eaten in silence, repeated daily – are a distillation from the larger depiction of the subjects' spiritual and material poverty. It is memorable, I think, for being one the bleakest of moments in

cinematic experience. And then Tarr repeats it the next day, and the day after, as each arduous day of existence cycles on interminably. And there is no respite for the audience as it sits through the bleak, bare sustenance as grimly as the film's subjects. This is where Tarr decides to end his film, too, on an empty table, the father and daughter facing each other, plates empty, and the lighting simply fading to a black screen. Nonetheless, Jacques Rancière closes his book on Béla Tarr with the following thought, 'The last morning is still a morning before . . . The closed circle is always open.'[37]

The coachman and his daughter, and their downtrodden, brutalised horse, the very horse that drove Nietzsche to madness, subsist at the lowest and barest levels of existence, and yet they, nonetheless, have formed their own, isolated hierarchy, he as patriarch, with his own little kingdom on this barren and isolated plane. As the film progresses, we forget the dramatic image retold in voiceover of Nietzsche throwing his arms around a horse in a busy square in Turin as a coachman whips the exhausted beast into submission. We forget this moment of immense empathy – apocryphal or not – which was also an affirmation of life summoned by Nietzsche as he intervened in the coachman's world. The coachman's tightly ordered hierarchy is shattered by Nietzsche's entry, and the desolate fray of the film's affective drudgery begins to lift with the re-remembering of Nietzsche's story: for it is this that carries along with it a sense of excitement for his ideas, even in the midst of his special 'madness'.

In the course of viewing the film, however, such ruminations get stomped on, and the only possible thought is to beg for the film to end. Then quite unexpectedly, a neighbour drops in for a 'chat' and *pálinka*. An hour in, with despair having reached its depths, this 'Nietzschean shadow', as Tarr has dubbed the neighbour,[38] marks the moment when *The Turin Horse* flips to its nether side, foisting to our corner little crumbs of deadpan humour. And I quote here the full eight minutes of dialogue in the hope that its humour hits the reader, as it did this viewer.

[A knock at the door]

Neighbour (N): I'm out of *pálinka*, would you give me a bottle?
Coachman (C): [thrusting bottle at daughter] Give him some . . .
Why didn't you go into Town?

[In the background, the neighbour and the coachman sit at the table, daughter foregrounded, with brandy gurgling from a container]

N: The wind has blown it away.
C: How come?

N: It's gone to ruin.

C: Why would it go to ruin?

N: Because everything is in ruin, everything is degraded. But I could say that they've ruined and degraded everything. Because this is not some kind of cataclysm, coming about with so-called innocent human aid. On the contrary ... It's about man's own judgment, his own judgment over his own self, which of course God has a big hand in, or dare I say, takes part in. And whatever he takes part in is the most-ghastly creation that you can imagine. Because, you see, the world has been debased. So, it doesn't matter what I say because everything has been debased that they've acquired, and, since they've acquired everything in a sneaky, underhanded fight, they've debased everything, because whatever they touch and they touch everything they've debased. That is the way it was until the final victory, until the triumphant end. Acquire, debase, debase, acquire. Or I can put it differently if you'd like, to touch, debase and thereby acquire, or touch, acquire and thereby debase. It's been going on like this for centuries. On, on and on. This and only this, sometimes on the sly, sometimes rudely, sometimes gently, sometimes brutally, but it has been going on and on. Yet, only in one way, like a rat attacks from ambush. Because for this perfect victory, it was also essential that the other side, that is, everything that's excellent, great, in some way noble, should not engage in any kind of fight. There shouldn't be any kind of struggle, just the sudden disappearance of one side, meaning the disappearance of the excellent, the great, the noble. So that by now the winners who have won by attacking from ambush rule the earth, and there isn't a single tiny nook where one can hide something from them, because everything they can lay their hands on is theirs. Even things we think they can't reach but they do reach are also theirs. The heavens are already theirs, and theirs are all our dreams. Theirs is the moment, nature, infinite silence. Even immortality is theirs, you understand? And those many nobles great and excellent just stood there, if I can put it that way. They stopped at that point and had to understand, and had to accept that there is neither God nor gods. And the excellent, the great and the noble had to understand and accept this right from the beginning. But, of course, they were quite incapable of understanding it. They believed it and accepted it but they didn't understand it. They just stood there, bewildered, but not resigned, until something, that flash on the mind, finally enlightened them. And all at once they realised that there is neither God nor gods. All at once they saw that there is neither good nor bad. Then they saw and understood that, if this was so, then they themselves did not exist either! You see, I reckon this may have been the moment when we can say that they were extinguished, they burnt out. Extinguished and burnt out like the fire left to smoulder in the meadow. One was the constant loser; the

other was the constant victor. Defeat, victory, defeat, victory. And one day, here in the neighbourhood, I had to realise, that I was mistaken, and I was mistaken, I was truly mistaken when I thought that there had never been and could never be any kind of change here on earth. Because, believe me, I know now that this change has indeed taken place.

C: Come off it! That's rubbish! [39]
[The neighbour shrugs, picks up his walking stick, takes some coins from his pocket, throws them on the table and walks about ten metres into the barren, gale blasted landscape, before taking a drink from the brandy bottle.]

That nihilistic rant, the hopelessness! Then that bathetic dismissal! *The Turin Horse* is actually funny. It takes us to quite preposterous extremes in a show of exaggerated and excessive absurdity – that paltry, daily, boiled potato, after all! And the film has many other comic moments, such as the attempt by a group of 'gypsies' to lure the daughter to a richer life, so that the line between pathos and humour, or between heaviness of soul and lightness of spirit is barely distinguishable. And if the rest of the film gets under one's skin, slowly deadening emotions from the inside, then it is the neighbour's fulminating outburst – his intervention into this isolated existence where words are few and human contact is merely instrumental – that gives political shape to the social conditions into which our subjects have been thrust. The coachman's response lightens things, quite unexpectedly, by tipping a bucket of icy water on reflection, on the possibility for resistance, but it is also a demonstration of his deep resignation.

Nietzsche does not appear in the film, since Tarr resists the temptation to restage the Turin horse scene; and yet thematically and affectively, *The Turin Horse* is a very Nietzschean film. One might say that Nietzsche infiltrates its every aspect, from its inherent nihilism to the adoption, as a structural thread, of Nietzsche's 'eternal return'. As Gilles Deleuze wrote:

> The eternal return is not the permanence of the same, the equilibrium state or the resting place of the identical. It is not the 'same' or the 'one' which comes back in the eternal return but return is itself the one which ought to belong to diversity and to that which differs.[40]

Of the slight variations that occur in each day's passing routine, Tarr repeats this thought: 'It was very important to show the differences. Daily life is always monotonous, you wake up in the morning, you get up, etc. But every day there is always some difference.'[41]

Scarcely leaving a trace, our carriage driver's life, his daughter's, these joyless people, she serving only to fulfil her invalid father's basic needs, undressing him, feeding him, tending to the horse, the horse too, with its entrenched sadness

appear each to be held in the anonymity of the everyday? But when survival is a daily burden, might this not present the perfect conditions for the manifestation of the 'unthought of thought', as Blanchot explains it? This essential requirement of the everyday for Blanchot are those moments of thoughtlessness, outside the social or political, these non-places where there can be no alienation, and where resistance is impossible. In Blanchot's terms, it would be inadequate to merely depict the everyday as the daily, the routine, the domestic: such mechanical acts are, as with boredom, nothing other than 'the everyday become manifest'. And since the everyday is without reflection, it is unfamiliar and thus cannot be represented. To attempt to represent the everyday would be to utterly neglect its allusive character, since 'what is unperceived is its essential and constitutive trait'.[42] Thus, as with Chantal Akerman's *Jeanne Dielman* (1975), we are held in the monotony of those slow, daily domestic tasks that constitute so much of both films.[43] And yet, following Blanchot, despite the boredom that these films summon, we do not find ourselves thrust into the everyday. Rather, they issue 'splendid moments' of awareness – our reflection, our distance, the neighbour's speech, the unexpected humour – that are not juxtaposed in a dialectical relation to the everyday: rather, these transcendent moments belong to another region altogether. The everyday 'is always elsewhere', Debord observes of its fragile quality, nudging closer to Blanchot.[44] The common sense of the everyday, its political possibility, Blanchot argued, disappears at the very instant it opens up to thought, transforming into something completely other and eternally unknown.

The seditious route Blanchot took in his navigation of Lefebvre's everyday revealed the impossibility of realising revolutionary desire in this enigmatic sphere, in these private, absorbing, selfish moments. The failure of Lefebvre to move from abstraction to action, from metaphysics to an effective Marxist critical theory, is revealed at a crucial moment in history, as the Left is appearing to fracture in response to the disappointments of 1968 (this symbolic marker of an impossible class politics), to the rise of post-colonial theory, to the spread of identity interest groups, to the enclosure of meaning within linguistic systems. And thus, I return, therefore, to the distinction between politics and the political as an example of the ungroundedness that Oliver Marchart calls our 'post-foundational moment'.

> On the one hand, the political, as the instituting moment of society, functions as a supplementary ground to the groundless stature of society, yet on the other hand this supplementary ground withdraws in the very 'moment' in which it institutes the social. As a result, society will always be in search for an ultimate ground, while the maximum that can be achieved will be a fleeting and contingent *grounding* by way of politics – a plurality of partial grounds.[45]

7

Encounter Three: Art and the Socialist State

All art is subject to political manipulation except that which speaks the language of the same manipulation.[1]

Political landscape – Neue Slowenische Kunst

In the early 1980s, artwork that refused for tactical reasons to directly reveal a political position was the *modus operandi* of Neue Slowenische Kunst (NSK), an umbrella art collective that evolved out of a punk ethos in Slovenia, a Federation member of the Socialist Federal People's Republic of Yugoslavia (1946–92).[2] Encompassing a heavy industrial music group (Laibach), a visual arts group (Irwin), and groups dedicated to theatre, design, architecture and philosophy, NSK formed part of an *alternative*, rather than an *oppositional* sphere of activity, rejecting the tactics of an older generation of political dissidents who utilised counter tactics. 'A concern was to avoid vanguardism and they became a group among other groups . . . The distinctive character-istic of the alternative scene was that it was free from the figure that played a central role in other socialist countries: the dissident. The alternative under-stood its own action as the production of the social sphere, the creation of social spaces of otherness, and would refuse to be characterised as dissent or opposition.'[3]

The formation of NSK had followed closely after the death of the dicta-tor, Josip Broz Tito (1980), and before the Yugoslav War (1991–9), which led to the breakup of the Federation into regional, religious-ethnic states.[4] Repressive methods of the ruling Communist Party would ultimately fail, but in the attempt to contain cultural expression in Slovenia, a period of upheaval ensued, which included severe police repression, show trials, threats that civil society would collapse, and a brief, yet unsuccessful invasion by Serbian nationalists. In the end, Slovenia would escape, precariously, the ethnic wars that sealed the destruction of other parts of Yugoslavia, but only through independence,[5] and only with the loss of a unified, multi-ethnic state.[6]

Laibach

As a part of the wider purging of the punk movement during the 1980s,[7] 'authorities and conservative social opinion' were 'determined to prove that alternative culture was simply a cover for the resurgence of fascism'.[8] Laibach, the music arm, played directly into this sentiment by appropriating nationalistic icons and uniforms that closely simulated fascist aesthetics, mimicking in particular 1930s' Nazi imagery and adopting the German name for the capital, Laibach, rather than using the Slovene name, Ljubljana.

Dressed in military inspired uniforms, with harsh expressionistic light and smoke, and arms raised in Nazi-style salute, Laibach's performances were re-enactments of the heavy, militaristic aesthetic of state-sponsored events. The mesmerising throb of industrial sounds was accompanied by porn and partisan films and unaccredited quotations from Tito, Goebbels, Hitler and Stalin (among others). The aggressively heavy beat alluded to the sense of alienation generated by industrial production. In particular, it was a pointed reference to the Slovene town, Trobovlje – the site Laibach had chosen to perform its first concerts in the early 1980s – 'infamous for its heavy industry, severe pollution and political extremism'.[9] Laibach's overall 'styling' was pointedly fascist and nativist and included the traditional Slovene imagery of stags, mountains and hunters.

Anthony Gardner has noted that a constitution known as 'The Internal Book of Laws' was drawn up with the formation of NSK, which demanded that personal taste, judgements and beliefs were set aside, while also insisting that the group operated in friendly comradeship. It governed the duties to which each group and each member was bound, with Laibach setting NSK's ideological direction.

> NSK was not just a collective but a highly regulated, highly bureaucratised art machine that mimicked the similarly bureaucratised and comradely Yugoslav state that worked, NSK claimed, 'in the image of the State', and whose repetitions of it could, perhaps be mistaken for affirmation.[10]

In 1989, as Slovenes took their first steps towards independence, Laibach held a concert in the centre of Serbian Belgrade, using the politically explosive mixture of Serbian and German. The concert, performed in the style of a 1930s' Nazi political rally, was based around two statements made by Slobodan Milošević and closed with a quote from Neville Chamberlain, a central force in the pre-war appeasement of Adolf Hitler. In the background was the screening of a German propaganda film made in 1941, which showed the bombing of the Serbian capital. The inclusion of Chamberlain's voice was meant to represent the weakness of democracy when faced with fascism, while Milošević's speech,

delivered in the style of the dictator, was in form and content as 'precise as a chemical formula that seemed to crystallise the exact moment of transition between Yugoslavian socialist speech and Serbia's emerging ethnic, national-ist rhetoric.'[11] For NSK, by refusing to differentiate one system from another, whether communist, fascist, democratic or nationalist, they were declaring that each system produces equally alienating affects.[12]

Irwin

Where Laibach presented a 'seamless' re-enactment of a fascist aesthetic, Irwin, the visual arts arm of NSK mixed (more ambiguously) criticism and trib-ute. In the mid-1980s, Irwin reproduced the Suprematist works of Malevich, focusing attention on his *Black Square* and also restaging his famous *0:10 The Last Futurist Exhibition*, Moscow (1915). This was not intended as a staging of the actual event, for that had already passed into mythology. Rather, it was a simulation, which included 'Malevich' himself whose death in 1935 was 'forgotten' at the very moment he re-exhibited copies of his own work under the name *Malevich from Ljubljana and Belgrade.*

> His resurrection was announced with the following sentence: Why? Why now (again), after so many years, wondered Kasimir Malevich in his letter (with a postscript note: Belgrade, Yugoslavia) published in *Art in America*, September 1986 [. . .] Yet this is not an attempt to copy the paintings as such, or to create 'forgeries' on the basis of photographs from that period and reproductions of originals, but an attempt to (re)create a system that has elaborated the institution of contemporary art as we know it today. In the projects of copying from the 1980s in ex-Yugoslavia the real artist's signature is missing, and even some 'historical' facts are distorted (dates, places), or better to say the sanctity of the History of Art as such . . . The schizophrenic temporality dis-played by the copies therefore represents opposition to the tendency to integrate art fully in a social order, into a continuum of closed and forever delineated history and its interpretation.[13]

Coinciding with its collapse into a closed and repressive dictatorship, the Soviet State's suppression of abstract art in the 1930s came with pressure (insistence) that artists produce art in the *Socialist Realist* style, a mimetic-realist style offer-ing narrative and pedagogical possibilities.[14] The most powerful opposition to abstract art, the conservative association of revolutionary artists, AkhRR (Association of Artists of Revolutionary Russia), was an association estab-lished in 1922 to promote nineteenth-century realist painting. The association eventually won support from the Communist Party, successfully arguing that

Socialist Realism was more accessible for the proletariat, and, thus, more effective as a didactic, ideological tool. Irwin's strategy of 'copying' earlier moments of avant-garde abstraction revealed its disdain for the way the state had instrumentalised art for social and political ends. In more specific terms, it was a criticism of the way such discourses had destroyed the expectation for change that had motivated the early avant-garde. What was to be glimpsed in the re-presentation of Malevich's early modernist works was a moment of great promise, just before its utopian ambitions had been repressed.[15]

> The legacy of constructivism, more precisely, the Great Russian master, Kasimir Malevich, was and still is very important from a moral point of view. This beautiful utopia about art as a positive power in transforming the society was the vehicle of hope for many progressive artists and Constructivism was a manifestation of the new aesthetics as well as a moral resistance for them.[16]

Irwin adopted the term 'retro avant-gardism' to propose a return to and illumination of the moment when the immense revolutionary possibilities of early twentieth-century abstraction were still potent. The impact of joining distinct and paradoxical conceptions together, 'retro' and 'avant-garde' would clearly distinguish it from 'rear-gardism' (another of their terms), the reactionary practice of copying early modernist works in a spirit of nostalgic aestheticism, such as the appropriation by an ageing rear-gardism of songs from the October Revolution.[17]

> Retro avant-garde is the basic artistic procedure of Neue Slowenische Kunst, based on the premise that traumas from the past affecting the present and the future can be healed only by returning to the initial conflicts. Modern art has not yet overcome the conflict brought about by the rapid and efficient assimilation of historical avant-garde movements in the systems of totalitarian states.[18]

By extracting the essence of utopian fervour from a mass of historical myths, Irwin hoped to liberate art from its use by the State. For Irwin, there was no distinction between communist and fascist leaders who they believed staged their 'grand parades and spectacles' through the exploitation of art, creating 'ritualistic dystopias' in which the 'people, twisted and manipulated to the service of politics became the material of the work'.[19] 'The whole socialist machine', Marina Gržinić wrote, 'was aimed at neutralizing the side effects of a pertinent interpretation of its reality and of art production, at covering up or renaming of history'.[20]

It is clear that Irwin had in its sights the lost and 'beautiful utopia' of suprematism. However, I would question whether the political intentions of the group were not obscured, and consequently the critical potential of the work limited, when Irwin used discordant iconography, such as Christian crosses and images of Slovene-kitsch? It meant that thematic tensions were now jostling with one another in the same exhibition, even in the same work. How was the viewer to interpret the range of images in Irwin's work? Would they see it as censorious of the institutionalised control that such practices had exerted on Slovenia? Or would they think that the work had been executed in a nostalgic mood, as a form of unconstructed longing (perhaps as rear-gardism, to put it in Irwin's own terms)? Operating as a lure prior to any engagement with the works' critical potential, the juxtaposition of abstract paintings, images of industry, of stags, of crosses (combined in icon-like forms) afforded the work a decidedly contemporary aesthetic for its time. In other words, as much as it was a criticism of political systems, the work was fashionably 'retro' and eclectic, a style that was prevalent in contemporary art across the world during the 1980s. It was a time when Joseph Cornell's surrealistic boxes reached a wider audience, with their Victorian era objects, maps, moving parts, globes, ballerinas and Hollywood stars, these wonderful assemblages of found materials that he constructed from the mid-1930s until his death in 1972. It was also a time when, the painter, latterly turned filmmaker, Julian Schnabel, was saturating his canvases with a cacophony of iconography, moving between two-dimensional and three-dimensional form. I am thinking in particular of *Exile* (1980), a work featuring actual antler horns and a repainting of Caravaggio's *Bacchus* (1595), among other references. It was also a time when clusters of critics judged such appropriation of randomly selected historical references as both a flattening of historical time and a forgetting of history. In 1981, Benjamin Buchloh wrote, 'The new language of painting – now wrenched from its original symbolic function – has become reified as "style" and thus no longer fulfils any purpose but to refer to itself as an aesthetic commodity within a dysfunctional discourse.' [21]

A history of invasion

Bringing these arguments into consideration at this point is not to remove the local conditions that led to the way Irwin positioned the group, but to show how tactics produced in one context have quite different outcomes in another. When Laibach adopted the German name for Ljubljana, the capital, a resolution was passed to ban them from playing anywhere in Slovenia under that name. [22] The use of German in describing Slovenian place names was a method for further entrenching nationalistic and fascistic 'styles'. It could also be read as a sign that Laibach was trying to disclose Slovenia's earlier support

for fascism, which had been suppressed under a plethora of post-war social-
ist propaganda by those scrambling for power in the new socialist Yugoslavia.
Beyond these tensions, however, the use of German held great significance for
many people in Slovenia. Slovenes had fought throughout the nineteenth and
twentieth centuries to preserve a cultural identity and language during various
foreign invasions and occupations, each one further de-stabilising Slovenia's
geo-political borders, and exposing Slovenes to different political economies.
Before the Federation in 1943, there had been centuries of Habsburg rule from
the mid-fourteenth century to its collapse in 1918, with a short interlude by
France in the Napoleonic era (1809–13), and then German and Italian fascism
during the Second World War. Communism dominated the second half of the
twentieth century under the Socialist Federal People's Republic of Yugoslavia
(renamed by Tito in 1963 as the Socialist Federal Republic of Yugoslavia),
followed in 1992 by the transition to a neoliberal market economy, after its
split from the Federation, which continues today. When Irwin amalgamated
Christian, Slovene-kitsch, communist, capitalist and fascist imagery they were
pointing to the vital influence each system played in the ongoing inculcation
of the Slovenian people to its sense of nation. And while this also played into
a sense of alienation, it also helped Slovenia escape the forthcoming war in
Yugoslavia.

From inside Yugoslavia, Slovenia was not only spared from the War that
ravaged the rest of the Union, but it had also been considered by the other
Federation members as the richest and most successful industrial state. Through
the years of Federation, Slovenia experienced the highest *per capita* living stand-
ards, six times greater, for example than the poorest State, Kosovo.[23] It also had
zero unemployment, making it a magnet for 'guest' workers from other parts
of Yugoslavia, and building on the perception that it was the most 'Western' of
all the States, albeit simultaneously stereotyped, according to Monroe, as 'cold,
Germanic, inward looking and provincial' by fellow Yugoslavs.[24] Despite this,
however, from the position of the contemporary West, as the commentator and
collaborator of NSK activity, Marina Gržinić wrote in 1996, Slovenia contin-
ued to be 'coded as Eastern Europe, stigmatised as the Balkans, and traumatised
as the former Yugoslavia'.[25] Significantly, though, Slovenia also teetered, along
with other Yugoslavian States, at the very edge of the once highly central-
ised Soviet system, further 'afield' politically, geographically and ethnically than
those of Hungary, East Germany, Czechoslovakia and Romania. Hence, the
death of Tito could mark the collapse of the Yugoslavian Federation nine years
before the collapse of the Berlin wall, without causing ruptures of any conse-
quence at the centre. As Edgar Morin has noted, the 'anti-totalitarian revolution'
that occurred in other parts of the East, 'started from above, which is to say that
instead of being repressed it was promoted by those in power'.[26]

This was not Slovenia's experience. Pressure from below, especially from a range of alternative social movements and post-'68 intellectuals who continued to prosper at the turn of the decade, coupled, importantly, with the danger Serbian aggression posed, and the concomitant fear in the Party's ranks that power would be lost, had forced the Communist Party to take significant moves towards independence and democracy.

The point in bringing up these geo-political and confederate perspectives is to consider the context in which NSK acted and thus the soundness of the tactics they adopted in the midst of a collapsing communist context – to give a small history that might explain why the Group chose an approach of intentional ambiguity, even if the outcome was to accommodate both supporters and retractors indiscriminately.

> The NSK strategies of representation and presentation and their collectivism were often equated with totalitarianism and their art was considered to be a menace to the existing social order. However, by defining NSK's activity as a point of 'potential terror and destruction', the state merely reinforced the opinion that, in fact, 'terror and destruction' resided in its own core ... NSK did not interpret the gaze as a menace, but showed that this 'menace was a social product determined by power and not a natural fact'.[27]

The work was delivered without humour or farce. And yet, since sitting at the heart of this project was the blurring of purpose, if these events were seen as parody, they were intensely funny moments in which the mechanisms of fascism, nationalism, communism and industrialism were open to ridicule. The reverse was true, of course, as many in the early 1980s chose to believe, for if the acts were taken seriously, it meant that NSK was endorsing these systems, particularly those sympathetic with the socialist State. Since NSK had never formulated or prescribed their intentions, audiences and viewers necessarily needed to bring their own context and perspective to events.

In 1992, NSK moved beyond the production of gallery pieces or the parodic restaging of political display, in what Anthony Gardner has called 'another remobilization',[28] to construct the mechanisms of a functioning NSK state and embassy, including the issuing of passports through the Internet for US$50.[29] The NSK State was constituted without physical statehood and without borders. It was framed as a peaceful, extra-territorial state that could materialise anywhere. Its first manifestation was organised by Irwin in a private apartment in Moscow in May and June 1992 as part of the East European underground art movement known as Apt-Art (Apartment-Art).[30] In 1993, the Group laid a giant Malevich black square in the Red Square; then in 1994

it was reconstituted as a state in the former territory of East Berlin. Visitors gained access only with a valid NSK passport, or for holders of other passports, by gaining a visa. As a state without body or boundaries, without racial or ethnic division, NSK put forward an alternative model to the territorial obsession of the ex-Yugoslavia in the 1990s.

> From all this it is thus necessary to draw what at first glance seems a paradoxical, yet crucial conclusion: today the concept of utopia has made an about-turn – utopian energy is no longer directed towards a stateless community, but towards a state without a nation, a state which would no longer be founded on an ethnic community and its territory, therefore simultaneously towards a state without territory, towards a purely artificial structure of principles and authority which will have severed the umbilical cords of ethnic origin, indigenousness and rootedness.[31]

From socialism to free-market capitalism

It was under the auspices of the stateless state, and in the wake of a newly disintegrated socialist state that Gržinić confidently declared:

> despite Guy Debord's claim to the contrary, that in modern times an excess of display has the effect of concealing the truth of the society that produces it, it is through display that political regimes reveal the truths [that] they mean to conceal . . . My primary thesis is that post-socialism can best be grasped through the way they display the ideology of the Socialist and post-socialist system.[32]

As with the conflation of communism and fascism, spectacle theory was simplified to correlate with the Group's concerns and experiences, reducing spectacle to display, while revealing how the tactical methods of NSK involved simple reversals of logic. In the 1980s, an internalised critique of the state apparatus had led to the Group's principal attack being forged against the aestheticisation of power, without distinguishing between the differing tactics of communist and fascist states. This was followed in the 1990s by the formation of the 'new' NSK state without borders, removing the stifling and repressive mechanisms that had maintained a closed socialist territory, while also excising the troubling racial and ethnic strife that marked former Yugoslavia. Despite the strategic turn from inward looking to decidedly outward in the post-socialist era, the nucleus of NSK's critique of contemporary society continued to be bound by the logic of the state form.

As such, the NSK State in Time becomes a trajective [*sic*] vehicle of a 'pure exterior', a core without interiority, a border without territory. The only form of existence of the NSK State [is] its embassies, ephemeral temporary materializations serving to make visible symbolic differences. The aim of the transposition of NSK, of movement, of travelling and the ensuing changes of location of the entire NSK organism can be seen in communication and exchange with this other (different) place.[33]

Fellow Slovene, Slavoj Žižek, whose Lacanian circle had influenced NSK's Department of Pure and Applied Philosophy,[34] argued that the tactics of NSK had the potential to wreak damage due to its 'over-identification' with the State's ideological mechanisms.[35] The 'evils' of any society (Žižek uses the Ku Klux Klan as an example) are tolerated, if not cherished, as long as they remain unspoken. This is the real form of conformity, Žižek argued, for transgressions are kept hidden as a way for the system to reproduce itself. In Žižek's terms, when NSK saturated the system with its own language and theatrical display, it was a transgression against an original transgression, bringing to the surface that which the system effectively tried to conceal. An example would be the attempt by Slovenia's leadership to remove from history evidence of Slovenia's collaboration with German and Italian fascism.[36]

What would have remained in sharp memory was the way politics in its ontic form had once fully saturated so many aspects of everyday life in Yugoslavia. It made the conditions upon which critique was applied quite distinct from those in the West. While this is to appreciate the more centralised nature of control in the Yugoslavian Federation, it is also to recognise that in NSK's approach there was a thinning-out of the complex causes and effects of the political condition. And this continued after the end of socialism. In other words, despite the spiralling complexity of globalising capitalism that now affected the social and economic constitution of Slovenia, NSK continued with the same tactics that they first devised for the Socialist State.

In the same period, confidence in the transformative possibilities of art had weakened in the West. The historical avant-garde had not mended the perceived fragmentation of art and life; nor had it prevented experimental modes of practice from 'returning' to the bourgeois sphere. In this context, therefore, any hope that art might contribute in a direct and focused way to effecting change in the political landscape, as NSK proposed, reached its lowest point in the 1980s and '90s. Concomitant with the intensification and spread of neo-liberal capitalism, the evolving conditions at the end of the century seemed to encourage a range of nihilistic responses.

Nihilism and the end of the century

An example of this is the post-'68 reaction of the French sociologist, Jean Baudrillard, who worked as Henri Lefebvre's assistant at the University of Nanterre (the cradle of the May '68 uprisings). Baudrillard reached his peak of influence as a social commentator in the latter years of the last century by presenting simplified theses on the corrupted state of western society, which he proposed had devolved into pure simulation (the real world had been lost somewhere in history). There would be no possibility for mounting an adversarial position, a possibility that was still available to the situationists (a group who were highly influential on his thinking), since by the late twentieth century, according to Baudrillard, there was no longer any 'point of view from which to criticise it external to that space.'[37] We are all trapped in a world of simulacra. He also announced that the flattening and thus equivalence of all things, meant an end to the dialectical tension that had once sustained the energy of the Left in the west, or more specifically, an end had come to the 'electricity generated by their contradiction.'[38] This represented the end of Baudrillard's Marxian period which began collapsing with his text, *Mirror of Production* in 1975.[39] The space that Baudrillard articulated was for him wholly seductive since seduction was the 'world's elementary dynamic',[40] masking, ultimately, a world devoid of meaning.[41] The hope that we might be liberated from this world, that we might construct a richer or more intensely experienced life through the conception of new ways of thinking – for example, as in Deleuze's and Guattari's pursuit of difference that could set free the philosophical impasse of fixed and enclosed hierarchies – was for Baudrillard absurd. The model for this new world was the United States, which he framed as a utopia achieved, and thus no utopia at all.[42] Commenting on the destruction of the World Trade Center in 2001, Baudrillard was confident enough to write:

> A surplus of violence is not enough to open up reality. For reality is a principle, and this principle is lost. Real and fiction are inextricable, and the fascination of the attack is foremost the fascination by the image (the consequences, whether catastrophic or leading to jubilation are themselves mostly imaginary).[43]

Building on his earlier comments on the 1991 Gulf War as a non-event, since it was an event that did not happen, Baudrillard proposed that the attack on New York was 'the pure event uniting within itself all the events that have never taken place.'[44] Thus, where the revolutionary imagination of the past was steered by ideology (a desire to change the world through relations of force), the new terrorist recognises that 'we are far beyond ideology and politics

now',[45] and has pushed the struggle into the symbolic sphere where the rule is that of challenge, reversion and outbidding. This strategy for political 'engagement' is a wholly symbolic and largely paradoxical act. Stephen Best sums up Baudrillard's position as his 'dream of the seamless closure, complete mystification, and perfected hegemony' of capitalism.[46]

I offer this brief overview of Baudrillard's position to try to emphasise the nihilistic atmosphere that overtook discourses on political art during this period, to set the work of NSK in its new context away from a socialist, centralist model to an environment governed by free-market economics.[47] With a little aside, therefore, I would like to draw an end to this overview of NSK. I first began researching the Group many years ago. Alta Vista was available, but Google did not yet exist, so it was at a time when the Internet was much smaller and not as readily searchable. It was in such an environment that I found what I believed was an NSK work and I was very excited about it. NSK had already set up by this time their own virtual consulate, issuing passports and visas. And it appeared that this work was touching on one of my favourite subjects, the horror of corporate bureaucratisation. The aesthetics of the site were dull, corporatised, bland (in line with the aesthetics adopted for the NSK State) and they had even set up a recruitment arm and chosen the dullest of all products, ball bearings.

Needless to say, this NSK turned out to be a functioning, multi-national manufacturer based in Japan. It is quite clear when you access the site today, but websites in the mid-1990s were more generic, flatter with fewer hyperlinks. There had been quite a time lapse between my finding the site and then realising that it was not an artwork. But in the meantime, I had already begun analysing it as a work of art under the general terms of the Slovenian art collective's tactics and was struck by how clever they were. And it was only much later again that this kind of indeterminacy, this approach that hides a work's political intent, revealed itself as an untenable tactic if an artist hopes to shake the ground a little.

Ambivalence and indeterminacy as a contemporary mode of practice

A tactic of indeterminacy can be found in art posing as political commentary today and I am presenting a moment in the practice of Simon Denny to illustrate how art can support, rather than critically mess up the *dispositif* or the police order.[48] Alongside the performance-readings of Marx's *Capital* at the 2015 Venice Biennale, the official New Zealand representative, Simon Denny (Berlin-based), had installed *Secret Power* (2015) in two venues, Marco Polo International Airport and Biblioteca Nazionale Marciana. It is a project

dealing with the National Security Agency (NSA) and Snowden controversy.[49] In the year leading up to this, however, in 2014, Denny's work, *All You Need is Data*, had been chosen as one of the finalists for the Auckland Art Gallery's Walter's Prize, which comes with a generous cash prize. It is a bi-annual event, with the work of four finalists selected by local curators, and the winner judged by an independent, international curator. In 2014, the judge was the European-based curator, writer and museum director, Charles Esche. By then, Denny and his work on Snowden had already been selected for the Venice Biennale by the New Zealand's Arts' Council, Creative New Zealand (CNZ).

In the same year, as New Zealand headed towards a general election, an investigative journalist, Nicky Hager, published *Dirty Politics: How Attack Politics is Poisoning New Zealand's Political Environment* (2014), an exposé of the illegal surveillance by the conservative government of New Zealand's opposition parties. The information was passed onto conservative bloggers. This was redolent of Snowden's NSA revelations in the abuse of citizens' privacy. And thus, Denny approached Hager to be a consultant on the project.

Another work by Denny, *The Personal Effects of Kim Dotcom* (2013), shown at the Museum Moderner Kunst Shiftung Ludwig,Vienna (MUMOK), was to be restaged later in 2014 at the Adam Art Gallery in Wellington. The subject of this work was the Internet entrepreneur and founder of Megaupload, Kim Dotcom, who, on having moved from Europe to New Zealand in 2011, had had all his property confiscated in a New Zealand police raid in 2012. His bank accounts were frozen and a host of charges were laid against him by the United States Justice Department, emanating from copyright infringement. Denny's work set about to reproduce all the confiscated items and resitute them in the gallery – black Mercedes and other cars, some kind of monstrous black jet-ski, artworks, motorbikes, mag wheels, numerous gadgets, clothes, a bed, and bags of 'stuff'.

These related but seemingly separate Denny events came together when Kim Dotcom decided to set up his own political party, called The Internet Party, to oppose the conservative Government in New Zealand's 2014 election, bringing Nicky Hager on board and video-linking Snowden into Kim Dotcom's press conference. All of this turned into a mighty failure for the new party, for which Kim Dotcom later apologised.

Denny's Walter's Prize artwork, in the meantime, dealt with an annual technology conference, Digital-Life-Design (DLD), which happens over three days every year in Munich.After shooting eighty hours of video footage of the 2012 conference, Denny then grabbed still images and quotes as the basis for ninety inkjet-printed, industrially stretched canvases of the same size to represent each conference session. One viewer interviewed, Peter Shand, observed

that it brought to light for him the lack of women and racial diversity of the group. The women in fact were all at the back, and he couldn't be sure how consciously the artist had arranged this. 'The incipient rage I was feeling', he said, 'turned into rage with a focus, when I was confronted with lines from the editor of *The Economist*, "Greed is good, Greed for good."'[50] At the black-tie dinner staged for the announcement of the Prize winner, the judge, Charles Esche made it clear that he despised the work, and made no attempt to conceal this from the assembled art patrons, politicians, artists, dealers, curators, writers and gallerists. Reportedly, Esche's comments on Denny shocked the audience and one guest reported that he found the comments 'so blatantly dismissive that they verged on rudeness to the point that all the air was sucked from the room.'[51] Esche had judged the work to be wholly complicit with the values of 'neoliberalism'.

Around the same time, a private donor who contributes money to help fund New Zealand's contribution to the Venice Biennale withdrew funding support for Denny's work – reportedly because Nicky Hager had been employed as a consultant for the Venice commission. In other words, the patron considered the work to be too cosy with those who were critical of the ruling government and its actions. So, here we have an artwork that has been interpreted negatively by both sides of a partition. But more than that, both sides were angry. And in many ways, such a response might be judged as a highly successful outcome. It was a response at least. In allowing meaning to be open and disputed, Denny's work respects the complicated and disputed nature of the political. However, in the end, the war with the 'police order' is simply neutralised. It recalls a criticism made by Vincent Descombes in relation to French existentialism in the early post-Second-World-War period. Even though there was a guiding belief that thought should commit itself to concrete situations to arrive at a political position, it was able to prove both the for and the against of any position without the least modification of its premises.[52] What this example from another time and another discipline demonstrates, I believe, is that we can easily slip into states of resignation when we bury our voices under ambiguity, when we fail to address the conditions specific to each moment in history, when we fail to apply sustained critical attention to the way our psychic responses have acclimatised to economic agendas and subsequent material conditions. Perhaps resignation is itself a political gesture today, albeit a passive one and in the negative and unseen and unheard; so perhaps not a political act at all.

There was another possible way for Denny to work more productively with ambiguity and radical ambivalence, as Jean Paulhan had in the twentieth century. (Paulhan will come back into discussion in Chapter 10, 'The Politics of Painting: Cliché, Fashion, Mimesis', in Part III.) What Paulhan toyed with,

as a way to shake up the blind spots riven from ideological 'certainty', was the most vulnerable part of an argument, the point at which an argument falls apart. The seemingly immovable positions in France about whether one resisted or collaborated during the Second World War produced a heated post-war atmosphere. In contradistinction, Paulhan insisted that both collaborators and resistance fighters were part of the same *patrie* and he refused to support the black-balling of writers who had worked with the Vichy regime during the War. By arguing that both sides were implicated, the blind similarities of partisanship were revealed. This was very different to Denny's work, where opposing voices were functionally neutralised by creating a work that facilitated all political sides.

The historical ground for such an approach was presented through the strategies of the Slovenian art group, Neue Slowenische Kunst (NSK). It led me to propose that once ambiguity was placed in the context of a market economy, an art market, then indeterminacy was largely ineffective, at best working against politics by appealing to all sides at once, and playing neatly into apathy and non-participation. It means that an audience is closed upon itself in a circular re-affirmation of its own beliefs and interests, and those of its cellular colleagues and like-thinking friends.

Part III

Political-Aesthetics and Contemporary Artists

Political-Aesthetics and Contemporary Artists: Introduction

Action or resignation?

Removed from the daily demands of the past when life tends to unfold in more crystalline detail, today's distanced (and abstracting) view reveals the seductive forces at play last century. Resignation about there being no possibility for change proliferated as the hardening of market ideology spread into areas of life previously immune to 'economic rationalism'. From such a distance, it is easier to see how creative practices were intertwined with the radical restructuring of class and labour in the 1970s.[1] Having lost hope by the end of his life, it is no surprise, therefore, to find the example of the French historian, François Furet, claiming that

> the idea of another society has become almost impossible to conceive of, and no one in the world today is offering any advice on the subject or even trying to formulate a new concept. Here we are, condemned to live in the world as it is.[2]

Following the devastation of the Second World War, the idea that capitalism was a severe impediment to art's critical potential gained greater momentum. A burgeoning of ideas came from artists about how to defeat art's commodification, from mailing letters to colleagues that doubled as artworks (Ray Johnson, the New York Correspondence School, Fluxus, On Kawara), to objects that self-imploded at the end of a performance (Jean Tinguely's *Homage to New York*, 1960). And yet, by the late twentieth century, as more and more artworks from this period found thirsty markets, there seemed to be greater floundering about how to establish value outside economic prognoses. Mel Bochner's dull folders on plinths, titled *Working drawings and other visible things on paper not necessarily meant to be viewed as art* (1966) is an example of an art project planned to have no exchangeable value but which now gains elevated prices in printed facsimile form, with the original folders and pages held as valued acquisitions in the Museum of Modern Art (NY) collection.[3]

It was proposed at the end of Part II that some artworks are so positioned that politics (as dissensus) is neutralised by allowing viewers to project their own

political positions onto the work, and thus digging deeper channels between the ideological divisions of our age. Another strategy is one of withdrawal, identified by Gregory Sholette, following his attendance at a conference early in the century:

> What does one make of a conference, entitled [*sic*] *Marxism and Visual Arts Now (MAVAN)*. Examples of contemporary visual art were all but absent and the few speakers who did address recent artistic practices hardly strayed from citing works and practices not already ensconced within the institutional art world. One possible explanation for this conspicuous absence is the understandable resignation that the progressive scholar or artist experiences when confronting a world dominated, almost without exception, by images of a triumphant, global capitalism.[4]

Influenced by Georgio Agamben's notion of 'bare life', Gregory Sholette describes contemporary art as 'bare art', his identification of the moment when 'the art system has revealed, in all its banality, the extent of its subservience to the interests of global power elites.'[5] This is the same logic that drove the French faction of the situationists when they rejected artmaking altogether in the wake of the Second World War, and it was intrinsic to the reasoning of Ian Burn, the Art and Language artist, when he moved his working life to the trade union movement later in the century. Such thinking falls into a common default position that says there is nothing more to make or write or think, for we have reached the end of history. This is a position summarised by Juliane Rebentisch as the *posthistoire* thesis where 'the implex, the implicit dynamic, or the potential of the currently given, has also been supplanted. Indeed, it has been supplanted in favour of a pseudo-dynamic, which is nothing other than the continuation and affirmation of the same.'[6] These beliefs seem even more saturnine if filtered through a twentieth-century avant-garde who believed that bourgeois values could be defeated by melding art with everyday activities (Joseph Beuys, Yvonne Rainer, Robert Rauschenberg). Unlike the obsessive return of the same, posed by Rebentisch, these earlier artists present an obverse point, closer to a Hegelian-infused teleology, where a superior and enriched existence meant an ebullient end to history.

Girded by the assumption that art's 'potential' (as a critical force) has been smothered by market interests, the darker currents of this century infuse contemporary art in complicated ways. For some artists, it has meant acquiescing to the texture of 'neoliberal' economics by adopting the persona and tactical acuity of free-market entrepreneurship. For others, wanting independence from economic concerns, the ossifying of 'product' with market has been so successful that the only possible solution is to form small, unfunded, ephemeral events made up of communities of friends. From within such a milieu, 'professionalism' is cast as the

new pejorative, conviviality is valued above networking or instrumentality, and non-exchangeability is turned into a source of joyfulness (as long as the artist and art writer have independent means). I offer these two responses to producing work in current economic conditions – artists working in symbiosis with the demands of neoliberalism and those who struggle with ways to oppose it – as a possible ground for critical questioning; to ask, in other words, whether work consists of mannered gestures, 'targeted' at a community schooled in left-leaning political discourses, while offering nothing more than the semblance of a critical position, or whether something much more disruptive (analeptic) is happening. It would be to sort out, through critical self-reflection, whether resignation has overpowered the responsibility of *tikkun olam* (to borrow from the Mishnah, Rabbinic teachings) as not only the care of one's own well-being but that of the wider society and its inequalities as well.

Lessons from the past

As I battled with my own shady, internalised senses of dread about the current political and social landscape, on the verge of retreating into a world of ambivalence, I happened upon two films over a couple of days that allowed me to critically reflect upon how to think through a political aesthetics today. *Soy Cuba [I Am Cuba]* (USSR, Cuba, 1964),[7] and *Winter Soldier* (USA, 1972)[8] were shot during the Cold War.[9] Both films deal, in their very different ways, with the barbaric functioning of imperialism: and both express coexistent feelings of hopefulness and resignation. This conflict, this antinomy, persists as an emotional tension in the films, particularly as the optimism that accompanies the fact of their making, comes up against the films' dark and sometimes horrifying narratives and personal accounts.

Soy Cuba

> *When a man is born, he has two paths open to him*
> *That of the yoke, which obligates and subjugates him*
> *Or that of the star that lights his way and kills him . . .*[10]

Through a series of vignettes that deal with the economic and cultural exploitation of Cuba's resources and people, *Soy Cuba*, directed by Mikhail Kalatozov and photographed by Sergey Urusevsky, charts the years leading up to the Revolution (1953–9). The subject, 'Cuba', speaks through the voice of a woman. It opens with a quote about the extraordinary beauty of the country from the perspective of Cuba's first European invader, Christopher Columbus, 'who took our sugar and left our tears', and then moves onto the imperialistic and commercial self-interests of its neighbour, the United States.

Its style is startling and experimental. Ninety-seven per cent of the film was shot on a hand-held camera,[11] and yet, it utilised the most audacious tracking shots and Dutch tilt angles, with a liberal use of filters and expressive lighting effects to emphasise shadows and darkness. The film also has the strangest aura, partly achieved by photographing with infrared film stock, supplied by the Soviet military, which is sensitive to wavelengths of non-visible light, rather than to light levels. The film stock and the filters blast objects with such intense whiteness that all of their finer details appear as though they have been embossed onto the film in post-production, while at other times objects morph into imposing abstract forms that force the blackest-blackness of space to the fore. Despite the cumbersome equipment of an early 1960s' film crew, many of the tracking shots are utterly perplexing – and I'm thinking in particular of the hotel scene, where the camera not only condenses the ugly side of capitalism into a heavy cacophony of bodies and excessive indulgence, but seems to travel so effortlessly, so lightly through the wateriness of the swimming pool and the solid structure of hotel floors.[12] Early in the film, a long shot follows a boatman as he negotiates the river and its inhabitants. He narrowly misses shacks with their foundations dug into the riverbed, women washing clothes, others sweeping, children playing, women cooking, old men sleeping. We dip very low with the boatman as he passes under buildings and bridges; the music is seductive, melancholic . . .

Winter Soldier

The same shit; that's exactly what this is going to bring out man, the same shit . . .[13]

A documentary – nay, much more a performance – *Winter Soldier* is a record of the testimony of a group of disaffected Vietnam veterans who carry out a senate-like enquiry into US atrocities during the Vietnam War in the early 1970s.[14] Unlike *Soy Cuba*, it is not the film treatment that gives *Winter Soldier* its greatest impact, although its editing, its choice of close-ups and long-shots, its timing, its rhythm, its cutting between testimony and archival footage are all artfully and efficaciously executed. What makes this film so affecting are the confessions and the revelations, the trauma-inducing reality that reaches into the deepest, psychological depths of its subjects as they painfully retell their stories about Vietnam.[15]

Even though *Winter Soldier* had a few screenings at European film festivals at the time, winning an award at Berlin,[16] it was largely unseen on its release, and was turned down by all major US television networks.[17] It also received very little press coverage,[18] although some articles did materialise, such as a 1972 review for *Playboy* by Bruce Williams. If this is an example of the tone

of the mainstream US press, then there was a tendency to underplay collective responsibility by pushing blame onto the individual soldiers themselves.

> What makes *Winter Soldier* uncommonly powerful is that the bearded contrite awakened young Americans who testify have so little in common with their counterparts from earlier wars, former Nazi henchmen, for example, who almost invariably pointed an accusing finger at some higher authority or at society as a whole. These soldiers never try to cop out, and their painful honesty may be the only hopeful sign in the horror stories told here.[19]

Compare this with the response of Amos Vogel writing for the *Village Voice* at the same time:

> There is simply no substitute for seeing the faces of the men as they testify, their strain, tears, hesitations, artless innocence – all inexorable guarantors of veracity, none available from a reading of the testimony. The enormity of our genocidal passion is recounted here in factual, chilling detail, resembling a criminal, cosmic jigsaw puzzle, any tiny part of which simultaneously contains within itself the totality of the over-all horror.[20]

Since both reviewers watched the same traumatic witness accounts and confessionals, perhaps we might hypothesise that they are summoning more than the predictable left-right divisions over governmental versus individual responsibility that has become the orthodoxy of United States' political discourse. Bob Westin, a former head of the documentary department for the American Broadcasting Company (ABC) claimed,

> Everyone was aware at that time – you're talking '72, '73 – that the Nixon administration had generated an enemies list. I think there would have been an extreme degree of caution in terms of doing something as provocative to the Nixon administration as running *Winter Soldier*.[21]

Soy Cuba was also shelved and nearly forgotten after receiving negative reaction from the USSR 'censors',[22] who, as Martin Scorsese believes,

> cited it as having too much formalism, too much style. I think they were afraid of it, I think they were afraid of it and just put it on a shelf, the emotion of it, the power of it, the beauty of it, and what could it have been? Perhaps they wanted a more traditional way of depicting the revolution.[23]

It was only after the collapse of European communism that the film began surfacing in North American cinephile contexts.[24]

And yet, perhaps it is not enough to be moved by *Soy Cuba*'s joyful, filmic qualities or *Winter Soldier*'s bold and moving confessions. We now live on the nether side of the films' events, witnesses to the shocking revelations of continued prisoner torture by the United States (Guantanamo Bay, Abu Ghraib, 2003; Khalid el-Masri, 2007). As expectations fade with every repeated failure, the resonating promise that change will come is easily stifled by history's reality.

The incomplete present

What does it entail, therefore, to actively entwine an art practice with a political position today? Surely it means holding onto a modicum of hope, to recognise hope regardless of the evidence that gathers to destroy it? Hope is not posed here in opposition to utter despair, but against resignation, either as the relinquishment of one's right to speak and act, or acquiescence to the existing order.

However, if we are to resist resignation as an urgent and ongoing task, then hope must be freed from a utopia or to a theological command to live a moral life (the promise of a deferred Paradise). I turn to Andrew Benjamin's conception of hope, which he frames in relation to an incomplete present, 'an ineliminable caesura as the present's own condition.'[25] It is this cut into the present that upsets the flow of time and opens to the 'complex interplay of repetition, renewal and hope.'[26] In accord with Walter Benjamin's philosophical concerns, Andrew Benjamin recognises a move from the universal to the particular, against the tendency of ontology to turn the particular into the same. The presence of differences 'is another way of understanding the presence of the incomplete.'[27]

I am quoting in some length Andrew Benjamin's formulation of the 'structural condition of the present',[28] which is also a productive 'affirmation of an incomplete present'.[29] His rejection of relativism or mere diversity as difference, and the threat of accompanying apolitical tendencies, led him to develop a new 'conceptual apparatus'.[30]

> Specifically, the response to the oscillation between loss and presence need not be based on an inexorable teleology, the presence of theology within philosophical thinking, nor on the utopian, the mythic response par excellence both to loss as well as to that conception of the partial that is generated by the retention of either destiny or an envisaged plenitude that is yet to be fulfilled or which has come undone. There is another possibility. This possibility will arise with the recognition that once the interdependence between loss and completion is put into

abeyance, then what will have to emerge is another thinking of the incomplete. No longer will it be that conception of the incomplete that is held by its opposition to differing forms of plenitude. Rather than being simply other, or merely different, its difference will raise the philosophical problem of how that alterity is to be thought. [31]

Hope brings questions of time into consideration. Writing is situated within time, as are artmaking and filmmaking. Each one responds to its own durational pressures of making that sit in relation to the maker's lived time, so that there is also *a* time of writing and *a* time of making.[32] However, it has already been noted that artworks and films operate within disciplinary discourses that entangle them in historical traditions. Such discourses are burdened by a history of privilege and exclusion that shape how they can be seen (how they become visible) and also what can be said about them at any cut into time. Rancière frames this as a configuration of domination and subjection, a struggle that arises as breaches open up and become visible within the aesthetic regime. I bring Andrew Benjamin back at this point to say that what activates the struggle, the dissensus in Rancière's terms, or conflict in Benjamin's, is the possibility of recognising hope as a condition of the present.

> The present is partial and intense because it is the site of repetition, the place continually structured by repetition as a working through, iterative reworking, and thus as the potential site of its disruptive continuity. In other words, the present maintains, by articulating the structure of hope.[33]

In speaking of his first viewing of *Soy Cuba*, Martin Scorsese spoke about his grasp of the reciprocity of perception, affection and thought that comes into play as we each encounter the event of art.

> As I was watching it – because of its vitality, because of its unique presentation of imagery and because of the nature of the way it chooses to tell a story – I suddenly got excited about filmmaking again . . . There's something about determination and the unadulterated joy and passion that the picture has in its filmmaking. And this for me overrode any political aspects of the picture in any way or the sense of 'propaganda' because the propaganda isn't really *in* the film. Yes, you can say that it is propaganda to a certain extent, but there's a purity to it because it's really like an epic poem.[34]

I share this belief in the potential of a work's vitality to overwhelm content. It is awareness of the capacity of art to convert moods of resignation into

moods of hopefulness; how it can make people excited about the possibility for change.

Accompanied by awareness of the way hope both structures and puts pressure on the present, a theme of *Artmaking in the Age of Global Capitalism* is that political-aesthetics is formed through certain approaches to making and its material affects. I would like to take a little time to explore the importance of this to the wider propositions of the book.

Approaches to making / materialism

The term 'approaches to making' is used to indicate a double sense of both a signpost and a method, a 'how to speak' and a 'how to make'. This double-approach carries an understanding that artists have the power and the right to have an encounter with politics today; that is, the 'power' in the Agamben–Aristotle sense of having the power to act, whether one exercises it or not,[35] and having the right in the sense that Foucault uses it in his lectures on 'parrhesia', as the right to speak the truth, coupled with his warning that such power and such parrhesia carries risks, since artists, speakers, writers and philosophers must also accept the consequences of their 'outspokenness'.[36] The danger of speaking out arises from the power of the 'tyrant' to react, not in the sense above, but in a much weaker form (ethically, ontologically) as the power to impose force. For Walter Benjamin, the power to act is coupled with the responsibility to act in a way that will ignite materialist effects.

I keep being brought back to Walter Benjamin's 1929 essay, 'Left Wing Melancholy', which has provided *Artmaking in the Age of Global Capitalism* with so many points of entry into the contemporary situation. It was here that Benjamin levelled an accusation against his compatriot writers: 'In short this left-wing radicalism is precisely the attitude to which there is no longer, in general, any corresponding political action.'[37] While there is no address by Benjamin about his own methodological position in this essay, Rolf Tiedemann clarified that 'for [Benjamin], as with Marx, historiography was inseparable from political practice: the rescuing of the past through the writer of history remained bound to the practical liberation of humanity.'[38]

Before digging deeper into Benjamin's method, I would like to touch, albeit lightly, on the Marxian context by returning to the opening lines of Marx's 'Thesis 1' of *Theses on Feuerbach*, written in 1845. It comes with awareness of the division between matter and ideality that haunts the European philosophical tradition. 'The chief defect of all hitherto existing materialism – that of Feuerbach included – is that the thing, reality, sensuousness, is conceived only in the form of the object or of contemplation, but not as sensuous human activity, practice, not subjectively.'[39] The complicated passage Marx designs from

thinking to acting allows for a productive opening to politics, as described by Étienne Balibar:

> Just as traditional materialism in reality conceals an idealist foundation (representation, contemplation), so modern idealism in reality conceals a materialist orientation in the function it attributes to the acting subject, at least if one accepts that there is a latent conflict between the idea of representation (interpretation, contemplation) and that of activity (labour, practice, transformation, change). And what [Marx] proposes is quite simply to explode the contradiction, to dissociate representation and subjectivity and allow the category of practical activity to emerge in its own right.[40]

Tiedemann's description of Benjamin's practical liberation of humanity points to the dynamic revolutionary potential that arises from Benjamin's use of *Jetz-tzeit* or now-time. The concept springs from Benjamin's borrowing of the bits of messianic thought that suited him, 'taking whatever he needed from the mystical heritage', as Irving Wohlfarth describes it.[41] The Messiah's return is the moment when history is at a standstill, forcing an interruption to the catastrophic continuum of time. *Jetzteit* holds a faint messianic thread, therefore, as a form of hope and responsibility that wrests utopian motifs (dreams) from the blind adherence to the myths of progress, be they collective or singular. And since redemption is ventured for Benjamin on the possibility of shifting from a historicist perspective (ruin, loss, 'progress') to a period transformed by historical materialism, it is fashioned as worldly hopefulness, and not deferred hope, which is infinite in the disconsolate sense that his colleague, Gershom Scholem, scholar of the Kabbalah, understood it.[42] Against Scholem, Benjamin's understanding of hope is one way to conceive the messianic as an earthly, non-theological concept. However, it has never been a simple or uncontroversial theme in Benjamin studies. 'Ironic Messianism' is a term coined by the liberal Rabbi, Leo Baeck, and used by Anson Rabinbach to describe the tensions that are carried when Benjamin adopts Messianic themes, the politicising of theology or the theologising of politics. 'It is not simply between action and passivity', Rabinbach writes, 'but between the normal politics of terrestrial beings, and a politics that transcends any spatial dimension.'[43]

It is known that the positive and elevating dimensions of Benjamin's philosophy never deserted him, even in his final, darkest days of exile and moments of despair. Until the end of his life Benjamin pursued ideas about the capacity of technologies to stimulate collective action, and this was most notably developed across three versions of his essay, 'The Work of Art in the Age of Its Technological Reproducibility' (1935–9).[44] In a recent study,

Matthew Charles explicates Benjamin's thinking and research into 'innervation' as a conduit of perception. The concern for Benjamin was to understand the way technologies (always tied to their historical moment) impacted on the collective body. Charles also shows how this Benjaminian concept has been largely ignored.[45] Perhaps it was misunderstood, or perhaps Benjamin's writings are just poorly synthesised due to divisions wrought between the political and theological readers of his work, and yet, it seems critical to a fuller understanding of Benjamin's political thinking. Charles does credit Miriam Hansen with tackling innervation:

> What is the effect [she writes] of industrial-capitalist technology on the organisation of the human senses and how does it affect the conditions of experience and agency, the ability to see connections and contradictions, remember the past, and imagine a (different) future?[46]

However, in the end, Charles shows how Hansen's analysis of innervation and its capacity to incite revolutionary action takes a misstep when she retreats into psychoanalytic explanations.

In 'Convolute W–Fourier' of the *The Arcades Project*, reframing phalanstery to mean a 'veritable hallucination', Benjamin writes:

> [Fourier's] conception of the propagation of phalansteries' through 'explosion' may be compared to two articles of my 'politics': the idea of revolution as an innervation of the technical organs of the collective . . . and the idea of the 'cracking open of natural teleology'.[47]

Charles's research shows how the importance of 'innervation' to Benjamin's politics came from a range of Soviet and German sources that shared a rejection of bourgeois subjective psychology, such as Freudianism.[48] Bringing together quotes from Benjamin's *Selected Writings*, Charles shows that

> these innervated bodily gestures provide a political model for a utopian will whose 'secret signal of what is to come' is 'not so much a signal of the unconscious, of latent processes, repressions, or censorship (as the psychologists like to think), but a signal from another world.'[49]

This is demonstrated by Benjamin's early encounter with surrealism and his eventual criticism of its methods.

Louis Aragon's novel, *Le Paysan de Paris* (1926) – instrumental in the ensuing significance of the outmoded to Benjamin's *The Arcades Project*, and André Breton's *Nadja* (1928), which traced the paths of Breton's protagonist and

her peculiar qualities – illustrated how to penetrate the grinding tedium of the everyday. Surrealism was able to pierce the inner spirit of 'things' through the revolutionary potential of shock experience. In his essay on Surrealism, Benjamin wrote: 'they bring the immense forces of "atmosphere" concealed in these things to the point of explosion.'[50] It led him back to the nineteenth century to recover the wish-symbols, or the dream-work of capitalism at the height of the seductive power of a thing (a commodity, architecture, manners, ideas and so on.). This was before their charm had dissipated (as the outmoded or the unfashionable). Nonetheless, he was contemptuous of the focus on the mysterious in surrealism, writing that:

> for histrionic or fanatical stress on the mysterious side of the mysterious takes us no further; we penetrate the mystery only to the degree that we recognise it in the everyday world, by virtue of a dialectical optic that perceives the everyday as impenetrable, the impenetrable as the everyday.[51]

In the final reckoning, surrealism failed to 'win the energies of intoxication for the revolution'.[52] Its revolutionary project, which was hailed as a permanent revolution by Breton, was driven off-course by an emphasis on the unconscious and on individual desire and not on the potential of recognisability of a time to come. This would fall, for Benjamin, on his use of the term 'the now of recognisability', which Werner Hamacher differentiates from 'time differential':

> It does so as complement of the time differential and thus is not a 'thought-time' (*Denkzeit*), but an 'event time' (*Geschehniszeit*) – a time of the happening of time. Their relation can be formally characterised such that it is only the time differential that opens up the latitude where a Now of recognisability and thus history can happen. Because 'time differential' and 'Now of recognisability' are two aspects of the same happening, it can be said: the Now is differential.[53]

'A time to come' is the term Deleuze uses to describe Foucault's approach to historical materialism, reminiscent of Benjamin but effectively stripped of allusions to the Messianic tradition:

> thinking has an essential relation to history, but is no more historical than it is eternal. It is closer to what Nietzsche calls the untimely: to think the past *against* the present – which would be nothing more than a common place, pure nostalgia, some kind of return, if he did not immediately add: '*in favour*, I hope, of a time to come'.[54]

In terms of Deleuze himself, Claire Colebrook encapsulates the materialist legacy in his and Guattari's work:

> Rather than being lost in a world of 'unreality' it is to think in terms of the emergence of the immaterial, the emergence of sense, the emergence of the virtual: which, they say, for good or for ill, is directly political. And that's Marxist, isn't it? Marxism is about the material emergence of the immaterial, the material conditions of expression.[55]

Deleuze's singularly authored texts also focused on defeating rigid identity formation by conceptualising difference (cast both immanently and univocally), he began with a sustained criticism of Platonism and transcendent being, bolstered by his investigations into the Stoics.[56]

> For the Stoics ... states of affairs, quantities, and qualities are no less beings (or bodies) than substance is; they are part of substance, and in this sense they are contrasted with an *extra-Being* which constitutes the incorporeal as a nonexisting entity. The highest term therefore is not Being, but *Something (aliquid)*, insofar as it subsumes being and non-being, existence and inherence.[57]

The materialist tradition being encircled here was taken up Elizabeth Grosz in what she calls 'immaterial materialism or corporeal idealism' through the Stoics, Spinoza, Nietzsche, Deleuze, Gilbert Simondon and Raymond Ruyer.[58] She shows that for these philosophers there was a shared meeting point between the material and immaterial, 'the dimension of ideality that suffuses all things, enabling them to signify' and in turn be reformulated. She proposes that there is always already something in the organisation of matter at its most elementary that contains the smallest but perhaps the most significant elements of ideality. In 'sometimes elaborate, and always complex' ways she reconceptualises 'extramateriality' or the 'prematerial', 'premised on a corresponding urge to think beyond dualistic or simplistic reduction'.[59]

Some commentators have shackled Grosz to the body of 'new materialism', but she seems to be attempting something quite distinct in conceptualising the incorporeal as that which 'orients a movement of concepts or thought',[60] whether a philosophy or a work of art, as 'an entwinement with a material order.'[61] To avoid the historic material/ideal dualism this tradition insists instead that they spring from the same elemental source. It is how philosophy, art and filmmaking might be thought together, without betraying the proposition of Deleuze and Guattari that philosophy is about the construction of concepts, while art is constituted by a bloc of sensations, percepts and

affects that sit outside of language.[62] As John Rajchman has written, Deleuze believed that 'a nonphilosophical understanding of philosophy is at work in and through the arts, and that philosophy always presupposes such an understanding, and, indeed, is in part addressed to it.'[63]

Deleuze and Guattari developed their concept of art as a bloc of sensations, percepts and affects, alongside the idea that artmaking is an experimental activity that sits in opposition to representation. Rajchman asks, 'What then does it mean to extract the "being of sensation" from representation and make it a matter of experimentation?' It is to 'discover something mad and impersonal', a madness comes before language, before thinking, before the 'I think'.[64] And when Deleuze is describing colour (in the films of Jacques Tati and Jacques Demy, for instance), or when he draws out the significance of the crystal to philosophical film-thinking, he often uses the term 'luminous sensation' and each time he does – for he uses this again and again to draw out the conceptual (the philosophical), which belongs peculiarly to films – it brings a wonderful image to bear on this very special madness.[65]

As outlined in Chapter 3, Rancière was part of a push in the aftermath of 1968 to find new, critical forms of materialism against Marxist orthodoxy.

Examining a method [he wrote] thus means examining how idealities are materially produced. 'Ideas are material forces', Marx says, 'when they take over the minds of the multitudes'. The formula is only half-materialistic. Ideas always are material realities, taking over bodies, giving them a map of the visible and orientations for moving.[66]

Furthemore, as Jean-Philippe Deranty writes:

These materialisations in turn affect the discursive and the conceptual. Discursive, conceptual realities, by informing the views of material realities, determine the types and forms of practice, and thus indirectly shape the material, while the material, being the only plane in which practical meanings can be realised, determines thoughts and discourses. It is as though Rancière's radical extension of the axiom of equality reached all the way into the material.[67]

The heightened interest in reframing material affects in philosophy was accompanied in both artmaking, and filmmaking by a re-enlivened pursuit of a purely sensorial experience. I am thinking in particular of some examples of French cinema, such as the films of Claire Denis (whose *L'Intrus* is covered in Part III), Philippe Grandrieux, Bruno Dumont and the early films of

Philip Garrel. They all build on a tradition in France that pursues sensation as a primary force, theorised by Antonin Artaud in the 1920s upon the belief that cinema, this new art form, must find a visual 'language' peculiar to itself.

What began dissipating in artmaking at the end of last century was the supremacy of 'analytical conceptualism' that began taking hold in the 1960s. Suffering a decisive reversal of fortunes this century, it is a form of work, in Lucy Lippard's words, where 'the idea is paramount and the material form is secondary.'[68] Artwork that had a material substrate to support the conceptual aspects of the work, an affect that would play as much on the senses as the intellect, seemed to now take precedence.

In *Artmaking in the Age of Global Capitalism*, a consideration of a work's political-aesthetics is informed by this century's renewed concern for materials and their effects. And this focus on the sensate realm seems to determine that a portion of any interpretation of work will include a subjective dimension. Georges Didi-Huberman is helpful in straddling the line between exegetical veracity and the parts of the work that are incommunicable. He insists that to 'see' a work is 'to use our imaginations and risk, in the last resort, unverifiability.'[69] It means retaining something unspeakable and mysterious that is tied specifically to the work art. In a similar way, although framed differently, T. J. Clark navigates the intricate intersections between history, world and work by writing from the work itself. He attends to 'the specificity of picturing' which is 'so closely bound up with the mere materiality of a given practice, and on that materiality's being so often the generator of semantic depth – of true thought, true stilling and shifting of categories.'[70] The writings of Didi-Huberman and Clark carry their own material effects, and I think of their art historical ways as counsel for my own approach, one that hopes to coexist with the works but to neither speak for them nor to make definitive demands or resolutions.

It also suggests that the kind of methods that might be successful in disrupting the aesthetic order of the day (of what is visible, sayable, thinkable) is both knotty and slippery. And I ask that this tension between the irresolute image of knot and slip be kept in play, for it leads me to a qualification. While respecting Rancière's claim that 'there is no criterion for establishing a correspondence between aesthetic virtue and political virtue',[71] and no sufferance for representational modes of artmaking, I nonetheless acknowledge that there can be a political exigency to the logic driving some artists' methods. The Palestinian artist and filmmaker, Emily Jacir, in her *Memorial to 418 Palestinian Villages which were Destroyed, Depopulated and Occupied by Israel in 1948* (2000) was an urgent rubbing against the grain of history. From title to content the work is pointed and descriptive.[72] There is to be no confusion about the destructive actuality wrought by this war. In New York, in exile,

she organised a team of more than 140 people to embroider onto a refugee tent the names of those who had become homeless due to the war. As Jacir wrote,

> The majority of [the embroiderers] I had never met before. They came as lawyers, bankers, filmmakers, dentists, consultants, musicians, playwrights, artists, human rights activists, teachers, etcetera. They came as Palestinians (some of whom come from these villages), as Israelis (who grew up on the remains of these villages) and people from a multitude of countries.[73]

This work avoided obfuscation of any kind, for Jacir wanted there to be no confusion about the intention of her work. The precise details and matter-of-factness of the title recalls the historical moment, the 1948 war, and each time the work is written about or discussed, it memorialises the names of the villagers, the horror of the temporary dwelling, and the realisation that despite the possibility of hope, the reality would be generational homelessness far into the villagers' futures. Jacir's *Memorial to 418 Palestinian Villages which were Destroyed, Depopulated and Occupied by Israel in 1948* is also a mechanism for remembering the continuing violence that underpins the occupation. In avoidance of the kind of indeterminacy about intent that occurred with the public reception of Simon Denny's work, or with the logic of ambiguity developed by NSK in their response to the socialist state, Jacir is unequivocal about pushing the work's political content to the fore. She avoids overwhelming her subject with symbolic or poetical gestures that might detract from her core concern, a focus on the displacement of Palestinians from their homes to refugee camps after the 1948 war.

At both the discursive and material levels, our discipline's distaste today for the representation of politics is proposed in *Artmaking in the Age of Global Capitalism* through an engagement with the history of making and its interconnection with social and political events. This is the gift and the promise of tradition, in Benjamin's terms, which, at the same time allows for the theories of Rancière to be recognised as something belonging to our own time. I opened with the claim that analyses of political activism were outside the concerns of the book, and I very loosely defined this as work that pushes politics as its *modus operandi*. However, such taxonomic approaches can also limit the interpretative possibilities of artwork, preventing opportunities that may be discovered once categorical parameters are challenged. The examples of Tania Bruguera, who treats political media as art material, and Emily Jacir who eschews obfuscation for clarity of intention, have been offered as complications to the binary of art and activism.

And thus, I now move away from the historical antecedents that constituted the earlier sections of this book to focus on the implications that flow from a close examination of contemporary works. It uses a method that works out of the artwork itself, and opposes an approach that first establishes an argument that then subsumes a work's uniqueness under the theorists'/writers' own premises. It is to risk, in Didi-Huberman's terms, unverifiability, by allowing thought to be carried into unknown places and in unpredictable ways. The artists and filmmakers – Alex Monteith, Angela Brennan, Claire Denis and Frances Barrett – are considered through a single or small sample of work, using first hand interviews, observations and theoretical or philosophical concepts. By using the work as the material for thinking, it is intended that the essential differences that exist in art and film practices will remain visible.

As with the earlier thinkers and artists covered in Parts I and II, in the final section, artists and their work have been chosen rather idiosyncratically and thus by chance, but with a consistency in each artist's rejection of the idea of 'political art'. And yet, Emily Jacir's work holds a warning about the difficulty of being overly prescriptive when it comes to representational forms of art practice. Artists and filmmakers will dip in and out of political content in the context of the specific demands made upon them by local political, social and historical conditions. This is the knotty and the slippery that I asked might be kept in play, and a warning too, not to be overly hubristic about one's own position for the context is constantly changing.

8

Frances Barrett – A Politics to Come

> In the ethical regime, works of art have no autonomy. They are viewed as images to be questioned for their truth and for their effect on the ethos of individuals and the community.[1]

I visited Frances Barrett today, in her studio, which is also her apartment, in an old industrial space of some kind, painted grey, not far from Central Station in Sydney. It was hard to find, and then I had to pick my way through a complex of plants, chairs, discarded structures and a garden swing, so strangely out of place and squashed into a corner. Yet, despite itself, despite its tall walls and over-looming windows, the small courtyardy space had good energy. Wondering what its former use might have been, I waited for Barrett . . . [2]

I first met Barrett in Melbourne a few months earlier in the middle of a performance called *Curator*, which has since had several iterations in different locations around the world. What had profoundly struck me about Barrett at the time was the way she was able to impose without imposing herself. This special way of existing in the world, this being-without-overbearing, was interesting for it seemed to be driving the intentions and outcomes of her performance.

Dear Joel and Danni –

You both, as the two Artistic Directors of Liquid Architecture, have asked me to participate in a program titled, *What does a feminist methodology sound like?* Your curatorial proposition. This email, and in turn this conversational thread, is the beginning of my response to this proposition.

What I am proposing is a new work called *Curator*, and I am asking that both of you realise this work with me.

So, let's go from here to hear. Here you both are, as the Artistic Directors of Liquid Architecture, and you have curated me here*, as an artist into this project. The word curator originates from the Latin word *cūrāre* which means to care for, to attend to. You, as the two curators of this

Figure 8.1 Frances Barrett, *Curator* (2015), black-and-white location still. Photo: Keelan O'Hehir. © The Artist

program have asked me to consider a feminist approach to the creation of a sound work and to the act of listening. So, Joel and Danni, Curators, let's undertake a project together of careful listening and care taking.

I consider that a methodology is a process, and a sound to be the outcome of an action. So, let's focus on the processual, and the feminist strategies of collaboration, listening, intimacy, and embodied action to get us there.

I invite you to 'care for me' over a 24-hour period. I will cover my eyes so that I will be unable to see throughout this time, which is a form of embodiment that I am unfamiliar with. I propose to be with you between 9pm Thursday 17 September until 9pm Friday 18 September, 2015. You will collect me from Melbourne airport on Thursday evening. As soon as we meet, the performance will begin.

> *I will not talk to you or look at you.*
> *I will not ask you for anything.*
> *I will not direct you towards anything.*

I will not suggest anything.
I will be in your presence for a continuous 24-hour period.
I will not carry a phone, any identification, or any money.

I want to be able to touch you for the complete 24-hour period – unless you choose not to on the occasions of sleeping, shitting, showering or pissing. When you are showering, or using the bathroom, you can choose to put me temporarily in the care of another Curator or place my two hands on the wall outside of the room that you will be occupying. You can choose to show me to the bathroom when you think I need to piss or shit or change my tampon. You must determine before the performance begins whether I will be menstruating during this time.

You must introduce me to everyone that you engage with over the 24-hour period with this statement: '*This is Frances Barrett, she is an artist who is participating in my program,* What Does a Feminist Methodology Sound Like? *as part of Liquid Architecture. This is her 24-hour performance, Curator.*'

If there is an emergency then you can choose to explain to me what is going on. I will then determine if the performance ends or not. If you think I have hurt myself then ask me, '*Have you hurt yourself? Do you want to end the performance?*' *I will then determine if the performance ends or not.*

You will provide a photographer throughout the 24-hour period to document parts of the process. I will be in your complete care. In the final hour of this performance I ask that you write an epistolary response to my proposition and to the experience of the work in the form of a 'reply all' email. After which I want you, as Curator, to read both these emails in succession to a live audience in West space on Friday 18 September 2015. For this reading, I want the photographer to compile a series of images taken of the performance to play in a slide show behind you. I want this final stage of the performance to be video and audio recorded. In your letter, I want you to address what we did across the 24-hour period, how you cared for me, and determine how, in your perspectives and with your experiences, I have addressed your original proposition. Perhaps it does. Perhaps it doesn't. On the conclusion of your reading, you can tell me to open my eyes and that the performance has finished.

From here to hear.
From here, as email. To hear, as script.
From here, as silent artist**. To hear, performing Curator***.

Any questions please do not hesitate to email me. Please note that I consider the negotiations of this performance crucial to keep via email thread. This is an intimate contract that I hope you are interested in agreeing to.

Sincerely. Always.
Frances Barrett

> * Directive for the live performance: Point to me.
> ** Point to me
> *** Point to yourself

The Melbourne version (2015) was part of a four-week performance event exploring feminist methodologies by Liquid Architecture, an organisation dedicated to presenting sound-based art from across the world.[3] If pushed to define what a feminist methodology might involve, 'what it might sound like', Liquid Architecture had chosen quicksandy soil to traverse. In proposing such a broad and contested premise, feminist methods would need to be approached with delicate skill if the artists were to avoid universal taxonomies or essentialist reductionism. This declaration, to claim feminism as a working methodology, not queer, nor queer feminism (although this is usually the implication), but feminism as a presumptive *Weltanschauung* – is widely claimed at the moment. And yet this approach, this way, is rarely elaborated upon, a moment of anticipated bliss perhaps, that dreams of radically tempering the world's testosterone-fuelled forces . . .

> *Ah . . . how easily I have allowed myself to resort to a passionate generalisation, rather than a richly nuanced and practicable working concept. By introducing a crude hormonal division tied to a questionable model of sex demarcation, I have taken myself down a dark hole. A theory that simply substitutes one gender for another means that institutionalised biases against non-normative identities remain undisturbed and idealist.*

At the public end of the performance, Barrett was asked by a member of the audience to explain how *Curator* encompasses a feminist methodology. I was keen to hear how she would avoid following false paths. She spoke about gendered socialisation, embodied reactions, capitalist and post-colonialist contexts,

artist-curator relationships as paradigms for larger social formations. Her words began to coagulate around a certain kind of currency, signifying a well-received form of political-fashioning that dominates contemporary art discourses. As I began to doubt whether Francis would find a way to break through the hum of entrenched ideas, she presented a possible working concept for an ethics that I believe marked *Curator*'s greatest challenge: 'I think that … um … by shifting one aspect of the way that we talk, by collaborating, by creating a bit more of a sensuous, intimate experience between each other, that for me is one gesture towards a feminist methodology.'[4] Barrett is responding to the power (*potenza*) that we each have to act ethically in the world, to have both the faculty (*potenza*) and the capacity (*potenza*) to act, as Agamben has argued in relation to the 'Aristolean doctrine of power' and from which an 'archaeology of subjectivity' remains.[5] Agamben uses the example of 'the musician of the zither' who has the power to play the instrument; that is, she has both the facility and the capacity to play, even in those idle times when the zither is not being played. 'It is the way in which the problem of the subject is announced to a thought that does not yet have this notion.'[6] And yet, it remains to ask, where might the volition to act on this power come, this 'vital practice', in Agamben's words, and to what ethical source might Barrett be appealing?[7]

I suggest that in the playing out, or in the performing of *Curator*, Barrett has no recourse to an external authority, but rather, relies upon an internalised measure to know how to act in the world. This articulation of an ethics of immanence would follow Deleuze (in a Spinozian and Nietzschean line), and from whom a distinction is also made between ethics and morals. Deleuze writes:

> We will say of pure immanence that it is A LIFE, and nothing else. It is not immanence to life, but the immanent that is in nothing is itself a life. A life is the immanence of immanence, absolute immanence; it is complete power, complete bliss.[8]

Since such modes are non-temporal and pre-personal, the plane of immanence is simultaneously that which has to be thought but also the un-thought of thought, and as such is not generated by a subject or an individual but merely actualised in them. 'The immanent event is actualised in a state of things and of the lived that make it happen.'[9] In other words, it is the actualising of the virtual from the modes of existence.

While Deleuze calls Nietzsche's method 'a logic of pure affirmation and a corresponding ethic of joy',[10] he also acknowledges that the actualising of the virtual can include not just the good but also the bad, and thus, we get the denouncement of the sad passions in Nietzsche and Spinoza:[11] 'the

slave, the tyrant and the priest . . . the moralist trinity . . . united in their hatred of life, their resentment against life'.[12] Deleuze notes of Spinoza that if there is

> a philosophy of life . . . it consists precisely in denouncing all that sepa-rates us from life, all these transcendent values that are turned against life . . . hatred, aversion, mockery, fear, despair, *morsus conscientiae*, pity, indignation, envy, humility, repentance, self-abasement, shame, regret, anger, vengeance, cruelty.[13]

It is from the perspective of these differing modes of existence – the affirm-ing of life and the negation of life – that Deleuze says: 'Art is resistance: it resists death, slavery, infamy, shame', even while deferring to a comment made by Philippe Garrel that the Louvre is full of works of tragedy.[14] For Spinoza, Nietzsche and Deleuze, moralism defines a set of externally generated rules to which one must defer and obey, a 'theological illusion', as Deleuze writes of his 'immoralist' Spinoza.[15] Ethics is 'a typology of immanent modes of existence, replacing Morality, which always refers existence to transcendent values.'[16]

Barrett had placed a clear time frame around when the work would commence and end, while also forming a contract between the curators and herself that apportioned responsibilities of dependency and care. What was also muddied was the line between being at work and being outside the work, making *Curator* an interesting case study for testing the ethical limits of contemporary art. In other words, as the work left the gallery and the dissolution of boundaries between work and non-work were enacted, I was led to ask how the artwork 'behaved' in the world. In making this demand, this inextricable unity of artist and work, a much heavier burden falls on art's role and function in the world, and this differs greatly from earlier moments in history when the perceived value of the work compen-sated for any other act of the artist in the world. And thus, before begin-ning a closer look at Barrett's performance, which rests on an approach that incorporates 'a sensuous and intimate relation' with others, and so to her intention to produce positive effects on the world, further qualification is required.

Rancière, the materialist, reverts to the origin of the term ethos as 'the dwelling and the way of being, the way of life corresponding to this dwell-ing', concluding that 'ethics, then, is the kind of thinking which establishes the identity between an environment, a way of being and a principle of action.'[17] And if it is accepted that this is a way of conceptualising the actualisation of

the virtual, then this is also the meeting point between the world, being and action. As Ernesto Laclau writes:

> In the same way that, with modernity, immanence ceased to be a theological concept and became fully secularized, the religious notion of evil becomes, with the modern turn, the kernel of what we can call 'social antagonism.' What the latter retains from the former is the notion of a radical disjuncture – radical in the sense that it cannot be reabsorbed by any deeper objectivity that would reduce the terms of the antagonism to moments of its own internal movement, for example the development of productive forces or any other form of immanence. Now, I would contend that it is only by accepting such a notion of antagonism – and its corollary, which is radical social division – that we are confronted with forms of social action that can truly be called *political*.[18]

This aligns with Rancière's insistence that disagreement (dissensus) is a defining feature of the political, and must be protected against any move to consensual models. Since suspicion is raised over anything that would threaten this essential condition of politics, morality takes on a quite different form to the Deleuzian tradition outlined above. If the latter defers morality to its theological origins, for Rancière morality constitutes the distinctive divisions (differences) within the people (at the level of the state, the law, and so on). What Rancière calls the 'ethical turn' is a concern for the loss of this division in favour of ethics for which, he argues, there can be no claim to division. In other words, morality once

> implied the separation of law and fact, what *is* from what *ought*. It implied concurrently the division of different forms of morality and of rights, the division between the ways in which right was opposed to fact. The abolition of this division has one privileged name: it is called consensus.[19]

What is termed by Rancière as 'the ethical turn' means that 'the specificity of political and artistic practices [is] dissolved' and 'the identification of all forms of discourse and practice' come 'under the same indistinct point of view'.[20] What is transformed here is a political community into an ethical one, 'the community of only one single people in which everyone is supposed to be counted.'[21] Where 'Politics fades away in the couplet constituted by consensus and infinite justice',[22] art fades into the un-representable. 'The non-representable is the central category of the ethical turn in aesthetic reflection, to the same extent that terror is on the political plane, since it is

also a category of indistinction between right and fact.'[23] Rancière ends his essay with the following summation:

> This movement takes its strength from its capacity to recode and invert the forms of thought and the attitudes which yesterday aimed for a radical political or aesthetic change. The ethical turn is not the simple appeasement of the dissension between politics and art in the consensual order. It appears rather to be the ultimate form taken by the will to make this dissension absolute.'[24]

This vision outlined by Rancière is not the fate of art and politics, it is not an historical necessity (for he rejects that the future could be closed down in this way), but instead offers radical openings (challenges) for an art and politics to come. This is his *partage du sensible*, riven with the optimism of a politics of equality, which extends to his positioning of himself as a political philosopher. Writing on Rancière, Jean-Philippe Deranty notes that it is not the intellectual's role to 'educate and/or lead' but to find ways 'to help others express their own experience, their thoughts, and their desires for recognition.'[25] This is not to suggest that Rancière is alone on this point, for the careful positioning of writer to reader, of artist to audience, of revolutionary to the subject of emancipation marks a rich tradition in French twentieth-century thought. And thus, it is to recall the moment when Deleuze addressed Foucault in a 1972 conversation with the following praise, 'In my opinion, you were the first – in your books and in the practical sphere – to teach us something absolutely fundamental: the indignity of speaking for others.'[26] Or to remember the expression of doubt in Jacques Derrida's letter (unsent) in response to a request by Jean Genet in 1971 to rally support for the jailed Black Panther, George Jackson. 'Where (who) are we now, who are exchanging these words like words to the wise?'[27] Earlier the problem of representation was raised in relation to a tradition in French thought that rejects, as an ethical exigency, the position of speaking on behalf of others.[28] It was a belief in the equality of voices and of the violence that ensues when one speaks for the other that led Rancière to share with Deleuze an antipathy towards representational modes, whether these are political or aesthetic.

All of this arises from an understanding of 'equality' as the fortifying agent that energises Rancière's thinking, perhaps better understood as the grounding premise that reaches into the smallest crevices of his thoughts, and which ties him to a particular form of materialism. Writing of his method in a humorous third-person distancing of writer to work, Rancière says, 'Ideas always are material realities, taking over bodies, giving them a map of the visible and orientations for moving.'[29] Rancière's materialism, as Deranty writes, 'emerges from a mode of thinking and writing that is sensitive to the constant exchanges and blurrings

between mental and material realities.'[30] When Barrett claimed that her method rested on a 'a sensuous and intimate relation' with others in the world, it pointed to the intrinsic and necessary materialist approach to her work, to her performances, which in the case of *Curator* also extended beyond work to everyday life. And, thus, it might be read from another perspective as a form of responsive ethics. As Emily Beausoleil writes, there is a 'recurrent turn to ethics as praxis, enacted through the daily practices of receptivity and responsiveness.'[31]

And thus, I propose these as the *a priori* conditions upon which to launch a critical consideration of *Curator*, to recognise that Barrett's approach is poised to tap into vital modes of being, which are best understood as an ethics of immanence, while adopting a materialist methodology that accepts disagreement as the basis of politics. Even if this has not been directly articulated in these terms by Barrett, this claim has been wrought from the presentation of the work and its accompanying documentation and what I can glean from it. I have come to this point by working back from the way the artist appears to position herself in relation to her world and the political implications generated from her work. And yet, still, I feel it is a little too certain of its own position, and should be taken with the undertow of doubt that drags along with it. To be clear, in other words, I have no interest in imposing intentions on artists that they themselves have not generated or agreed upon. My approach is to see what material affects and conceptual concerns can be discerned from a particular work or practice, and then to consider how this relates to the way artists speak about their work. It is to get as close as possible to the intersection between intention and reception. And it is to understand that intention does not wholly direct the social effects of the work, as it moves into the world to be greeted by others.

However, in saying all of this, it is not to also neglectfully ignore that the work *was* developed in direct response to a curatorial premise that asked what a 'feminist' methodology might sound like. What I would like to propose, provisionally, therefore, is that the term 'feminist' does not in itself beg for an internally coherent thesis to be formed from a set of theoretical ideas, out of which an exclusive position becomes a point of ideological determination (a kind of feminist court that accepts or rejects members). Instead, I am treating it as a place-holder for critical strategies and productive material forces formed in response to the negative effects of patriarchal-capitalism. As such, it summons, each time it is uttered, the conditions of privation produced by a system that promotes the domination of one group over another. In its fullest sense – and this would be its ethical objective – it rejects the claim that some members of a social-political grouping are privileged over others, but rather that we are each weakened by the conditions produced by the system. I proceed tentatively and provisionally on this premise.

The tolerant artist

Barrett arrived to collect me from the courtyard and we climbed the substantial stairs to the first floor; there was still a little uncertainty and awkwardness hanging between us. She took me into a space divided by screens and a fill-in kitchen, the kind of *ad hoc* amenities pieced together to overcome old zoning regulations. The forced separation of work and home was a familiar policy of former eras, supported by regulations claiming to protect the health of those who worked in the polluted cities of our industrial pasts. Regulations are so often clothed in paternalistic care. At the time, there would have been a great motivation to stop disease from moving across class borders – from the slums that encircled our cities to the leafier suburbs, further afield. Remembering how insistent the belief was among assorted bourgeoisie (writers, suffragettes, doctors, intellectuals and others) for Eugenics at the time, I am reminded of Wendy Brown's argument about 'tolerance' entailing both a 'luxury of power' as well as 'power's disguise', for slum survivors at the utmost point between 'putting up with' and 'elimination'.[32]

Tolerance, as a gesture of care, a 'demeanour', is an attitude found widely in contemporary art. However, Lars Tønder has shown that questions over the value of tolerance as a political position also rents a bifurcation of opinion in contemporary political scholarship.[33] In many ways, artworks replay this division. Wendy Brown has presented a form of tolerance that

> anoints the bearer with virtue, with standing for a principled act of permitting one's principles to be affronted; it provides a gracious way of allowing one's tastes to be violated. It offers a robe of modest superiority in exchange for yielding.[34]

I raised the vision of such artwork earlier for failing to adequately reflect upon the ethical implications of speaking for the other, and for placing the artist in a position of intellectual and moral superiority over its subject matter. This would be its codicil, the point where the goodness of tolerance is shadowed by a self-concerned nether side. 'It is clear that tolerance entails suffering something one would rather not, but being positioned socially such that one determines whether and how to suffer it, what one will allow from it.'[35] Might this be considered as an interpretive mechanism for identifying a maker's position, their attitude towards another, a flag perhaps, signalling that something else may be going on in the work?

> Despite its pacific demeanour, tolerance is an internally unharmonious term, blending together goodness, capaciousness, and conciliation with discomfort, judgement, and aversion. Like patience, tolerance is

necessitated by something one would prefer did not exist. It involves managing the presence of the undesirable, the tasteless, the faulty – even the repugnant, or vile.[36]

It is not difficult to find examples of this in contemporary art that purports to have political intentions. It falls heavily into the realm of Benjamin's 'clowning of despair' that he used to describe self-interest dressed as radical left concern.[37] It is work that claims to be uncovering an historical or current imbalance of power, speaking from the perspective of a dominant or privileged position on behalf of a weaker or marginalised one, which then buries those voices under the authorial voice of the maker. Not wanting to give too much air to this, I offer a single example, which perhaps is a little blunt, but since it initiated a first questioning about the position of the artist in works with political intent, I believe it is an apt one. In 2009, at an artist's talk held at the contemporary arts organisation, Artspace (Auckland, New Zealand), the Danish artist, Jens Haaning spoke about his work, which he promotes as having a concern for 'the way power is expressed' in Western nations (particularly in relation to migrants and refugees). In 1996, in the gallery, de Vlesshal, in Middelburg, The Netherlands, Jens installed 'a textile factory (infrastructures and employees)' and 'for the entire duration of the show, one could watch the immigrant workers of the garment company, Maras Confectie, going about their daily business.'[38]

> The Turkish owned clothing factory Maras Confecti, located in the same region as the kuntshalle, was relocated into the exhibition space. The relocation included the whole factory: the production section, the office and the lunchroom. In the exhibition hall the Turkish, Iranian and Bosnian employees proceeded with their production of towels, summer dresses, bed cloth etc. according to their normal schedule.[39]

The workers remained voiceless, nameless, their labour posed for the gaze of the visitor, reified as material for 'tolerant' visitors, these gallery visitors who were presumed wholly ignorant of factory work, observing (somewhere between simulation and performance) the working lives of these strangers. Does the act of displacement also mean that the workers signify as wholly exploited others, exhausting all other possible understandings? All of this was filtered through the voice of Jens. And what remained unrecorded were the thoughts and feelings of the workers.

I offer *Middelburg Summer 1996* as an example of the thoughtlessness of representation, an extreme example, perhaps, of the paradox that speaks for powerlessness while mounting further layers of privilege over the subjects

of the work – that of the artist, the curator, the gallery director, the factory bosses. And as such it 'amplifies' by its very absence the workers' voicelessness. To think in terms of Deleuze and Rancière for the moment, there is nothing about this work that passes out of representation into experimentation, nothing that materialises the voice of the subject, nothing to disrupt the aesthetic regime or re-order existing conditions.

I also offer *Middelburg Summer 1996* as backdrop to *Curator* and to ask where Barrett's work might be placed in relation to this undoing of tolerance. I was interested to hear, for instance, how Barrett would defend *Curator* against its critics, particularly the challenge that it mimics, or more precisely, simulates the non-normative body from the position of a healthy and privileged one, and also to ask in this context whether *Curator* merely simulated care in the same way that *Middelburg Summer 1996* simulated the conditions of the factory for the workers?[40] Lars Tønder's objective in his book on tolerance was to rescue it from it being cast wholly in the negative, 'to break the stalemate' of divided opinion about where power lies by showing instead the 'continued relevance of tolerance for a vibrant democracy'.[41] In his forming of a sensorial orientation to politics, tolerance plays out for Tønder as an embodied and passionate relation with the other. This is much closer to Barrett's desire to use intimacy with others as an ethical-political act.

In terms of power relations, is it too obvious to say that one important difference between *Curator* and *Middelburg Summer 1996* begins with the medium itself? As a performance artist, Barrett is both the content and the initiator of the work, and yet, *Curator* was only realisable by collaborating with others. This included not only the curators, but also the members of the audience. Regardless of whether they were witnesses to the performance or not, they were cast as questioning interrogators who collaborated in the final documentation of the work, the point that marked the end of the performance. In the agreement that the curators and the audience participate in the production of the work, it felt as though authorship was dispersed, there seemed to be a shared sense of ownership for the project. Although *Curator's* form and content began with the singular intent of the artist, it was posed as a non-hierarchical structuring with inter-dependent parts. As such there was never the sense that an event was being staged, no distancing of subject to audience, no theatricality, but an immersion in the actions of the work that involved the participants' experiences.

The email thread that laid out the work's intentions and boundaries had isolated listening and caring as the core conceptual concerns. At its bluntest end, therefore, *Curator* focused on the residual understanding of a 'curator' as guardian and protector of property (originally, from the Old French, *curate*, to describe a protector of a group's spiritual well-being), and arising from the

same Latin root as *cūrāre* (to cure, to care). However, it also incorporates the responsibility to be guardian over property, from *respondare* (to respond), which carries an ethical dimension, the obligation to be responsible, encapsulated earlier in the Hebrew term, *tikkin olam*. By confining the performance to these originary senses of the term, 'protecting', 'caring', taking 'responsibility', Barrett peeled away the other descriptive layers that had been amassing over the art curator in recent decades. Since the 1990s, in the establishment of numerous professional bodies, in the proliferation of dedicated postgraduate and undergraduate university degrees, in professorial appointments, conferences, and academic journals, 'Curatorial Practice' has undergone rapid professionalisation, with the curator now holding presumptive power over highly competitive fields of practice. This has also led to the tipping of balance towards the curator and away from the artist as active producer of arts' meaning. However, it would be a mistake to assume that Barrett conceived of *Curator* as a narrowly cast reflection upon the figure of the contemporary curator, or even a concern to actively reveal systems of power in the 'industry'.

> *[Oh, how to name this thing, this contemporary art thing, this industry, this body, this world . . . this mutable and critical body that is complicated by hubris, and a complex of multiple concerns and self-interests, a specialist body that rarely touches the lives of most people, one that continues to play with the myth of non-commerciality, while at its peak is the exchange of objects that can see extraordinary rates of return on investment, a thing that holds instances of brilliance, as well as energy-deflating phases of mediocrity, a body that continues to be structured at all points of its activities and across the globe by gender inequality; a great exploiter of labour that attracts, nonetheless, bright, educated and willing workers who agree to low wages or no wages at all. How would this 'thing' survive without unpaid interns?]*

To think that Barrett might have conceived of *Curator* as a self-critique of her own discipline would be to miss something much more elemental, the inter-relationship between ethics and politics that motivates her claim for an embodied methodology.

The Curators, Danni and Joel, were responsible for predicting all of Barrett's personal and public needs, not only managing her eating, drinking, sleeping, washing and toileting, but also her entertainment and safe-keeping, which meant that they had willingly entered into a contract that would see them exceed the usual demands made upon them as curators. However, in the agreement to move the performance from the gallery to the street, from playful artifice to the pragmatism of the everyday, the stakes were raised for the Curators. It meant that if they were to ensure the artist's safety, a very

close and vigilant level of care would be required, placing a quite different set of demands on the curators' times and responsibilities. It meant that all parties had rendered themselves vulnerable and exposed, whether as the receiver of care, the dependent, or as the responsible carers who had agreed to be accountable. And there were other risks. There was no address in Barrett's email, for instance, to indicate where blame would fall if something went awry, and as the work traversed its way around the City, there was no protective net provided by a museums' Occupational, Health and Safety checks (noting the ambivalence that both despises a bureaucracy's interference while simultaneously, at least for the wary ones, desiring its security); no demand for Liquid Architecture to ensure that its insurance covered personal and public damage in such circumstances. Barrett would tell me later that she only thought of these potential risks once *Curator* was taken to Hong Kong a few months later.[42] These stranger and more alien spatial configurations placed, retrospectively, a qualification over the sense of vulnerability and dependency that Barrett had experienced in Melbourne; even as a visitor, she must have felt after all a little at home in this City. However, it also meant that what existed between the participants in Melbourne was a social relation without legal hindrance, or rather without the consciousness of the performance's legal implications, once they crossed from the institution (broadly framed) onto to the street.

It is worth surmising, I think, that the professional relationship – the necessary distance between commissioning curators and artist – would quickly be left behind as participants got deeper into the required acts of care that would secure the well-being of their now dependent-other. Furthermore, whether they would have chosen this outcome, the performance inevitably forced the curators into a state of intimacy with the artist, radically transforming the relationship. This was not simply because the participants 'behaved' as they were instructed, but also because the artist would brazenly bare herself to these relative strangers, willing them to confront some of our most common collective fears. It may be remembered that a warning came with the artist's instructions: the curators may have to make contact with Barrett's bodily excretions.

I note, however, as a small diversion, a friendly relationship between the participants pre-dated the performance,[43] which leads me to ask how friendship might have mitigated the affective implications of the performance. In Agamben's conception of the friend, they are:

Not an other I, but an otherness immanent to selfness, a becoming other of the self. The point at which I perceive my existence as sweet, my sensation goes through a consenting which dislocates and deports

my sensation toward the friend, toward the other self. Friendship is this de-subjectification at the very heart of the most intimate sensation of the self.[44]

Could friendship minimise a looming threat for the carers, the impact of another's leaking bodily matter? In anticipation of the performance, Danni from Liquid Architecture confessed her abject fear that Barrett may be menstruating and that she would then have to 'handle' it.[45] One of the most interesting aspects of *Curator*, therefore, is the way the performance produced anxiety for at least one of the curators. Danni's anticipation that the abject body might become a reality meant that a feeling of squeamishness permeated the performance before it had even begun.

Prior to this, though, before the visceral and the raw and the abject, there is space, a spatial positioning of self and others, and a disorientating-ocular-disturbance: a blindfold.

To be immersed in the physical space of the City

I observed some of the intricacies of *Curator* for a short time when Barrett, Danni Zuvela and the photographer, Keelan O'Hehir, dropped into a reading group I was attending. Afterwards, we shared a Japanese lunch under the massive plane trees that shelter the courtyard of one of the University's nineteenth-century Gothic-Revival buildings. Its form had been radically altered by the addition of a modernist, glass extension late last century. I wondered how Barrett was experiencing the space, the rough benches, the shady cold, the dank smells of this sunless patch, the noises of the students, the distant traffic and the confusion of echoes bouncing off solid masonry and swathes of modern glass. Despite her muteness, her sightless dependency, her entourage of carers, Barrett never imposed herself onto the group and it never felt as though we were particularly conspicuous. This is what first drew me to the work, the way she was present without demanding much attention, and the way no one seemed to be inquisitive about this blindfolded woman, her guide and photographer. We caught an old tram back to the centre of the city (the sort with deep, unsafe steps that must have sounded to Barrett like a huge amalgam of loud, crashing metal and the force of people pushing for seats). I wondered how her body, disorientated by an incapacity to see or speak, was reacting to this city.

So, let us not place any particular value on the city's name. Like all big cities, it was made up of irregularity, change, forward spurts, failures to keep step, collisions of objects and interests, punctuated by

unfathomable silences; made up of pathways and untrodden ways, of one great rhythmic beat as well as the chronic discord and mutual displacement of all its contending rhythms. All in all, it was like a boiling bubble inside a pot made of the durable stuff of buildings, laws, regulations, and historical traditions.[46]

I have turned to this small passage by Robert Musil to try to think through Barrett's immersion in the city and how she was thrown into the middle of a city's complicated clash of concerns and the unpredictable psychologies of its inhabitants and visitors: 'the whole indeterminate, disintegrating, fluctuating mass', as Walter Benjamin described the crowd, in his analysis of the motifs of capitalism in nineteenth-century Paris.[47] It is an image that brings us a little closer to Melbourne's beginnings, with its remnants of gold-fuelled wealth and imposing neoclassical architecture, its rapid rise in population and coexistent destruction of Indigenous traditions and cultures. It may have a different cadence today. No longer are there sharp daily peaks of workers entering and leaving the city for the suburbs. The crowd has dispersed, or rather, has become more constant but also more diffuse and less homogenous.

A city remains a material reflection of the workings of capital, as T. J. Clark demonstrated in his Manet-inspired dip into the archives of nineteenth-century Paris.[48] In a confluence of capital and political interests, the kind of brutal 'Hausmannisation' experienced in Paris in the mid-nineteenth century has been repeated across the world in varying degrees ever since. Old quarters are removed. Residents are wrenched from their pasts. A sense of loss is induced. In Melbourne, it is found in ongoing generational battles between developers fighting for profit over the same bit of stolen Wurundjuri land (deeply mourned by the ancestors), and in the sprouting of little encampments set up by those who sleep rough among the penetrating signs of retail exchange and unaffordable rents.

As the performance moved from its base in the West Space gallery to the city outside, it crossed a threshold. Certain effects are released in such a symbolic shattering between the inside and outside, carrying, too, a greater sense of danger. A threshold is always sacred, originally an altar, according to Ivan Illich, and its crossing is deeply implicated in various traditions.[49] Illich describes the Arab practice of slaughtering a lamb on the threshold, while the visitor remained outside until all the sacrificial blood had been released.[50] As city-states developed, the threshold was extended beyond the house to 'a new kind of threshold at the city gate'. The practice of welcoming the stranger into one's domain, while protecting citizens from harm, was institutionalised into 'a formal delegation of the hosting authority'.[51] Once the artist and curators crossed the threshold from gallery to city, this more significant responsibility took precedence. A burden greater than the navigation of uncertain terrain,

they took on the role of the hosting authority for the artist. It connected them to a deep and powerful tradition that carries the sense of both hospitality and 'hostility' (from the same Latin root). Ivan Illich shows that 'hosting' takes on the mantle of servants to the divine and powerful guest-master, Zeus, the ultimate patriarch, who holds power over the European imagination (Greek, Hebrew and Christian).[52] 'And the hospitality extended to guests is always based on *xeno-philia*, the love of *xenos*, the other Greek. It cannot be offered to the *barbaroi*, babblers, who speak no language a Greek can understand.'[53] However, has not the figure of the host been radically altered by distance, by the breaking of tradition through modernity? Are each of us not also today's strangers (*xenos*) who must negotiate the clashing interests of unknown people, not just the non-citizens of the past, but modern identities who flaunt their individuated, selfish desires? 'Invidious individualism' is how Ivan Illich framed the modern person in his study on gender.[54]

The host and the threshold are inextricably tied to patriarchal power and in Illich's history he begins by giving women less consideration than the 'barbaroi' (the babblers):[55]

> Remarkably, bishops were not satisfied with the title of *abba*, father. They soon came to call themselves educators, coining a term that institutionalises the new father in motherhood! In classical Latin, the verb *educare* means nursing, and consistently demands a female subject. When the word is used to describe a man's action, it means that he is playing wet nurse to an infant. *Educare* means the care of *in-fantes*, that is, non-speakers, babblers. The traditional saying goes: '*Educat, nutrix, decet magister.*' The wet nurse educates, it is the master who teaches or instructs.[56]

Since this so beautifully illustrates patriarchy's hierarchical ordering of society, might it not also stand as a perfect metonym for a totality that forces privation upon those over whom it directs? If Illich had continued to ignore women in his history of the hospitable host, then she could have been written in as a sign of absolute resistance, enacting an exhumation of hidden resistances against the figure of the father.

Research into gender marked an important development in Illich's thinking, the genesis of which, according to Fabia Milana, goes back to at least 1975. He eventually fashioned a convergence of critical perspectives, wrought against contemporary conditions.[57] What had strongly affected Illich – this Catholic priest, historian, linguist and activist – amounted to a list of disappointments about the direction modern life was taking. The normalising effects of institutions (medicine, schooling and so on), consumerism that corrupts desire, environmental destruction of the earth,

the mobilising of his students to oppose the spread of nuclear missiles around the world, and a heated exchange of ideas with the German medical historian and sociologist, Barbara Duden, all led him to develop his ideas for a book on gender, eventually published in 1982.[58]

For Illich, gender inequality exists under capitalism because of a melding of gender differences at a specific moment in history. Defining patriarchy 'to mean a power imbalance under the assumption of gender', he argued that conditions had severely worsened by the introduction of the concept of 'sexism' that 'is clearly not the continuation of patriarchal power relations into modern societies. Rather it is a hitherto unthinkable individual degradation of one-half of humanity on socio-biological grounds.'[59] It is on this point that his own, conservative turn on gender comes sharply into play. In 'the reign of economic sex' that marks the modern period, gender is broken by the 'personal degradation of each individual woman who ... is forced to compete with men.'[60] This is contrasted to what he calls 'the reign of vernacular gender' (ending in the eleventh century), when differences between the sexes were harmoniously divided along lines that sprung organically from the gendering of tools (techné). 'The sad loss of gender ... [leads] to the double ghetto of economic neuters.'[61] He uses the example of unequal pay, which would never have arisen if women had not strived for equality, if they had not demanded access to incompatible tools. This is merely a way of saying that gender, which in Illich's terms is understood as a clear male/female dualism, springs naturally from our very humanness.

Feminist–ethical intersections

Illich's writing on gender brings me coldly back to the reality of our times, and to the initial motivation for *Curator*, the question of a feminist methodology, which I earlier placed in abeyance. In saying this, however, I am not wanting to repeal my earlier treatment of what constitutes a 'feminist' position, but rather to amplify its position as a performative. The uttering of the term 'feminist' becomes both word and action, instituting a mechanism for bringing awareness of patriarchy into sharp relief. In a refusal to rely upon an external set of rules, it is also one of the motivations for applying an ethics of immanence, which resonates more richly in an understanding of Barrett's methodology as an embodied, affecting relation. As Emily Beausoleil notes, referencing the work done by Judith Butler and others, there has in recent years been a 'recurrent turn to ethics as praxis, enacted through the daily practices of receptivity and responsiveness':[62]

> It is the recognition that politics and ethics are embodied and that we survive not as bounded and independent beings but through our reliance on networks of relation beyond our own skin – demands an

ethos of responsiveness to others, makes such an ethos possible, and yet also provokes defensive and ultimately violent responses of projection, denial, and revenge.[63]

I met up with one of the curators, Joel Stern, at a café in Melbourne. He was not at the reading group or the lunch that followed, and I had heard from the other curator, Danni, that he did not sleep over on the night of the performance. It seemed that a clear gender-divide had worked its way into *Curator* over its twenty-four-hour life. Furthermore, I had heard Joel speak about *Curator* a few times before, but at none of those presentations had he responded to the vulnerable position into which he had been thrown. Happily, I was about to see a turnaround.

I did not see this as the most important question, but it was the first question I wanted to ask him. Did he feel the greater responsibility for the well-being of the artist had fallen on his female co-director? He began by saying that this is the division of labour that had engrained itself over the fifteen years of their collaboration. He was concerned with strategic questions, while the emotional care of the artist was something Danni felt very strongly about. This had created its own tensions, the over-concern for care becoming more important than other organisational concerns, and, on the other side, the directing of strategy taking precedence over the social relations formed between the Directors and their community. The historical clichés of gender, where mind battles with emotions, was not the point for Joel, since he saw this as an outcome of the personalities of each of the partners. I appreciate that I could dig deeper into this divide, but I offer it merely as a passing observation, lest it lead me back to distracting and crude gender dissections. The critical reason for wanting to speak directly with Joel had been to explore his perspective on the performance that had been missing at his previous presentations. I was especially interested to know how the experience of the work affected him, not the conceptual or intellectual ramifications, but the bodily, sensuous affects that came to him during his time with the work. The response will come without prodding.

Joel mentioned several times that *Curator's* most difficult demand was that he and Danni would need to respond publicly to the work, and with detailed reflection, just before the close of the performance; that is, before Barrett formally removed her blindfold at the West Space gallery that evening to signal the work's completion. Was Barrett aware that she had asked for both distancing reflection and immersive participation at the same time, to demand the impossible, as Michel de Certeau has written, at once to be the 'totalising eye of the painter … making the complexity of the city readable, as well as the walkers … whose bodies follow the thicks and thins of an "urban" text they

write without being able to read it.'[64] This impossibility of being at a distance, to be a 'solar-Eye', while entangled in a blind navigation of the ground,[65] approximates the position of the artist for Barrett.[66] And although she could not predict the outcome, Barrett considered the public response by the curators as an enactment of the artist's role, a reversal, if you like, and also to be the crux of the work. It was to ask the curators to see from the perspective of the artist, as with de Certeau's positioning of the totalising eye, while they were still grappling with the labyrinthine confusion of everyday care-giving.

Curator was only one of a very full programme of events that Joel Stern had taken responsibility to organise that night, under the aegis of a feminist methodology, and he found Barrett's demand difficult and confronting.

> The work is clever because it also asks for an epistolary letter to be written in the final hour. When I was exhausted and still in an intimate relation with the work, I was asked to be analytical. Separating the twenty-four hours, which was very task orientated, meant dealing with one problem at a time, how to get Frances from one point to the other, as well as dealing with the rest of the schedule. It was a day with six other artists and an event to organise.[67]

However, it was on this point, at the West Space gallery that evening, that Joel was criticised by an audience member. He was told that many people need to manage multiple and diverse responsibilities at once, including, and most importantly, the care of a dependent person. According to Stern, this challenge became a crucial mechanism for his reappraisal of his own position, to open him up critically and perhaps emotionally for the first time to the advantages he enjoyed in the world. 'I was now just tasting what it is to have this responsibility.' Over the two years since the performance, Stern's response has evolved, calling it a moment 'of self-recognition' and saying that he 'was made vulnerable by the work, tired, jittery and on the edge of not being fully in control'.[68]

Joyful and sad passions

Many months after my first visit to Barrett's studio, and with our initial awkwardness dissipated, Frances and I went to see Kelly Reichardt's film, *Certain Women* (2016). With *Curator* fresh in my mind, Reichardt's treatment of the narrative and the characters was revealing, for it forced me to think more critically about the material effects that Barrett had hoped to put into the world through the performance.[69]

Reichardt's images are slow and cuts are assiduously chosen. From the opening scene, a fixed camera shot catches the quietness of the remote

landscape as a distant goods train pushes its slow, lumbering way through this empty, overcast plain. Snowy mountains are seen in the distance. As the train reaches the front of the frame, the film cuts to an aerial shot of a small town, and the sound of the train is replaced by the chatter of a local radio announcer, and then to an apartment, an interior, a wide shot, a woman and a man. He is dressing in one room and she in another, each thrust to the outer edges of the frame. This opening is our entry into the lives and relationships of three women from Montana. What is of relevance to *Curator* are the actions and reactions of the women and the people sharing their lives – a client, a husband, a lover, a teenage daughter and a desired but impossible other. I am going to focus on two of the characterisations.

In one scene, a young rancher (Lily Gladstone), who remains unnamed in the film, drives away after an uncomfortable interaction with a woman, the recently graduated lawyer, Elizabeth Travis (Kristen Stewart) whom she has travelled hours to meet. We are already a little sad and anxious for her, this young woman who lives and works alone with her horses, but as she leaves a perplexed Elizabeth in a car park, the film seems to be moving towards an inevitable crisis brought on by this hopeless and ill-matched infatuation. The tension rises on the long drive home and we are afraid for her safety when she falls asleep at the wheel. It is such a wonderful, tightly controlled scene, and also a summation of Reichardt's way of filmmaking, for our expectation that a crash is imminent is soon thwarted. Instead, the rancher drives off the road only to come to a gentle stop in a flat field of grain.

The second character, Laura (played by Laura Dern) is the woman from the early post-coital scene, a lawyer, a little world-weary, deflated, and frustrated by her client, Fuller (Jared Harris) who demands constant attention and emotional support, while ignoring her legal advice. At one point, connected with his defunct legal case, Fuller holds up a security guard with a gun. Laura is called to talk him down and we see that the police depend on her for resolving their hostage situation. Fuller desperately begs her to let him escape, again simperingly and without care for the professional obligations she should be upholding as a lawyer. He implores her to visit him in prison. She is seen again driving him home after his release. He leans heavily on her for support, while disregarding her own well-being (at one point she has to call in a male lawyer to substantiate her legal advice). It is Laura's acquiescence to Fuller's emotional manipulations that forms the substance of their relationship.

Reichardt structured *Certain Women* as though she had made a cut into the continuum of her character's lives so that we might travel along with them for a short time. Its slow tempo is a closer approximation to the non-explosive moments of everyday life, as both a consciousness of time and a losing oneself in time. This is how Reichardt is able to amplify the small, messy interactions

of her characters and the clashing wills and desires that falter in the midst of an imbalance of power and powerlessness, of self-interest and naïvety, of troubled psychologies crashing into each other. Moving with the characters in their everyday lives is to bear witness to their very particular singularities. Paradoxically, in avoiding dramatic cuts and suspenseful pacing (cinematic clichés), the durational choices made by Reichardt also means that viewers are never wholly lost in the film but are brought in and out of awareness of the film's artifice.

Thinking about *Certain Women* in the context of *Curator* revealed that Barrett's performance did not so much step into the lived reality of its participants lives, but rather toyed with certain kinds of social interactions, as experiment, perhaps. In dreaming that a world might change through positive actions – to this ideal, this perfection, and also this purity – the unexpected actions and reactions of others is under accounted. Spinoza's lesson in his *Ethics* was to not situate beings 'in nature as a dominion within a dominion' as entities that through a weakness of character disturb nature,[70] but rather to be a part of nature means to affect and be affected by fundamental passions. 'By affect', he writes, 'I understand the affectations by which the body's power of acting is increased or diminished, aided or restrained.'[71] These are 'the two poles' of 'joy-sadness' that Deleuze describes: 'Sadness will be any passion whatsoever which involves a diminution of my power of acting, and joy will be any passion involving an increase in my power of acting.'[72]

And so, I need to modify my earlier observation, that *Curator* avoided theatricality by immersing the participants in the actions of the project. How *Curator* would begin and end was outlined in the instructions, and this also demarcated artifice from non-artifice, work from non-work, forming clear lines around the performance and the lived reality beyond the performance, while ensuring another life for the work by insisting upon photographic documentation. Such is the complex *eidos* of the medium itself, to be both spontaneous and unmediated, but also effecting a very different afterlife that brings it closer to other media, such as film and photography.[73] Barrett's feminist methodology, riven by responsible care through touch, placed certain limitations on the difficulties of being with others in the world; that is, from the passions that affect us, and our own that affect others in moments of social interaction.[74] *Curator* carried a hopeful intention, a strategy for limiting the potential 'violence' implied in social encounters by suggesting a fecund wave of 'positive' (embodied and practical) passions, joyful passions that might negate in some way the bad passions encountered in the world. As they opened up to the responsibilities of care, Danni Zuvela and Joel Stern separately claimed to be changed by the experience, since the work made them actualise the risks of care-giving via bodily demands and affective experiences.

The blindfold

Following our tram-trip from the University back to the centre of the city on the day of the performance, I parted from Frances, Danni and Keelan. With Barrett's hand on the curator's shoulder, the small group moved onto the next activity, a massage, I believe, and a masseuse with overly touchy hands who would cause Frances to suspend the performance momentarily. Since Barrett was able to untie the blindfold wrapped around her eyes and finish the performance at any moment, the limits of her vulnerability and dependence were clearly determined.

Barrett was made aware, many months after the performance, that among disability studies' researchers a blindfold is seen as a 'mocking' simulation of people with visual impairment.[75] At the same time, the blindfold was said to completely miss the experience of having a visual impairment. It would not be an exaggeration to say that Barrett was completely discomposed by this response, sending her to urgently rethink her plans to perform *Curator* in Jakarta (Indonesia) a month later. Consulting widely with disability groups who were divided as to whether the blindfold was an insult or not, Barrett decided not to perform *Curator* after all. However, such circular argumentation that renders the blindfold problematic, even while claiming that it could never approximate the experience of visual impairment, reduces the work's wider concerns to this singular objection.[76] From the position of a sighted and verbal person, the decision not to see nor to speak was made perhaps rashly and thoughtlessly in light of these criticisms. And yet perhaps there is another way of receiving the work.

To have her eyes shut or open, to speak or not speak, I am reminded of a beautiful phrase written by Michaël Lévinas: 'Disengaged from all trivial orality.' He offered it as a small chink of light onto the relationship he witnessed between his father, Emmanuel, and Maurice Blanchot who (ironically) rarely met face-to-face.[77] He describes one moment in 1961 after the defence of his father's thesis, *Totality and Infinity*, at the Sorbonne, and another when he overheard a phone conversation on the death of Maurice's wife. We know these thinkers had divergent histories, the Vichyist, and the Heideggerian Jew. They were cast on very different paths, but they found each other somehow, and a friendship was reached through a shared understanding of each other's work, and an eventual connection of ethical-political principles. And this is where their relationship existed, mostly as an exchange of ideas via correspondence and book endorsements. The withdrawing of speech is another way of thinking about *Curator*'s distillation down to the barest and most critical aspects of ideal social interaction: how to listen, how to care and how to live harmoniously with

others. Rightly or wrongly, ignorantly and carelessly, this is also how I perceived the blindfold at the time. The privation of sight and speech was not only a way to increase the need for care, to insist upon an embodied politics, but also a way to intensify the participants' sensitivities to the nonverbal needs of another. *Curator* bored into the details of social exchange so that concentration on the more conspicuous and superficial exchanges were deflected onto the unexamined, dusty crevices of sociality. By focusing on the detail, rather than the universal, *Curator* also penetrated the distracting surface of charm (insincerity, narcissism and self-interest), although I also note, that self-interest is double-edged, as Alexandre Lefebvre has argued through Bergson, that the unconditional concern for the other is also concern for oneself.[78]

Afterword

I met with Barrett again, two years after the performance. She sees her practice as being based on conceiving uncomfortable situations as a personal and ongoing challenge. 'I would never choose to spend twenty-four hours with anyone', she admits. *Curator* was also conceived as a way to reveal what is at stake for curators when working with artists, particularly during a performance, to think through the dynamics that are constantly shifting and changing, and the wider implications of this if the performance extends beyond the gallery space. I wanted to see whether she thinks differently now about the claims she made at the time. I was particularly interested in asking whether she still considers her method to be an 'embodied-feminist' one, and whether the experience of working through *Curator* had altered the way she interacts with people on a daily basis.

During the performance, a personal belief in touching as an embodied experience that hoped to engender positive forces in the world was thwarted by one of the events introduced by the curators. Since touching was a core principle of the work, it was a logical and generous gift for the curators to provide a massage for the artist in the closing hours of the performance. However, this positive gesture collapsed into a failure of care, as Barrett was left, without knowing who else was in the space, naked and with an unknown masseuse. However, such a conflict also induced self-criticality and a rethinking of her approach to works. In live performance, there is no foreseeing an outcome; no way of drawing lines in the sand. Without rejecting the tenor of a queer/feminist position, Barrett now speaks more of a shifting horizon, an ideal towards which she continually moves. To adopt an intimate and embodied approach when encountering others in the world is also an ideal, also a horizon. During an art performance, this is elevated as an

action or gesture, where in daily interactions, such intimacy is fragmented, selective. To continue the metaphor of the horizon, it is not to claim a stake in something, but a method that insists upon continual revaluation of shifting conditions. If Barrett hopes to influence those around her, then she also understands that she is in turn influenced by them.

9

Claire Denis – The Intruder

What an abyss of uncertainty whenever the mind feels that some part of it has strayed beyond its own borders; when it, the seeker, is at once the dark region through which it must go seeking, where all its equipment will avail it nothing.

(Marcel Proust, In Search of Lost Time, trans. James Grieve)

Such grave uncertainty, whenever the mind feels overtaken by itself; when it, the seeker, is also the obscure country where it must seek and where all its baggage will be nothing to it.

(Marcel Proust, In Search of Lost Time, trans. Lydia Davis)

I would like to consider the themes covered in Barrett's performance, *Curator* – care, hospitality, feminism and borders – by looking at a work that was conceived very differently and with quite different material effects. It is Claire Denis's *L'Intrus* (2004), co-written by Jean-Pol Fargeau and photographed by Agnes Godard, a film that demonstrates how political provocations can be thrown into the orbit of contemporary audiences by manipulating narrative structures, rather than depending on narrative content to carry political messages. I am proposing that is a tactic used by Claire Denis to make us feel viscerally the sensation of borders, as the narrative collapses quite early into a series of 'frustrating' sequences that promise, and yet never satisfy narrative coherence or closure. What appears initially as a conventional 'thriller' becomes instead a film of political and intellectual inquiry through which various themes are doubled in the bodily sensations stimulated by a disturbing and alienating narrative form. I hope to show how the narrative structure is only one tactic utilised by Denis to reinforce conceptually complex layers of meaning about intrusion, homelessness and heartlessness, as vectors for discussing more targeted political questions, such as the place of refugees, colonialism and feminism.

 L'Intrus opens with a black screen. A young woman with a Russian accent slowly appears, embodied in the palest of blue lights, her voice rising above

layers of imperceptible sounds – 'Your worst enemies', she says – and then the snap of a cigarette lighter, 'are hiding inside, hiding in the shadows' [credits begin] 'hiding in your heart.' Who is this woman dwelling in what transpires to be a cave? Throughout the film, unnamed women, young women such as this, torment the film's central protagonist, Louis Trebor (played by Michel Subor) – the girl from the forest, the wild girl with the dog, the young Russian woman, the Korean masseuse, and, in the final mesmerising scene, the smiling woman (Béatrice Dalle) on her sled racing through the snow. In an interview, Denis commented that she saw these women as Trebor's 'crown of distant planets.'[1] These alien figures capable of triggering, in Denis's words, his 'nightmarishly masculine dream', are they the questioning accusers of a guilty 'father', Trebor and his conscience? When Trebor is lying alone in his hotel bed in Switzerland, suddenly he is shown in France being dragged inexplicably behind two white horses across a snow-laden countryside by the wild woman from the forest, accompanied by a young man. I can only speculate as to how the scene might connect with the narrative. Trebor owes her a debt, perhaps, and yet, what this debt might be is left wholly to conjecture. I cannot be sure whether it is an image from the future or the past, or simply a leaky bad conscience. There was a moment of greater confusion early in the film when through the darkness (lit with the same blue light as the opening) Trebor leaves his lover and his bed and seemingly murders the young cave dweller who is lurking near his house. An instant later, however, she appears to be alive. Perhaps after all, it was just part of Trebor's troubled imagination. The scene is so quick and dark and everything is so baffling at this stage that the moment is easily lost in the larger flows and breaks that structure the narrative ... And then, much later on in the film, she is found dead under ice in a snow-choked lake.

A broken narrative

From the film's earliest scenes, Denis leads the viewer down faulting narrative paths. There is an early scene of a customs agent (Antoinette, Trebor's daughter-in-law, as it emerges, played by Florence Loiret-Caille) and her dog, guarding the border between France and Switzerland. This uniformed wife returns home to yield submissively to her husband, Sidney (Grégoire Colin). The scene is paired with another of scrambling, 'illegal' bodies moving furtively through the countryside at night ... *What borders have they crossed to get here? And where are they heading?* ... Then the main title appears. At this stage of the film, I'm still waiting in anticipation for the narrative to resolve itself, but since both scenes will be shown to be tangential, the illegal immigrants and the son's family will soon fade into the background. These vignettes also

form the film's early narrative breaches, sitting between the young woman in the cave and the main title. They act as delaying devices to shroud the viewer momentarily from the central protagonist of the film, Trebor, whom I soon discover is in need of a new heart.

Martine Beugnet has observed that the narrative of *L'Intrus* does not rely 'on a chain of events' but is instead structured by 'the superimposition of block-like ensembles that are edited together to create series of contrasts and resonances.'[2] I would like to speculate instead that there is a chain of events, but that this chain is strained to breaking point at crucial moments, bringing a very different structure to bear, a treatment Denis herself claims is 'straight' but 'erratic.' As *L'Intrus* progresses, it becomes apparent that Denis will repeatedly draw the viewer to the very edge of discovery, and yet each time resolution of the narrative seems imminent, she will suddenly shoot the story off in a newly intriguing direction, leaving in its wake a black, indiscernible hole: it as though we are encountering a semblance of a thriller with all the thrilling bits withdrawn at the brink of an expected climax. It is not a matter, therefore, of finally pulling together disparate scenes or time frames or waiting for the inevitable unfolding of the story as it comes to an end, but living with the guttural 'shock' of grappling with this damaged story. I would approach this point a little differently, therefore, by suggesting that where Beugnet sees the correspondence between narrative blocks as a rhythm of contrasting or resonating relations, my concern is with the gaps *between* sections, which fall away as infinite abysses at each potential breaking point, leaving a corresponding pit in the gut and a sense of voiceless frustration. A guttural intensity has already been registered, before an intellectual response begins to form. This trick of cinema allows the greater impact to fall on the effect of the images themselves, not on a story as such, although the pressure to find a story is certainly tickling at the edges of my consciousness.

I am suggesting that the structure is related to a discussion that Deleuze has in *Cinema II* about *Ici et ailleur* (*Here and Now*, 1974), an experimental documentary by Jean-Luc Godard and Anne-Marie Miéville, who, to critically reflect upon the Group's earlier methods, re-use footage shot four years earlier as part of their Dziga Vertov Group (1968–72).[3] Deleuze writes:

> The fissure has become primary, and as such grows larger. It is not a matter of following a chain of images, even across voids, but of getting out of the chain or the association . . . It is the method of BETWEEN, 'between two images', which does away with all cinema of the One. It is the method of AND, 'this and then that', which does away with all the cinema of Being= is. Between two actions, between two affections,

between two perceptions, between two visual images, between two sound images, between the sound and the visual: make the indiscernible, that is the frontier, visible.[4]

I cannot know if the association drawn by Deleuze between the gap and the frontier influenced Denis or is simply coincidental, but it helps explain how the film's structure might then affect the viewer so that she cannot see or hear, but feel only a 'totally physiological sensation'.[5]

Intensity

It was Antonin Artaud who first believed in the possibility of pure cinema and to insist that images not merely describe things or events:

No matter how deeply we dig into the mind, we find at the bottom of every emotion, even an intellectual one, an affective sensation of a nervous order. This sensation involves the recognition, perhaps on an elementary level, but at least on a tangible one, of something substantial, of a certain vibration that always recalls states, either known or imagined, that are clothed in one of the myriad forms of real or imagined nature. Thus, the meaning of pure cinema would lie in a movement and follow a rhythm, which is the specific contribution of this art.[6]

Artaud argued that cinema is able to release non-cognitive, corporeal affects that convey rather than represent the forces that act on the body. Working out of both Artaud and Deleuze, it is also what Beugnet, calls 'corporeal cinema' or 'cinema of sensation'.[7] The movement of images, for Artaud, has the capacity to communicate directly to the brain, beyond all representation, and in a kind of physical excitement that reaches into the depths of consciousness. This is cinema's secret power, to activate potential forces that until then had never been activated.[8] The virtual power of images is 'the unthinkable in thought', as Deleuze describes it, 'a matter of neuro-physiological vibrations . . . a nerve-way which gives rise to thought.'[9] So even if Artaud is finally disappointed with cinema,[10] an affective sensation remains cinema's promise. When Deleuze takes up Artaud's case in *Cinema II*, he picks up the thread in Artaud's thought that is 'oddly capable of restoring hope in a possibility of thinking in cinema through cinema.'[11] However, this only speaks to the corporeal effect of sensation and not to how the unthinkable moves to thinking. As Rajchman points out, a basic problem Deleuze faced in developing his aesthetics was how to 'introduce this sense of 'intensity' into the very idea of 'sensation' and our relation with it – into the very concept of 'aisthesis'.[12] Intensity for Deleuze

is an encounter within sensation by which 'thought comes to us.'[13] A concept that was central to Deleuze's structuring of pure difference in–itself, intensity is at the same time both 'the imperceptible for empirical sensibility' and the perceptible to 'the transcendental sensibility' which apprehends it immediately as an encounter.'[14]

> The privilege of sensibility as origin appears in the fact that, in an encounter, what forces sensation and that which can only be sensed are one and the same thing, whereas in other cases the two instances are distinct. In effect, the intensive or difference in intensity is at once both the object of the encounter and the object to which the encounter raises sensibility.[15]

Rajchman situates Deleuze's conceptualising of aesthetics through sense and intensities within an ethical frame:

> The problem in Deleuze's experimentalist aesthetic is the sense of Suf-focation' against which the search for 'possibility in the aesthetic sense' is always directed; and the basic affect through which this sense is given is depression or what Spinoza called 'the sad passions' – for, as Jacques Lacan remarks, Spinoza turns depression into a kind of ethical failing. Effect in Spinoza becomes the sensation of what favours or prevents, augments or diminishes, the powers of life of which we are capable each with one another; and it is in something of this same 'ethical' sense that Deleuze proposes to extract clinical categories (like 'hysteria' or 'perversion' or 'schizophrenia') from their legal and psychiatric contexts and make them a matter of experimentation in modes of life in art and philosophy.[16]

The call is to try to reject the sad passions. And, this needs to be drawn out (activated) because as *L'Intrus* moves from one gaping gap to the next, it induces a bodily, intense, melancholic suffering. If the story is no longer the carrier of meaning, no longer the tool for the didactician, then this shift into the sensate realm, this discombulating moment is Denis's way, perhaps, to liberate political thinking from the burden of narrative, to focus instead on directing a 'shock' directly to the body, forcing a confrontation with the vitality of a life.

My objective, however, is not to settle the discussion here, for it is still not enough to suggest that the affective register of *L'Intrus* occurs in spaces where thinking is confounded by intense sensations prior to thought. Such a claim fails to adequately account for the way – in stubborn insistence – a story seems to move forwards. As Denis explains: 'I was not trying to break the

narration; no, I was trying to follow it as surely as I could.'[17] In light of this, a fuller description would be to suggest that despite a paucity of back-story, and regardless of my ongoing confusion as I try to assemble the slender and erratic narrative pieces, there is nonetheless a feeling of anticipation that the story is moving towards a goal (Trebor *will* find a heart), even if in the end, I fear this hope may not satisfy him. Pre-shadowing these thoughts is a long sequence of Trebor cycling with much effort through the mountains near his home, and yet, this movement forwards, pursued with such purpose, turns out to be exercise-as-an-end-in-itself. I suppose this is a foretelling of Trebor's imminent journey, because this ailing man's movement around the world, as with his cycling, will turn out to be a wholly self-interested pursuit, a journey without redemption or discovery.

I want to propose that this is an extremely subtle tactic, this ghost-like progression, this simulation that I now see as an aberrant movement-image in the era of the time-image. However, as an account to finally explain how political concerns in the film avoid didacticism by suggesting that sensations sit alongside a ghost-like narrative arc, still falls short. It fails to encapsulate how a position on refugees, post-colonialism and feminism arises out of the film's treatment itself, rather than relying on representational content alone.

Taxonomy of borders

Breaking Sidney's daily routine of washing and feeding their babies, a uniformed wife, Antoinette, returns home, submitting to his playful, erotic fantasy (*Vous êtes dans une forêt de sapins, obscure, hostile*), only to have this game shattered by the sound of their babies through the baby monitor.

A nightly stealth of 'foreigners' traverse the local French territory, their movements caught momentarily in the tenuous net of the damaged narrative.

A heartless man's consciousness is abruptly seized by his own repressed guilt . . .

There is no obfuscation about the importance of borders and their breaching in *L'Intrus*, since according to Denis, each scene is structured as an intrusion scene.[18] This is not confined to the more obvious violation of political borders that open the film, such as illicit goods and custom guards, or illegal immigrants and 'national sovereignty'. Partitions separating nations, bodies, species, genders, classes, conventions, realities and epistemologies are all shown to be

unstable . . . vulnerable. This is seen in the undulating contours that separate a sense of dreaming and waking; in the inter-cutting between what appears to be Trebor's 'conscious' and subconscious realms; in the persistent ontological slippages drawn between women, animals, dogs and men; in the unfathomable gap between the young feminine and the old masculine; and in the ethical ambiguities of an economy that purports to save lives (for the wealthy) by trading in illegal organ transplants (of the poor). In this panoply of limits, as Henri Lefebvre declares 'once bounds have been breached, there are no limits.'[19] In opposition to classifying conventions that protect hardened lines of demarcation, Denis persistently poses her taxonomy of borders as tenuous and problematic, as lines always already crossed.

However, I cannot forget that one of the ways in which *L'Intrus* achieves its critical position is by playfully reorganising cinematic expectations, which in turn, intensify the sense and the conceptual implications of 'intrusion'. I have noted that the narrative structure operates in this way, those black abysses that Denis has strategically placed within the story to produce sensations as catalysts, or moments of transition to cognitive processing, and which act to diffuse and delocalise the possibility for narrative to form during moments of intensity. Another example is Denis's positioning of the film's credits. Credits might be considered as a cinematic convention that separates the everyday-world from a cinematic-world, or a single work from the totality of work, and yet Denis places the young Russian woman from the forest before and after the opening credits, on both sides of what might be thought of as a film's 'natural' borderline. Speaking from her cave dwelling, she says that our worst enemies are found in our hearts (*tes pires ennemis . . . sont à l'intérieur . . . cachés dans l'ombre, cachés dans ton coeur*). Of course, in the end, they are the same thing, those external, hostile forces that end up settling 'inside', habitually disturbing our psychic equilibrium. The woman in the cave not only reinforces the theme of intrusion in the opening scene of the film, but she also forms a symbolic border, between 'I' and the other, introducing the related and intrinsic theme of the 'stranger'.

The stranger within

> Receiving the stranger must . . . also necessarily entail experiencing his intrusion . . . Hence the theme of the *intrus* is inextricable from the truth of the stranger. Since moral correctness [*correction morale*] assumes that one receives the stranger by effacing his strangeness at the threshold, it would thus never have us receive him. But the stranger insists, and breaks in [*fait intrusion*]. This is what is not easy to receive, nor, perhaps, to conceive . . .[20]

It isn't necessary to know, although it enriches the experience of the film, that Denis and Fargeau developed the script after Denis had read an essay by the philosopher, Jean-Luc Nancy, also titled *L'Intrus*. Nancy's essay discusses the 'metaphysical adventure' and 'technical performance' of his heart transplant performed ten years earlier. The figure of the stranger (the stranger's heart) is the mechanism to explicate a range of philosophical questions about identity and the other.[21]

> I feel it distinctly; it is much stronger than a sensation: never has the strangeness of my own identity, which I've nonetheless always found so striking, touched me with such acuity. 'I' has clearly become the formal index of an unverifiable and impalpable system of linkages. Between my self and me there has always been a gap of space-time: but now there is the opening of an incision and an immune system that is at odds with itself, forever at cross purposes, irreconcilable.[22]

Reading Nancy's text made Denis aware of the sensation (the facticity) of her own heart for the first time. In an interview with Damon Smith, Denis noted:

> The experience of reading was so physical to me ... with no jokes... so penetrating that I felt almost physically the heart transplant. The rejec-tion of the immunity system, it was like a battle ... I have been feeling something in my chest ... actually it was my heart: but I have never felt my heart before.

Many surgeons, she continued, consider a heart transplant as a simple operation: 'they say it's like being a plumber', but since the metaphysical implications are extremely complex, this 'aspect is very heavy.'[23] There is the fact of Nancy's failing heart, its irrevocable obsolescence, and the growing sense that this deteriorating heart is becoming increasingly strange; whereas the adverse effects of welcom-ing the new heart, a stranger's heart, bears a shattering of self, an inevitable loss produced by the invading 'stranger'. Such impassable dilemmas in our contact with alterity are found in both the filmic and essayistic versions of *L'Intrus*. From Nancy's experience of his transplant he explicates the ordinariness of strangeness expressed as a 'constant self-exteriorisation', a rupturing, which is paralleled in Denis's menacing women who encircle the physical and the unconscious spaces of Trebor's existence.

> At the very least, this is what it amounts to: identity is equivalent to immunity, the one identifying itself with the other. To reduce the one is to reduce the other. Strangeness and strangerness become ordinary,

everyday occurrences. This is expressed through a constant self-exte-
riorisation: I must be monitored, tested, measured. We are armed with
cautionary recommendations vis-à-vis the outside world (crowds, stores,
swimming pools, small children, those who are sick). But the most vigor-
ous enemies are inside: the old viruses that have always been lurking in
the shadow of my immune system – life-long *intrus*, as they have always
been there.[24]

In the confusion that arises between the strangeness of being and its familiar-
ity, the ontological status of the intruder and the stranger are thereby impos-
sibly entangled. An approach to this is found in Nancy's description of his
transplant as an apneic experience, a moment of breathlessness. One imagines
that his immunity's defence – the rejection of his new heart, his cancer, his
shingles – will lay dormant as long as he remains suspended in the moment
between two breaths . . . And this single breath (this staying still, while passing
over) means that neither breathlessness nor breathing is folded into dialecti-
cal synthesis, but remain impassable, aporetic, denoting both the metaphysical
and technical antinomies of the transplant. A gaping opening, 'a void suddenly
opened in my chest or my soul – it's the same thing.'[25] In the spaces that so
brutally interrupt the flow of the narrative in Denis's film, it is as though I
am also passing over while remaining still, simultaneously suspended in the
nothingness that threatens to take hold during these narrative abysses, while
also being forced to move forwards with Trebor as he travels from France to
Switzerland, to Korea and finally to Tahiti.

 The strongest correspondence, therefore, between Nancy's account and
Denis's faulting narrative structure is found in Nancy's incapacity to extricate
'the continuous from the interrupted.' One becomes suspended along with
Nancy and Trebor in the duration of a single breath in which everything and
nothing happens at once, so that it is impossible to determine whether Trebor
is dreaming or awake in the film, or if Denis is operating in the symbolic reg-
ister or the metonymic. And yet, such wandering observations fail to capture
what is perhaps the most commanding sensible register of the film, the device
that draws me closest to an encounter with the quivering, expressionlessness
of being.

The bleakness of beauty

I am persistently lost and bewildered, magnetised and frightened by the beauty
of Agnes Godard's cinematography, which is used in *L'Intrus* with specific
effect. On filming in the Pacific, the location of Trebor's earlier life, Denis
described her aesthetic choices with equivocation: this place of dream, this

prelapsarian paradise is undone by the reality of its inevitable traps and disappointments:

> I didn't want to be hypnotised by the beauty of those islands – I wanted to be like someone who had already experienced them and knew that beneath the beauty and the charm, the extreme beauty, and the gentleness of the people, there was something lethal – It is something I understood by reading Gauguin's diary and by reading Stephenson's short stories from the Pacific.[26]

Against the dream of Paradise, Denis offers a Tahiti of grey skies, of rubbish-dotted beaches and dismal towns. A token of the overall sensibility of the film, its baleful beauty, this menacing coalition, means that such beauty is presented not in its tradition-bound form, unmediated and harmonious, but in a much bleaker and darker way. Perhaps it moves more closely to Walter Benjamin's thinking about 'beautiful semblance' in which two main forms are distinguished: one behind which something is concealed (and Benjamin uses the example of the Mediaeval Lady World whose back is devoured by worms, while her front is beautiful and magnetic); and the other, designated as the much more potent form. It is a form more authentic, Benjamin claims, inconceivable outside the visual realm and behind which nothing is concealed.[27]

This form of beauty is intrinsic to the cinematographic treatment of *L'Intrus.* There is a moment when Trebor is poised between his old life in France with his failing heart and troubling dreams, and a potential life, a new life that he believes will come once he returns to Tahiti. He drives through the night, his car lights catching glimpses of people furtively running across a midnighty-blue-bathed forest . . . and a flash of uniform, perhaps his daughter-in-law, Antoinette, trying to catch the 'intruders'. Along with this illumination of another reality comes the revelation that this man's final chance for a renewed life, this singular life, has fleetingly rubbed up against the hopes of the world's displaced people – a passing in the dark. On the very periphery of the new day, he stops his car, and against a frosty green-blue landscape, still and quiet, he shaves. The white of his shirt provides the only contrast in this scene, which is sombre but also highly seductive, beautiful. A sweeping camera shot, lifting to the top of the misty, dark pines is guided by the drone of the shaver . . . paralysing, quivering . . . And then a brutal cut to a pallid Geneva.[28]

In a tussle with the ways in which Denis's differing moods vie for attention in *L'Intrus*, there are moments of undifferentiated and ineffable sensation. These moments grab and suffocate me, captivate me and will not let go of me. Earlier, this was described rather clumsily as 'voiceless frustration', the point at

which my powers of expression dissipate into a feeling of gagging hollowness. I return to Benjamin in an attempt to put a little more flesh on what remain shadowy and ambiguous thoughts about the paralysing effect of beauty in Denis's films.

> No work of art may appear completely alive without becoming mere semblance, and ceasing to be a work of art. The life quivering in it must appear petrified and as if spellbound in a single moment. The life quivering within it is beauty, the harmony that flows through chaos and – that only appears to tremble. What arrests this semblance, what holds life spellbound and disrupts the harmony is expressionless [*das Austdruckslose*]. That quivering is what constitutes the beauty of the work; the paralysis is what defines its truth.[29]

As Gary Smith notes, what for Benjamin would be a 'specifically modern but semantically filliated correlate to his early thoughts on beauty' was his thinking on aura.[30] According to Smith, it was beauty's 'problematic features' that contributed to Benjamin's abandonment in his later writings of the 'notion of *schoener Schein* [beautiful semblance] for the new notion of "aura"', and in particular 'the relationships between beauty and truth [and] beauty and semblance.'[31] As Benjamin insists, the inextricable nature of the veiled and the unveiled is crucial to his conception of beauty. However, it also raises a 'fundamental enigma', such that it would be a misstep to think that the truth of beauty is revealed simply through its unveiling (or by the shattering of its surface). Instead this would lead only to the revelation of the 'idea', while beauty's secret, its critical value, would be destroyed along with it. This 'secret' cannot be explained through philosophical means, for it belongs not to the idea but to that which is necessarily inexpressible (which as Smith notes is a digression from Plato's claim that a philosophical idea can be beautiful).[32]

> The expressionless is the critical violence, which, while unable to separate semblance from essence in art, prevents them from mingling. It possesses this violence as a moral dictum. In the expressionless, the sublime violence of the true appears as that which determines the language of the real world according to the laws of the moral world. For it shatters whatever still survives as the legacy of chaos in all beautiful semblance: the false, errant totality – the absolute totality. Only the expressionless completes the work, by shattering it into a thing of shards, into a fragment of the true world, into the torso of a symbol.[33]

Benjamin's overarching project was to ask how perception, and therefore, experience (innervation) operates in conditions of industrial capitalism, and thus it may appear anachronistic at this point in history to consider *L'Intrus* through the summoning of either 'beautiful semblance' or 'aura'. As précised by Miriam Hansen, 'aura' represented, for Benjamin, a form of sense-perception that encapsulated the 'singular status of the artwork, its authority, authenticity, and unattainability', and is thereby opposed to 'the productive forces that have been rendering it socially obsolete: technological reproducibility, epitomised by film, and the masses.'[34] The interest here, however, is not to think about the technological conditions that led Benjamin to theorise aura, but to dig into the way Benjamin's thoughts about the decay of aura come to the reader as an ambivalent intermixing of promise and loss. This is consistent with Benjamin's wider thoughts: the way time is structured as a complicated entanglement of future dreaming and past memories, or the way excitement for change (for a new future) intermingles with childhood dreams that are never actualised. It is to see Benjamin's ambivalence as a quality and an expression of modernity itself, and therefore, not a structural flaw, nor a moment of nostalgia, but recognition of the way many contemporary approaches to beauty seem to issue from similar confusions of melancholy and expectation, an enthusiasm for unbridled possibility, which simultaneously carries the despair for a loss of tradition. 'One day I sat beauty on my knees and I found her bitter', wrote Arthur Rimbaud,[35] as though beauty in its harmonious form is this loss, this impossible past that history has now rendered obsolete. It manifests in work such as *L'Intrus* as a dark and hollow force, potentially disruptive in the very oscillation it enacts between passages of lightness and moments of regret. It is a destabilising force, this kind of beauty; an expression that paralyses at first, before transporting the viewer to a much bleaker and melancholic place.

Denis's collaboration with Agnes Godard in the earlier film, *Beau Travail* (1999), achieved similarly immobilising ends. *Beau Travail* is Denis's re-working of Herman Melville's *Billy Budd, Sailor* (1888) set in the Gulf of Djibouti. The devastating, passionless and remote beauty of the landscape forms the background to a journey the viewer will take with the protagonist, Galoup, as he leads a group of Legionnaires through day-to-day routines. Their isolated and seemingly futile distant campaigns, their sorties, their washing, their ironing, their training, are all formed into an erotic/homoerotic composition that is fascinating and sumptuously beautiful.

The commanding officer, Bruno Forestier, is played by Michel Subor and it is he who sets the film's tragic events in play when he shifts his favouritism from his second-in-charge, Galoup (Denis Lavant) onto a new recruit, Sentain (Gregoire Colin). Forestier's withdrawal of patriarchal attention becomes the

springboard for Galoup's jealousy and brutal bullying of Sentain, bringing about Galoup's final demise. Back in Marseilles and alone, dismissed from the Legionnaires, Galoup is now an outcast in a world of outcasts, and we see him applying the same unyielding fetishism of order and discipline that was demanded of him in the army to his now secluded and private domestic tasks. In a powerful and curious final scene, he is alone and ruined, dancing frenetically to the disco song, 'Rhythm of the Night' (1995), performed by Corona. How strange is this ending? There is no redemptive moment for Galoup, no revelation. Held in a rhythmic trance-like dance, in which the emptiness of his future without the Legionnaires is laid out before him. He is suspended over the abyss, as Charles Taylor described it.[36] The music is particularly crucial here in creating the kind of tremor we feel between absolute beauty and absolute bleakness, between strangeness and familiarity.

Eleanor Kaufman, writing on Maurice Blanchot's 'inertia of being', offers another way of thinking about these ambivalent affects:

> This is a type of movement that never really attains a goal or even a concrete expression of thought. If anything, the movement works to obscure thought, but in this act it illustrates thought of another order, an even more exterior form of thought. Yet, on the other hand, it is 'the depth of being's inertia', being's seeming unworking, not also beckoning to an ontology of its own, even while resisting such a fixedness of being?[37]

As with Blanchot's inertia of being, Denis's aesthetic choices have produced another order of thought, an exterior form of thought that concurrently is an undoing of the certainty of being.

Beautiful semblance, this poetic use of image, is intricately entwined with Denis's political position. At first seductive and elevating, Denis and her cinematographer, Godard, push beauty to the very edge of the void, transforming the experience into a deathly, paralysing present. These contradictions are integral to the kind of response *Beau Travail* and *L'Intrus* encourage – the attraction, the lightness, as well as the final pull into certain darkness.

The figure of the Father

Such instability is already embedded in Jean-Luc Nancy's short text and as I continue to read his *L'Intrus* my own sense of being becomes increasingly and perilously unstable. Nothingness, or non-being, is the most intrusive of intruders at this moment. And yet, against the ceaseless and menacing

intrusion of the other, this shaking of being is not because I am unable to imagine harbours of respite.

> Becoming foreign to myself does not reconcile me with the *intrus*. Rather, it would seem that a general law of intrusion is exhibited: there has never been only one [*il n'y a jamais eu une seule intrusion*].' [32] As soon as intrusion occurs, it multiplies, making itself known through its continually renewed internal differences.[38]

There is a direct correlation between the treatment of the 'I' in Nancy's text, which has been split in numerous and menacing ways by the intrusion of the stranger's heart, and the way Denis divides and multiplies boundaries and borders as a tool for thinking estrangement and invasion. But what is of particular interest in Denis's *L'Intrus* is the way she translates metaphysical concerns into bodily affects, which then become channels to confront concrete political concerns. It matters not that the images of refugees are fleeting and dispersed in *L'Intrus*, for Denis is still able to reach a critical position on what is perhaps the most pressing of geo-political concerns, the mass displacement of people wrought by the continuing and rupturing forces of decolonisation and disparities in global wealth. Sitting underneath this is Denis's treatment of patriarchy in *L'Intrus*, which she has described as Trebor's 'masculine dream'.

In *Beau Travail*, Denis named the squad's commanding officer 'Bruno Forestier', in reference to the role Subor played in Godard's *Petit Soldat* (1963). This opens the possibility that a central theme of Denis's work is the changing consciousness about patriarchy through the crucial decades of the 1950s to the end of the twentieth century, and that this began its fermentation with *Beau Travail*. A central figure in Denis's development of this theme is the actor Michel Subor who was also the catalyst for bringing about the tragic consequences in *Beau Travail*. In fact, Denis claims Subor as a secondary source for the film:

> Now *L'intrus*, in a way for me, was a sort of homage to Michel Subor, but I couldn't say that to Michel, as I could not say that to Jean-Luc because Jean-Luc was in a way, not jealous, but he could not understand how that man could be anyone but him.[39]

In support of her claim that *L'Intrus* is as much about the actor Michel Subor, as it is of Nancy's text, Denis intercuts scenes of Subor taken from an earlier film, *Le Reflux* by Paul Gégauff, shot in 1965 in one of France's last colonies, Tahiti.[40] The intrusion of the old black-and-white footage inflicts a

shocking break in the temporal flow, aligning with the way the character of Trebor now seems to disintegrate, as though Michel Subor, the actor, had been the pivot of the story all along, and Trebor had merely been a flimsy ruse to lead the viewer to this same conclusion. Thus, it is no surprise to hear Denis's claim: 'On the set of *L'Intrus*, he captivated everyone, but nobody wanted to pierce his mystery. Michel Subor is not the character of *The Intruder;* he is the intruder.' (*Sur le plateau de L'Intrus, il a captive tout le monde, mais personne n'a voulu percer. Michel Subor [sic] n'est pas le personnage de L'Intrus, il est L'Intrus*).[41]

In another interview, Denis expands on this thought:

> Michel was Trebor but the strange thing is that Michel pretends now that Louis Trebor changed him. And I keep telling him that he was already like that but he didn't want to look at it clearly: but every-thing, every detail of this man comes from him. If you look at *Petit Soldat*, I think, if I got so much of this desire to work with Michel, and I don't want to be rude to actors, but I think Michel was never an actor. He is the young man in *Petit Soldat*, as he is Louis Trebor in my film because Michel has a way of non-acting presence that was almost shocking for me when I saw *Petit Soldat*. And not just for me, for many directors do not want to work with Michel after *Petit Soldat* because they thought he was a right-wing terrorist. Michel is absorb-ing. Some people act because they want to reflect something. Michel is like a black hole in the cosmos – he is absorbing all the energy and you feel it.[42]

Along with the continually renewed internal differences that Nancy describes as an outcome of receiving a stranger's heart, Denis introduces the experience of the actor Subor discombobulating in response to the force of his role as Trebor. The place for the amalgam of Trebor/Subor is Tahiti. Up to this time, Trebor failed to connect in any meaningful way with the people around him – those hostile figures who personified the modes of his self-estrangement – his son, his son's family, his lovers, his fellow travellers, and his neighbours. And yet, this failure of character, articulated most profoundly in the fraught, loveless relationship of father to son in France, which is reinforced by an uncomfort-able exchange of money early in the film, is placed in question by an appar-ently deep love the same father has for a 'lost' son in Tahiti. By the end of the film, though, we realise that this loved son, this distant and unknown son, this 'dreamed of' son is only an extension of Trebor's relentless narcissism, while his son in France, now full of loss is seen at one moment crying in his father's empty house, and then later appearing in a morgue in Tahiti with his heart cut out.

In this paradise of French colonialist imagination, there is something more than Trebor's story to discover, for this figure also stands as a muscular symbol for the ruinous remains of European imperialism and faltering patriarchy. 'What a strange self,' Nancy remarks,[43] as his account of his heart transplant becomes a register for an identity stripped of certainty and constructed in fragile and shifting relation to the other. Perhaps then it is not a stretch to see *L'Intrus* as a sequel to *Beau Travail* in terms of the way patriarchy is presented. In *Beau Travail*, the withdrawal of patriarchal approval is still a potent catalyst for bringing about the self-destruction of the spawned 'son', whereas in *L'Intrus*, the male patriarch no longer holds such command, even if he doesn't yet realise it. On ordering his new heart, Trebor insists: 'So it is agreed. I want a young heart. Not an old man's heart or a women's heart. I am a man. I want to keep my character. You understand?' (*On est bien d'accord. Je veux un coeur jeune. Pas un coeur de vieillard, ou une femme. J'suis un homme. Je veux garder mon caractère. Vous comprenez?*)

Perhaps this is how to best explain some of the most enduring images in the film, such as the enigmatic, 'smirky' smiles that Dallé holds in her exchanges with Trebor. As with old Europe itself, this ailing man, this 'heartless man' as Denis calls him, is under siege. His enemies are familiar forces, and yet they remain wholly unknowable. This man (this system) is unable to comprehend the feminine, the animal, the ex-colonial subject, the absolute otherness of a radically changing world...

Denis says she added nothing to the film that was not already in the text, yet Jean-Luc Nancy failed at first to recognise it.[44] Proliferating in the fertile spaces that have opened up between *L'Intrus* the essay and *L'Intrus* the film are the unavoidable misrecognitions that characterise all translation, and that become through the 'echo of the original', as Walter Benjamin writes, something other than the mere reproduction of meaning. 'Whereas content and language form a certain unity in the original, like a fruit and a skin, the language of the translation envelops its content like a royal robe with ample folds.'[45] Denis's film casts its most effective line in the dynamic folds that procreate between the original and its translation, for here we find meanings and sensations that were imperceptible in Nancy's essay.

One such instance comes from the convergence of two themes; the place that women and dogs hold in the film as a questioning of patriarchy, and the relationship this holds with the theme of the stranger, from which the problem of hospitality flows manifestly,[46] particularly in consideration of the work on the host and hosting of Jacques Derrida and Emmanuel Levinas.[47] As a starting point, Derrida took from Levinas the host's unconditional obligation to the stranger, who at all costs and in the name of justice must be welcomed across the threshold of the host's domain, even though this crossing will always be a

transgressive step, and hospitality an unfailingly impossible act. However, for Derrida – and this is an important departure from Levinas – unconditional obligations must be tempered by 'what in the intrusion of the *intrus* is intolerable.'[48] Although this was raised in relation to Frances Barrett, it is worth repeating, this time through Derrida, that the source of the word 'hospitable' is 'of a troubled and troubling origin, a word which carries its own contradiction incorporated into it, a Latin word which allows itself to be parasitised by its opposite, "hostility".'[49] It encompasses what Derrida calls 'the double law of hospitality: to calculate the risks, yes, but without closing the door on the incalculable, that is, on the future and the foreigner. It defines the unstable site of strategy and decision.'[50]

The first question that Derrida poses in his book, which I see as Denis's question too, is how to interrogate the question of hospitality as a question *of* the foreigner, a question that comes *from* the foreigner first.[51]

> The Foreigner shakes up the threatening dogmatism of the paternal logos: the being that is and the non-being that is not. As though the foreigner had to begin by contesting the authority of the chief, the father, the 'master of the house,' of the power of hospitality.[52]

In *L'Intrus*, foreignness is encapsulated in the strangers who torment Trebor's psyche – Tahitians, women, dogs, and also the refugees who pass him in the night – the *Other* figures of historical, European androcentrism. The sharply drawn contrast to Trebor's troubled relationships is the strong alliance between '*La reine de l'hémisphère nord*' (The Queen of the North, Béatrice Dalle) and her dogs. Trebor eventually abandons his own dogs in the forest after Dalle refuses to take care of them. 'Get out', Dalle says to Trebor, with her characteristic smile, 'You drive my dogs nuts.'

I would like to bring this chapter to a close, therefore, by thinking about the theme of 'illegal immigration' in the film. The scenes of people crossing into French territory bring into question, albeit furtively, the consequences of decolonisation and disparities of wealth between Europe and its post-colonial south. Recent estimates from the European Union claim that between 1.8 and 3.3 million people are living in European Union countries without residency or working permits.[53] And yet, such abstraction of people into numbers obscure individual stories, playing into the hand of those who would increase bureaucratic regulations and nets of statistics to tighten borders. It forms the context for Derrida's observation that immigration moves in a 'gloomy, tense and irritated atmosphere' – somewhere between pragmatism, realism and xenophobia.[54]

Hospitality consists in doing everything to address the other, to accord him, even to ask him his name, while keeping this question from becoming a 'condition', a police inquisition, a blacklist or a simple border control. This difference is at once subtle and fundamental: it is a question, which is asked on the threshold of the 'home' and at the threshold between two inflections. An art and a poetics, but an entire politics depends on it, an entire ethics is decided by it.[55]

What is this art, this poetics, if not the delicate handling – the thinking, the negotiating, the acts of hospitality, the spaces of desire – that would welcome people across borders, recognising both their strangeness and their request for immigration? This is where Denis's poetics is found – her particular way of visualising this messy composite of intrusion and hospitality, which are also cut at every point with the noise of competing political positions – and for which, in a panel with Jean-Luc Nancy, Denis observed, 'There was nothing comforting in the project.'[56]

This chapter on Claire Denis's *L'Intrus* and the previous chapter on Frances Barrett's *Curator* dealt with the themes of 'hospitality', 'borders' and 'care', through the different mediums of film and performance. Both works touched on questions of patriarchy. By situating *L'Intrus* in the context of her wider body of work, it was suggested that the porous boundaries that structured Denis's film, also revealed her depiction of changed societal attitudes in the figure of the patriarch (commander, father, neighbour, colonist), as seen in the differing roles of Michel Subor, her male protagonist. Subor played the powerful figure of the patriarch not only in *L'Intrus* but also in her earlier *Beau Travail*, where she named him Bruno Forestier after the character he played in Jean-Luc Godard's *Petit Soldat* of 1963. It is possible to recognise in Denis's film that the figure of the patriarch has crumbled over these forty years. Might *L'Intrus* and *Curator* stand as evidence that patriarchy is challenged/challengeable today, readily readable as such? If so, the works present a more complex image of the power of patriarchy than one that is reducible to questions of gender. I am suggesting that they release the political potential of feminist utterings that would break 'feminism' from the stasis, the sterility of taxonomically-generated definitions. Denis achieves this by treating patriarchy as an historical phenomenon. She infers that the estrangement between father and son was as much generational as it was familial, clearly shown in the scene of the son caring for his babies, without there being a sense that this occurs through any kind of 'feminising', in a patriarchal sense of the term. However, these observations are tangential to the overall objective of the chapters.

Crucial to both *L'Intrus* and *Curator* was the way politics was realised through an inducement of sensuous and affective responses from audiences and participants. While the chapter on *Curator* was concerned with ethics as a positioning of the political, this chapter on *L'Intrus* focused on the political implications of affect, out of which then flowed certain ethical implications. As such, the two chapters are companion pieces that insist upon the inter-connectedness of ethics and politics, and in particular, how feminism might be thought today as an intimate positioning in relation to one's world.

10

The Politics of Painting: Cliché, Fashion, Mimesis

Through investigations into cliché, fashion, mimesis and the new, this chapter explores the political-aesthetics of painting, culminating in a close examination of work by painter, Angela Brennan, whose practice spans more than three decades. In articulating a political-aesthetics, Brennan's painting offers a challenge in that it makes no direct appeal to a political position. Nonetheless, I will propose that it is in the very poetics of the work that a defined political-aesthetics resides.

In the latter decades of the twentieth century, coinciding with the general disparagement of representational art, the capacity for painting to disrupt or critique hegemonic conditions was openly questioned by many artists and critics. Its denigration coincided with a wider loss of faith in the dominant discourses of the time, particularly the western art canon that had been sanctioned by a small group of 'master' historians. European art history was considered by the late twentieth century to encompass narrowly constructed stories of art that tied judgement to lines of artistic 'refinement', and which somehow excluded or threw to the periphery whole groups of painters from other cultures, as well as painters who happened not to be men.

While this historic rebuke was a significant moment in a power struggle over what art could be, and who could be seen to be making it, in the first decades of this century, with a renewed critical interest in materials and aesthetics being applied to contemporary modes of making and thinking, painting was being re-evaluated in terms of what constitutes political-aesthetics. In the entangled exchanges between painting's production and its reception, this marks a decisive shift away from the 'anti-aesthetic' decades of last century.

Walter Benjamin and Jean Paulhan

If you remember the little painting, *Angelus Novus* (1920), by Paul Klee and owned by Walter Benjamin, you will know that it formed the centrepiece of his 'Theses on a Philosophy of History'. According to Benjamin, the angel, with its wings splayed, is straining against the world's mounting wreckage. He is witness to our human-made disasters, while we (arrogantly, ignorantly) turn our backs

on the past, dreaming distractedly only of our futures. This is the stuff of progress, Benjamin says, and the debris of the world's unchecked and accumulating disasters make the Angel's task a tortured and unhappy one. And yet, when I look at Klee's angel, he seems to be on the edge of a strange and perplexing smile, more playful than tortured, this angel who seems to be skipping along as though he holds a secret joke under his wings. What is this breach of misunderstanding that opens between Benjamin's description/ perception and my own? Conceivably, those tiny sparks of latent messianic power, which Benjamin finds concealed among the debris is warming this playful Angel who balances so lightly on the tips of his toes. It is only the angel, after all, who faces the past, witness to those moments that could have once altered history and which still lay claim to a promise for redemption today. 'The past carries with it', as Benjamin remarks, 'a temporal index by which it is referred to redemption.'[1]

Benjamin bought Klee's painting in 1921, carrying it with him on his continual travels and exiles, before a synthesis of thought and image composes his final work on history.

> As for your question about my notes, which were probably made following the conversation under the horse-chestnut trees, I wrote these at a time when such things occupied me. The war and the constellation that brought it about led me to take down a few thoughts which I can say that I have kept with me, indeed kept from myself for nigh on twenty years. This is also why I have barely afforded you even more than fleeting glances at them. The conversation under the horse-chestnut trees was a breach in those twenty years. Even today, I am handing them to you more as a bouquet of theses.[2]

Benjamin's 'bouquet' to his friend Gretel Adorno, his *Theses*, were completed in the same year as his death and thus function as a kind of summation of his thinking and writing, particularly a melding of his concerns for the estranged trajectories of messianic and Marxist thoughts. It was the angel who now bears the weight of Benjamin's final political and philosophical beliefs, his dreams of redemption. This was an assurance that the future's debt to the past would be recognised, and that the past (history) retains, albeit faintly, the possibility for perceiving a new future. If one is to adopt the mantle of the historical materialist and to deny the obstinacy of historicism, then the task is to seize images as they 'flash up in a moment of danger'.[3]

In negotiation with the uneasy field of painting, I am hereby nominating Jean Paulhan as my historical materialist – to see beyond the remnants of art history's past hegemonies: first of painting, and then of installation, of formalism and then conceptualism, to circumvent the repressive nature of its many crises, widespread malaise, and multiple deaths, and to abstain from the crude and worldly posturing of 'naming' ('The Contemporary' as the saddest and

more recent *denouement* of art's unlimited possibilities).[4] It is an amusing coin-cidence, therefore, that in my digging into the past to avoid the ineluctable legacies of dominant histories, I discover a little portrait of Paulhan by Jean Dubuffet (1946), very like Klee's *Angelus Novus*.

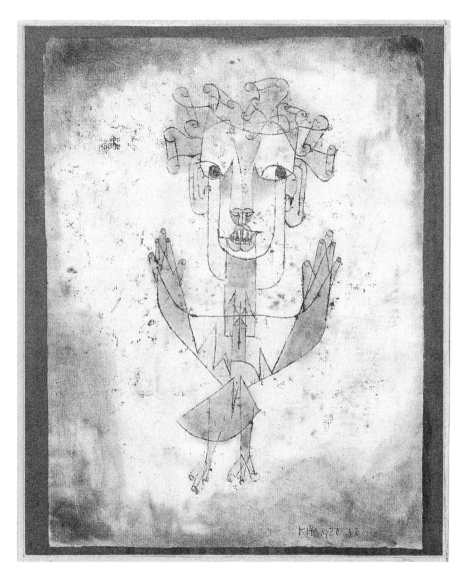

Figure 10.1 Paul Klee, Swiss (1879–1940), *Angelus Novus* (1920). Oil transfer and watercolour on paper, 318 x 242 cm. Gift of Fania and Gershom Scholem, Jerusalem, John Herring, Marlene and Paul Herring, Jo-Carole and Ronald Lauder, New York. Collection: The Israel Museum, Jerusalem, B87.0994. Photo: Elie Posner. © The Israel Museum, Jerusalem

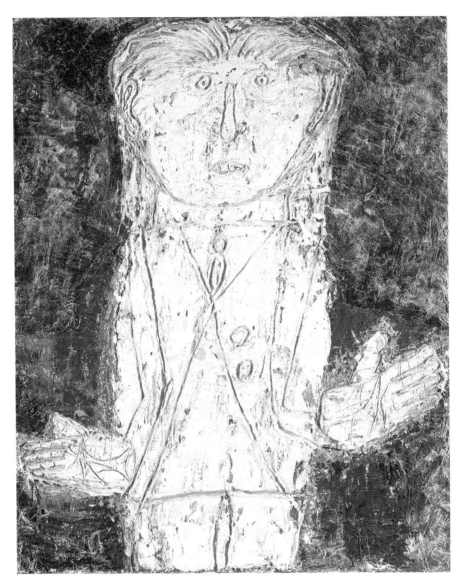

Figure 10.2 Jean Dubuffet (1901–85), *Jean Paulhan* (1946), acrylic and oil on Masonite, 108.9.x 87.9 cm. Jacques and Natasha Gelman Collection, 1998 (1999.363.20). Photo: Malcolm Varon. The Metropolitan Museum of Art. Image source: Art Resource, NY. © ARS, NY

The lightness of Benjamin's angel is clearly missing, and so are his dancing feet, for Paulhan looks worried, even frightened, and a little paralysed by the blackened ground of the painting. This figure of a concerned Paulhan, painted a quarter of a century after Klee's, is severely cropped, forcing attention on the

hands. The hands are the point, I think, the hands and the eyes, those deflect-
ing hands, so reminiscent of the wings of Benjamin's Angel, fixed in heavy,
deeply scarred impasto, fixed and perhaps a bit desperate, and the eyes, a little
scared and a little close together. The wreckage of history that threatens to
overwhelm us while our gaze is distracted, might this be Dubuffet's Paulhan,
attempting to ward off that which finally cannot be stopped, an angel-witness
to the world's accruing tragedies? Or are his hands reaching out to be saved
(a sign of existential desperation), an attempt to try to withstand the inevitable
fall backwards into Dubuffet's abyss? And would this make him not one of
Benjamin's angels at all, but closer to one of us?

The desperation I see in Dubuffet's portrait, though, is not evident in
Paulhan's writings, which are funny and playful. Or perhaps, through the rift
of translation, I cannot recognise the signs of cynicism or melancholia that
might veil a weightier soul?

> Indeed, the casualness he sometimes lets himself be suspected of is both
> a defence against a certain heaviness which inhabits the reversal – the
> volte-face – and yet is an invitation to jump, and also an insistence
> upon lightness which seems by contrast, to warn us, and turns us back
> towards gravity, but an uncertain gravity which is lacking the guarantee
> (the security) of seriousness.[5]

Paulhan died in Paris in October 1968, a few months after the Paris uprisings.
The frequent citing of this event as an intervention between the past and the
future, the old-world and the new is the way Maurice Blanchot viewed Paulhan's
death when he wrote about it in the following year as emblematic and disclosing:

> John Paulhan was beginning to leave us, just when we had planned to see
> each other again once the spring returned. I wish to begin by recalling
> this gravity of history . . . in the end it remains true that great historical
> changes are also destined, because of their burden of absolute visibility,
> and because they allow nothing but these changes themselves to be seen,
> to better free up the possibility of being understood or misunderstood
> intimately, and without having to spell things out, the private falling
> silent so that the public can speak, thus finding its voice.[6]

Conditions had been very different in the years following the Vichy regime
for Paulhan when stances seemed immutable. Fearful of the blind spots and
stases formed by ideological 'certainty', Paulhan wrote:

> The chief effect of war is that everyone generally ends up more con-
> vinced than ever: the revolutionary, more revolutionary; the believer,
> more believing; the impious, much more impious; even the pacifist,

who only thinks that events proved he was right. So everyone ends up more simplistic, more intolerant, and, for that very reason, far more likely to cheat (since things in themselves remain complicated). Language, meanwhile, becomes more obscure.[7]

In his 1948 book, *De le paille et du grain* (*Of Chaff and Wheat: Writers, War and Treason*),[8] Paulhan questioned the right of the *Comité National des Ecrivains* (National Committee of Writers) to compile a black list of collaborationist writers following the Second World War.[9] Collaborators were widely and harshly excluded from public positions (a purging and a cleansing of national conscience). In Paulhan's typically equivocal way, *De le paille et du grain* moves between and across positions, sometimes seeming to reflect an extreme nationalist position, while at others seeming to oppose it:

> If France was divided between Collaboration and Resistance, Pétain and de Gaulle, then these could be seen, according to Paulhan, as two halves of the patrie, which he then defines variously as physical and spiritual, sentimental and intellectual, contingent form and inner essence, and carrying it across into the linguistic realm, words and ideas. Any 'side' that claimed to be the unique representative of the patrie world, according to Paulhan, would be indulging in partisanship, not patriotism.[10]

Michael Syrotinski reveals that the arguments in *De le paille et du grain* fall around a central French proverb (untranslatable). As with the Malagasy proverbs that Paulhan studied during a youthful, colonial posting, this becomes the point at which the arguments' separate positions meet and collapse. With the promise and subsequent failure of the book to separate the 'chaff from the wheat', it is both a performance and an explication of Paulhan's radical ambivalence. And yet, despite the internal logic structuring the book, 'by going against the grain of the predominant ideology of the time', Paulhan was judged to be politically naïve.[11] For Paulhan, writing before the political (and in turn, theoretical) reverberations of May '68, there was a heavy political price to pay for insisting on the middle ground.[12] Transported to the 'extreme middle' of 'politics' (to the unburdened word), it is here that Paulhan discovered the 'purity' of ambivalence. And perhaps this is also where his influence on Blanchot and Derrida was at its brightest,[13] for in seeing both sides at once, he discovers an argument's most vulnerable point, the point of its very collapse. As Syrotinski notes, 'With this plea for a certain untranslatability as the condition of possibility of translation, it becomes clear that the text and its various analogies are not reducible to the rhetorical structure of a reversible chiasmus, a neutralisation of opposites.'[14]

In the wearing-down of polarised differences, the collapse of the argument does not equate with the destruction of literature or a denial of the political, where the specificities of politics and literature are obliterated. And this is what separates Paulhan's methods from those of the Neue Slowenische Kunst (NSK), discussed in Chapter 7, who appear to neutralise political positions. In contrast, As Jennifer Bajorek observes, Paulhan 'always wrote from or to that place in which every possible distinction between the literary and the political becomes impossible', a particular Paulhanian understanding 'that forecloses the dialectical assimilation of opposition while simultaneously calling forth a labour of distinction nearly infinite in its own right.'[15] And it rests on the possibility that the 'word' shall be liberated, necessarily, from the weight of ideological division to recover its original spontaneity and directness. This also contributed to painting's expatriation, which not only aligns directly with Paulhan's ideas on rhetoric, but also, through a twist of thinking will culminate later in the century as a source of painting's redemption.

Cliché . . . catastrophe

> Literature exists. It continues to exist despite the inherent absurdity that lives in it, divides it, and makes it actually inconceivable.[16]

A year before Paulhan's death, Michael Fried began sorting out his thoughts on the impact of minimalism, a then relatively new and radical way of approaching art's purpose and intent: 'Painting is here seen as an art on the verge of exhaustion, one in which the range of acceptable solutions to a basic problem – how to organise the surface of the picture – is severely restructured.'[17] This was a concession by Fried (a resignation of sorts) that a younger generation were rejecting conventional art thinking. In the sights of the minimalists were the abstract expressionists and their hubristic claims to transcendence. At a time when critics were still grappling with a way to understand this new art, Donald Judd (writing on Robert Morris's *Grey Show*, held in The Green Gallery, New York in 1964) set the younger artists' intentions:

> Morris' work implies that everything that exists in the same way through existing in the most minimal way, but by clearly being art, purposefully built, useless and unidentifiable . . . You are forced to consider the ordinary things and to question whatever was thought important in art.[18]

Distancing themselves from crafting, from making, the minimalists offered industrially constructed boxes and forms that would fashion them, in the words of Thomas Crow, as 'intruders in the space of aesthetic delectation.'[19]

In such a milieu, the painter is confronted by two choices: to discard the practice of painting altogether, or else confront this now diminished visual schema as a catastrophe to be endured and overcome. The recognition that cliché is the catastrophe is how Deleuze described the process of painting: the painter must overcome an overworn visual schema in new and challenging ways.[20] It is both an acknowledgement of cliché, and a challenge to produce (to reinvigorate) the visual order each time cliché is recognised. If painting necessarily begins with the burden of overused visual coordinates, this would be its *eidos* and part of its ontological structure, so that even if the painter is incapable of seeing these clichés, they nonetheless remain rooted in the territory of painting. And yet, this seems to encircle endlessly, but never resolve the hub of Fried's dilemma, uttered at the moment of minimalism's ascendancy. It escapes, in other words, a direct confrontation with the problem of painting's exhausted potential. How might cliché become both the material and the opening point for 'something new' to emerge? To consider this question from another approach, and with more brutality, 'What are clichés?' Above, I sought to encapsulate an understanding of this in the idea of a now depleted visual form waiting to be reinvigorated by the painter. But this is still wholly deficient, since it accounts just as aptly for something that has passed out of fashion. And since the unfashionable may simply leave us 'cold', what is crucially missing from such a denuded account was the sense of 'disgust' that accompanies cliché, that puritanical suspicion. It becomes also a 'reproach' of the 'lazy or facile' artist.[21] 'They are not thinking, they are never thinking.'[22]

Some interesting parallels are found between the problems of writing and those of painting in Paulhan's text, *Les fleur de Tarbes*, begun as early as 1925 but not published until 1936. The reader will stumble across the exhausted nature of the word (the completed image), concretised as cliché.

> A commonplace expression is said to reveal a thought that is not so much indolent as it is submissive, not so much inert as it is led astray, and as if possessed. Clichés, in short, are a sign that language has suddenly overtaken a mind whose freedom and natural movement it has just constricted,[23]

Not only inert, lazy and slavish, therefore, but in Paulhan's interpretation, writers are also betrayed when they use ready-made language, for they 'drag their thoughts behind them, shamefully resigned thoughts.'[24] In other words, they allow 'language' to steal 'thought', which is the life force of a writer's independence. 'Since rules and genre follow cliché into exile', rhetoric is the art of cliché.[25]

Paulhan playfully opposes cliché with its nether side, 'Terror'. For those writers in search of the purity of the word, Terror is the relentless undoing of cliché driven by the demands of 'difference, originality and absence'.[26] Sustaining autonomy, originality and authenticity at all costs are central concerns of Terrorist writers 'who demand continual invention and renewal, and denounce rhetoric's codification of language, its tendency to stultify the spirit and impoverish human experience.'[27] But Paulhan warns that Terror holds a similar trap to rhetoric because it also betrays the unlimited freedom implicated by its promise, by its potential. In the continual fight against cliché, the Terrorist writer is 'paradoxically enslaved to language, since they spend all their time trying to bypass it, or rid it of its clichés.'[28] Terror's 'optical illusion', as Michael Syrotinski writes, 'takes the form of a kind of blindness to its own rhetorical status.'[29] For, as Paulhan insists:

> Terror depends first of all on language in this general sense: that the writer is condemned to only express what a certain state of language leaves him free to express: restricted to the areas of feeling and thought in which language has not yet been overused. That's not all: no writer is more preoccupied with words than the one who is determined at every turn to get rid of them, to get away from them, or even to reinvent them.[30]

Terror may free the word from the prison of rhetoric, with its rules and regulations, and its established institutions, but the search for the purity of thought to word becomes a prison of its own kind. Rhetoric may enslave thought, limiting its clarity and forcing it into compliance with rules and genre, but it has the capacity, nonetheless, to free the writer from compulsive concerns with style. Blanchot expands on this point:

> By 'thought' [Paulhan] understands not a pure thought (any perceived thought is a first language) but a disorder of isolated words, fragments of sentences, a first fortuitous expression – and by 'language' an ordered expression, the ruled system of conventions and commonplaces. This observation thus allows us to say that for Paulhan – at least in this secret book that we credit to him – if thought is to return to its source, that is to abandon the first, cowardly clothing that covers it, it must bend itself to clichés, conventions, and rules of language.'[31]

Writers and painters who are keenly attentive to the failures of their particular histories, methods of making and compositions are subjected to the persistent anxieties that accompany the 'un-writing' of writing, and the 'un-painting' of

painting. It is understood that familiarity will inevitably dull the euphoria of newly arranged language, newly formed visual coordinates, forcing the writer and painter to live 'at the cost of an infinite flight'.[32] 'And it is not without good reason', Paulhan writes, 'that we canonised Rimbaud who stopped writing – and indeed emigrated – at the age of twenty.'[33]

By the end of his elucidation on the failings and rewards of cliché and Terror, it is discovered that Paulhan has sided with neither position. For where rhetoric makes thought a priority over language, and Terror preferences language over thought, this amounts to a conflict of differences, an aporia old and irresolvable, between style and affect (form and expression). By establishing Terror and Rhetoric as rivals, however, Paulhan was able to illuminate the ambiguity that gets locked into each position at the moment of its unravelling. Furthermore, as Syrotinski shows, *Flowers of Tarbes* is 'a performance of the very radical ambiguity that it talks about, an ambiguity which is not simply an equivocation about what the book is saying, but which suspends it between saying and doing, stating and performing, original and commonplace.'[34] It might be remembered that cliché is not only contagious,[35] but also liberating in the pause it gives us from the burden of thought, and while the adventure of terror uplifts and refreshes, in Paulhan's words, it is also 'both pretentious and disappointed, mad and silent.'[36]

As I now shift the focus of Paulhan's argument from the figure of the writer to that of the painter, I find the sign of painting slightly altered by Paulhan's reflections. It is possible to recognise in recent history the same relentless search for clarity of form, which will enable thought to arise spontaneously (Terror), unadorned by rules or tradition (Rhetoric). I see, too, in 'the uncompromising demand for originality',[37] how method became a means that was also an end in itself. And this was interesting enough in its circularity, in its bearing down on the details and minutia of making, for earlier, I suggested that Paulhan finally supported neither cliché nor Terror, and yet his strategy was even less transparent. He burrowed out of the weighty limitations of Terror by not simply dismissing cliché, but by embracing it, humorously, playfully. Echoing Deleuze's painting dilemma, Blanchot notes:

> Let us recall its conclusion: it is that clichés would no longer be lacking anything if they always appeared to writers as clichés. All we need to do, says Paulhan, is to make commonplaces common, and to restore to their proper usage the rules, figures of speech and all the other conventions, which suffer a similar fate.[38]

Things were tough for painting in the midst of art's many institutional resistances and ontological critiques through the 1960s and 1970s. As its vibrancy was swamped by the brilliant polemics of its detractors, painting

seemed obsolete. It is still possible to remember the way painting's auratic power was destroyed by mechanical reproduction (Benjamin, Warhol), how its interests were easily seduced by the market (Situationist International, Art & Language), the way its unbreachable distance to its audience was seen as alienating (Fluxus), and how its gender-biases became increasingly unacceptable (feminism, performance). And while its claims to transcendence were effectively challenged, overthrown (minimalism, conceptualism), we find as the twentieth century progressed, another shift in the twists of making and reception (and reception and making) – a renewed interest in materials and aesthetics. However, there was another aspect to painting's expatriation, which not only aligns directly with Paulhan's ideas on rhetoric, but also, through a wriggle of thinking will culminate later in the century as one source of painting's redemption.

Whitney Bedford is a painter from Los Angeles who paints shipwrecks.[39] Shipwrecks are not only images of crumbling adventure, but also historically loaded motifs of European commercial and imperial interests, and thus, these genre-pieces, these clichés, instigate a shift in our expectations. Bedford painted the 'scenes' at the most anxious moments of the narrative, just before the ships had lost their battle to survive, or at the very moment spectres of ghost ships intermingle on a desolate sea, or in the calm passing of icebergs before they transform into beautiful, icy sirens enticing inattentive sailors. And at the core of the event, in the midst of the image, is found the overbearing weight of paint that coalesces in Turneresque flurries of abstraction. These 'catastrophes' seem to produce an intensification of time amplified in a chaos of paint: for this is also the point at which Bedford suspends the narrative, resting at the very edge of danger (seconds before the tragedy is to enter the world). In other works, the ships are gone (already lost) and we are left with anxious abstractions, sitting atop lines that were once horizons. The works perform, therefore, a double return; first to a moment of possible escape, or a possible rewriting of history, and also a return to the source of the image itself, to the Academic paintings that first attracted her, and upon which she then enacts a form of 'unwriting'. I should not want to forget, too, that the humour and playfulness that animates Whitney's work is not only an affect visibly traced across her images' surfaces, but also embedded in the very armature of their forms (in their undoing and their redoing).

Cliché has been somehow altered, so in one way it has been removed, since Bedford's paintings have taken her a long way from her source pictures. And yet in another way, as with her ghost ships, cliché still clings to the edges of the image as a faint memory, as spectre. I think this is what Paulhan was hoping for when he claimed that all a 'cliché needs – if it is to avoid becoming a sign of defeat and cowardliness – [is] to be constantly rethought, put into question, cleansed.'[40] As Bedford works closely, intimately with the form and content

of the original image, she enacts a process of disassembly and reassembly that is a specific and conscious distancing, many removes from the original or from the specificity of its subject matter. 'My paintings are battlegrounds on which structures and meanings are torn apart . . . This process creates a dialogue between old and new images – it pulls apart and rebuilds.'[41] Her choice of subject matter has been described in the following way: 'The shipwreck as a motif that appears recurrently in Whitney Bedford's work is a metaphor for a more contemporary squall – the turbulent political and social situation in which we live today.'[42] Rather than testing this claim, I would like to leave Bedford here to explore a very different question to that of cliché, but one, nonetheless, that places as much pressure on critical comprehension of the political aesthetic and its capacity to shake up the police order.

Politics + (fashion + the contemporary)

On the route to a closer understanding of what a political aesthetic might entail for painting, I would like to undertake an examination of the effect of a seemingly different kind of an aesthetic order. It is an affect that is both open and indistinct and which obscures from the senses all other possible qualities. It is the eternal present haunted by the fleeting and ephemeral that stings (seduces) not only the individual but also a community of viewers and receivers: it is the effect of fashion.

In trying to define this enigmatic 'thing', I concur with Gilles Lipovetsky, who sees fashion as resting on two systems: flux or ephemerality and seduction, or what he calls aesthetic fantasy.[43] To be in the middle of its charm is to be absorbed by a heady and embracing fever. And I am unable to determine whether this exciting and disturbing configuration is preventing my susceptible mind from forming clear and reasoned thoughts.

Fashion is the contemporary's most palpable and most maligned sign, this nebulous and difficult concept that attaches itself to objects, commodities, manners, thinking and ways of being.[44] Its bodiless affect was deemed by many theorists in the nineteenth and early twentieth centuries to be an internal mechanism of modernism itself, particularly in the way fashion opens onto regenerative, rupturing and creative energies.[45] Even as fashion is drawn into analyses of class, history or economics, these political forces will never exhaust the composite of its qualities. It will have flipped into something not purely of itself. Something will always escape, a kind of excess. This is what makes it so enduringly impenetrable, and all the more interesting for this. What is it that escapes? It is fashion's utopian and transformative promise that sits outside economic or social analyses. Economic considerations may bring to light the operations of reification and commodification, but only at the level of the

exchangeable commodity that uses fashion's charms to pull us towards it. The fashionable commodity comes to us as a whole, a totality of charming affects. In fact, the seductive qualities of 'fashion' will continue to float freely, even in the process of it being concretised as commodity. I am not suggesting that all makers and their works are in synch with the aesthetic flux of their time, but when works (in this case, paintings) carry a strong sense of contemporaneity, they carry this inevitable paradox: a work is marked by the fashion of its time, of its making, at particular historical junctures, but it will come to the viewer as a timeless whole. This is also fashion's radical ambivalence, for fashion is charming and distracting and timeless (wholly contemporary), but once the affect dissipates, the 'host', the thing to which it has attached itself, just as quickly repulses, becoming charmless, illegible, and thereby irrelevant.

The outmoded is the unpalatable: and it was this recognition, this revulsion that took Benjamin back to Paris in the nineteenth century. I would like to stress that full intent of the outmoded is miscalculated when it is treated as something capable of being recuperated as the fashionable. Hal Foster references this inclination by quoting from two sources; the surrealist, Robert Desnos and Claude Lévi-Strauss. The surrealists, Foster wrote, 'are aware of this tendency within surrealism, of the outmoded recouped as the retro, of the aura of the old placed in the service of the empathic commodity. As early as 1929 Robert Desnos noted the "pseudo-consecration" that 'time or market value confers upon objects".' Foster adds that in 'a retrospective essay fifty years later Claude Lévi-Strauss . . . described the recuperation of the surrealist outmoded within the very system of exchange that it once critiqued – a transformation that sees the flea market *trouvaille* become the fashion boutique accessory.'[46]

This approach, this historical juncture in time, misunderstands the term 'outmoded' as Benjamin applied it. The outmoded is the perpetually out-of-fashion. An object recuperated into the realm of the fashionable is no longer the outmoded but its own fashionable other. Benjamin wanted to feel the excitement of the then fashionable that had since fallen into disrepute.[47] It was Louis Aragon who first revealed the revolutionary possibilities of the outmoded to Benjamin, via the moribund arcades of the early twentieth century.[48] However, it was Benjamin who proposed a radical reversal, a revolutionary chance in the flight of the fashionable towards its inevitable privation.[49] Would the power of capitalism be better appreciated by understanding a 'thing's' popularity at the peak of its charm, that is, before the gulping and visceral disappointment of its charmless ways send us off in search of new aesthetic configurations? Might this power also be the point of capitalism's greatest vulnerability?

This was Benjamin's Arcades Project, and his political objective in cataloguing his and others' thoughts about fashion.[50] In this way, both his Convolute

B on fashion and his essay on Baudelaire had a political end, even though – and this will be central to my proposition – fashion, this thing of aesthetic and seductive flux, is itself without politics. Perhaps I might proffer a pre-emptive note at this point about where my thoughts on fashion are heading. When something is in full synchronisation with the aesthetic of its time, it is also in harmony with the 'police order'. And at a particular temporal juncture, when fashion's charm is fecund and rich, my head is foggy, my seduction complete. I have been blindsided. Such intoxication is generated from within and singularly, even though it may be a moment shared with others, or others may be affected at different moments in chronological time. I would like to re-emphasise that in this account, fashion is not just a sign that attaches itself to a 'thing' (in our case 'painting') that carries the effects of contemporaneity, as though generated mysteriously and passively from the thing itself. It is more mysterious than that and involves activating perceptive faculties, which may not be open to everyone at the same time.

Some theorists speak about fashion by conflating fashion and clothing. Giorgio Agamben's writings on the contemporary are valuable but also limited by his falling into the trap of trying to concretise something that should never be given form. And thus, he talks unfashionably about fashion itself, via the tailor and the fashion show. However, it does lead him to say that the model is always and only in fashion, and it is 'precisely for this reason' that they 'are never truly in fashion'.[51] His inference is that time appears to flow smoothly and harmoniously with the *apparatuses* of the day, to use his translation of *dispositif* – but that such consonance is also what separates contemporaries from fashion's 'followers'.[52] For Agamben, it is only when chronological time is perceived as broken and dispersed that the contemporary actually appears, for it is s/he who, in coming too-soon and already-too-late, is able to urge, press and transform it.[53] This is where the poet is to be found, in the middle of an enhanced present, timeless and obscure, an emanation that is dark and unsettling, or what Agamben describes as the 'shattered backbone of time'. It is the poet, he writes, who falls into 'the exact point of this fracture', concluding that the poet *is* the fracture. And thus, it is possible to begin to discover how fashion and the contemporary begin to divide. Contemporaries, for Agamben, are not those who live in harmony with the current times, for they 'neither perfectly coincide with it nor adjust themselves to its demands . . . They are thus in this sense irrelevant [*inattuale*].'[54] Importantly, therefore, Agamben believes that to be very much *of* this world is also to be a little out of step with it. 'Contemporariness', Agamben writes, is 'a singular relationship with one's own time, which adheres to it, and, at the same time, keeps a distance from it. More precisely, it is *that relationship with time that adheres to it through a disjunction and an anachronism*.'[55] Furthermore, a contemporary is one

'who firmly holds his [*sic*] gaze on his own time so as to perceive not its light but rather its darkness.'[56]

Another way to approach 'the discordance of time' is to refer to the ancient problem of time, or, as Robin Durie frames it, a problem in thought that forces time to be out of joint, even while it seems to advance ceaselessly in our everyday life.[57] I have hinted earlier in this chapter that the theorisation of the contemporary, which arises out of the discipline of art history, limits art's potential by containing and defining it. It re-perpetrates art history's most contentious tendency, to periodise art in ways that restrict and judge. And, I would direct my current criticism here to Terry Smith who says of Agamben's concept of the contemporary that it represents 'both the strength and the limit of the most advanced thinking on these matters.' He calls Agamben's theory a 'landing pattern' for writers.[58] He takes it no further and, thus, his objection is shallow and lacks explication. I wonder whether Smith has missed Agamben's point by mixing up two very different intentions? For me, Agamben's 'contemporary' demonstrates a move from logic to practice, from mind to affect. In other words, Agamben has dug into the long philosophical tradition that poses the aporetic problem of time in terms of a failure in logic, to theorise instead the dark effects of time as a broken and impossible reality. For it is only when time is multiplied, dispersed, or broken that the apparatuses might be shaken or disrupted. This is the role of the artist, filmmaker and poet.

> It means that the contemporary is not only the one who, perceiving the darkness of the present, grasps a light that can never reach its destiny; the contemporary is also the one who, dividing and interpolating time, is capable of transforming it and putting it in relation with other times.[59]

What I am wanting to hone in on here is an abounding present-ness that gives the contemporary its sense of timelessness. For the poet, filmmaker and artist it comes as a darkness and a distancing, but it is also the same pressure of the present that gives fashion its vitality and charm. For Simmel, as it would be for Benjamin, fashion contains within it a fragment of the past and the future that is suspended at the threshold of the new and the old, and it is here that we find the strongest sense of present-ness. In Simmel's words: 'Fashion always occupies the dividing-line between the past and the future', and consequently conveys a stronger feeling of the present, at least while it is at its height, than most other phenomena. What we call the present is usually nothing more than a combination of a fragment of the past with a fragment of the future.[60] Benjamin's 'present' or 'now-time', however, incorporates knowledge of the

past and a dreaming of the future that overturns the propensity within dialectical thinking – a feature not present in Simmel's treatment of fashion – for reconciliation and the push towards something new and future orientated. In Benjamin's terms, the 'now of recognition' is the point at which fashion fulfils its most alluring promise, where it affects its strongest hold.[61] It represents the end of wishing, of dreaming, utopia realised, and it is thus the moment when dialectical movement is immobilised (for each time we dream of the messiah's arrival, we return to Paradise, bringing about the end of history).[62] However, in Benjamin's 'dialectic at a standstill', fashion, as the keeper of the wish-symbols (utopias) turns out, through its fetishistic replaying of the Messianic moment, to be a false utopia:

> Novelty is a quality which does not depend on the use-value of the commodity. It is the source of the illusion which belongs inalienably to the images which the collective unconscious engenders. It is the quintessence of false consciousness, of which fashion is the tireless agent. This illusion of novelty is reflected, like one mirror in another, in the illusion of infinite sameness.[63]

Fashion in this sense is a marker for a form of progress that is finally only chimerical, a false sense of moving forwards, while the apparatuses remain unchanged. Perhaps Benjamin was too clear-headed to be seduced by its charms, or too much the poet to be blindsided by its aesthetic totality, because importantly fashion has the propensity to obscure the viewer's vision in a way that only passing time might possibly hope to restore. It is a moment of heated, yet inexplicable attraction, this forceful desire and it confuses to the point of making a work's political potency blurry and inconclusive. If I am to appreciate whether a work is effectively reconfiguring the political-aesthetic order, then I must be in full control of my senses and be capable of removing myself from fashion's intensive glare.

The painterly

My observations so far have concentrated very much on a generalised discussion of the image itself. And while a response to painting that locates its social and collective significance remains important, reflections upon how our senses are affected have moved increasingly into the foreground of recent art discussions. It is an acknowledgement that different art forms produce different forms of perception. Painting produces a different experience to film, for instance, and film is negotiated very differently to sculpture and installation, with their particular spatial configurations. The observation that materials have

an independent existence was a claim made for film by Jean-Luc Godard, as he 'mourned' the coming of digital last century.[64] He suggested that memory resides in a filmic image in complicated ways, not just as a record of subject matter, not just as traces of the maker, but as itself, as living material, and that this preserver of time is all the more significant because of the sensational response it can induce in a viewer. Although it operates very differently to film, painting too has sensate potential, a way of affecting our senses by locking us into the time of the work, the time of its making. And yet, painting is capable of surpassing historical time. It is a sense of vitality inscribed on the surface of the painting that persists through time.

Furthermore, while the formal heterogeneity of contemporary painting practices that rely for their influence and legibility upon reticular systems of production and meaning is popularly discussed today, I find that the meaning and logic of these arguments are not disturbed if the word 'painting' is replaced with the word 'art'.[65] And, therefore, I would introduce a nebulous and evasive term, 'the painterly', as an attempt to isolate what might be particular to painting, and to nothing other than painting, while also insisting that such a thread of thought is not meant to strip painting of its interconnectedness with other practices and histories. It rejects, in other words, the essentialist judgements that Clement Greenberg applied last century that made painting an isolated and discrete practice.[66] The attempt to find something peculiar to painting is also to recognise that painting operates for many artists today as only one material choice among a plethora of possibilities that are likely to flow from specific conceptual demands. Taking these qualifications into consideration, if 'the painterly' is to be a useful way to understand something about painting, then it is important that its defining qualities are applied tentatively and its possibilities kept in play.

Perhaps 'the painterly', therefore, might be better approached obliquely, beginning with painting's relation to the immaterial-materiality of digital. It is an old claim that painting needs to be seen and experienced directly. And yet, it is worth saying again that painting's reproduction and dissemination through the unforeseeable pathways of the Internet and other digital spaces, where colour and size adjustment tools are on hand, leads to a strange transformation of a painting into manipulable pixelated surfaces. This has the effect to radically transform what this thing once was, this painting. As painting is translated into a digital representation of itself, it undergoes a process of reduction, which is also a form of loss. In other words, painting becomes a mere picture of itself, an arrangement of picture cells. As a numeric-based medium, digital is wholly other to the chemical structure of paint and is far removed from the activities of painting. To give digital its due, however, a digital version can tell us a lot about a painting,

particularly about its form, even if it is incapable of communicating certain formal and material qualities. In other words, I can see what a painting is 'about', if not what it 'is'. So, even while recognising that a loss of certain values is inevitable – for example, a painting's substructure, its memory of wetness, as well as the particularity of its surface, and the specificity of its texture and its touchability – digital representations are nonetheless a good source of information. For even if in the end digital delivers only bare form, it enables representations of painting to be disseminated widely, mitigating painting's exclusivity, its presence in a situated space and time, as Benjamin theorised in different versions of his 'The Work of Art in the Age of Its Technological Reproducibility'.

This is not to fetishise paint as a material above other materials and, by extension, the painter over other artists, but to try to better understand how we might experience 'painterliness' as something particular to painting. And, thus, it comes with the qualification that a discussion of the painterly forms only a small part of a much wider (and necessarily contested) field of activity. Today, there is no single concept of painting that would be adequate to meet the miscellany of painters' diverse methods or singular ways of negotiating the world. Appreciating the painterly in painting is not a move to isolate painting from its political, social, philosophical or wider aesthetic contexts. On the contrary, it is posited as a way to try to understand the specificity of the medium and its differences to other art forms; a way to dig down, if you like, into the material quality of artwork, and then to try to rebuild on this, a political-aesthetics of painting itself. This is a political move too, for it is fighting against the tendency to reduce all media to the universal category of 'contemporary art'.

Angela Brennan – the politics of the Image

At a first seeing,[67] Angela Brennan's figurative works look naïve, even child-like. I am thinking in particular of *Angel with Green Hands* (2016),[68] a picture of an angel on its knees in blank space hovering over a small and fragile figure of a woman, a Marion figure, her arms crossed tightly against her chest. There is a tree with sparse leaves, but she is barely protected by it, and the empty ground means that she and the tree are holding onto their world with the slightest of grips. Perhaps a precipice is about to swallow them up? Physical vulnerability is mutating into existential suffering. Unexpectedly, the angel's feet grab my attention. The way Brennan has drawn the toes makes it possible for the angel to rest on its knees, while also poised ready to propel its body heavenwards at any moment; and this is emitting a certain lightness, a lightness of being.

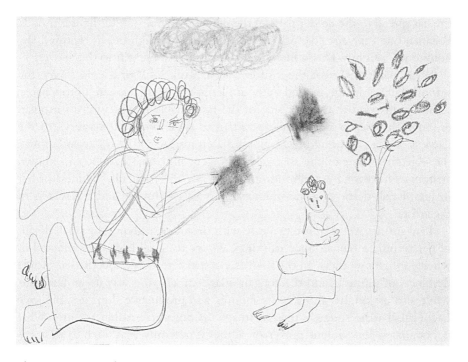

Figure 10.3 Angela Brennan, *Angel with Green Hands* (2016), crayon and pencil on paper, 24 x 34 cm. Photo: Christo Crocker. © Private Collection

This is the trick of the work, I think, the way the rendering of the animated toes rubs up against the work's initial impression of naïvety. The feet, in this agoraphobic landscape, are a restful space for the eyes. They stabilise the work, in a mimetic-pullish kind of way. I have already fidgeted my way around more attention-grabbing places of focus: first the green, fluffy hands of the angel, appearing to bestow spiritual gifts with animated urgency upon the isolated figure of the woman; and then that wonderful cloud, blackened-blue for an imminent storm. The image is portentous, and yet, the image is also overwhelmingly joyful. It is the strange feet that grab my attention and they are also the very source of the joy that I find in the work. 'The image touches me', to quote Jean-Luc Nancy,

> and, thus touched and drawn by it and into it, I get involved, not to say mixed up in it. There is no image without my too being in its image, but also without passing into it, as long as I look at it, that is, as long as I show it *consideration*, maintain my regard for it.[69]

And now the pleasure I found in the angel's feet is radiating across the whole surface of the image, as though in finding the toes' special communication a

fire has spread to the colder parts of the drawing. In a search for lighter moods, Brennan often traverses darkish spaces, and then once lightness is captured, she holds onto it tightly. This is her skill, I think, but also her gift to the viewer.

Some paintings greet the visitor with a blank look or a cold shiver, the smooth-talking image, crafted without blemish. Such images are untouchable, a sour reality, and the nether side of the fashionable image, with its utopian promise. Brennan is wonderfully resistant to these poles of 'mastery', to the flawless or the charming image. She is drawn instead to the oddity of a thing: the objectless stare, or the strangely abhorrent limb that matches no known anatomy. However, by confronting too directly the particular oddness of her images, I risk destroying the unknowability of the image, and the secrets of the artist.

I am sitting over a laptop in a café with Brennan, studying the small details of her favourite Renaissance paintings. We try to recall how they affected us when we first saw them 'in the flesh', so to speak, to recall, too, the irresistible fleshiness of mimesis, and the way an image attracts, the way it can fascinate, while also making us aware of its 'failures' and productive slippages. Philippe Lacoue-Labarthe suggests that an image becomes irresistible because 'what is essential is the violent power of mimesis, not only inasmuch as desire is mimesis but, much more fundamentally perhaps, inasmuch as mimesis provokes desire.'[70] He stresses that 'in mimesis, in effect, there is something, troublesome.'[71] I think this is the source of its wonder, for at the moment the abyssal 'ground' of mimesis is revealed (which is just another way of declaring its groundlessness) the impossibilities of representation become manifest.[72] This laying bare of the intricate contradictions of mimesis opens a troubling/exciting critical path to appreciating the unreachability of the real.

> This is why the only recourse, with mimesis, is to differentiate it and to appropriate it, to identify it. In short, to *verify* it. Which would without fail betray the essence or property of mimesis, if there were an essence of mimesis or if what is 'proper' to mimesis did not lie precisely in the fact that mimesis has no 'proper' to it, ever (so that mimesis does not consist in the improper, either, or in who knows what 'negative' essence, but *eksists*, or better yet, 'de-sists' in this appropriation of everything supposedly proper that necessarily jeopardizes property 'itself').[73]

Only a click away, with their unfathomable peculiarities and strange ways, is an unlimited source of pictures. Teasing, seductive, they soon draw us completely into their orbit. We settle on one of art history's most famous paintings, but also one of its most curious, Piero della Francesca's *Flagellazione di Cristo* [*The Flagellation of Christ*] (c.1460).[74] Despite multiple encounters, and without the

dulling familiarity that comes with other institutionally sanctioned paintings, *Flagellazione* persists through time as an odd (and intriguing) image. The rendering of classical architecture was a felicitous way to illustrate the era's obsession with perspectival illusion, and in *Flagellazione*, Piero uses it to close in on a distant group of men, stiff, bloodless, little figures, action paused, every drop of pathos removed. And then, cut off from the theatrical scene in the background, almost dividing the image in two, he has placed his Renaissance contemporaries at the front of the picture plane, dwarfing both the architecture and the flagellation. It feels claustrophobic, even though the tableau spans interior and exterior space. Putting aside the loss of painterly qualities in the immateriality of the reproduction, and in spite of the distractions of our café setting, it is the experience of being submerged with Angela in the works of Piero that moves me closest to appreciating the odd ways of her own paintings and drawings, the oddness of her drafting, her wonderful colours, her sly complexity.

The feeling that figures are hovering over a precipice in *Angel with Green Hands* is partly due to the expanse of untreated canvas. In *The Erroneously Named Mistake* (2016),[75] this title/text sits a little uneasily atop an abstract ground, saturated with paint, colour and movement. And yet, elevated to a much knottier register, the *horror vacui* remains. How, then, might the totality of Brennan's painting, this seemingly indivisible conjunction between image and word, be understood? 'The difference between text and image is flagrant', Jean-Luc Nancy writes, 'The text presents significations, the image presents forms.'[76] While this clear dichotomy plays its part in Brennan's text-paintings – for there is a text and there is an image sitting underneath the text, and, thus, the chasm between text and image is significant, and infinitely so – the work is also a refutation of this very reasonable principle. It opens itself to the concerns of the semiotician and to the complications that arise when one attempts to stabilise meaning. And yet the letters within the text are also 'objects' within Brennan's field of painting. In the process of painting, a letter brushes up against another as a form, as a shape, which sits aside another shape in a chain of shapes. But then, in that irresistible compulsion to read all the words that pass one's eyes, the text is illuminated and the pictorial schemata is overshadowed. And at that moment the objects begin to dissolve into a signifying structure, and the possible meaning of the sentence pushes its way forth.

Then the playful tautology of the title materialises – *The Erroneously Named Mistake*, 'the erroneous mistake', the 'mistaken error' – and another chasm is thereby opened. It is not (directly) an existential one, nor is it the aporia that removes the possibility to translate word into image or image into word. This time the abyss falls somewhere between the maker and the receiver. The

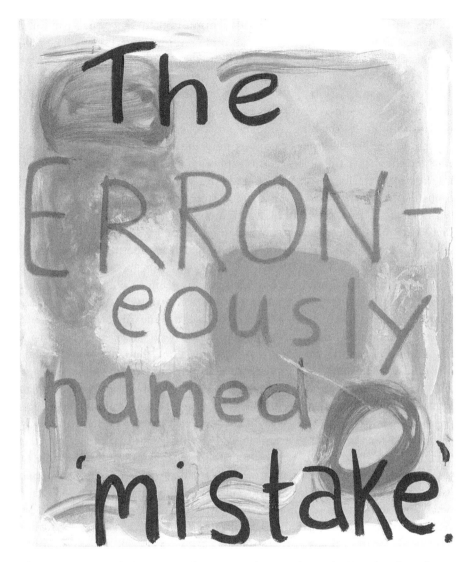

Figure 10.4 Angela Brennan, *The Erroneously Named Mistake* (2016), oil on linen, 91 x 61 cm. Photo: Christo Crocker. © Private Collection

receiver is not the trusting one who remains open to the artist's ways, but the judging critic who speaks of 'quality' and of 'perfection' as though such values are absolute and the critic the source of such transcendent ideals. As early as 1956, the American academic, John Alford, was bemoaning the loss of an adequate ground upon which to qualify art's value.

> There has, in short, ceased to be any common language of art or language about it, and if one can fasten responsibility on any one class of people for the current effect of 'chaos', it is on the critics and educators for their failure to establish any standards of value by which works of art can be judged.[77]

Concerns about who gets to judge today has fed the idea that we live in 'post-critical' times, marooned without terms by which to determine 'good' from 'bad'.[78] I too feel the heavy air of a flattened contemporary art world with its endless reproduction of the same. However, valid political and ethical reasons have brought us this point in history, with resistant voices successfully arguing for ways to redress an historical imbalance. Who gets to speak and for whom? And such a position demands taking sides.

'Nothing is left but judgement and every judgement bears upon another judgement.' This is a line taken from a short essay on literature by Deleuze. It stands as a *précis* of his denouncement of the transcendent ground of Platonic judgement, as well as his support for a tradition of immanence:[79] 'What Plato criticises in the Athenian democracy', he writes, 'is the fact that anyone can lay claim to anything; whence his enterprise of restoring criteria of selection among rivals.'[80] To bring order to this chaos, Plato developed a system in which 'difference is not between species, between two determinations of a genus, but entirely on one side, within the chosen line of descent: there are no longer contraries within a single genus, but pure and impure, good and bad, authentic and inauthentic, in a mixture which gives rise to a large species.'[81] The limitlessness of becoming (a becoming insane, a becoming hubristic) is contained, but it also instigates a complete subjugation of becoming so that 'there is no chaos in the cycle, the cycle expresses the forced submission of becoming to an external law.'[82] For Plato, as the keeper of the model and copy, the broad notion of sameness and difference is regulated and controlled and this speaks as much for identity as it does for art, as much for the suppression of difference as it does for the recognition of the new.

> Judgement prevents the emergence of any new mode of existence … it creates itself through its own forces, that is, through the forces it is able to harness, and is valid in and of itself inasmuch as it brings the new combination into existence. Herein, perhaps, lies the secret to bring into existence and not to judge. If it is so disgusting to judge, it is not because everything is of equal value, but on the contrary because what has value can be made or distinguished only by defying judgement. What expert judgement, in art, could ever bear on the work to come?[83]

There is an ethical/political dimension to Deleuze's opposition to Platonism, with its hierarchies and divisions, its models and copies, in which 'everything or every being lays claim to certain qualities.'[84] For the purpose of this chapter, I am focusing on two thrusts of concern: how difference is valued over representation (how it is incorporated as a political and ethical exigency); and how the new is able to be recognised (or brought into being), how it escapes from the prison of selection.

Central to a Deleuzian politics is the way time is conceived.[85] Turning to Henri Bergson, Deleuze found a theory of duration that would preserve the full force of becoming and avoid conceptions of time that produce points of discontinuity (Bergson's response to the ancient problem of how to make time flow). As Keith Ansell-Pearson writes:

> A conception of the evolution of life in terms of a virtual multiplicity is opposed to the idea that we are only ever dealing with an actual kind. If we approach evolution in terms of an actual or spatial multiplicity, then time becomes little more than the process of mechanically bringing about the realisation of pre-existent possibilities. The notion of the virtual, then, is opposed to that of possibility.[86]

Coupled with the preservation of becoming as a core political position is the aim to avoid representation (that is, the institution of pre-determined qualities or sameness) and to encourage experimentation. Thus, for Deleuze, there are two schools of influence guiding his rejection of a supreme and external judge. The Stoics were the first to show Deleuze how 'the doctrine of judgement' could be 'reversed and replaced [with] the system of affects',[87] and it was Nietzsche who broke with 'the consciousness of being in debt to a deity', which had become 'infinite and thus unpayable'.[88] To avoid falling into the problem of originary 'guardians',[89] as Deleuze frames it, is to engage with a tradition that avoids judgement as suppression of difference. Nietzsche's will to power, Spinoza's affects, and his own pure immanence were for Deleuze, a life 'in the name of higher values'.[90] This would be 'complete power, complete bliss'.[91] They are higher values that unfold not from moralising but from Spinozian ethics as immanent modes of existence.

> It is not a question of judging other existing beings, but of sensing whether they agree or disagree with us, that is, whether they bring forces to us, or whether they return us to the miseries of war, to the poverty of the dream, to the rigours of organisation. As Spinoza had said, it is a problem of love and hate and not judgement; 'my soul and body are one . . . What my soul loves, I love. What my soul hates, I hate

…All the subtle sympathisings of the incalculable soul, from the bitterest hate to passionate love'. This is not subjectivism, since to pose the problems in terms of force, and not in other terms, already surpasses all subjectivity. [92]

This is where Deleuze ends his short essay, and the point from which I hope to open up the political context for Brennan's paintings and drawings. Establishing a communion between maker and maker across centuries, Brennan's research into Piero della Francesca led her to bemoan critics who blast their judgements into history. It becomes for her a matter of ethics, a matter of how to act in the world. Deleuze observed that 'each of [Spinoza's ethics] sends out bridges in order to cross the emptiness that separates them.'[93] He acknowledged that it 'is extremely hard, extremely difficult. The joys and sadnesses, increases and decreases, brightenings and darkenings are often ambiguous, partial, changing, intermixed with each other.'[94] This is 'a passional struggle',[95] distinct from 'understanding', or from what John Rajchman calls a 'unified consciousness'.[96] It is the 'being of sensation' prior to moralising or judging. The being of sensation for Deleuze avoids what he frames, in political terms, as the violence of representation, insisting instead on experimentation. Rajchman writes: 'To extract sensation from representation is thus to discover something mad and impersonal in it, prior to the "I think" or the "we judge".'[97]

In a similar vein, Brennan's empty spaces may appear as encounters with darkly existential, epistemological or ontological concerns. And yet, she consistently counter-poises them with elevating colours and surfaces that are inexplicably affective and pre-verbal, touching the senses directly. It is here, in the ungoverned ground of sensation and experimentation that I find Brennan's political aesthetic. It is where I see her spaces acting less as cold abysses, and more like *Bir Tawil* طويـل بــر, that stateless region between Egypt and Sudan, which neither state dares to claim. This aptly named 'no-man's-land' (ungoverned) has been inhabited by a nomadic people: they move, they wander, they search for fertile ground and in the process, they *déterritorialise*. Thus, it is here – sheltering in this *Denkbild* or thought-image of a geo-political space that operates without dominion – that I find Brennan's political aesthetic, her experiments, her refusal to judge, her radical plane of immanence. Maurice Blanchot explained that poetry consists of 'the peculiarity of turning toward, which is also a detour. Whoever would advance must turn aside. This makes for a curious kind of crab's progress. Would it also be the movement of seeking?'[98] This 'movement of seeking', entangled with the conflicting emotions and sensations of making, entails a becoming-other, throwing subjectivity into doubt, into movement and change.

Final words (fallibility)

I would like to bring these observations about painting to a close. When a painting (art) is subsumed by a fashionable aesthetic it can sing and soar, but finally it will disappoint. For, on the realisation that its affect is chimerical, the painting's charm will have flipped into revulsion. Other paintings may seem charmless because they equate to mere 'information', neither seductive nor disruptive. They comply with the language of 'the dominant organisation of life', and are not capable of upsetting the ordering of paint on a surface.[99] To say that some paintings acquiesce to the order of the day is to confer upon others a certain responsibility (a burden perhaps) to be more than mere pictorial information, more than the fashionable circulating through channels of receptive art markets.

Reiterating Agamben's point that contemporaneity flows through art as a dark and broken emanation, this is its critical distance and its potential to disrupt Rancière's police order. As with poetry, the language of painting with its configuration of sensations, percepts and affects, is part of the struggle at the heart of power:

> Conversely, poetry must be understood as direct communication within reality and as real alteration of this reality. It is liberated language, language recovering its richness, language breaking its rigid significations and simultaneously embracing words and music, cries and gestures, painting and mathematics, facts and acts. Poetry thus depends on the richest possibilities for living *and changing* life at a given stage of socioeconomic structure. Needless to say, this relationship of poetry to its material base is not a subordination of one to the other, but an interaction.[100]

Paintings that allow thought to flourish in an open and malleable arena are always in play (and often playful), and it was here that Jean Paulhan was found. Through his investigations of cliché, it was he who revealed certain qualities and moods in our encounters with the world. Cliché disclosed the tentative and provisional nature of today's painting practices that are always open to reversal or collapse, teetering unsteadily on the threat of discursive fallibility.

11

Alex Monteith – Na Trioblóidí and Decolonising Tactics

Background

Alex Monteith works within the flow of 'real' world actions using various filmic processes, often designed for multi-channel projections situated in galleries. Her practice falls somewhere in the interconnecting threads of performance, situation and place, and often involves working with different kinds of communities. In the past, these have included air-force pilots, helicopter rescue crews, motorcyclists, surfers and Indigenous groups. Of central importance to Monteith are the ethical implications that arise from working with others, which she treats as a process of continual self-criticality and reflection. She asks, in other words, how her ways and methods of making respect the specific demands of different communities and their actions in the world, while preserving the dignity of individual histories. However, besides noting the importance of the ethical dimensions in Monteith's work, I would like to avoid falling into a kind of essayistic hole that might then demand a meta-description of her practice. Instead, I want to respect its slippery, shifting relation with the world.

Monteith was born in Northern Ireland and works between her home in Aotearoa/New Zealand and her birthplace. Two of the works discussed in this chapter were made in Northern Ireland and the Republic, *Chapter and Verse* (2005) and *Shadow V* (2017), produced at either end of a twelve-year divide. Both films intersect with The Troubles (*Na Trioblóidí*) and the personal life of the artist. Once Monteith moved with her family to New Zealand, her identity and relation to the land was radically altered from colonial subject to immigrant. To make artwork in Aotearoa necessitates a very different set of protocols and a heightened sensitivity to how one engages as a pākehā (non-Māori) with local Indigenous people, their lands and their artefacts. The final work discussed is *Murihiku Coastal Incursions* (2014–), a project that began with a story circulating in contemporary Auckland about an archaeologist and the Murihiku Māori artefacts he had removed without consultation in the 1970s.[1] This has become a major project, still in development, necessitating expanding

and complex circles of collaboration and consultation to be established. Today there are formal protocols to be met when dealing with Indigenous artefacts, but the project also demands ethical reflection upon the role of a pākehā artist in this project, albeit one who is highly informed about Indigenous sensitivities and rights. I am interested in how Monteith negotiates her duel position, as a Northern Irish woman, and as a European living in Aotearoa.

Chapter and Verse

As much an experiment with cinematic effects as it is witness account of The Troubles, *Chapter and Verse* (2005) is Monteith's feature length film about her childhood home of Northern Ireland. In drawing witness interviews from across the divide of thirty years of sectarian conflict, one of the film's most direct, political consequences is to build historical memory into a new assemblage. What protects the work from closing down around a simple synthesis of competing voices (its modest tilt to conventional documentary) is the way the film turns on a coalition of content and form, continually melding 'information' with cinematic and poetic affects. As the witness accounts insinuate the viewer into the pain and instrumentality of conflict, the film's structuring around chapters, the treatment of time, the texture of the shots from the painterly to the denuded means that quite different sensible registers are operating at the same time. The question guiding this chapter, therefore, is to ask how the film's political voice is heard in the meeting of coexistent, yet irresolvable affects, which are at once painful and beautiful, tense and mediative, informational and poetic.

A skirmish

In an objective to unravel the knotty intermeshing of the film's content with its poetic qualities, I begin by first alluding to an abstract framing device used by Monteith when she exhibited the work in a group show, *The Globalising Wall* in Mangare, New Zealand in 2012.[2] Monteith originally shot her film on 16 mm. It underwent a digital transfer for exhibition purposes and was then screened alongside separate footage which had taken on an unexpected afterlife. She had documented a small melee in the Catholic sector of Strabane, County Tyrone as potential material for *Chapter and Verse*. In the middle of filming the event, Monteith was surrounded by police wagons and threatened with criminal charges for what might be described as an 'overly knowing knowingness'; that is, for supposedly being aware of upcoming trouble but not reporting it to the police. After the footage had been confiscated, the police carried out a cine transfer from 16 mm to VHS format, thus encasing the 'action' in a form for wider dissemination.

A central tactic of *Chapter and Verse* is the layering of different forms of time: linear, historical, poetic, impersonal and biographical. The technological life of Monteith's confiscated footage marks another form of time: originally 16 mm to VHS and now transferred from VHS to digital by Monteith, the spanning of analogue to digital technologies marks a serendipitous parallel to the years of The Troubles (the thirty years from the late 1960s to the Good Friday Agreement in 1998). In symbolic resistance to recent, post-Agreement outbursts of sectarian violence in Northern Ireland, this original VHS tape, with its outmoded technology and increasing invisibility, acted as allegory for a forgiving but not forgetting of The Troubles.[3]

The Police had taken over the footage, named it, labelled it, and copyrighted it to 'The Chief Constable of the Royal Ulster Police', to be used as evidence against the rioters. This severed the footage from its original 'author', its copyright stolen, it was then edited by unknown technicians. The Royal Ulster Constabulary (1922–2001) was a wholly compromised institution.[4] It patrolled, set up borders, and stood alongside the British Army as the unofficial arm of Protestant majority interests in Northern Ireland. In a course that turned Monteith from witness to felon, the threat of criminal charges now dangled over her head.[5] She had experienced directly, but not for the first time, the interpenetration of the police and the military in the everyday reality of individual, civilian life.[6] Perhaps this is better understood as a crossing of the micro-political threshold that forms between the messy, complex workings of personal and social life and the ordering mechanisms of state-bureaucratic, disciplinary systems. Northern Ireland was at the forefront of the implementation of a loss of rights that were once considered to be inalienable.[7] Although, after 11 September 2001, we would all come to experience, in many more countries around the world, how assumed 'rights' are easily overturned by nervous (opportunistic?) governments.

After a few months, the police did finally drop the threat and in a happy bit of good fortune, they also returned the confiscated footage. As mentioned, the tape became an element of an exhibition and she also uploaded an image of it onto her website, titling the footage: *Chapter and Verse; 16 mm film recorded on the Melmount Road, Strabane, Co. Tyrone, Northern Ireland, 11th July 2001 with fast forward and slow motion speed changes authored to VHS by the Royal Ulster Constabulary for the purposes of prosecution.*[8] Had it not been for this constellation of forces – this day, this small uprising, this police action, this happenchance of filmmaker found filming – the whole event might have disappeared into the multiple tongues of local history, too insignificant perhaps for it not to be generalised as just another stone-throwing event by Catholic youths in the long years of The Troubles. What I particularly like about this story, though,

is the way the footage was originally conceived by Monteith as a possible documentary fragment to edit into a greater whole, but due to the decisions of the police, both to confiscate and then return the footage, this small, fairly inconsequential, rock-throwing skirmish has been magnified, enlarged and, monadic-like, now holds within itself, all the frustrations, interventions, violations and hopes of this troubled community.

The film

Chapter and Verse opens with a grey title page, 'Chapter 1', 'Act 1, County Tyrone', ... 'A country road, a tree, evening'. Meditation upon this dull, grey page, with its unobtrusive, black typeface is broken by the rising sound of birds whistling. And then a dusky blue-green cinematic, country road (a border road) comes into view. The image is still, quiet, not a rustle of movement. Many seconds pass before the film moves from painterly stillness to black-and-white footage of a busy town, filmed from a fast-moving car.[9] Alternating between a sense of calm and moments of restlessness, and from colour to black-and-white, these rural Counties – so deeply enmeshed in The Troubles, with their landscapes and townscapes and entrenched traditions, their snowy roads, and rusty rivers, and modest homes, their cemeteries with their freshly flowered tombstones – form the imagery that accompanies the film's witness accounts, heard in voiceover. Sometimes there are incidental glimpses of the speakers as they stand by graves, or sit alone on town steps, but mostly the images and words are kept apart.

A series of grey inter-titles listing the streets of County Tyrone, Castlederg, L/Derry, County Armagh, County Antrim, punctuate the film. They are a reminder that The Troubles were abstracted through a mundane marking out of very specific geography, repeated through the years with monotonous regularity. As with the landscape in Claire Denis's *L'Intrus*, with its broken and breaking borders, the landscape in Monteith's film is equally conflicted. At times it is seemingly peaceful, while at others it continues to hold onto the remnants of war, which we discover had been reified, only a short time after the Good Friday Agreement, as propositions on offer for 'terrorist tourism'. The murals, the burnt-out cars left on country roads, the sites of the most horrific conflicts during The Troubles, such as Bloody Sunday, the city of Derry, all of these attract visitors keen to retrace the physical paths of this violent past. The term 'dark tourism' has been used to describe the popular phenomenon of tourists taking taxi rides to visit and photograph places of conflict, often oblivious to the deeper social and emotional scars that such sites still have on the conscience of many residents.

Even at the time of shooting the film, however, as witness stories in *Chapter and Verse* cut across sectarian divisions and old checkpoints, Monteith sensed that this was a community in transition. It was a feeling that she was able to seize at the editing stage by leaving her images in flux. She observed that the scenes she filmed soon after the Good Friday Agreement had now mostly vanished. The unforeseen, the transitional, which were sensed but not known, was to be the neighbouring Republic, sitting unexpectedly on the verge of economic transformation (1995–2007); that is, after Ireland's currency and focus was swinging away from the suffocating dependency upon Britain, to the larger and more hopeful context of the European Union (again an optimism in transition, prior to the 2008 economic collapse and well before its neighbour's wider Brexit vote in 2016).

The first voiceover in the film is a methodical reporting of car bombs and other deaths of soldiers, loyalists, Republicans and civilians repeated over and over by an unnamed man. He counts down the forty-six dead from the area around Castlederg, Monteith's home, concluding matter-of-factly: 'That covers the persons murdered within the Castlederg area from the period ten/ twelve/seventy-one through to twenty-three/six, nineteen ninety-three, that's a year before the ceasefire.' A different witness observes: 'This is a history of a brutalised people. Are [those imprisoned] to be held responsible for everything that has ever happened in Northern Ireland?'

Nearing the end of the film, there is another reading (this time by Carole Monteith, Alex's mother) of the names of those killed between 1969 and 2001, delivered now not as a systematic, year-by-year account, but rather as a reading of the anniversary dates of the dead that align with the days of filming by Monteith. In this way, time lurches back and forth through the thirty-two years of killings, a structure that shatters linear time, enforcing a fractured and dispersed memorialising of the anniversaries of so many deaths, and the impossibility of reconciling (representing) the pain that spirals around the traumatic core of The Troubles. We are 'struck by something intolerable in the world and confronted by something unthinkable in thought' making progression to a neat resolution inconceivable.[10] Neither the images, nor the voices, in *Chapter and Verse* are devices of conventional story telling or documentary filmmaking. There has been no attempt by Monteith to stitch a narrative from the unresolved, multivalent history of The Troubles, nor is there an assumption that 'authentic' witnesses will provide access to the essential truth of events, as though a process of objective reasoning will be able to pick its way through a mass of conflicting evidence to reach a point of consensus. *Chapter and Verse* offers instead fragmented and implacable positions that are irresolvable. What kind of politics, therefore, is being enacted in this early work by Monteith?

Words /images /sensations

Words and images are never transparent. For the uninitiated, the outsider, the dense geographical details in *Chapter and Verse* (road names, county names, town names) and the biographical details (the witness stories and lists of names) assume a form of truth-telling. And, yet, such documentary authority fades with awareness that *Chapter and Verse* is equally a work of 'fiction'. As Trinh Thi Minh-hà once insisted: 'there is no such thing as documentary.'[11] The grey inter-titles in *Chapter and Verse* not only mark out the geography of The Troubles, but they also underline, in quite deceptive ways, the artifice of filmmaking. They also suggest a certain order that is linear and progressive, an end-point or resolution which never arrives. The actual temporal structure of *Chapter and Verse* is non-linear in form, dashing back and forth through the years of The Troubles. Together, the inter-titles and the disjointed time frames reinforce the point that this is a construction, another version of The Troubles, and an artwork tied closely to its maker.

However, the inter-titles also point to a problem of cinema's history. As an aid to communicating narrative in silent cinema, the inter-titles used by Monteith in *Chapter and Verse*, as with the title itself, flag cinema's frequent and unthinking dependence on literary, rather than visual or sensible forms. This becomes clear in her cheeky quoting of Antonin Artaud: 'It has not been definitively proved that the language of words is the best possible language.' Using words to criticise words, Artaud was highly reproving of cinema that failed to directly tap into the sensate strata. Cinema's potential as an art form, as outlined in Chapter 9, on Claire Denis's *L'Intrus*, depends on affecting the senses, or rather, on reaching the substantial vibrations and rhythms of pure cinema.[12]

In *Chapter and Verse*, images move restlessly back and forth through time, and from colour to black-and-white, from summer dusk to snowy winter, from night to clear days, from public realms to domestic intimacy, from skirmishes to boiling kettles, from kitchens to the *objets d'art* of people's lives. Some images are crisp, others grainy, some are moving, but most are anchored by the camera's fixed position in the centre of the frame. Even when filming from a car, the camera is immobile, sucking its energy from the movement of the vehicle. This prevents *Chapter and Verse* from the chaos of conflicting textures and styles and gives the work its cohesion, its unity. Extended, still-like sequences and the balancing of light and weight at the editing stage, has produced a meditative affect, a space to explore the implications of everyday life that were so disturbed by The Troubles. I think it is possible to imagine how immersion in the lived reality of sectarian

Figure 11.1 Alex Monteith, Digital screenshot from 'The Scullery', *Chapter and Verse* (2000), original format, 16 mm, 90 mins. © The Artist

divisions would leave no taste for partisanship. And any attempt to prise the political from the aesthetic in *Chapter and Verse*, or the images from the interviews, which are at once painful and beautiful, tense and mediative, informational and poetic, would affect a violent breach in the work, upsetting its affective balance.

A final word on *Chapter and Verse*, therefore, one of the effects of Monteith's tethering of the dead to the dates of the film's production, is to faintly produce another story: the fainter, lighter movement of the filmmaker as she retraces the terrain of her own childhood, via the memories of those who lived at the sharper edge of its politics. About this place, so saturated by politics, with its conflicting stories and interpretations, there is nothing more to say, for consensus (truth) has long been lost under the piles of retribution. What remains, however, is to 'know' The Troubles through its production of particular ways of being and particular sensibilities. There is a forceful moment when the second witness speaks in a strong, impenetrable rural accent: except for a few decisive utterances here and there ('What can you say?'/ 'Her leg was cut off.'), the rest of the story remains opaque to the outsider. What becomes painfully tangible, despite this, is her sadness, her great sense of loss, transcending the restraints and limits of dialect.

Shadow V

History has a way of working into our bones and forming mysterious configurations, sometimes with a sense of loss that creeps into the smallest crevices of our being; sometimes it can lead to a kind of fear that is magnetic, desiring its own strange and deathly gamble. And yet, whether as coincidence or a sense of destiny we can be taken on strange and unexpected paths. . .

Monteith lives next to black, crystal-like sands at Te Piha, an hour from Tamaki Makaurau (Auckland) on Aotearoa's West Coast, with her partner, their children, their old dog, and her surfboards, her motorcycles, her boat. There is another West Coast, an hour from her Irish home at Castlederg. It was on a return spell to Ireland, while making *Chapter and Verse*, that Monteith first got to know the local surfers who live around Donegal and Sligo, and who ride the waves of Mullaghmore. They became her friends and for a while she was part of the Women's National Irish Surf Team.

It was in the winter of 2010, as the *Irish Times* reported, that from a small boat dangerously positioned thirty-metres from the back of a wave, the massive swells that meet the West Coast of Ireland were captured on camera.[13] This precariously captured footage revealing a secret surfing location, Mullaghmore, had been known only to the locals. It opened up the region to big-wave surfers from across the world, and, to a quite different kind of tourism from the dark tourism from Northern Island.

It was from a cliff top at Mullaghmore, more than thirty years earlier, that the Provisional IRA assassinated Lord Mountbatten of Burma, godson of Queen Victoria and the Emperor of Russia, Viceroy of India, along with his grandson, Nicky, aged fourteen, the Lady Dowager, and Paul Maxwell, fifteen, an Irish boy who had a summer job on the boat. The 23-kg bomb that blew up the small wooden boat was made, but not detonated, by a carpenter turned IRA munitions expert, Thomas McMahon (from Belfast and thus thought of by the locals as an outsider). First jailed for life and then released as part of the Good Friday Agreement, the person who detonated the bomb was never named or convicted. The Garda says the case remains open.[14]

Monteith is never far from the ocean – it is life-giving and life-taking. These daunting images, one from the shore and one from a boat, are the pivot for her most recent work, *Shadow V* (2017).[15] It consists of a large, two-channel projection of heavy waves, mirrored and thus doubled, producing a strangely unnatural form, made stranger still by a line separating the screens. A perpendicular length of fluorescent lighting forms a strong graphic border at the far edge of the moving image. It marks the place for a possible third projection, but instead Monteith installed a neon sign. The text, staggering down the wall, reads: 'As it neared' . . . 'it made no sound'. *Shadow V* is a collaboration with

Figure 11.2 Alex Monteith, *Shadow V,* 2-channel video projection installation shot. Gow Langsford Gallery, Auckland, 15 June–2 July 2016. ©The Artist

Paul Maxwell's mother, Mary Hornsley, and the lines are from her poetry. She has been writing to her son since the explosion in 1979, regularly, without abating. And thus, this fragment, this missing third screen, is also a place of absence. Hornsley and Monteith selected five poems to be handed to visitors as they entered the exhibition. The footage was filmed by Monteith at Mullaghmore, in the County of Sligo, on the west coast, during the massive storms in winter 2014–15. Through hail, wind and snow, 'it meant driving most days from Castlederg to the coast', and 'getting bogged in inches of snow at five in the morning on the Old Kilter Road', and then Monteith laughs, 'amassing around four thousand miles in four months.'[16]

And thus, it is to imagine the visitors, poems in hand, being drawn to the light at the rear of the gallery, the neon words floating against the wall, the light refracting on the foam of the huge waves crashing near the dark, wintery shores, and the darkness of the space folding around them, just as one imagines blackish waves wrapping around Monteith, both as an engulfing and an endangering, but also as an embodiment of water and surfer. To wait, to sense, to 'know' that singular point when rider and wave come together, this point of intensification, of pure vitality, that will carry the rider towards the shore, even as fear clings to this moment – a sudden crash, a wipe-out – and thus a decree

to go with the force of the ocean, to be carried perhaps to the bottom, and then to be thrust upwards, but to not quite reach the surface, and with a slight panic, an exhilaration, a never knowing in those moments if the ocean will deliver the surfer to the shore. Or perhaps she might falter for a second and not take the wave, to be left behind, at the back, isolated, with a kind of deflation, and a little feeling of failure, as she waits for the next wave to come...

Today, in the midst of human-induced climate change, a constellation of weather effects has made Mullaghmore one of the most powerful surf spots on the shores of the Atlantic. Some talk about it being another Hawaii.[17] And it is dangerous, this big surf place, so far from a European's longings for the Pacific. This place, this wintery force entails multiple variables coming together to create its massive waves. One local remarked that we waited 'years for it to happen and conditions are really rare. It's our secret so I can't say exactly where it is.'[18] The 2014/15 winter brought the largest storm, terrifying the land and forming what has been dubbed the 'big, black swell'.[19] It is what drew Monteith back to Ireland to experience and film it, and what led another to note:

> Mullaghmore is a hard place to like as a wave. It's a beautiful town, it's a harbour town, but the wave is very extreme, it's dangerous, it's not perfect, it's got plenty of ledges, lumps and bumps and you do get some severe beatings out there.[20]

Despite the cold, snow, hail and unyielding offshore squall, enthusiasm for Mullaghmore quickly spread across the world and more and more big wave surfers now head to the stormy coast. This also attracts sponsors, competitions and rules about how to measure waves and rides, and defibrillators being installed on the beach.[21] The texture of Sligo is changing.

And yet, none of this diminishes the deathly horror of these huge waves because such fear is also replicated in the memory, many decades earlier, in summer, when waves are small and conditions are good for boating, that on that day it was beautiful, blue and peaceful – as witnesses seem compelled to remark – just moments before the bomb exploded. The bomb that killed Paul was targeted at his English employer, this privileged man, so close to the Crown, a near Royal presence, who continued to take his summer holidays in his coastal castle, in disregard of 'the local Garda Síochána [who] had warned Mountbatten that, while they had no specific knowledge of a threat to his life, they could not guarantee his safety.'[22] An accomplice by implication, Mountbatten, who was involved in the partitioning of India, a naval officer, a warrior, was holidaying at Classiebawn in his 'fairy-tale yellow sandstone castle' by the sea.[23] Perhaps it was the shock of the assassination that saw the *Guardian* lead with a story a day after his death, titled, 'Mountbatten: A Noble with a

Common touch', even though the same article noted that 'inevitably, most of yesterday's tributes have come from those who were famous and powerful like him.'[24] And, although it is said that he loved Ireland and the Irish, as father-colonists are wont to say, with his castle located twelve miles from the border of Northern Ireland, he was a conspicuous symbol of centuries of English colonisation.

> Classiebawn has long had a bloody history. Its land, nestling in the foot-hills of Benbulbin – Yeats's mountain inspiration – was snatched from the kings of Sligo, the O'Connors, by Oliver Cromwell's men during the 17th century and ended up in the hands of Sir John Temple, the Master of the Rolls. His successors built the castle in the 19th century as a holiday home around the time of the Great Famine, and it became one of the famous Big Houses of the Anglo-Irish era – a place where the aristocracy had tennis parties, balls and hunting expeditions, their needs tended to by an increasingly resentful local population.[25]

Partisanship, ideology, localism, or a belief perhaps that some of us can sit out-side the politics of our time – the locals were horrified that a member of the IRA would cross the county border, Monahan to Sligo, and use their sum-mer coastal town for such ends. On the same day, a group of British soldiers were killed by the IRA in County Down and the next morning, with such disregard for the circles of sadness that ripple from the family and friends of those killed with Mountbatten, the *Guardian* headline read, 'IRA bombs kill Mountbatten and seventeen soldiers.' At the same time, painted across the wall of the Falls Road Library in Belfast – '13 dead but not forgotten – we got 18 and Mountbatten.'[26] I think of Mary Hornsley's poems playing a dual purpose, therefore, not only to hear about her son, whom she has not forgotten, nor that day, now nearing forty years past, but also to retrieve the history for those who were killed or maimed, and who must scream to be heard over the mas-sive figure of Mountbatten, the main target of the attack.

As with the interviews in *Chapter and Verse*, Hornsley's words are presented directly, unmediated. Since each new project for Monteith triggers a reas-sessment of her ethical-political position, a concern for *Shadow V* was not to re-induce a mother's trauma or pain. In this delicate undertaking, we hear the poet's voice framed by her sadness, but it is also liberated from the concerns of ideology or partisanship. Monteith describes a picture of Hornsley's relent-less writing and her singular focus on her son through the years. As she kept writing, with each decade a further opening onto her loss, she imagines her son at different stages of an impossible future. And as Paul's death becomes more and more intertwined with all of those caught in conflicts across the

world – the number of deaths captured only as vague abstractions – Hornsley's poems return a certain reality, a gift perhaps, for those who had forgotten. For Monteith, *Shadow V* is not only personal (her beach, her homeland), the work incorporates a way to remember The Troubles through a son and the continuing pain of his family. Monteith speaks of a wider concern as well and that is the way deaths get scribbled out of our memories when larger geo-political concerns are at play. She mentions, in particular, the drownings in the Mediterranean of refugees heading for Europe in 2014.

When the storm is at its peak

Waiting, attending, when the storm is at its peak and the offshore winds are at their fiercest, Manannán, Mac of Lir materialises. With his five magical powers, he is the guardian of the sea and god of the weather. This great protector appears in the waves with a boat that he steers by thought alone. He is shielded by a cloak of mist, and he brings white horses that accompany him when the offshore winds are at their fullest. The historian, Mark Williams, proposes that this non-deity figure became part of the great conversion of Ireland, sometime in the fifth century.[27] Drawn into Christian pedagogical texts, Manannán with his 'deep knowing' became one of the first pagan figures to be used as an allegory for Christianity.[28] The 'Most Highest pilot of that carriage, who is Christ, the true Father, the Charioteer of Israel, over the channel's surge, over the Dolphin's backs, over the swelling flood, reached even unto us.'[29]

The oceans and their myths are a means by which Monteith expresses a deeply felt relation to her dual homelands of Ireland and Aotearoa. For Māori, the sea god is Tangaroa and before entering his watery domain, offerings need to be presented. This resonates for Monteith with the myth of Manannán, Mac of Lir, so profoundly embedded in her Celtic consciousness that describes seeing faces tumbling in the waves during a storm.

Oceans hold the political imagination of a dispersed Irish people, those who risked treacherous sailings across the world throughout history.[30] Some leave for adventure. But for others it came from desperation: in times of famine,[31] of land thefts, of the murdering of its rebels, the transportation of its political prisoners, an escape from the hopelessness of centuries of colonialisation and sectarian wars, a diaspora larger than the population itself. They took with them not only Irish ways, but also sectarianism, even as far as the Antipodes, where nineteenth-century street battles between Catholics and Protestants are still recorded. In 1867, Protestants fired on a crowd killing an eleven-year-old boy,[32] another episode of ongoing violence and hatred:

The disturbances which we are about to record must tend very materially to injure the well-being of the province, and unless some prompt and decisive measures are adopted for the suppression of such scenes as described below, we much fear blood-shed, and all the consequences attendant upon party, or religious dissension, will soon be as prevalent, and cause as many heart burnings as those which have for centuries disturbed the peace of Ireland. Sunday last, the 12th of July, being the anniversary of the Battle of the Boyne, the members of the Orange Society in Melbourne resolved to celebrate the event by holding a festival on the following day, at the Pastoral Hotel, in Queen-street. Accordingly, on Monday morning, the Orange flags were unfurled in front of the Pastoral, projecting from the windows; such a sight, it appears, excited all the prejudices, and all the animosities which have, unfortunately, been in existence for so many years between the Orangemen and those professing the Catholic Faith.[33]

What is it to be local and who is expendable? What is it to be innocent? These are questions that Monteith considered in the conceiving and making of *Shadow V.* Both John Maxwell, Paul's father, and Mary Hornsley joined the reconciliation visit by Prince Charles to Mullaghmore in 2015. Reconciliation is important for Maxwell who tried to meet, without success, Thomas McMahon, the bomb maker, after his release from prison. It was the first time that Hornsley had been back to Mullaghmore since the attack. And yet, this visit by the Royal family, touted so loudly as a momentous moment in history, did not appeal to everyone. One local thought that the public events meant 'being brought back to the grave again.'[34] I think this is important in coming to understand how land holds onto pain and how forgiving is not a simple move of forgetting.

Divisions wrought by colonisation

A few years ago, Monteith heard about an old archaeological dig from the 1970s from which thousands of artefacts had been removed from Te mimi o Tūte Rakiwhānoa, including Tamatea/Dusky Sound, in the far south of New Zealand/Aotearoa. It had occurred without consultation or regard for Indigenous moral rights. So, in 2014, Monteith, along with a group of artists, hired a small ship, the PV Pembroke, launched in 1962 for Fiordland cruising.

One of the artists, Mark Adams, a photographer, had taken this trip late last century, to photograph the sites of Cook's expedition,[35] particularly the waterfall that featured in the painting, *Cascade Cove: Dusky Bay* (1775),[36] by William Hodges (1744–97). Hodges was the official draughtsman on James

Cook's Voyage to the Pacific (1772–5), an expedition that spent more than two months in Tamatea in 1773. The painting, of which there are thought to be at least three versions (one of them held in the Auckland Art Gallery Toi o Tāmaki) was executed for the Admiralty on Hodges return to England.

Positioned next to the waterfall in this verdant and secluded region is a Māori family whom the explorers, we discover, had met earlier. Their isolation means that they were likely to be estranged from wider *iwi* (tribe) connections. Knowing that colonisation is soon to corrupt Māori traditional ties to land, culture and wider tribal networks, the family now appear as a sign of loss and longing for a very different way of life. The event was recorded in the journal of George Forster (1754–94), a German scientist on Cook's expedition, along with the sighting of a rainbow:

> The first object which strikes the beholder, is a clear column of water, apparently eight or ten yards in circumference, which is projected with great impetuosity from the perpendicular rock, at the height of one hundred yards ... We mounted on the highest stone before the bason [sic], and looking down into it, were struck with the sight of a most beautiful rainbow of a perfectly circular form, which was produced by the meridian rays of the sun refracted in the vapour of the cascade. Beyond this circle the rest of the steam was tinged with the prismatic colours, refracted in an inverted order.[37]

Such an experience (painfully) indescribable in its intensity, and in its vastness, is located somewhere between this journal entry and Hodges' subsequent visualisation of this event. In the painting's liberal use of chiaroscuro, its scumbling and vigorous brushstrokes that form the thrashing and dangerous white waters of the waterfall, the spectrum of light that overarches this vicious turbulence, turning the waterfall and its vapour (powerful enough, according to Forster, to soak the voyagers from 100 yards away[38]) into a radiant cynosure. And then, as the focus shifts skyward, another intense concentration of light emits from the clouds above this unfamiliar and precipitous terrain, with each element of the painting contributing to the theatrical affect cast by Hodges over this dark land.[39] It is not surprising, therefore, that Hodges' treatment of the landscape leads some observers to borrow from European descriptions of the sublime, in particular that of Edmund Burke,[40] which was gaining popularity at the time.[41] This is a 'romanticised' scene of early contact set within a dramatic landscape.[42]

Before comparing Hodges' painting with another executed across the Tasman, sixty-four years later by an English landscape painter and Tasmanian settler, John Glover (1767–1849), I would like to interrupt the story by offering the decolonising context that falls in these paintings' wake.

So much had passed in those relatively short years between the paintings of Hodges and Glover. Cook had already declared Australia to be *terra nullius* in 1770, priming the land for invasion, and facilitating the advancement of plans to establish a colony. This blatant moral failure, this trick of semantics that refused to recognise Aboriginal cultures and societies, justified the invasion and subjugation of more than fifty Aboriginal nations through a falsely constructed logic of European expansionist ideology. Successfully challenging a picture of a nomadic culture, Bruce Pascoe has gathered historical documents, anecdotes and scientific evidence to show how European farming methods were imposed upon a people already practising the cultivation of land. Aboriginal methods worked in harmony with local conditions to ensure ongoing food supply.

> The Assistant Protector of Aborigines of the Port Phillip District (1939–42), before it became the colony of Victoria, Charles Sievwright, decided to introduce the European theory of farming to the Aboriginals assembled at his Lake Keilambete Protectorate. They took one look at his English ploughing technique and immediately hoed the soil across the slope of the land and broke down all the larger clods. They'd been farming the land for thousands of years and weren't about to allow erosion to ruin the land.[43]

Neither the British Government nor the settlers ever sought to understand Aboriginal knowledge about food production and indigenous plant varieties. They ignored the systematic bush-burning methods that Aboriginal people use to protect the ecology, and to revitalise flora and fauna. Thus, early settlers suffered from devastating famines, soil erosion, rampant bush fires and a future of immense ecological challenge. They also refused to acknowledge that this re-shaping of country by human design was clear evidence of prior ownership.

Much work has been done in recent decades to retrieve the invasion stories that were (perniciously) written out of history throughout the first two-thirds of the twentieth century. Henry Reynolds has shown in *Forgotten War* that a historical legacy of 'forgetting' was instituted by historians presenting a peaceful settlement story: 'Several generations had been taught a comforting and deeply ideological story of mild natives who melted away and heroic pioneers whose main enemy was the recalcitrant land and fickle climate.'[44] Reynolds's research demonstrates the breadth and depth of aboriginal resistance throughout history and recognises that the Colony was at war with Indigenous nations.[45] A more general intention of Reynolds was to contest the narrative that Australia's only war experiences occurred

overseas and were not of the nation's making. *Forgotten War* was published to coincide with the centenary of the First World War battle at Gallipoli, Turkey (1915), memorialised each year as Anzac Day. This public holiday receives intensive attention and has become an inflated symbol of nationalistic mourning. It was only after the first-hand witnesses were all dying at the end of the last century that the day began rolling away on its myth-making path. In certain circles, it has garnered 'sacred' stature. This shift in public perception forced one media figure, Scott McIntyre, a public television sports journalist, to lose his job for tweeting on the day: 'Remembering the summary execution, widespread rape and theft committed by these "brave" Anzacs in Egypt, Palestine and Japan.'[46] And then, on Anzac Day two years later, Yassmin Abdel-Magied, a presenter working for Australia's government broadcasting corporation (ABC), came under widespread attack for tweeting, 'Lest we forget (Manus, Nauru, Syria, Palestine . . .).' She also received condemnation from the conservative, Deputy Prime Minister at the time, Barnaby Joyce, who began issuing veiled threats to force the ABC to 'act' on her supposed 'indiscretion'. With disregard for the ABC's charter that enshrines its independence from government interference, Joyce raised the spectre of the expenditure committee, the Government body that sets ABC funding levels and claimed that the ABC is out of step with Australia. Even though Abdel-Magied had apologised 'unreservedly' for being 'disrespectful', as a prominent Sudanese-Australian woman who is also a Moslem, she suffered from relentless racist, misogynist and anti-Islamic bullying.[47]

The debates that were ignited in these incidents, both heated and divided, reflect upon the role history plays in the national imagination. In response to the surging number of stories about colonialist atrocities in the later decades of the twentieth century, the conservative Prime Minister of Australia, John Howard, throughout his Government's incumbency (1996–2007), championed the disparaging slogan, 'A black armband view of history', a term borrowed from the historian, Geoffrey Blainey, to express the idea that positive stories are wholly overlooked in favour of negative ones. An actual black armband had been used by Aboriginal activists for many decades in a spirit of mourning and as a symbol of resistance, 'most notably at times of national celebration for White Australians', such as Australia Day (a day proposed in the 1930s by the Nativist Society to celebrate the arrival of the British Navy and its claim over the land). This highly contentious day is now dubbed 'Invasion Day' by many Aboriginal people and their supporters. In response to the disparaging term, 'black armband version of history', the term 'white blindfold' was used to describe those who refuse to acknowledge the atrocities of history. These will come to be known as the History Wars and they arose from the anxieties

of a subject position that had been shaped by the diminishing certainties of colonialist supremacy, particularly those who identified with these values in the post-imperialist era. The battle to preserve this will generate its own histories and debates.

One such account is the immense and overarching history of economic development, mass emigration, mushrooming populations, and the hubris of fledgling states, titled *Replenishing the Earth: The Settler Revolution and the Rise of the Angloworld, 1783–1939*, written by the New Zealand historian James Belich.[48] Its central thesis is that during a period of geographical and economic expansion, 'Anglo-settlerism', transformed the world by bringing positive and enduring change.[49] Belich's attention is narrowly construed around economic indicators, particularly booms and busts measured through periods of growth and decline in demography and wealth, while the details of specific national histories remain well beyond the book's concern. Belich is Benjamin's historicist, claiming that regional histories are too parochial and myopic to comprehend how the larger trans-regional settler revolution was forming beyond its borders. And yet, the grinding of many national histories into a 'Anglophone' white paste of self-congratulation excludes from consideration, even at the level of meta-analysis, decisive points of history. Penal transportation, wars of independence, slavery, the treatment of Indigenous cultures, and differing immigration policies are some of the factors that have had substantial and far-reaching effects on the shape of individual settler nations. The actions taken against First Peoples, including the policies, treaties, reconciliations and ongoing disputes, combined with the very significant impact of millions of non-British settlers and immigrants who contribute to the economic and cultural weave of Belich's settler nations are defining influences that cannot be hastily brushed aside. It is worth reflecting for a moment, therefore, upon those excluded from Belich's white settler narrative – those whose numbers were radically reduced in the crucial period of his research focus – the Australian Aboriginal nations. In his influential *Economics and the Dreamtime*, Noel George Butlin wrote:

> The aboriginal economy was a stably ordered system of decision-making that amply satisfied the wants of the people. British occupation resulted (note that there was no indication of intent) in the destruction of Aboriginal economy and society and the decimation of its population. We have two counter-balancing experiences – a rapidly expanding British society and a rapidly declining Aboriginal society between 1788 and 1850. Over this period, Australian history seen from the point of view of human beings as a whole is a dual process, not simply one of European expansion.[50]

Belich ends his history at the beginning of the Second World War, allowing for the long-term consequences of British Empire, and the ensuing re-shaping of the contemporary world around heightened regions of ethnic and religious conflict, to fall neatly outside his vista. The ecological effects of industrialisation that continue to challenge the world's political, intellectual and scientific resources are also beyond consideration. Even under the terms of Belich's meta-history, *Replenishing the Earth* is less than the full story.

Pastoral ambitions

By the time the landscape painter, John Glover, migrated from England, many fleets of soldiers and convicts had already been delivered to Australian shores, and increasing numbers of land-grabbing settlers had followed.[51] As an active member of a settler community, where pastoral ambitions were wholly incompatible with Indigenous hunting and land-management practices,[52] Glover painted *The River Nile, Van Diemen's Land from Mr Glover's Farm* (1837) in a very different context to Hodges' *Cascade Cove*.[53] Glover's arrival from England in 1831 fell in the middle of the forced, mass removal of Aboriginal people from their lands to Wybalenna on Flinders Island, and he would not have been, as Jeanette Hoorn has shown, unaware of the debates surrounding dispossession that were active and heated at the time.[54] Glover settled at Patterdale, the property he acquired as part of the British Government's 'Lands Grant Scheme', and by this time, the land had already been 'cleared' of the local Plindermairhemener people by his neighbour, a convict's son, John Batman (1801–39), who would shortly scope the Melbourne area for future settlement, and George Augustus Robinson (1788–1866), Governor Arthur's 'Aboriginal conciliator', whom Glover greatly admired and supported.[55]

The River Nile, Van Diemen's Land from Mr Glover's Farm is on permanent display at the National Gallery of Victoria. The subject matter, ostensibly the local Plindermairhemener band of the Ben Lomond tribe, positioned in a river landscape is unknowable, belonging to another place, even otherworldly in its imaginary folly and Arcadian allusions. The first effect emitted by the English settler's view of this recently invaded land is puzzling for contemporary sensibilities. With closer attention, such mild befogging turns into a more brutal shock. The conceit of paternalistic primitivism is deeply inscribed in the crudely drawn figures, generalised and unspecific; one climbing a tree to catch a possum, another facing the viewer with a huge, white smile and bulging eyes (imperceptible in reproductions), and next to him a man whose arm merges indistinguishably with his boomerang, so that the frozen, curling motion appears at first to simulate a tail.[56] Around the clear waters of the river and its smooth, rocky bed, the trees, particularly the trunks of those framing the foreground to ensure compositional impact, are sinuously exaggerated; a typical mannerism of

Glover that John McPhee suggests is an 'attempt to compose the unruliness of the Australian bush.'[57] Devoid as it is of all signs of European contact, the work suggests loss and perhaps regret, and yet the civilising ideologies of Colonial expansion are still clearly reflected in its idealised setting (untainted by invasion or Christianising missions) and its highly generalised and impersonal figures.[58] The people bathing in the river, on the riverbanks, or in the distance by the campfire, rather than expressing the decisive, unbreakable connection of land to people, are indistinguishable in the painter's vision. Despite passing reference to hunting in the frozen boomerang thrower and the climbing possum-catcher, insinuating Aboriginal custom and bountiful food supply, this is primarily an image of non-productivity, of Arcadian idleness. This imagined place, prior to invasion, this dark, watery expanse is painted for its picturesque charm and for a settler's landowning ambitions.

To return to Hodges' visualisation of the early contact between Māori and Europeans, how different is the depiction of Māori and their lands in *Cascade Cove: Dusky Bay* (1775) by Hodges? We see that two women are turned to the waterfall, ostensibly becoming part of the spectacle, but a third faces forwards in a pose that mirrors the posture of the man (presumed to be the women's husband).[59] In the treatment of Māori – the husband, assertive, comfortable, his body resting with ease against his *taiaha*, and the woman, also self-possessed, leaning against her spear – there is regard for the accuracy of an encounter with strangers that is patently lacking in Glover's work.[60] As Bernard Smith and Rüdiger Joppien observe,

> we come to realise that Hodges has broken through the schemata of ethnography and is now drawing the people of Dusky Bay as he might have done figures in the landscape back home in England, with a feeling for the individual posture and living presence of the person.[61]

Hodges' painting demonstrates a quite different concern from Glover's. In the *River Nile*, it is as though salt were being rubbed into the wounds of usurpation, of death, for the sensation of life, so tangible to Smith and Joppien in Hodges' work, is plainly absent.

David Bindman, in describing Cook's expedition, establishes that this was an incisive moment that 'opened the South Seas to the European Imagination', at a time 'when the Franco-British Enlightenment was at its height.'[62] It was an opportunity, furthermore, for testing 'common assumptions about humanity, raising an urgent need to place the "new people" within existing frameworks of human development.'[63] This historical context – a compulsion for investigation and exploration, not yet formed into the acquisitiveness of the settler – separates significantly the visual schema of the artists. Hodges' painting is a first-hand document of a journey into the imagination

of eighteenth century European aesthetic and intellectual concerns, and since Hodges' painting operates as much as documentation for the British Navy of its expedition to remote corners of the Pacific, as it does as a romanticised first response to Māori and their lands, there is little sign of the personal self-interest that is so conspicuously flaunted in the title of Glover's work. It makes Glover's work, I believe, a befitting indictment of exclusion and exile, in which the desire for mimesis is turned instead into the self-interests of history, of Colonialist systems of possession.

Sarah Munro, *Trade Items*

However, a close examination of Hodges' more sympathetic representation of Indigenous peoples cannot immunise the early explorers from their part in the consequences of future settler invasions and continuing occupations. In 2014, in their motorised craft with crew and daily weather reports, and with future art projects forming in their minds, our group of artists arrived in the remote regions of Tamatea/Dusky Sound. They came with a history of colonial dispossession, memories of Indigenous wars, of racial divides, of archaeological theft and, perhaps, with decolonising sensitivities in place, they were nonetheless aware that they too were participating in a form of travel that carries colonialist implications. With the location's uncertain weather conditions and difficult terrain, the artists – Alex Monteith, Sarah Munro, Frank Schwere and Mark Adams – set out to pursue their projects, coming together for discussions, meals, jobs, conviviality. . .

Part of a series (a collaboration), there is a photograph taken at the site of Hodges' painting at Pickersgill Harbour of Munro, taken by Schwere. Munro is clothed in contemporary outdoor garb (polar fleece, thermal balaclava, insulated rubber boots) and sitting upright on rocks covered in 'Neptune's Necklace' (*Hormosira banksii)*, a species of seaweed common in New Zealand and Australia that forms into beads filled with seawater. There is a large rock lobster lying in the foreground. Having retreated from her former practice of making large, abstract painting/sculptures, Munro is here in the process of embroidering *Trade Item* (2018) a series of intimate re-workings of the drawing, '*Māori Bartering a Crayfish* (1769). The drawing is held in the British Library, attributed until very recently to Master of the Chief Mourner, even though it was clearly marked in Joseph Banks's hand as *Otaheite*' (Tahiti).[64] Later it was identified as the work of Tupaia, a painter, high priest, navigator and geographer living in Tahiti in exile from the island of Raiatea in the Pacific. The British Navy had ventured to Tahiti to observe the transit of Venus across the sun, predicted for 3 June 1769, as part of a scientific investigation, and Tupaia had taken his western pictorial style from the explorers he had met there.[65]

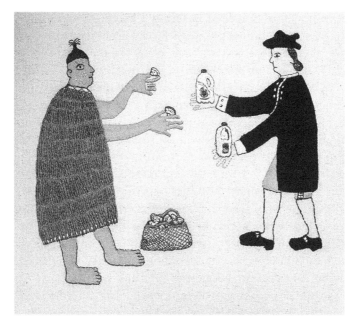

Figure 11.3 Sarah Munro, *Trade Items: North Island Dairy Industry Toheroa Tuatua Bivalve Molluscs* (2018), cloth and thread, 30 x 30 cm. ©The Artist

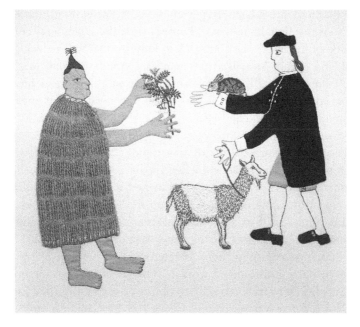

Figure 11.4 Sarah Munro, *Trade Items: Kowhai, Rabbit, Goat* (2018), cloth and thread, 30 x 30 cm. ©The Artist

As Munro slowly re-visualised in thread a meeting between Māori and a British officer, now identified as Joseph Banks, according to his own diaries, she playfully altered the object of trade, replacing the original *kōura papatea* (rock lobster) with an indigenous bird, a *kiore* (rat), a *toriura* (stoat) and other *kaimoana* (shellfish), to finally place at the centre of the trade a two-litre, plastic milk container.[66] It is a symbolic moment, a moment suspended just before a trade of goods takes place. Trade brings different cultures together under the presumption that a 'fair' deal will be reached. With this small cleavage in history, one imagines time bifurcating: in one direction is the promise of non-exploitation, of a deal between equals, and in the other, a fear that it could all turn out quite badly. In Munro's repetition of this originary moment she amplifies the promise, the trust, as well as the possible disappointments to follow, a going back to a point before the dialectic rolls history out of Māori hands. And we know too, that this scene pre-figures Tupaia's early death aboard The Resolution on his way, according to Banks's own diary, to become the wealthy botanist's exotic spectacle in England.[67]

The image, and its remaking two centuries later by Munro, restages a point in history when two cultures may have formed quite different relations. She brings back the neglected Tupaia, who was so respected across the Pacific in his time for his knowledge and his magic, and who was then usurped and forgotten. As Nichols Thomas notes, Tupaia, the navigator, produced an extraordinary map: 'a graphic document that fuses an indigenous perception of the world with the moralising cartography of the Enlightenment.'[68] Thus, as with the documents collected by Bruce Pascoe of the imperious and reckless disregard that settlers had for ancient Aboriginal land care in Australia,[69] the map also symbolises similar loss. It shows (again) the failure to place Indigenous knowledges in a non-hierarchical relation to European epistemologies. In Thomas's words, Tupaia's map is 'at once a gesture of scientific imperialism and an insistence upon their shared humanity and their common stake in beneficial knowledges.'[70]

Immersion for Munro in this remote region of Aotearoa/New Zealand, meant that the bush, the rocks, the edge of the dark sea, became her studio. She explained, 'Hodges had carefully delineated the botanical features of the "exotic" vegetation, ferns, creepers and giant forest trees', so in acknowledgement of these nineteenth-century naturalists and artists whose project it was to document fauna and flora during these 'scientific explorations, I sourced botanical drawings and used them as references for adding plants and animal species into my embroidered works.'[71] This meeting, first documented by Tupaia, was believed to have taken place on the East Coast of the North Island at Uawa Nui A Ruamatua (renamed Tolaga Bay by Captain Cook). Munro's re-picturing of this time in history, this first contact, draws a long and fulsome line, not a return or a circle, nor a progression, but a remapping *ex post facto* that implicates the explorers in colonialist avarice. With their drawings, journals

and scientific investigations, Munro's work is a reminder that colonialism is not just about large, momentous invasions, its impact will be felt down to the smallest and seemingly most insignificant of exchanges.

Murihiku Coastal Incursions

The trip 'down south' for Alex Monteith offered an opportunity to pursue a long-planned project, *Murihiku Coastal Incursions*, an investigation into the archaeological digs carried out between 1968 and 1972 by the Australian archae-ologist, Peter Coutts. It was during these years, while Coutts was undertaking doctoral study at the University of Otago, that he began to work on Indigenous digs. His initial research had been to investigate early European whaling and sealing settlements in Southland. However, with acquisitive avidity, he ended up excavating over 390 boxes of bones, woven harekeke, seal skin shoes and other objects removed from Māori middens around Murihiku. These artefacts spanned the dates 1000 AD to early post-contact colonial years, encompassing late pre-historic artefacts as well as those that came after Cook's arrival in 1773. Remaining uncatalogued, this enormous store of artefacts had been sitting in the Southland Museum and Art Gallery, and the Otago Museum University, from the time Coutts first deposited them. When Monteith began this project, the materials were inaccessible, unrecorded, unknown ...

Figure 11.5 Alex Monteith, *Tamatea 2014 Island FL8A3934* (2014). ©The Artist

The dates of the Southland dig are significant. They fall at a crucial time in colonial history when awareness of Indigenous rights, precipitated by Indigenous activism, was gaining increasing momentum across the world, and was beginning to seep through to wider European/Pākehā consciousness. Surely, as Coutts was in the process of removing so many artefacts from this remote area – to place them in storage, undocumented and out of reach of the Murihiku descendants – he would not have been unaware of the political arguments that were beginning to reshape his discipline at the time? It poorly reflects upon an archaeologist who would undertake digs as a first response, without intending to make detailed notes of removed material, and regardless of whether resources were available to support proper analysis. However, it is also a question loaded with a myriad of ethical implications for the discipline of archaeology. Foremost are the divisive debates over who owns archaeological finds. As James O. Young has noted, the field of interest here extends beyond the discipline of archaeology, to touch on law, Indigenous activism, anthropology and philosophy, with at least four possible candidates for ownership – an individual who found the object or has acquired it legitimately; a cultural group; a nation state; or humanity as a whole.[72] All of these possible ownership rights have been tested in various courts and courts of appeal, including UNESCO, where, as Young notes (falling directly in the middle of Coutts's dig) the 1970 Convention on the *Means of Prohibiting the Illicit Import, Export and Transfer of Ownership of Cultural Property, falls heavily on the rights of the patrimony of nations.*[73] Young distinguishes, however, the differing rights of homogenous cultures from multi-cultural states where Indigenous claims may accrue greater rights over those of the nation as a whole.[74] He goes on to argue for the benefits and limitations of various terms upon which ownership might be claimed. For instance, the claim of inheritance by descendants of the artefact is countered by the example of the Parthenon Marbles. Young relates evidence recorded at the time of the Marbles' removal that were abandoned by Athenians and sold freely to tourists. Such an argument, however, fails to account for changing community views about value, or prior power relations that may have been in force at the time. It also skips over the question of original ownership and cultural significance, which is often applied by interested groups to all artefacts removed from digs. This principle, Young argues, may also transcend the rights of legally acquired artefacts if they can be shown to have greater significance for another culture. The final factors are conservation, preservation, access and integrity (determining, in other words, whether the integrity of an isolated artefact would be enriched if it were to form part of a group of objects).[75]

The number of dig sites carried out by Coutts exceeded thirty. In the context of Aotearoa/New Zealand, the scale of removed material is unparalleled, which resulted in a ban being placed on any further digs in the area. As Monteith enters this highly vexed field of inquiry, her foundational conviction is that the moral rights of *taonga* Māori rests on *iwi* securing access to the materials of their ancestors. And thus, one of the first aims of Monteith's *Murihiku Coastal Incursions* was to secure funding to pay for an archivist/archaeologist to digitise the collection, making it accessible as an online database for researchers and interested *iwi*. The first presentation of the artwork was planned to consist of multi-channel, large-format videos of the area where the digs took place, alongside a collection of historical materials and artworks. It would also include a Tamatea/Dusky Sound painting by Hodges. The project is an ambitious one, with the hope that it will become a nucleus around which deliberations over the ethical handling of Indigenous material culture can take place, and reflecting more generally upon archaeological collection processes, Māori intellectual property and *taonga* Māori rights.

Murihiku Coastal Incursions is an ongoing project, and thus it is a work in transition, evolving possibly in yet unknown ways. The project has attracted expanding circles of interested collaborators who need to be considered at every step. Some groups were formed to respond to formal protocols, and others, to reflect upon the ethical implications of the project. During an early stage of cataloguing the artefacts, (sacred) *koiwi* tangata (human remains) were found. This initiated a critical response to government guidelines, the managing body of which enforces compliance across a range of legislation.[76] There were times when the public presentation of *Murihiku Coastal Incursions* occurred in galleries or museums (The Museum of Otago in 2016, and St Paul Street Gallery, Auckland in 2017) and these will cut into the ongoing process of identifying and cataloguing artefacts. Each public presentation, thereby, produces an intensified concentration on how to present an artwork in the context of the critical need to abide with ethical sensitivities to Indigenous histories and materials.

How might we come to an understanding of the archaeologist, Coutts, in all of this? Can we excuse his lack of consultative protocol with Indigenous communities on the basis of his actions being 'of their time?'[77] I would argue not. To situate his actions as merely part of a cultural/historical 'norm' ignores the Indigenous and other activists who worked throughout colonial history to push for increasing levels of awareness to Indigenous rights and culture. To retrospectively excuse Coutts is to accept and perpetuate a Eurocentric vision of a historical moment – an erasure of the oppositional and activist (non-white) forces that operated within that time.[78]

I began this section with examples of historical paintings produced at two decisive moments of European contact with Indigenous groups across Australasia. John Glover's rendering of featureless, cartoonish-like people in the early decades of colonialist rule in Australia are representations that appear morally compromised today, and even incomprehensible to contemporary eyes. However, the work is also a document of the papering over of history that Australian Aboriginal communities are still fighting to address.[79] And despite a seemingly more sympathetic picturing of Māori by William Hodges, the paintings he produced were, nonetheless, romanticised representations of the Other just prior to the invasion and subsequent devastation of traditional ways of life and land in Aotearoa. In both examples, the unknowable gulf between Indigenous and European knowledges had been inscribed in the foreign surface of the painter's canvases and materials. Both Monroe and Monteith brought to light the distorted power relations that were at play in a remote region of Aotearoa, initially with the 'explorers' first contact, and then in the longer vision of invasion that Monteith is capturing through the figure of the archaeologist, Coutts, whose practices appear to predominantly satisfy personal and short-term gain, while not serving the discipline of archaeology, nor the advancement of ancestral *iwi* knowledge.

Afterword (collaboration)

Monteith's *Chapter and Verse, Shadow V* and *Murihiku Coastal Incursions* each offered a different set of problems about how to present an ethically positioned political-aesthetics. Monteith's own position sets up two differing relations: as a woman of Northern Irish descent and a colonial subject, and then as a European living in Aotearoa in relation to Māori and the continuing after-effects of colonial rule. How Monteith negotiates these relations sits at the core of the conceptualisation and realisation of her art projects.

A distinction was raised at the beginning of *Artmaking in the Age of Global Capitalism* between art and political activism, and at times Monteith's projects fall consciously into activist modes of practice, where she uses art-like tactics but foregrounds politics as the content of the work. Such work is often designed with doctrinal, rather than heuristic, intentions. A small work, *1020 meters in 26 minutes Waitangi Day Auckland Harbour Bridge Protest* (2008), projected as a two-channel video installation, on a 26-min. looping cycle, was made in response to the refusal of the Auckland City Council to fly a flag of Māori sovereignty on Waitangi Day (a public holiday to commemorate the Treaty with Māori) on the major Bridge linking the City to the North Shore. The video documents a vehicle hauling a gigantic Māori flag behind it as it crosses the bridge at crawling pace. Monteith carries out

such works as a member of the activist group, Local Time, and although there are obvious crossovers in intention and political position, these actions are separate from her art projects. Her artworks privilege poetics borrowed from formal art and filmmaking histories and conventions, out of which the politics is left to emerge slowly but decisively, fusing the viewer into a non-didactic relation with the political dimension of the work.

The most challenging question around Monteith's work is foregrounded in the success she has had in exhibiting work in major museums and bi/trienni-als across the world, rarely havens for disrupting the order of the day. Thus, it is to ask whether such success might point to her supporting the contemporary *dispositif*, in Foucault's terms, or is she critically opposing it? My response is to fall into the latter camp, but it takes work to unpick the political-aesthetics in the work. When *Chapter and Verse* was shown in Melbourne in 2015, I heard that some (casual/busy) viewers had criticised it for being in support of the Orange 'side', and yet no serious or close viewing of the work could possibly come to this conclusion. Monteith's political position is clear and decisive, if one takes the time to consider the whole work and its implications. Since pushing politics as the content of the work is an approach no longer 'tolerated' in the field of contemporary art, because, to recall Rancière's point, it 'is a principle of the representative tradition that the aesthetic regime of art has called into question,'[80] I go back to the objective of the book, how to carefully manoeuvre an effective intervention into the political-aesthetic, to be both successful in the contemporary art industry (to work as an artist), while also being scratchy and annoying (disruptive). I am not suggesting that Monteith is reforming or reordering the police order, those moments of momentous changes in the aesthetic regime that fascinate Rancière. (I am thinking here of his description of Wordsworth establishing new poetic forms to describe post-revolutionary France as he walks through the French countryside.[81]) But I would argue that Monteith's work consistently encourages new formations within communities, whether this is around The Troubles or, as with the Murihiku *iwi*, in helping to open up his-tory to new understandings. It abides with Benjamin's historical method, not to identify great, historical shifts, but to focus on the details, the subversions, and particularly, the forgotten possibilities: 'Redemption', he argues, 'depends on the tiny fissure in the continuous catastrophe.'[82]

Conclusion

I felt that something was askew when I began to ask how visual artists and filmmakers were responding to current social and economic conditions. Rebounding through art discourses was mistrust, or even outright rejection of the category 'political art'. And yet despite this, art that critically addresses inequality in its myriad forms was continuing to be made. *Artmaking in the Age of Global Capitalism* was written from the perspective of this rejection/continuation, with the objective to better appreciate how (and why) artists and filmmakers are reconceptualising the form and content of the political aesthetic at this moment in history.

The 'why' led me back to some conflicts in political philosophy that seemed to split the 'left' through the closing decades of last century, and how this influenced creative practices. It seemed crucial for the cogency of the proposal that 'master voices' and grand, epic-like proclamations were avoided, as forms of historicism. As such, the divisions were approached through a series of small, material examples drawn from the later decades of last century and from within progressive social and political milieus – Pasolini and Calvino, Blanchot and Lefebvre and the Neue Slowenische Kunst (as the group negotiated socialist and then free-market conditions with tactics of ambiguity). This seemingly random selection of examples, these fragments, could be treated by the reader as isolated moments, or alternatively shaped into a larger picture of division and uncertainty.

This was a time when the utopia of revolution was fading in the closing decades of last century, alongside the introduction of neoliberal economics that began to infiltrate global policies, spreading across and then down into the tiniest crevices of social life. It seemed to arrive quickly but brutally, especially for debt-ridden nations from across the Americas in the 1980s, which were forced to take extreme austerity measures as conditions for further borrowing. They were forerunners to the European Union's strict austerity programme that was forced upon Greece this century. The Greek refusal to accept the programme was an elevating moment, as are the continuing actions on the ground of those working to reduce the impact of global

economics in local communities. At this point, however, there seems to be no reduction in the chasm between the very rich and the rest (now called the 99%), no revival of strong unionism (collectivism), no seeming change in the related rise of casual and precarious employment conditions, and no re-evaluation of the way a 'good', such as education and art, is calculated solely on the financial return it brings to the economy. But if there are signs that things are changing, not all of these changes are good. The growth of right-wing populism and its variances is a form of resistance to 'neoliberalism', but it comes with its misogyny, its othering, and its nostalgia for the racial superiority of white patriarchy. It means that the time has never been more urgent for art and film to play its part in questioning inequality, from the uneven distribution of the world's resources, to climate change, and to economic systems that favour the wealthy, while reducing social welfare and social services.

Therefore, while the 'why' encouraged a dip into a range of encounters, as well as philosophical and economic perspectives, the 'how' meant considering the methods being used by artists and filmmakers to critically respond to these conditions. If the desire is for art to disturb the prevailing *dispositif*, then it was proposed, via an extended wander through a small selection of works by Frances Barrett, Angela Brennan, Claire Denis and Alex Monteith, that it was still possible to present other ways of perceiving the world. Consistent with the historical materialist intentions of the book, there was no presumption that this small group of works stood in for universal claims about the contemporary political aesthetic. They were presented as examples of how artists were operating in the contested spaces of the political aesthetic, offering ways of thinking differently and critically about power and inequality. And they did so from the material bases of their projects: Frances Barrett as a performing and emoting body; Angela Brennan with paint and absurd naïve figures that defy judgement; Claire Denis (and Agnes Godard) with their control of the sensible qualities of film, while also cutting (mercilessly) into the comfort of narrative resolution; and, finally Alex Monteith, with her films, actions and collaborative networks that aim to refocus our understanding of history.

Embedded in each of their practices is a renewed interest in aesthetics; specifically, a concern for the way the manipulation of materials and their effect on the senses is connected to a wider politics.[1] Perhaps it was in reaction to the so-called 'anti-aesthetic' years (Hal Foster) in which the dominant concern for the 'idea' took precedence over the materials used (Lucy Lippard). Or perhaps it was simply a seductive, unstoppable force that led to a renewed interest in poetics and 'affect'. For along with a concern for appreciating the importance to art and film of the unthinkable in thought, came

a rejection of 'representation', as that which, in its senseless repetition, denies art's experimental essence, as well as its affective fusion of perception and sensation (Deleuze and Guattari). Ranciére is unequivocal about there being no separation between politics and aesthetics, which, as an inextricable unity, is a site of contestation over what can be seen and said. The representation of a political subject, therefore, belies the very eidos of the political aesthetic. 'Representation' is a problem in another way. The rejection of work that speaks for the other (Ranciére, Derrida), or work that represents the other, ties the political aesthetic to an ethical demand that includes the impact a work has on the world, how it might contribute, or positively add to a community's well-being (Simon Critchley).

This was evident in Barrett's desire to use intimacy with others as a politics driven by an ethical exigency. She enacted this from within the fold of a queer/feminism, developed from the particular demands of her own practice; that is, through experimental performance methods, rather than from a set of fixed theoretical demands imposed from the outside. Barrett is informed by theory, of course, but this is tested in the world, changed, modified, evolving. It was from such a position that Claire Denis developed *L'Intrus* from a text by Jean-Luc Nancy, commenting in an interview (light-heartedly, laughingly) that Nancy could not recognise himself in the film. His sensing of intrusion and alienation during his heart transplant were loose frames that allowed Denis to locate the women, animals and refugees in *L'Intrus* as the intruding strangers. It was discovered that at the edges of her treatment was an archaeology of devolving patriarchal power, referenced in an interview of the various film roles performed in the career of her leading man, Michel Subor. Denis had inserted into *L'Intrus* scenes from a black-and-white film starring Subor, *Le Reflux* by Paul Gégauff (unfinished and unreleased), shot in the Pacific in the 1950s. This unexpected break into *L'Intrus* – reverberating from the future back into the past – announced that patriarchy and colonialism are in the process of falling apart.

For both Barrett and Monteith, their work demonstrates a strong commitment to make collective/collaborative methods explicit priorities of practice, and although this may not be manifest at the point where concept and material are developed, it arises for both artists as a complex interrelationship with others that informs the making, presentation and reception of work. Despite the specificity of their differing conceptual and material concerns, both Barrett and Monteith have structured their practices as reciprocal mechanisms between work and world, which then trigger critical and ongoing self-reflection about the impact each work has on collaborators and audiences. Where Monteith has an activist practice as part of the group, Local

Time, Barrett's 'other life' is to produce work as part of an artist-led collective, currently named 'Barbara Cleveland', after a fictional performance artist from the 1970s. Moving from their own practices to collective practices is a finely calibrated balance between the singular, self-interest of the 'auteur' and the subsumption of this into a form of limited anonymity via collective artmaking/filmmaking. At one level (and perhaps this is still contentious), might this positioning of artists' responsibilities be a reaction to earlier periods where the actions of makers in the world were considered to be unconnected to the value of the work? *Artmaking in the Age of Global Capitalism* rests instead on the importance (as Simon Critchley has proposed) of the inter-relationship between ethics and politics.

The objective to become more familiar with the way contemporary artists are approaching the political-aesthetic also raised two common counter-methods that appear to seamlessly support the police order (Rancière). The first is the type of work that represents social inequalities through the singular and authorial 'voice' of the privileged artist. This 'revealing' of the pain of others becomes a spectacle enclosed in an artist/audience circle of privilege. It reduces the discussion to a quickly consumed cause and effect that is little more than the representation of politics, or the representation of the other in the service of an artist's career (it was discussed in terms around which 'tolerance' has been theorised). It is a form of artwork that is well supported in the special spaces of museums and biennales. The 2014 Sydney Biennale was an example of the way a questioning of contentious political issues was acceptable to those in power, as long as the issue remained securely bound within the confines of the art institution.

A second form of work that plays into the prevailing political aesthetic is so positioned that a viewer is free to project onto it whatever political opinions they hold, without rupturing the prevailing police order (again, Rancière) or their own sensitivities. Such work aligns with the current mood for political consensus (liberalism), an approach that contributes to the destruction of the very essence of the political as dissensus/agonism (Jacques Rancière, Chantal Mouffe, Ernest Laclau) while, at the same time, paradoxically, allowing ideological division to be more deeply entrenched. This seems to be how western democracies experience politics today, with irresolvable impasses, despite the urgency of the problems facing the world, such as climate change politicised along divided party lines that leaves action for the planet's survival in jeopardy.

It seems appropriate, therefore, to finish with a quote from Benjamin's final essay, written just before his death: 'Every age must strive anew to wrest tradition away from a conformism that is working to overpower it.'[2] The artworks

and films covered in *Artmaking in the Age of Global Capitalism* were developed for this particular historical moment, and despite their differing ways they share a common theme: the critical revaluation of forms of power – particularly those emanating from patriarchal structures or judgements – through material methods of making.

Endnotes

Introduction: The Gift of Being Disgusted

1. In an interview in 1977, Michel Foucault defines 'Apparatus' in the following way: 'What I'm trying to single out with this term is, first and foremost, a thoroughly heterogeneous set consisting of discourses, institutions, architectural forms, regulatory decisions, laws, administrative measures, scientific statements, philosophical, moral, and philanthropic propositions – in short, the said as much as the unsaid. Such are the elements of the apparatus. The apparatus itself is the network that can be established between these elements.' Quoted in Giorgio Agamben, 'What is an Apparatus?' in *What is an Apparatus and Other Essays*, trans. David Kishik and Stefan Pedatella (Stanford: Stanford University Press, 2009), p. 2.
2. Walter Benjamin, 'Left-Wing Melancholy' [1928], trans. Ben Brewster, in Howard Eiland and Michael W. Jennings (eds), *Walter Benjamin Selected Writings*, vol. 2 (Cambridge, MA and London: Harvard University Press, 1996), p. 424.
3. See also Kerr Houston who charts the decreasing frequency with which the term 'political art' has appeared in art discourses from 1990. 'The Decline of "Political Art"', *BMoreArt: Creative, Critical, Daily* (27 January 2016), <www.bmoreart. com/2016/01/the-decline-of-political-art.html>, last accessed 4 July 2018.
4. Jacques Rancière, 'Interview for the English Edition', *The Politics of the Aesthetic: The Distribution of the Sensible,* trans. Gabriel Rockhill (New York and London: Continuum, 2004), p. 61.
5. Jacques Rancière, *Aisthesis: Scenes from the Aesthetic Regime of Art,* trans. Zakir Paul (London and New York: Verso, 2013), p. xii.
6. In contradistinction to a consensus model of the political, and despite Schmitt's compromised position as a member of the Nazi Party, 'Agonism' is the term Chantal Mouffe and Ernest Laclau utilise after they refashion his theories for progressive politics.
7. Carl Schmitt, *The Concept of the Political* [1927] (Chicago and London: University of Chicago Press, 1996), p. 30.
8. Ibid. p. 26.
9. Rancière's treatment of this distinction 'does not maintain a strict terminological distinction between politics (*la politique*) and the political (*le politique*). He often distinguishes the latter as the meeting ground between politics and the police. In this sense, the political is the terrain upon which the verification of equality

confronts the established order of identification and classification.' 'Glossary of Technical Terms', *Politics of the Aesthetic,* p. 89.

10. Oliver Marchart, *Post-foundational Political Thought: Political Difference in Nancy, Lefort, Badiou and Laclau* (Edinburgh: University of Edinburgh Press, 2007), p. 7.

11. Roberto Esposito, 'The Metapolitical Structure of the West', *qui parle,* vol. 22, no. 2 (Spring/Summer 2014), p. 148.

12. Andrew Benjamin, 'Time and Task: Benjamin Heidegger Showing the Present', in Andrew Benjamin and Peter Osborne (eds), *Walter Benjamin's Philosophy: Destruction and Experience* (London: Routledge, 1994), p. 217.

13. Ibid.

14. Andrew Benjamin, 'Hope at the Present', in Benjamin, *Present Hope: Philosophy Architecture, Judaism* (London: Routledge, 1997), p. 9.

15. Ibid.

16. Jacques Rancière, *The Politics of Aesthetics,* p. 13.

17. Ibid. p. 3.

18. Jacques Rancière, 'Glossary of Technical Terms', *Politics of Aesthetics,* p. 89. Italics in the original.

19. Jacques Rancière, 'The Thinking of the Dissensus: Politics and Aesthetics', in Paul Bowman and Richard Stamp (eds), *Reading Rancière* (London and New York: Continuum, 2011), p. 1.

20. The Police Order is further defined, 'As the general law that determines the distribution or parts and roles in a community as well as its forms of exclusion, the police is first and foremost an organisation of "bodies" based on a communal distribution of the sensible. For example, a system or coordinates defining modes of being, doing, making, and communicating that establishes the borders between the visible and the invisible, the audible and the inaudible, the sayable and the unsayable. This term should not be confused with *la basse police* or the low-level police force that the word commonly refers to in both French and English. *La basse police* is only one particular instantiation of an overall distribution of the sensible that purports to provide a totalising account of the population by assigning everyone a title and a role within the social edifice.' 'Glossary of Technical Terms', *Politics of the Aesthetic,* p. 89.

21. Jacques Rancière, 'The Emancipated Spectator' *Artforum,* vol. 45, no.7 (March 2007), p. 272.

22. Jacques Rancière, *The Future of the Image* (London and New York: Verso, 2007), p. 91.

23. Jacques Rancière interview with Fulvia Canevale and John Kelsey, 'Art of the Possible', in Emiliano Battista (ed. and trans.), *Dissenting Words: Interviews with Jacques Rancière* (London: Bloomsbury, 2017), p. 230.

24. Rancière, Fulvia Carnevale and John Kelsey in Conversation, 'Art of the Possible', *Artforum International,* vol. 7, no. 45 (March 2007), p. 257.

25. Jacques Rancière, 'A Few Remarks on the Method of Jacques Rancière', *Parallax,* vol. 15, no. 3 (2009), p. 114.

26. T. J. Clark, *The Sight of Death: An Experiment in Art Writing* (New Haven, CT and London: Yale University Press, 2006), pp. 122–3.

27. Simon Critchley, *Infinitely Demanding: Ethics of Commitment, Politics of Resistance* (London and New York: Verso, 2007), p. 3.

28. Emily Beausoleil, 'Responsibility as Responsiveness: Enacting a Dispositional Ethics of Encounter', *Political Theory,* vol. 45, no. 3 (2017), p. 294.

Part I: Introduction

1. Walter Benjamin, 'Left-Wing Melancholy' [1928], trans. Ben Brewster, in Howard Eiland and Michael W. Jennings (eds), *Walter Benjamin Selected Writings*, vol. 2 (Cambridge, MA and London: Harvard University Press, 1996), p. 424.

2. Erich Kästner was an author of fiction, children's books, journalism and poetry. Watching his own books being burnt for their 'degeneracy', he was one of the 40,000 people who attended the student book burning on 10 May 1933 and remained in Germany throughout the Nazi years. See George Diaz, 'How the Nazis Ruined Erich Kästner's Career', *Der Spiegel* (18 April 2013), <www.spiegel.de/international/zeitgeist/nazi-book-burning-anniversary-erich-kaestner-and-the-nazis-a-894845.html>, last accessed 21 April 2018.

3. Benjamin, 'Left-Wing Melancholy', 'Their function is to give to give rise, politically speaking; not to parties but to cliques; literally speaking, not to schools but to fashions; economically speaking, not to producers but to agents', (p. 424).

4. Ibid. p. 426.

5. Laura Cumming, 'More of a Glum Trudge Than an Exhilarating Adventure', *Guardian* (15 May 2015), <www.theguardian.com/artanddesign/2015/may/10/venice-biennale-2015-review-56th-sarah-lucas-xu-bing-chiharu-shiota>, last accessed 28 January 2015.

6. Rachael Withers, 'Venice Biennale 2015: The Arsenale Stuffed with Guns, Stripped of Hope', *The Conversation* (13 May 2015), <theconversation.com/venice-biennale-2015-the-arsenale-stuffed-with-guns-stripped-of-hope-40856>, last accessed 28 January 2019.

7. Walter Benjamin, 'Left-Wing Melancholy', p. 426.

8. The artists who boycotted the Biennale were Gabrielle de Vietri, Bianca Hester, Charlie Sofo, Nathan Gray, Deborah Kelly, Matt Hinkley, Benjamin Armstrong, Libia Castro, Ólafur Ólafsson, Sasha Huber, Sonia Leber, David Chesworth, Daniel McKewen, Angelica Mesiti, Ahmet Öğüt, Meriç Algün Ringborg, Joseph Griffiths, Sol Archer, Tamas Kaszas, Krisztina Erdei, Nathan Coley, Corin Sworn, Ross Manning, Martin Boyce, Callum Morton, Emily Roysdon, Søren Thilo Funder, Mikhail Karikis, Mikala Dwyer, Rosa Barba, Sara van der Heide, Henna-Riikka Halonen, Shannon Te Ao, Hadley+Maxwell, Ane Hjort Guttu, Yael Bartana, Emily Wardill, Agnieszka Polska, Bodil Furu, Eglė Budvytytė, Eva Rothschild, Annette Stav Johanssen, Synnøve G. Wetten, Tori Wrånes, Siri Hermansen, James Angus. See *#19BOS Working Group*, <19boswg.blogspot.com>, last accessed 28 January 2019.

9. According to Admir Skodo, 'Since 1980, all major Western states practice what they call civil or administrative confinement of undocumented immigrants and non-citizens.' With UK, USA, Italy and Australia all outsourcing the management of the facilities to private companies. 'How Immigration Detention Compares Around the World', *The Conversation* (19 April 2017), <theconversation.com/how-immigration-detention-compares-around-the-world-76067>, last accessed 5 June 2018. In 2015, the Australian Human Rights Commission released a report *The Forgotten Children: National Inquiry into Children in Immigration Detention,* which had 'found that one-third of children in immigration detention centres had a mental health disorder that required psychiatric support.' Karen Zwi, 'Detained Children Risk Life-long Physical and Mental Harm', *The Conversation* (19 February 2015), <theconversation.com/detained-children-risk-life-long-physical-and-mental-harm-37510>, last accessed 5 June 2018.

10. The Sydney Biennale, while receiving public funds, had been established as a private industry initiative in 1973 by the founding patron, Franco Begiorno-Nettis, Luca Begiorno-Nettis's father, and head of Transfield Holdings, to coincide with the opening of the Sydney Opera House.

11. Quoted in Melanie Tait, 'Biennale Boycott', Radio National Archive (15 March 2014), <www.abc.net.au/radionational/programs/archived/weekendarts/biennaleboycott/5323094>, last accessed 20 May 2018.

12. 'Former Biennale Head Hits Back at Critics', presented by Michael Cathcart and Sarah Kanowski, *Arts and Books,* ABC Radio (italics mine), <www.abc.net.au/radionational/programs/booksandarts/5312000>, last accessed 20 May 2018.

13. Quoted in Joanna Heath, 'Turnbull Accuses Biennale Artists of "Vicious Ingratitude"' *Australian Financial Review* (11 March 2014), <www.afr.com/lifestyle/arts-and-entertainment/turnbull-accuses-biennale-artists-of-vicious-ingratitude-20140311-ixlsu>, last accessed 10 May 2018.

14. Alana Lentin and Javed de Costa, 'Sydney Biennale Boycott Victory Shows that Divestment Works', *Guardian* (11 March 2014), <www.theguardian.com/commentisfree/2014/mar/11/sydney-biennale-boycott-victory-shows-that-divestment-works>, last accessed 20 May 2018.

15. Interview with boycott artist, Charlie Sofo (31 May 2018).

16. In 2001, in the weeks leading up to a federal election year, the then Prime Minister, John Howard, down in the polls, claimed that 433 asylum seekers on a sinking boat called the Palapa were throwing children overboard to gain sympathy for their plight to get to Australia. The Norwegian rescue boat, the *MV Tampa*, was thrust in the middle of a diplomatic crisis when Howard ordered the Australian special forces to illegally board the ship and remove the asylum seekers. It was later revealed that no one on the sinking refugee boat had thrown their children overboard, but the incident was the foundation for both Liberal and subsequent Labor Governments' Pacific solution (or offshore detention).

17. Antony Loewenstein, 'Australia: "If You Have a Pulse You Have a Job at Serco"', *Disaster Capitalism: Making a Killing Out of Catastrophe* (London and New York: Verso, 2017), p. 557.

18. Ibid. p. 564.
19. Ibid. p. 606.

1 Benjamin's Challenge for the Twenty-first Century

1. Walter Benjamin, 'Left-Wing Melancholy', p. 425.
2. Helen Grace, 'So I Joined the Teamsters', *Artists Think: The Late Work of Ian Burn* (Sydney and Melbourne: Power Institute and Monash University Gallery of Art, 1996), p. 56.
3. Ibid. p. 57.
4. Jacques Rancière (ed.), Beth Hinderliter, William Kaizen et al., *Communities of Sense: Rethinking Aesthetics and Politics* (Durham, NC and London: Duke University Press, 2009), p. 34.
5. 'The first Coalition budget in 2014 cut $87 million from the arts, and the next year Brandis restructured arts subsidies by redirecting $105 million from the Australia Council for other arts programs. Brandis's successor as arts minister, Mitch Fifield, returned $8m a year to the Australia Council.' Quoted in Matthew Westwood, *The Australian* (2 August 2016), <www.theaustralian.com.au/arts/coalition-punished-artists-for-biennale-boycott-by-cutting-funding/news story/6ebf1792902f887c60 fb93c1c722bc76>, last accessed 20 May 2018.
6. Ibid.
7. Editorial, 'Full List of Casualties from Brandis' Arts Bloodbath Revealed', *Crikey* (13 May 2016), <www.crikey.com.au/2016/05/13/brandis-arts-bloodbath>, last accessed 22 May 2018.
8. Ronald F. Inglehart and Pippa Norris, 'Trump, Brexit, and the Rise Of Populism: Economic Have-nots and Cultural Backlash', *Roundtable, Rage Against the Machine, Populist Politics in the U.S., Europe and Latin America'*, The annual meeting of the American Political Science Association, Philadelphia (September 2016), p. 3.
9. Ibid. p. 5.
10. The methodology used by Inglehart and Norris to analyse evidence involves multivariate logistic regression models to account for multiple predictors and criteria. Ibid. p. 4.
11. Ibid. p. 3.
12. Speaking of her experiences while making a film about Australia's offshore detention centres, Eva Orner said, 'I've been making films for more than 20 years and this is the hardest film I have ever made. If I'd known how hard this would be, I likely wouldn't have done it. *Chasing Asylum* is a film about places you are not allowed to go to and people you are not allowed to talk to – and halfway through the making of the film, it became a criminal act with a prison sentence of up to two years for people working with asylum seekers to speak out about what was happening.' *Aljazeera*, 'Why Australia's Detention Centres on Nauru and Manus Island are Still Open', <www.aljazeera.com/blogs/asia/2017/08/australia-detention-centres-nauru-manus-island-open-170813142449181.html>, last accessed 20 August 2018.

13. At the time of writing, Peter Dutton is Minister of Immigration and Border Protection. He was given the extra portfolio of Minister for Home Affairs in 2017. He represents the 'hope' of the far right in the conservative Liberal Party and as of August 2018 had twice challenged the Prime Minister for the leadership. The extreme right faction of the Party has successfully destabilised moves to combat climate change and to close coal-fuelled power generators for more than a decade in Australia.

14. Quoted in *The Guardian*, Australian edition (14 August 2017), <www.theguardian.com/australia-news/2017/aug/14/dutton-retreats-on-offshore-detention-secrecy-rules-that-threaten-workers-with-jail>, last accessed 9 May 2018.

15. Ronald F. Inglehart and Pippa Norris, 'Trump, Brexit, and the Rise of Populism', p. 4.

16. Nicos Poulantzas, *Fascism and Dictatorship: The Third International and the Problem of Fascism*, trans. Judith White (London: Verso, 1979), p. 11.

17. Judith Butler's interview with Christian Salmon first appeared in French as: 'Judith Butler: pourquoi «Trump est un phénomène fasciste»' (19 December 2016), <www.mediapart.fr/journal/international. The English translation by David Broder, appeared in Verso Blog (29 December 2016), <www.versobooks.com/blogs/3025-trump-fascism-and-the-construction-of-the-people-an-interview-with-judith-butler>, last accessed 17 January 2019.

18. Madeleine Albright, *Fascism: A Warning* (New York: Harpers Collins UK Audio, 2018), chapter 4.

19. Michel Foucault, 'Preface' to Gilles Deleuze and Felix Guattari, trans. Robert Hurley, Mark Seem and Helen R. Lane, *Anti-Oedipus: Capitalism and Schizophrenia* (Minneapolis: University of Minnesota, 1972; 1977), p. xiii.

20. Mariana Valverde, '"Despotism" and Ethical Liberal Governance', *International Journal of Human Resource Management*, vol. 25, no. 3 (1996), p. 359.

21. Jacques Rancière, 'Glossary of Technical Terms', *The Politics of the Aesthetic,* p. 89.

2 A Community of Sense

1. Howard Caygill, *On Resistance: A Philosophy of Defiance* (London: Bloomsbury, 2015), p. 192.

2. Quoted from the artist's website, <www.taniabruguera.com/cms/586-0 Migrant+People+Party+MPP.htm., Bruguera has also set up a network collective for Useful Art, see: <www.arteutil.org/about/activities>, last accessed 4 June 2018.

3. Ibid.

4. Jacques Rancière, trans. Zakir Paul, 'Prelude', *Aisthesis: Scenes from thee Aesthetic Regime of Art* (London and Brooklyn: Verso, 2013), p. x.

5. Jacques Rancière, *The Politics of the Aesthetic*, p. 3.

6. Jacques Rancière, 'Community as Dissensus', trans. Emiliano Battista, *Dissenting Words: Interviews with Jacques Rancière* (London and New York: Bloomsbury, 2017), p. 143.

7. See Jean-Luc Nancy, *The Inoperative Community*, trans. Peter Connor and Lisa Garbus (Minneapolis and Oxford: University of Minnesota Press, 1991).

8. Jacques Rancière, 'Community as Dissensus', p. 144.

9. Maarten Simons and Jan Masschelein, 'Governmental, Political and Pedagogic Subjectivation: Foucault with Rancière', *Educational Philosophy and Theory*, vol. 42, nos 5–6 (2010), pp. 588–605.

10. Jacques Rancière, 'Community as Dissensus', pp. 144–5.

11. Jacques Rancière, 'Contemporary Art and the Politics of Aesthetics', ed. Beth Hinderliter, et al., *Communities of Sense: Rethinking Politics and Aesthetics* (Durham and London: Duke University Press, 2009), p. 32.

12. See Gregory Ruggiero, 'Latin American Debt Crisis'. <www.angelfire.com/nj/ Gregory Ruggiero/latinamericancrisis.html>, last accessed 10 June 2018.

13. 1% is a term coined by the economist and *Vanity Fair* journalist, Joseph Stiglitz, to explain the concentration of 40% of US wealth in the hands of 1% of the nation's population. 'Of the 1%, by the 1%, for the 1%', *Vanity Fair,* 31 March 2011. It sparked The Occupy Movement's 99% campaign, <www.vanityfair.com/ news/2011/05/top-one-percent-201105>, last accessed 20 June 2018.

14. Michael Hardt and Antonio Negri, *Empire* (Cambridge, MA: Harvard University Press, 2000), p. xiii.

15. Ronald F. Inglehart and Pippa Norris, 'Trump, Brexit, and the rise of populism: Economic have-nots and cultural backlash', p. 2.

16. See, in particular, Kean Birch, *A Research Agenda for Neoliberalism* (Cheltenham and Northampton, MA: Edward Elgar Publishing Ltd, 2017).

17. I am thinking, in particular, of the archives unearthed by the art historian, T. J. Clark in his book on Manet and capitalism in nineteenth-century Paris, particularly the elevated sense of loss and melancholy that he found throughout the documents during a time of radical refashioning of Paris during the process known as Hausmannisation. *The Painting of Modern Life: Manet and His Followers* (Princeton: Princeton University Press, 1984).

18. Walter Benjamin, 'Left-Wing Melancholy', p. 425.

3 Crisis on the Left

1. Antonio Negri, 'Ricominciare da Marx, sempre di nuovo' presented at conference, *The (re)Birth of Marx(ism): Haunting the Future*, Maynooth University (4 May 2018). Published as 'Starting Again with Marx', trans. Arianna Bove, *Radical Philosophy,* no. 2.03 (December 2018), pp. 1–9.

2. Ibid. p. 1.

3. Ibid. p. 4.

4. Ibid. p. 5.

5. Ibid. p. 8.

6. 'Union leaders, many of whom were members of the Communist Party (PCF) set out to control the strike [13 May 1968] and prevent it from developing in a radical direction. The PCF, with its 300,000 members and control of the largest

union confederation in the country, was the strongest organisation on the French left. It had been excluded from power since 1947 and was desperate to enter into a coalition government. This meant it had to prove itself to be a party committed to parliamentary methods and so was very hostile to more militant tactics. Its trade union officials worked to demobilise the rank-and-file and keep them separated from revolutionary students wherever possible.' Quoted in Editorial, solidarity.net.au (May 2018), <www.solidarity.net.au/mag/current/114/may-1968-worker-student-revolt-stopped-france>, last accessed 20 January 2010.

7. André Gorz, originally published as *Adieu au Proletariat* (Paris: Éditions Galilée, 1980). Trans. Michael Sonenscher, *Farewell to the Working Class: An Essay on Post-Industrial Socialism* (London and Sydney: Pluto Press, 1982), p .16, italics in the original.

8. Jacques Rancière, 'On the Theory of Ideology: The Politics of Althusser' (drafted for an anthology on Althusser published in Argentina) and first published in *Radical Philosophy*, no. 7 (Spring 1974).

9. Jacques Rancière, *Althusser's Lessons*, trans. Emiliano Battista (London and New York: Continuum, 2011), p. 64.

10. Jacques Rancière, *The Ignorant Schoolmaster: Five Lessons in Intellectual Emancipation*, trans. Kristen Ross (Stanford: Stanford University Press, 1991), p. 2.

11. Nicholas Thoburn, 'There are interesting questions about why Deleuze and Guattari declare themselves to be Marxists: it's not straightforward, and I think this declaration has a number of functions in their work. Some of these would seem to amount to a deliberate provocation in the face of neoliberal consensus, "Marx" being a contentious name to invoke at what was a time of general unpopularity for Marxism.' Eric, Alliez, Claire Colebrook, Peter Hallward, Nicholas Thoburn and Jeremy Gilbert (chair), 'Deleuzian Politics? A Roundtable Discussion', *New Formations*, no. 68 (Spring 2009), p. 143.

12. Étienne Balibar, *The Philosophy of Marx*, trans. Chris Turner (London:Verso, 2014), pp. 62–3. Originally published in French as *La philosophie de Marx* (1993).

13. Jean-Philippe Deranty, 'Jacques Rancière's Contribution to the Ethics of Recognition', *Political Theory*, vol. 31, no. 1 (February 2003), p. 152.

14. Ibid.

15. Robert Young, *White Mythologies: Writing, History and the West* (London: Routledge, 1990), pp. 4–5.

16. Ronald F. Inglehart introduced the term 'postmaterialism' to describe the priority of identity-self-expression over economic determinants. *The Silent Revolution: Changing Values and Political Styles Among Western Publics* (Princeton: Princeton University Press, 1977).

17. Phillip Rothwell, 'Unfinished Revolutions: Gaps and Conjunctions', *Signs,* vol. 32, no. 2 (Winter 2012), p. 271.

18. At the same time, some on the left, such as Jean-François Lyotard, developed end-of-modernity narratives, which spread rapidly through art writing circles, but also just as quickly disappeared as viable theses at the end of the century.

19. Gilles Deleuze and Félix Guattari, *Anti-Oedipus: Capitalism and Schizophrenia*, p. 42.
20. Vincent Descombes, *Modern French Philosophy,* trans. L. Scott-Fox and J. M. Harding (New York and Melbourne: Cambridge University Press, 1980), p. 16.
21. Ibid. Descombes explains that by 1965, the word *praxis* was replaced with the word *practice*, despite it being one of the key words of the years 1950–60, because it was so closely associated with Marxist-Existentialism (p. 17).
22. As Mark Poster has noted, there was an appreciation that both Marxism and existentialism were 'incomplete and partial, that each needed to revise its basic concepts, that sectarian purity did not encourage critical thought.' *Existential Marxism in Postwar France: From Sartre to Althusser* (Princeton: Princeton University Press, 1975), p. 209.
23. In Éric Alliez, Claire Colebrook, Peter Hallward, Nicholas Thoburn and Jeremy Gilbert (Chair), 'Deleuzian Politics?', p. 144.
24. Nicholas Thoburn, 'Deleuzian Politics?', p. 144.
25. Gilles Deleuze's discussion with Antonio Negri, 'Control and Becoming' was first published in the journal, *Futur Antérieur* (Spring 1990). English translation: Martin Joughin, *Negotiations* (New York: Columbia University Press, 1995), p. 171.
26. Nicholas Thoburn, *Deleuze, Marx and Politics* (London: Routledge, 2003), pp. 2–3.
27. Gilles Deleuze and Antonio Negri, 'Control and Becoming', p. 171.
28. Email exchange with Charlie Sofo (2 June 2018).
29. Developed by Michel Foucault for Collège de France Course Lectures, 1971–84. Publication accessed, Michel Foucault, *The Government of Self and Others,* ed. Frédéric Gros, trans. Graham Burchell (Basingstoke: Palgrave Macmillan, 2011).
30. See, in particular, Michel Foucault's *Discipline and Punish: The Birth of the Prison,* trans. Alan Sheridan (New York: Vintage Books, 1995); and *History of Sexuality,* vol. 1, trans. Robert Hurley (New York: Pantheon Books, 1978).
31. In 1990, Deleuze updated Foucault's interpretation of power and the structure of later twentieth century institutions in his short essay, 'Postscript to Societies of Control' ('Post-scriptum sur les sociétés de contrôle)' published in *L'autre* (May 1990), appearing in English, trans. Martin Joughin, *October,* no. 59 (1992), pp. 3–7.
32. Daniel Zamora and Michael C. Behrent (eds), *Foucault and Neoliberalism* (London: Polity Press, 2015), p. 15.
33. In 1977, 'Deleuze and Foucault found themselves in quite obvious mutual opposition, first in the debate over the New Philosophers and then in relation to the [Klaus] Croissant case [a former lawyer for Red Army Faction, later turned Stasi informer].' Mathias Schönher, 'Deleuze, a Split with Foucault', *Le foucaldien,* vol.1, no.1 (2015), p. 2.
34. Peter Dews, 'The *Nouvelle Philosophie* and Foucault', *Economy and Society,* vol. 8, no. 2 (1979), p. 128 and fn 2, p. 169.
35. Daniel Zamora, 'Foucault, the Excluded, and the Neoliberal Erosion of the State', *Foucault and Neoliberalism,* p. 55.

36. Antonio Negri, 'When and How I Read Foucault', trans. Kris Klotz, in Nicolae Morar Thomas Nail and Daniel W. Smith (eds), *Between Deleuze and Foucault* (Edinburgh: Edinburgh University Press, 2016), p. 72.
37. 'Why, then, was I interested in Foucault? At this time, the social and political "movements" that were contesting the current political situation in Italy were experiencing an intense conflict with the Italian Communist Party (ICP) and the trade unions. The latter were in the process of establishing an alliance with the forces of the right concerning social and parliamentary grounds. They called this alliance "the historical compromise".' Antonio Negri, ibid.
38. Ibid.
39. Étienne Balibar, *The Philosophy of Marx*, p. 16.
40. Ibid. p. 23.

4 'Efficient Market Ideology'

1. An example of the failure of the system is the risk to global financial stability of banking practices such, as sub-prime mortgage lending, targeted at the poorest communities. Despite this being blamed for the source of the GFC of 2007–8, the regulatory protections established to combat such practices, have been largely reversed by the Trump administration.
2. Karl Marx, *Capital: A Critique of Political Economy, Volume* 1 (Moscow: Progress Publishers, 1978), p. 43.
3. 'Separation Perfected' is the title of Guy Debord's opening chapter to *The Society of the Spectacle*, trans. Donald Nicholson-Smith (New York: Zone Books, 1995), first published as *Le société du spectacle* (Paris: Buchet-Castel, 1967).
4. Guy Debord, *The Society of the Spectacle,* p. 12.
5. Ibid.
6. As Kean Birch points out, liberalism arose in response to fascism in the 1930s. However, what is of interest here is its evolution into neoliberalism that privileges the ideologies of individual pursuit, small government, and low taxes. For research into the prevalence of the use of terms, such as 'globalisation', 'free market' and 'neoliberalism', as well as their contested nature and cross-overs from academic to popular audiences, see Birch, *A Research Agenda for Neoliberalism* (Cheltenham and Northampton, MA: Edward Elgar Publishing, 2017).
7. Guy Debord, 'Préface à la quatrième edition Italienne de *La Société du Spectacle*', included in the French edition of *Commentaires sur la société du spectacle* (Paris: Èditions Gallimard, 1992), pp. 132–3. The English translation cited above has been taken from Guy Debord, 'The State of Spectacle', in Hedi El Kholti, Sylvère Lotringer and Christian Marazzi (eds), *Autonomia: Post Political Studies*, Los Angeles: Semiotext(e), 1980, p. 97. However, this is not the full translation of the 'Introduction', as it suggests, but starts well into the text, which begins instead with Debord's criticisms of the poor translations that have appeared in many languages, 'partout infidèles et incorrectes'. *Commentaires sur la société du spectacle* (Paris: Èditions Gérard Lebovici, 1998), p. 122.

8. Thomas E. Janoski 'Challenging Dominant Market Theories in Five Ways', *DisClosure: Journal of Social Theory*, vol. 24 (2015), p. 45

9. See also Theodore William Schultz, *Investing in People: The Economics of Population Quality* (Berkeley and Los Angeles: University of California Press, 1981).

10. Gary S. Becker, *Human Capital: A Theoretical and Empirical Analysis, with Special Reference to Education* (Chicago: University of Chicago Press, 1993).

11. David Harvey, *A Brief History of Neoliberalism* (Oxford and New York: Oxford University Press, 2005), p. 2.

12. Fred L. Block, *Postindustrial Possibilities: A Critique of Economic Discourse* (Los Angeles: University of California Press, 1990).

13. Guy Debord, *Comments on the Society of the Spectacle*, trans. Malcolm Imrie (London: Verso, 1988), p. 9.

14. The idea of approaching capitalism as a total system will be derided through the latter decades of the century. Writing in the 1990s, in reference to Guy Debord's *Society of the Spectacle*, T. J. Clark and Donald Nicholson-Smith defended the idea of totality. 'Conceived and written specifically for bad times [as] it was intended to keep the habit of tantalisation alive . . . This was the moment . . . when the very word "totality", and the very idea of trying to articulate those forces and relations of production which were giving capitalism a newly unified and unifying form, were tabooed (as they largely still are) as remnants of a discarded "Hegelian" tradition.' T. J. Clark and Donald Nicholson-Smith, 'Why Art Can't Kill the Situationist International', *October*, no. 79 (Winter 1997), p. 13.

15. György Lukács, 'The Phenomenon of Reification,' *History and Class Consciousness* [1923], trans. Rodney Livingstone (London: Merlin Press, 1971), pp. 83–110.

16. Guy Debord, *Society of the Spectacle*, p. 15.

17. I should note that Debord continued to make films prior to, and well after, this period, beginning with *Hurlements en faveur de Sade de Sade* (1952) to his final film, *In girum imus nocte et consumimur igni* (1978).

18. J. V. Martin, J. Strijbosch, R. Vaneigem and R. Viénet, 'Response to a Questionnaire from the Center for Socio-Experimental Art', trans. Kenneth Knabb, in Knabb (ed.), *Situationist Anthology* (Berkeley: Bureau of Public Secrets, 1981), p. 146.

19. Ian Burn, 'The Art Market: Affluence and Degradation', *Artforum,* vol. 13, no. 8 (1975), pp. 34–7.

20. Helen Grace records how Ian Burn joined the International Brotherhood of Teamsters Union while working in a Harlem picture framing business, participating in various strike actions and picket lines. For this reference and for further information on the activities of the Artworker's Union of Australia, see Helen Grace, 'So I Joined the Teamsters', *Artists Think: The Late Work of Ian Burn* (Sydney and Melbourne: Power Institute and Monash University Gallery of Art, 1996), ibid.

21. For the connection between art, labour, activism and the North American experience, see Julia Bryan-Wilson, *Art Workers: Radical Practice in the Vietnam Era* (Berkeley and Los Angeles; University of California Press, 2009).

22. To see how this thread of cultural-labour activism continues today, particularly around resisting precarity, I suggest Greig de Peuter and Nicole S. Cohen, 'Emerging Labour Politics in Creative Industries', in Kate Oakley and Justin O'Connor (eds), *The Routledge Companion to the Cultural Industries* (New York: Routledge, 2015), pp. 305–6.
23. David Harvey, *A Brief History of Neoliberalism*, p. 2.
24. Frédéric Lordon, *The Willing Slaves of Capital: Spinoza and Marx on Desire*, trans. Gabriel Ash (London and New York: Verso, 2014), p. 11. *Willing Slaves* was originally published as *Capitalisme, désir et servitude* (Paris: La Fabrique éditions, 2010).
25. Catherine Malabou, *What Should We Do with Our Brains?*, trans. Sebastian Rand (New York: Fordham University Press, 2008), p. 4. Malabou conceives the brain as having the 'capacity to annihilate the very form it is able to receive or create'. And that it is 'situated between two extremes: on the one side the sensible image of taking form (sculpture or plastic objects), and on the other side that of the annihilation of all form (explosion)' (Ibid. p. 5).
26. Massimo Cacciari, *Architecture and Nihilism: on the Philosophy of Modern Architecture*, trans. Stephen Sartarelli (New Haven, CT: Yale University Press, 1993), p. 103.
27. Ibid.
28. Frédéric Lordon, *The Willing Slaves of Capital*, p. 88.

Part II: Introduction

1. Razmig Keucheyan, *The Left Hemisphere: Mapping Critical Theory Today* (London and New York: Verso, 2014), p. 7.
2. In respect to Howard Caygill's research, the events of May '68 are used here as way to speak about shifts in leftist thinking and not to overload the significance of the event. As Caygill proposes, the uprisings of May '68 began in Paris on 27 October 1960 as a demonstration against French colonial rule in Algeria that ended in brutal police repression. Over the decade, this turned into a cycle of resistance/repression/ counter-resistance. *On Resistance: A Philosophy of Defiance* (London: Bloomsbury, 2015).
3. Alain Touraine stresses that to see, as many commentators have, the 'May–June crisis' in terms of three phases – a student phase, a workers' phase, a political phase, leading to the progression into a revolutionary crisis – is to misunderstand the central force of the students and the significant role they played in the emerging social movements that for him marks May 1968. It is a conformism, he insists, to see the events as 'a crisis of French society or as an ensemble crisis of modernisation and change [for] the May Movement questioned the forms of domination and alienation in any advanced capitalist society.' *The May Movement; Revolt and Reform: May 1968 – The Student Rebellion and Workers' Strikes – The Birth of a Social Movement* [1968], trans. Leonard F. X. Mayhew (New York: Random House, 1971), p. 77.
4. Keith A. Reader, with Khursheed Wadia, *The May 1968 Events in France: Reproductions and Interpretations* (Basingstoke: Macmillan, 1993), p. 16.

5. Keith A. Reader, *The May 1968 Events in France,* p. 11.
6. Angelo Quattrocchi and Tom Nairn, *The Beginning of the End* (London and New York: Verso, 1998), p. 2.
7. Ibid. p. 40.
8. Quoted in Angelo Quattrocchi and Tom Nairn, *The Beginning of the End*, p. 14.
9. M. Winock, *Chronique des années soixante* (Paris: Editions du Seuil, 1978), quoted in Keith A. Reader, *The May 1968 Events*, p. 11.
10. Ibid. p. 14.
11. Peter Uwe Hohendahl, 'Autonomy of Art: Looking Back at Adorno's Ästhetische Theorie', *The German Quarterly*, vol. 54, no. 2 (March 1981), p. 133.
12. Ibid.
13. Ibid. p. 134.
14. Peter Osborne, *Anywhere or Not at All: Philosophy of Contemporary Art* (London and New York: Verso, 2013).

5 Encounter One: Pier Paolo Pasolini and Italo Calvino

1. The poem *Lines* by Arthur Rimbaud (c.1874–5) is reprinted in *Arthur Rimbaud Complete Works,* trans. Paul Schmidt (New York: Harper and Row Publishers, 1976), p. 221. The poem was chosen as an introduction to Pasolini ostensibly for its evocation of Paolo Pasolini's *Le Ceneri di Gramsci* (*The Ashes of Gramsci*) (1957). Rimbaud was an important, early influence on Pasolini. As Enzo Siciliano, in the Foreword to *Pier Paolo Pasolini: Poems*, notes: 'He who believed as a boy that after Rimbaud poetry was dead, after having been a poet, celebrates the funeral rite of his own poetry, sings its dirge.' Ed. Norman MacAfee (New York: Farrar, Straus, and Giroux, 1996), p. xi.
2. *Stracci* is colloquialism for sub-proletariat, the literal translation of which is 'rags'.
3. According to Paisley Livingston, in a review of *Pasolini*, ed. Maria Antonietta Macciocchi (Paris: Grasset, 1980), 'Defending his 'naïve' belief in the realism of the cinematic image, Pasolini contested the truths of semiology and structuralism at the time of their greatest popularity.' *MLN*, vol. 96, no. 4, French Issue (May 1981), p. 913.
4. Pier Paolo Pasolini (1922–82), *A Desperate Vitality*, 1964. I am using the Pasquale Verdicchio translation here, reprinted in Jack Hirschman (ed.), *In Danger: A Pasolini Anthology* (San Francisco: City Lights Books, 2010), p. 79.
5. Translator's footnote says that the specific Godard film reference is *Mepris (Contempt)* 1963, Pasquale Verdicchio, in Hirschman, p. 62.
6. Pasolini's references to Jean-Luc Godard and his sighting of Belmondo could be seen as a way to evoke a Godard-like spirit or even fashion which, in its seductive fashionability, dilutes for Pasolini its claimed political intent.
7. Walter Benjamin, *The Arcades Project,* [D2a,3], trans. Howard Eiland and Kevin McLaughlin (Cambridge, MA and London: Harvard University Press, 1999), p. 105.
8. Hirschman, p. 8.

9. Pasolini, 'Italo Calvino's *Invisible Cities*', in Hirschman, p. 116.
10. Ibid. pp. 119–20.
11. Calvino, 'To Piero Pasolini – Rome' Paris, 7.2.73, in *Italo Calvino: Letters 1941–85*, trans. Martin McLaughlin (Princeton: Princeton University Press, 2013), p. 427.
12. Ibid. p. 428.
13. Calvino, 'To Mario Socrate and Vanna Gentili – Rome', San Remo, 26.6.70, *Letters*, p. 383.
14. Italo Calvino, 'Finding One's Way as a Writer: A Sequence of Letters', trans. Martin McLaughlin, *New England Review*, vol. 34, no. 1 (2013), p. 57.
15. Raymond Queneau and François le Lionnais founded *Ouvroir de littérature potentielle*, which translates as 'Workshop for Potential Literature' in 1960. Calvino joined Oulipo in 1968.
16. Anna Botta, 'Calvino and the Oulipo: An Italian Ghost in the Combinatory Machine? *MLN*, vol. 112, no. 1, Italian Issue (January 1997), pp. 81–9. Botta outlines the rejection in 1990 of Calvino's books of 'the Paris period' by ten Italian critics. They were judged as 'greatly inferior' (p. 81) to his earlier works and overly affected by 'the French poison of à la Queneau and Perec' (p. 83) and thus 'ceased to be recognizably Italian' (p. 83).
17. Roland Barthes, 'The Death of the Author' in *Image, Music Text*, trans. Stephen Heath (London: Fontana Press, 1977), pp. 142–8. An updating for a twenty-first century context of Barthes' thesis can be found in Jacques Rancière, 'The Death of the Author, The Life of the Artist', *Chronicles of Consensual Time*, trans. Steve Corcoran (New York and London: Continuum, 2010), pp. 101–5.
18. Pasolini, 'Italo Calvino's *Invisible Cities*', in Jack Hirschman, pp. 119–20.
19. At the time, Calvino, along with Umberto Eco were categorised as Postmodernists.
20. Jonathan Galassi, 'The Dreams of Italo Calvino', *New York Review of Books* (20 June 2013), <www.nybooks.com/articles/archives/2013/jun/20/dreams-italo-calvino>, last accessed 28 January 2019.
21. Ibid.
22. Alessia Ricciardi, *After La Dolce Vita: A Cultural Pre-History of Berlusconi's Italy* (Stanford: Stanford University of Press, 2012), p. 3.
23. Ibid.
24. Ibid.

6 Encounter Two: Lefebvre and Blanchot

1. Henri, Lefebvre, *Critique de la vie quotidienne, vol. I,* 1947; as *Critique of Everyday Life,* trans. John Moore (London: New York: Verso, 1991), p. 127.
2. Henri Lefebvre, *Everyday Life in the Modern World,* trans. Sacha Rabinovitch (New York: Harpers Torchwood, 1971), p. 37f.
3. There was a second volume of *Critique de la vie quotidienne: Fondements d'une sociologie de la quotidienneté, vol. II* (Paris: L'Arche, 1961).
4. Lefebvre, *Critique of Everyday Life,* p. 258.

5. Ibid. p. 97.
6. Ibid.
7. Ibid. p. xiv. With Lefebvre's ambition to infuse Marxism with new life, as well as his valorisation of Hegel in the context of Western Marxism, there are obvious connections to be drawn with György Lukács and his earlier *History and Class Consciousness* (1919–23). As Michael Trebitsch notes in the 'Preface' to *Critique of Everyday Life* (pp. xvi–xix): '*The* full significance of the relationship between Lukács and Lefebvre emerges quite clearly if we think not in terms of influence but rather in terms of two parallel but chronologically separated intellectual journeys, both leading from ontology to Marxism.' Lefebvre had not been exposed to the earlier text directly but had come to similar conclusions via his knowledge of Heidegger's *Being and Time*, in which the concept of *Alltäglichkeit* as the inauthentic existence of *Dasein* was shown by Lucien Goldmann (French philosopher, sociologist and a Lefebvre co-author) to owe so much to Lukács' *History of Class Consciousness.*
8. Lefebvre's *Critique of Everyday Life* was developed out of an earlier paper entitled *La Conscience mystifée*, co-written with Norbert Guterman (Paris: Gallimard, 1936.)
9. 'Preface', p. xiv.
10. *Everyday Life in the Modern World*, p. 13.
11. Henri Lefebvre, *Critique of Everyday Life, Volume I*, p. 510.
12. According to Mark Poster, Lefebvre was finally expelled from the Party in 1957 for his criticisms of intellectual life under Stalin, which brought him before the Central Committee to be interrogated about his 'lack of discipline' for publishing articles without the approval of the Party. Mark Poster, *Existential Marxism in Postwar France: From Sartre to Althusser* (Princeton: Princeton University Press, 1975), p. 238. However, in the 'Preface' to *Critique of Everyday Life*, Trebitsch identifies the years between 1948 and 1957 as a time when Lefebvre 'did not publish a single work of Marxist theory' due to the Party putting a stop to most of his projects (pp. xiii–xiv).
13. Ibid. p. 242.
14. Lefebvre's assistant at the University of Nanterre, Jean Baudrillard, published *Mirror of Production,* trans. Mark Poster (St Louis: Telos Press, 1975). It is a prolonged, critical exploration on this very aspect of Marx's theory of alienation. His arguments developed here will be expanded, exaggerated, and eventually disbanded to become the launching ground for his eventual move from a more grounded semiurgy to his later, entrapping accounts of hyperreality. See especially works published from the early 1980s onwards, such as *Simulacra and Simulation,* trans. Sheila Faria Glaser (Ann Arbor: University of Michigan Press, 1994).
15. Henri, Lefebvre, *Everyday Life in the Modern World*, pp. 30–1.
16. Ibid. p. 31.
17. Aside from personal insults, there were also reciprocal accusations of plagiarism that eventually soured the relationship. For a description of the relationship that

was forged between Lefebvre and the situationists from Lefebvre's perspective, see Kristin Ross, 'Lefebvre on the Situationists: An Interview,' *October*, no. 79 (Winter 1997), pp. 69–83.

18. The situationists were active at the universities of Strasbourg and Nanterre where Henri Lefebvre's lectures were popular rallying points for a range of young Leftist groups, including Debord and the situationists. It will be from the new University of Nanterre, situated in a bleak, satellite town on the outskirts of Paris that May 1968 first bursts forth on its way to engulfing the Sorbonne and then the rest of Paris and beyond.

19. Unaccredited, 'The Sound and the Fury', *Internationale Situationniste* #1 (June 1958), reprinted in Kenneth Knabb, *Situationist International Anthology* (Berkeley: The Bureau of Public Secrets, 1981), p. 41.

20. Guy Debord, 'Perspectives for Conscious Alterations in Everyday Life' (1961), at a conference of the Group for Research on Everyday Life, convened by Henri Lefebvre in the Centre of Sociological Studies, Knabb, p. 69.

21. Ibid. p. 72.

22. Ibid. p. 69.

23. Ibid.

24. *Everyday Life in the Modern World*, p. 31.

25. Maurice Blanchot, 'Everyday Speech' [1959], trans. Susan Hanson, ed. Alice Kaplan and Kristin Ross, *Yale French Studies*, no. 73, special issue, *Everyday Life* (1987).

26. Ibid. p. 17.

27. Ibid. p. 15.

28. Maurice Blanchot, 'Everyday Speech', p. 20.

29. Ibid. p. 19.

30. Guy Debord, 'Perspectives for Conscious Alterations in Everyday Life', Knabb, p. 70.

31. Blanchot, p. 17.

32. Ibid. p. 16.

33. *The Turin Horse* (Hungary), 2011, dir. Béla Tarr, 35 mm, black and white, 186 mins.

34. Bela Tarr noted, '*The Turin Horse* is about the heaviness of human existence. How it's difficult to live your daily life, and the monotony of life. We didn't want to talk about mortality or any such general thing. We just wanted to see how difficult and terrible it is when every day you have to go to the well and bring the water, in summer, in winter … All the time. The daily repetition of the same routine makes it possible to show that something is wrong with their world. It's very simple and pure.' Interview between Béla Tarr and Vladan Petkovic, Cineuropa.org <http://cineuropa.org/it.aspx? t=interview&lang=en&documentID=198131>, last accessed 2 January 2016.

35. Although, he is unnamed in the film, the credits identify the coachman as Ohls-dorfer.

36. As Edward Lawrenson notes, following this long opening shot, 'The subsequent six days unfurl in only twenty-eight shots that explore this peasant couple's envi-

ronment in elegant, gliding movements attuned to the sluggish rhythms of the characters' activity.' 'Edge of Darkness', *Film Quarterly*, vol. 64, no. 4 (Summer 2011), pp. 66–7.

37. Jacques Rancière, *Béla Tarr, the Time After,* trans. Erik Beranek (Minneapolis: Univocal Publishing, 2014), pp. 80–1.

38. In the Cineuropa.org interview with Vladan Perkovic, Bela Tarr said of the visitor, 'He is a sort of Nietzschean shadow, we had to show that, but he had to differ from Nietzsche. Our starting point was Nietzsche's sentence, God is dead. This character says, "We destroyed the world and it's also God's fault", which is different from Nietzsche. The key point is that the humanity, all of us, including me, are responsible for destruction of the world. But there is also a force above human at work – the gale blowing throughout the film – that is also destroying the world. So both humanity and a higher force are destroying the world.' <http://cineuropa.org/it.as px?t=interview&lang=en&documentID=198131>, last accessed 28 January 2019.

39. English translation taken from the subtitles of the Artificial Eye DVD, 2011.

40. Gilles Deleuze, *Nietzsche and Philosophy*, trans. Hugh Tomlinson (London and New York: Continuum, 2005), p. 43.

41. Interview between Virginie Sélavy and Béla Tarr, *Electric Sheep: A Deviant View of Cinema* (4 June 2012), <www.electricsheepmagazine.co.uk/features/2012/06/04/the-turin-horse-interview-with-bela-tarr>, last accessed 28 January 2019.

42. Maurice Blanchot, 'Everyday Speech', p. 16.

43. Chantal Akerman, *Jeanne Dielman, 23 Commerce Quay, 1080 Brussels* (1975) colour, 35 mm, 201 mins.

44. Guy Debord, 'Perspectives for Conscious Alterations in Everyday Life', Knabb, p. 69.

45. Oliver Marchart, *Post-foundational Political Thought: Political Difference in Nancy, Lefort, Badiou and Laclau* (Edinburgh: Edinburgh University Press, 2007), p. 8.

7 Encounter Three: Art and the Socialist State

1. *Prerokbe ognja (Predictions of Fire)* (Slovenia/USA), documentary on NSK, dir. Michael Benson, 1996, colour, 90 mins.

2. Christopher Bennett noted, 'The 1980s in Slovenia were something of a golden age as far as cultural creativity and artistic innovation are concerned.' *Yugoslavia's Bloody Collapse: Causes, Course and Consequences* (London: Hurst and Company, 1995), p. 102.

3. Tomaz Mastnak, 'From Social Movements to National Sovereignty', in Jill Benderly and Evan Kraft (eds), *Independent Slovenia: Origins, Movements, Prospects* (New York: St Martin's Press, 1995), p. 94.

4. Tomaz Mastnak noted, once the more liberal days of the 1960s had dissolved into harder times in the 1970s, 'a systematic and massive purge of economic, political, and cultural apparatuses marked the dawn of the leaden seventies, the era of the cultural revolution Yugoslav style.' Ibid. p. 93.

5. Bennett stresses that Slovenes 'were very committed both to the Yugoslav ideal and the state which had shielded them from German and Italian nationalisms and enabled them to evolve a thriving and independent culture' (p. 103).

6. Bennett notes, 'The same disillusionment with Yugoslavia's bankrupt Marxist-Leninist ideology which evolved into extreme nationalism in Serbia spawned a confident, albeit cynical, modern Slovene national identity, prepared, if necessary, to go it alone and turn its back on the rest of the country.' *Yugoslavia's Bloody Collapse*, p. 11.

7. See Mastnak, 'From Social Movements to National Sovereignty' and Gregor Tomc, 'The Politics of Punk', both from *Independent Slovenia*, p. 94.

8. Alexei Monroe, 'Twenty Years of Laibach. Twenty Years of . . . ? Slovenia's Pro-vocative Musical Innovators', *Central Europe Review*, vol.2, no.3, 2000, <www.ce-review.org/00/31/monroe31.html>, last accessed 28 January 2019.

9. Alexei Monroe, 'Twenty Years of Laibach'.

10. Anthony Gardner, *Politically Unbecoming: Postsocialist Art against Democracy* (Cambridge, MA: MIT Press, 2015), pp. 119–20.

11. Quoted in *Predictions of Fire*.

12. Alexei Monroe comments in 'Twenty Years of Laibach' that the Slovene language is spoken by a population of only 2 million and considered obscure even by the other South Slavs, it is often seen as 'hopelessly provincial'.

13. Marina Gržinić, 'Synthesis: Retro-avant-garde, or Mapping Post-Socialism in Ex-Yugoslavia', *ARTMargins* (September 2000), http://www.artmargins.com/index.php/8-archive/258-synthesis-retro-avant-garde-or-mapping-post-social-ism-in-ex-yugoslavia-, last accessed 16 January 2019.

14. Magdalena Dabrowski, Leah Dickerman and Peter Galassi (eds), *Aleksandr Rodchenko* (New York: Museum of Modern Art, 1998) 14ff.

15. In 1930, all of Malevich's documents were destroyed for his supposed over-famil-iarity with the West.

16. Katalin Néray, 'Irwin in Budapest', Néray, Katalin, et al., *Irwin: Interior of the Planit* (Ljubljana, Slovenia: Moderna galerlja, Budapest and Ludwig Museum, 1996), unpaginated.

17. *Predictions of Fire*.

18. Irwin, and Eda Cufer, *Retroavantgarda: Mladen Stilinovic, Kasimir Malevic, Irwin* (Ljubljana, Slovenia:Visconti Fine Art Kolisej, 1994).

19. *Predictions of Fire*.

20. Marina Gržinić, 'Total Despair', *Telepolis* (19 June 1997), <www.heise.de/tp/eng-lish/speical/mud/6145/1.html>, last accessed 28 January 2019.

21. Benjamin Buchloh, 'Figures of Authority, Ciphers of Regression: Notes on the Return of Representation in European Painting', *October*, no. 16 (Spring 1981), pp. 39–68, p. 44.

22. As Gregor Tomc notes, a resolution was passed banning the use of the name as an infringement of law, 'Politics of Punk', *Independent Slovenia*, p. 122.

23. Christopher Bennett, *Yugoslavia's Bloody Collapse*, p. 5.

24. Alexie Monroe, 'Twenty Years of Laibach'.

25. Marina Gržinić, 'Synthesis', *ARTMargins.*

26. Edgar Morin, 'The Anti-Totalitarian Revolution,' *Between Totalitarianism and Postmodernity,* ed. P. Beilharz, Gillian Robinson and John Rundell (Cambridge, MA: MIT Press, 1992), p. 95.

27. In the spirit of collectivism promoted by NSK, this statement, including the reference to Norman Bryson, has been attributed to both Eda Cufer and Irwin, 'NSK State in Time', *Irwin: Interior of the Planit.*

28. Gardner, p. 125.

29. *Predictions of Fire.*

30. Marina Gržinić, 'Synthesis', *ARTMargins.*

31. Slavoj Žižek, 'Es gibt keinen Staat in Europa' (1992), in: Padiglione NSK/Irwin, Gostujoci umetniki – Guest artists, exhibition catalogue XLV, Biennale di Venezia 1993, Moderna Galerija, Ljubljana 1993, quoted in Inke Arns, *Continued: Mobile States . . . / (NSK)*, <www.backspace.org/everything/e/hard/texts2/cnsk.html>, last accessed 16 January 2019.

32. Marina Gržinić, 'Synthesis', *ARTMargins.*

33. Ibid. Inke Arns.

34. Gardner, p. 118.

35. *Predictions of Fire.*

36. *Predictions of Fire.*

37. Quoted in Judith Williamson, 'An Interview with Jean Baudrillard', trans. Brand Thumim, *Block*, 15 (1989), p. 17.

38. Jean Baudrillard, *Paroxysm: Interviews with Philippe Petite* (London and New York: Verso, 1998), p. 2.

39. Jean Baudrillard, *Mirror of Production*, trans. Mark Poster (St Louis: Telos Press, 1975).

40. Jean Baudrillard, 'Seduction, or, the Superficial Abyss', *The Ecstasy of Communication,* trans. Bernard Schutze and Caroline Schutze (New York: Semiotext(e) Columbia University, 1987), p. 59.

41. Ibid. p. 62.

42. Jean Baudrillard, *America*, trans. Chris Turner (London and New York: Verso, 1988), p. 76.

43. Ibid. p. 27.

44. Jean Baudrillard, *The Spirit of Terrorism and the Requiem of the Twin Towers*, trans. Chris Turner (New York and London: Verso Books, 2002).

45. Ibid. p. 4.

45. Ibid. p. 9.

46. Steven Best, 'The Commodification of Reality and the Reality of Commodification: Baudrillard, Debord and Postmodern Theory', in D. Kellner (ed.), *Baudrillard: A Critical Reader* (Cambridge, MA and Oxford: Blackwell, 1994), p. 62.

47. It is strange to discover that in 2015, Laibach became the first-ever Western group to perform in North Korea's capital, Pyongyang, returning to the restraints of a Communist state, while playing a set that included songs from *The Sound of Music*, as well as some 'Laibach originals'. They named the show the *Liberation Day Tour*,

purportedly to mark the seventieth anniversary of North Korea's independence from Japan after the Second World War, an historical moment that was also of significance to Slovenia in its post-war communist transformation. An official statement said of Laibach's return, a homecoming of sorts that: 'The Performers showed well the artistic skill of the band through peculiar singing, rich voice and skilled rendition.' 'Laibach and North Korea's First Western Concert', BBC News (Asia) (20 August 2015), < www.bbc.com/news/world-asia-33995268>, last accessed 2 August 2017.

48. For Rancière, Foucault's term *dispositif* includes the police order. See *Dissensus on Politics and Aesthetics*, trans. Steve Corcoran (London and New York: Continuum, 2010).

49. This is a project that dealt with Edward Snowden's release through Wikileaks in 2013 of classified and highly sensitive documents from the United States' National Security Agency (NSA).

50. Phone interviews over several weeks with Peter Shand, Head of Elam School of Fine Art, The University of Auckland.

51. Interview with guest, Peter Shand. Shand was also a guest at the dinner for the announcement of the 2014 Walters Prize. The winner, selected by the guest curator, Charles Esche, was Luke Willis Thompson, who was also a finalist for the 2018 Turner Prize (Tate).

52. Vincent Descombes, *Modern French Philosophy,* trans. L. Scott-Fox and J. M. Harding (New York and Melbourne: Cambridge University Press,1980), p. 19.

Part III: Introduction

1. David Harvey, *A Brief History of Neoliberalism* (Oxford and New York: Oxford University Press, 2005), p. 2.

2. François Furet, *Passing of an Illusion: The Idea of Communism in the Twentieth Century,* trans. Deborah Furet (Chicago: University of Chicago Press, 1999), p. 502.

3. *Working Drawings and Other Visible Things on Paper Not Necessarily Meant to be Viewed as Art,* 1966, Medium: 4 identical loose-leaf binder folders. Dimensions: 29.8 x 29.2 x 7.9 cm. First exhibited in Visual Arts Gallery, New York, 1966. The work is held in the collection of the Museum of Modern Art, NY. A facsimile of the work was published in 2008 and is still in print, titled 'A Selection of Xerox Printed Preliminary Works by Artists – Based on the 1966 Book by Mel Bochner . . . '.

4. Gregory Sholette, 'Dark Matter, Activist Art and the Counter-Public Sphere', ed. Matthew Beaumont, Andrew Hemingway, Esther Leslie and John Roberts, *As Radical as Reality Itself: Essays on Marxism and Art for the 21st Century* (Bern, Switzerland: Peter Lang, 2007), p. 448.

5. Summarised by Kim Charnley, Foreword, 'Art on the Brink: *Bare Art* and the Crisis of Liberal Democracy', from Gregory Sholette, *Delirium and Resistance: Activist Art and the Crisis of Capitalism* (London: Pluto Press, 2017), p. 4.

6. Juliane Rebentisch, 'The Contemporaneity of Contemporary Art', *New German Critique*, vol. 42, no. 1 (124) (February 2015), p. 224.

7. *Soy Cuba* (1964) (translated as *I Am Cuba*), directed by Mikhail Kalatozov, co-production of the Soviet Mosfilm studio and the newly formed, Instituto Cubano del Arte e Industria Cinematográfic (Cuban Revolutionary Film Institute). It was directed and photographed by Sergey Urusevsky.

8. *Winter Soldier* (USA), Winterfilm (comprising 18 filmmakers who chose to remain anonymous) and the Vietnam Veterans Against the War (VVAW), 1972, black and white, colour, 16 mm, 96 mins.

9. As Dennis West notes, 'Development of the *I Am Cuba* project was begun in late 1962, soon after the failed CIA-supported invasion at the Bay of Pigs and the Cuban missile crisis that had swept the superpowers to the brink of nuclear disaster.' '*I Am Cuba* by Mikhail Kalatozov', *Cinéaste*, vol. 22, no. 2 (1996), p. 52.

10. Voiceover from *Soy Cuba*.

11. The film was shot on an Eclair Cameflex, using a 9.8mm Kinoptik lens. The Eclair Cameflex freed up camera movements through the 1950s and 1960s. The camera was owned by the Director of Photography, Sergey Urusevsky. 'Handheld Heaven, Agitprop Purgatory', *Film Comment*, vol. 31, no. 2 (1995), pp. 87–8.

12. This is just one moment among many. As Dale Thomajan writes, 'Some of the film's shots look technically impossible. Consider the one that follows the ramblings of the old farmer, driven half mad by Yankee capitalism. At one point, after tracking him back and forth through an open field, the camera levitates without a cut to fix him in an overhead shot as if it's wound about a tree that isn't there.' 'Handheld Heaven, Agitprop Purgatory', *Film Comment*, vol. 31, no. 2 (1995), pp. 87–8.

13. Commentary from a veteran in *Winter Soldier*.

14. In 1971, over three days in January and February, the Vietnam Veterans Against the War (VVAW) held the Winter Soldier Investigation hearings in Howard Johnson's New Center Motor Lodge in Detroit, Michigan. It covers the testimony of 116 veterans and 16 civilians who had participated in, or witnessed atrocities by the US forces in Vietnam from 1963 to 1970. The film was released in 1972.

15. Rather than transcribing the stories here, and thus losing connection with the 'confessor', it is better to watch the film, which is currently available on YouTube: <www.youtube.com/watch?v=h4ZkGYKYFak>, last accessed 28 January 2019; and the full testimony was published in the *Congressional Record of April 6 and 7, 1971* and was published as *The Winter Soldier Investigation: An Inquiry into American War Crimes* (Boston, MA: Beacon Press, 1972). Writing at the time, Jake McCarthy noted, 'Americans haven't rushed to read about it ... how do we achieve amnesty for the American soul, which knows it has been guilty of sin in Vietnam, and doesn't have the guts to face the issue.' See 'A Film You Shouldn't See: A Personal Opinion', *St. Louis Post-Dispatch* (23 October 1972), <www.wintersoldierfilm.com/reviews_102372_stlouis. htm>, last accessed 31 January 2019.

16. In Europe, *Winter Soldier* won the Interfilm Award, Forum of New Cinema at the Berlin International Film Festival. In 1972, it was reviewed at the Cannes Film Festival, and screened in selected cinemas in Europe and on German TV.

17. As *Variety* noted, in May 1972, 'during Critic's Week at Cannes, *Winter Soldier* was offered to television in the US but rejected by all three commercial networks and public TV (ABC, CBS, NBC and PBS). This was in spite of the Pentagon's inability to criticise or refute any of the testimony. After many months, the film was aired on WNET-TV, the New York non-commercial station, and just previous to that was seen in part, along with a panel discussion, on WNYC-TV's *All About Television* series. (WNYC-TV is New York's city-owned UHF station. Also, the hearings were aired via eight hours of tape on Pacifica Foundation's listener-sponsored stations – ED.)'

18. Michael Wile, a Winterfilm member, commented in an interview: 'We figured the media would ignore it, and they did. Swarms of reporters showed up but there was little real coverage. I personally saw story after story killed. Feeds went out over the wire, but nothing was ever printed.' Quoted in Sally Helgesen, 'Scenes', *The Village Voice* (27 January 1972), < http://www.wintersoldierfilm.com/reviews_012772_voice.htm>, last accessed 31 January 2019.

19. Bruce Williams, 'Winter Soldier Review', *Playboy* (May 1972), <www.wintersoldierfilm.com/reviews_0572_playboy.htm>, last accessed 31 January 2019.

20. Amos Vogel, 'Atrocities and Artless Innocence', *The Village Voice* (3 February 1972).

21. '*Winter Soldier,* A Remembrance of Vietnam Atrocities', National Public Radio broadcast (August 2005), <www.npr.org/templates/story/story.php?storyId=4800067>, last accessed 28 January 2019.

22. 'The Brazilian filmmaker Vicente Ferraz interviewed crew members about their experiences making the film. They explained, in short, that the Cuban audience "felt insulted". The characters seemed to react mechanically to structural circumstances, like pawns in a revolutionary chess game. Sergio Corrieri, who played a student-revolutionary in the film, recalled people saying, "This really isn't our reality. This character doesn't exist, it isn't Cuban . . . it was the Cuban reality seen through a Slavic prism".' Quoted in Blake Scott, 'I Am Cuba, For Sale, 1964', Not Even the Past, <http://notevenpast.org/i-am-cuba-sale>, last accessed 28 January 2019.

23. Martin Scorsese continues, 'If we had known this picture existed back in 1964, maybe cinema would have been different now.' Introduction to the Milestone Film and Video production of *Soy Cuba,* transcribed from: <www.youtube.com/watch?v=cMSHXWda_J0>, last accessed 28 January 2019.

24. Ibid. Martin Scorsese and Francis Ford Coppola were asked to endorse *Soy Cuba*'s 're-release'. Scorsese explains in the introduction to the film that he was in production for *Casino* (1995) at the time, so that would make it the early 1990s.

25. Andrew Benjamin, 'Hope at the Present', in Benjamin, *Present Hope: Philosophy Architecture, Judaism* (London: Routledge, 1997), p. 10.

26. Ibid. p. vii.

27. Ibid. p. 8.
28. Ibid. p. 1.
29. Ibid. p. 2.
30. Ibid. p. viii.
31. Ibid.
32. Andrew Benjamin, 'Benjamin Heidegger Showing the Present', in Andrew Benjamin and Peter Osborne (eds), *Walter Benjamin's Philosophy: Destruction and Experience* (London: Routledge, 1994), p. 217.
33. Andrew Benjamin, 'Benjamin and Heidegger Showing the Present', in Benjamin, *Present Hope: Philosophy Architecture, Judaism* (London: Routledge, 1997), p. 53.
34. Martin Scorsese, ibid.
35. Giorgio Agamben, 'The Power of Thought', *Critical Inquiry,* vol. 40, no. 2 (Winter 2014), pp. 480–91.
36. Michel Foucault, *The Government of Self and Others: Lectures at the Collège de France, 1982–1983,* ed. Frédéric Gros, trans. Graham Burchell (Basingstoke: Palgrave Macmillan, 2011), pp. 41–59.
37. Walter Benjamin, 'Left Wing Melancholy', trans. Ben Brewster, in Howard Eiland and Michael W. Jennings (eds), *Walter Benjamin Selected Writings*, vol. 2 (Cambridge, MA and London: Harvard University Press, 1996), p. 425.
38. Rolf Tiedemann, 'Dialectics at a Standstill', *The Arcades Project: Walter Benjamin,* trans. Howard Eiland and Kevin McLaughlin (Cambridge, MA and London: Belknap Press of Harvard University Press, 1999), p. 944.
39. Karl Marx, *Theses on Feuerbach* (Spring 1845), Marx/Engels Internet Archive, <www.marxists.org/archive/marx/works/1845/theses/theses.htm>, last accessed 12 May 2018.
40. Étienne Balibar, *The Philosophy of Marx*, trans. Chris Turner (London and Brooklyn: Verso), p. 146.
41. Irving Wohlfarth, '"Männer aus der Fremde": Walter Benjamin and the "German-Jewish Parnassus"', *New German Critique*, no. 70 (Winter 1997), p. 12.
42. Gershom Scholem, *Kabbalah* (Jerusalem and Toronto: Keter Publishing and Quadrangle, the New York Times Book Company, 1974), p. 167.
43. Anson Rabinbach, 'Between Enlightenment and Apocalypse: Benjamin, Bloch and Modern German Jewish Messianism, *New German Critique*, no. 34 (Winter 1985), p. 121.
44. For a close analysis of the nuances of translation across these essays, see Tobias Wilke, 'Tacti(ca)lity Reclaimed: Benjamin's Medium, the Avant-Garde, and the Politics of the Senses', *Grey Room*, no. 39 (Spring 2010), pp. 39–55.
45. Matthew Charles 'Secret Signals from Another World: Walter Benjamin's Theory of Innervation', *New German Critique*, vol. 45, no. 3 (135) (November 2018), pp. 39–40.
46. Miriam Bratu Hansen, 'Benjamin's Aura', *Critical Inquiry*, vol. 34 (Winter 2008), p. 336.
47. Walter Benjamin, *The Arcades Project,* trans. Howard Eiland and Kevin McLaughlin (Cambridge, MA and London: Harvard University Press, 1999), p. 631.

48. Charles, 'Secret Signals', p. 39.
49. Matthew Charles, ibid.
50. Walter Benjamin, 'Surrealism: The Last Snapshot of the European Intelligentsia', *One-Way Street* (London and New York: Verso, 1997), p. 229.
51. Walter Benjamin, 'Surrealism', *One-Way Street*, p. 237.
52. Ibid. p. 237.
53. Werner Hamacher, '"Now": Walter Benjamin on Historical Time', in Heidrun Friese (ed.), *The Moment: Time and Rupture in Modern Thought* (Liverpool: Liverpool University Press, 2001), p. 195, n. 45.
54. Gilles Deleuze, 'Michel Foucault's Main Concepts', in Nicolae Morar, Thomas Nail and Daniel W. Smith (eds), *Between Deleuze and Foucault* (Edinburgh: Edinburgh University Press, 2016), p. 59.
55. Claire Colebrook, 'Deleuzian Politics? A Roundtable Discussion', *New Formations* (2009), p. 145.
56. See Gilles Deleuze texts, *Différence et Repetition* (1968); *Difference and Repetition,* trans. Paul Patton (New York: Columbia University Press, 1994); and *Logique du sens* (1969) *Logic of Sense,* trans. Mark Lester with Charles Stivale (London: Athlone Press, 1969).
57. Ibid. p. 7, italics in the original.
58. Elizabeth Grosz, *The Incorporeal: Ontology, Ethics, and the Limits of Materialism* (New York: Columbia University Press, 2017), p. 18.
59. Ibid. p. 250.
60. While many new materialists claim to be forming ways to escape human-centric thought by giving agency to things, they seem instead to anthropomorphise all matter, and thereby remain imprisoned in a circle of their own making. For a systematic response that looks more fulsomely at the this, see William Connelly, 'The New Materialism and the Fragility of Things', *Millennium: Journal of International Studies* , vol. 41, no. 3 (2013), pp. 399–412. Connelly uses this as research for *The Fragility of Things: Self-Organizing Processes, Neoliberal Fantasies, and Democratic Activism* (Durham, NC: Duke University Press, 2013) to critique what he sees as a piecemeal approach to contemporary forces.
61. Elizabeth Grosz, *The Incorporeal*, p. 250.
62. Gilles Deleuze and Felix Guattari, *What is Philosophy?*, trans. Hugh Tomlinson and Graham Burchell (New York: Columbia University Press, 1994), p. 164.
63. John Rajchman, *The Deleuze Connections* (Cambridge, MA and London: MIT Press, 2000), p. 114.
64. Ibid.
65. Gilles Deleuze, *Cinema II: The Time Image,* trans. Hugh Tomlinson and Robert Galeta, *Cinéma II, L'Image-Temps,* 1985 (Minneapolis: University of Minnesota Press, 1989).
66. Rancière, 'A Few Remarks on the Method of Jacques Rancière', *Parallax,* vol. 15, no. 3 (2000), pp. 114.
67. Jean-Philippe Deranty (ed.), *Jacques Rancière: Key Concepts* (Oxford and New York: Routledge, 2014), p. 187.

68. Lucy Lippard, *Six Years: The Dematerialization of the Art Object from 1966 to 1972: A Cross-reference Book of Information on Some Aesthetic Boundaries* (London: Studio Vista, 1973), p. vii.

69. Georges Didi-Huberman, *Confronting Images: Questioning the Ends of a Certain History of Art*, trans. John Goodman (University Park: Pennsylvania State University Press, 2005), p. 20.

70. T. J. Clark, *The Sight of Death: An Experiment in Art Writing* (New Haven, CT and London: Yale University Press, 2006), pp. 122–3.

71. Jacques Rancière, 'Interview for the English Edition', *The Politics of the Aesthetic: The Distribution of the Sensible,* trans. Gabriel Rockhill (New York and London: Continuum, 2004), p. 61.

72. Materials consist of refugee tent and embroidery thread. See Jenny Gheith, 'Exhibiting Politics: Palestinian-American Artist Emily Jacir Talks about her Work', *The Electronic Intifada* (4 November 2004), <http://electronicintifada. net/content/exhibiting-politics-palestinian-american-artist-emily-jacir-talks-about-her-work/5295>, last accessed 28 January 2019.

73. Emily Jacir, *Made in Palestine*, The Station Museum, Houston, TX, <www.stationmuseum.com/Made_in_Palestine-Emily_Jacir/jacir.html>, last accessed 28 January 2019.

8 Frances Barrett – A Politics to Come

1. Jacques Rancière, 'The Aesthetic Revolution: Implotments of Autonomy and Heteronomy', *New Left Review* (March/April 2002), p. 135, fn. 1.

2. Many months later, Barrett told me that the building has been used by artists for a few decades now, but she knows nothing else about its history.

3. 'What would a feminist methodology sound like?' West Space, Melbourne, 17–18 September 2015. Liquid Architecture was formed by Danny Zuvela and Joel Stern. It is a curatorial-led arts organisation for artists working with sound and sonic experiences: <https://liquidarchitecture.org.au/info>, last accessed 28 January 2019.

4. Taken from the digital recording, 'West Space, Friday September 18, 2015', <https://liquidarchitecture.org.au/about>, last accessed 4 October 2016.

5. Giorgio Agamben, 'The Power of Thought', *Critical Inquiry,* vol. 49, no. 2 (Winter 2014), p. 482.

6. Ibid.

7. Ibid.

8. Gilles Deleuze, *Pure Immanence: Essays on Life*, trans. Anne Boyman (New York: Zone Books, 2001), p. 27.

9. Ibid. p. 31.

10. Gilles Deleuze, *Nietzsche and Philosophy*, trans. Hugh Tomlinson (London and New York: Continuum, 1986), p. 17.

11. Gilles Deleuze, *Spinoza: Practical Philosophy*, trans. Robert Hurley (San Francisco: City Lights Books, 1988), p. 20.

12. Ibid. p. 25.
13. Ibid. p. 26.
14. Gilles Deleuze, *Negotiations*, p. 173.
15. Deleuze, *Spinoza: Practical Philosophy*, p. 22.
16. Ibid. p. 23.
17. Jacques Rancière, trans. Jean-Philippe Deranty, 'The Ethical Turn in Art and Politics', *Critical Horizons*, vol. 7, no. 1 (2006), p. 2.
18. Ernesto Laclau, 'Can Immanence Explain Social Struggles', in Paul A. Passavant and Jodi Dean (eds), *Empire's New Clothes: Reading Hardt and Negri* (New York and London: Routledge, 2004), p. 23.
19. Jacques Rancière, 'The Ethical Turn in Art and Politics', p. 2.
20. Ibid.
21. Ibid.
22. Ibid. p. 10.
23. Ibid. p. 12.
24. Ibid. p. 18.
25. Jean-Philippe Deranty, 'Jacques Rancière's Contribution to the Ethics of Recognition', *Political Theory*, vol. 31, no.1 (February 2003), p. 140.
26. The conversation between Foucault and Deleuze was recorded on 4 March 1972, and first published in English in Donald F. Bouchard (ed.), *Language, Counter-Memory, Practice: Selected Essays and Interviews by Michel Foucault* (Ithaca, NY: Cornell University Press, 1977), p. 209.
27. Jacques Derrida, 'Letter to Jean Genet (fragments)', trans. Peggy Kamuf, in *Negotiations: Intervention and Interviews, 1971–2001* (Stanford: Stanford University Press, 2002).
28. For an interesting mapping back to Pascal of this tradition, see Richard Vernon, 'Pascalian Ethics? Bergson, Levinas, Derrida', *European Journal of Political Theory*, vol. 9, no. 2 (2010), pp. 167–82.
29. Rancière, 'A Few Remarks on the Method of Jacques Rancière', *Parallax*, vol. 15, no. 3 (2000), p. 114.
30. Jean-Philippe Deranty (ed.), *Jacques Rancière: Key Concepts* (Oxford and New York: Routledge, 2014), p. 187.
31. Emily Beausoleil, 'Responsibility as Responsiveness', p. 294.
32. Wendy Brown, *Regulating Aversion: Tolerance in the Age of Identity and Empire* (Princeton: Princeton University Press, 2006), p. 26.
33. Lars Tønder, *Tolerance: A Sensorial Orientation to Politics* (New York: Oxford University Press, 2013).
34. Ibid. p. 25.
35. Ibid. p. 26.
36. Wendy Brown, *Regulating Aversion*, p. 25.
37. Ibid. p. 426.
38. Jens Haaning, *Hello My Name is Jens Haaning*, Centre d'Art Mobile Besancon and Danish Contemporary Art Foundation, ed. Vincent Pécoil and Jens Haaning (Dijon: Les Presses du Réel, 2003), p. 8.

39. Jens Haaning, *Hello My Name is Jens Haaning*, p. 28.

40. Incorporates the criticism of an email sent to the artist in May 2017, by a colleague.

41. Lars Tønder writes that 'the most prominent' negative relation to tolerance 'might be the 1995 Declaration of Principles on Tolerance. Issued by UNESCO to celebrate the United Nation's fiftieth anniversary, the declaration stands out because it places tolerance within a globalized discourse of civilization that splits the international community into two dichotomously opposed characteristics: tolerance and intolerance, peace and war, reason and passion, deliberation and violence, choice and repression, moderation and fundamentalism. At the same time as these dichotomies define tolerance negatively, identifying what tolerators must reject to comply with the international society's principles of citizenship, the dichotomies also help to justify tolerance as a universally attractive concept that people of all stripes can practice without violating their commitment to a certain faith, culture, or creed' (p. 23).

42. See Yeung Yang, 'Art and What is Missing in the Socially-Engaged', *Art Review Hong Kong,* no. 1 (2006), p. 11.

43. Meeting with Joel Stern (29 June 2017).

44. Giorgio Agamben, 'The Friend' (*L'amico*, 2007), *What is an Apparatus?*, trans. David Kishik and Stefan Pedatella (Stanford: Stanford University Press, 2009), p. 35.

45. Meeting with Danni Zuvela (6 April 2016).

46. Robert Musil, *The Man Without Qualities* [1930–43], trans. Sophie Wilkins (London: Picador, 2017), p. 31.

47. Walter Benjamin, citing Karl Marx, *Charles Baudelaire: A Lyric Poet in the Era of High Capitalism,* trans. Harry Zohn (London and New York: Verso, 1997), p. 12.

48. T. J. Clark, *The Painting of Modern Life: Paris in the Art of Manet and his Followers* (Princeton: Princeton University Press, 1984).

49. Ivan Illich, 'Hospitality and Pain' (paper presented in Chicago, 1987 to a theological seminary), p. 4, <www.davidtinapple.com/illich/1987_hospitality_and_ pain.PDF>, last accessed July 2019.

50. Ibid. p. 5.

51. Ibid.

52. Illich outlines that Zeus, as guest-master, gave us the root, *ghosti* (guest, host, and hostility). The root of 'power' is *pit* or *pot*. And thus, 'hos-pit-ality', carries this double bind, the power of the host and the power of the hostile. Ibid. p. 4.

53. Ibid. p. 5

54. Ivan Illich, *Gender* (New York: Pantheon Books, 1982), p. iv.

55. Ibid. p. 5.

56. Ibid. p. 7.

57. Fabio Milana, '*Gender*: Notes to the Text', *The International Journal of Illich Studies,* vol. 5, no.1 (2016), p. 75.

58. Ibid. p. 78.

59. Illich, *Gender*, p. 84, fn. 34.

60. Ibid.
61. Ibid. p. 179.
62. Beausoleil, 'Responsibility as Responsiveness', p. 294.
63. Ibid. pp. 297–8.
64. Michel de Certeau, 'Walking in the City', *Practices of Everyday Life* (Berkeley, Los Angeles and London: University of California Press, 1984), pp. 92–3.
65. Ibid.
66. Phone call with Frances Barrett (9 July 2017).
67. Meeting with Joel Stern (29 June 2017).
68. Ibid.
69. Kelly Reichardt adapted the screenplay from three short stories written by Maile Meloy.
70. Spinoza, 'On the Origin and Nature of the Affects', pt III. *Ethics*, trans. Edwin Curley (London: Penguin Classics, 1996), p. 68.
71. Ibid. p. 70.
72. Gilles Deleuze, *Cours Vincennes*, trans. Timothy S. Murphy (24 January 1978), <www.webdeleuze.com/textes/14>, unpaginated, last accessed 24 July 2017.
73. Outside of the concerns of *Artmaking in the Age of Global Capitalism* are the discourses from the discipline of performance studies that look at the material resonances of the medium, such as the attenuated debates about whether liveness is the only pure form (Peggy Phelan), and her conviction that remediation via documentation destroys the essence of performance, or the counter-arguments about the value of documentation (Amelia Jones).
74. At this point, it is tempting to think about the problem of representation dealt with so extensively by Emmanuel Levinas in *Totality and Being*. How metaphysics has conceptualised representation throughout the history of Western philosophy becomes the foundation upon which he builds ethics as a first principle of metaphysics. The inevitability upon which 'Desire and goodness' become the 'asymmetrical of the I and the other' (p. 297) for Levinas is a starting point for delimiting the level of violence that underrides our face-to-face encounters with the other, and where the importance of the other is situated before the self. Emmanuel Levinas, *Totality and Infinity: An Essay on Exteriority*, trans. Alphonso Lingis (Pittsburgh: Duquesne University Press, 1969).
75. I was also alerted to the blindfold having become a central motif in public actions and discourses of the Black Lives Matter movement. It is a symbol for those who deny that racial bias exists in the United States' justice system. See also Alejandra Zilak, 'The Racism Blindfold', *Huffington Post* (22 June 2017), <www.huffingtonpost.com/entry/the-racism blindfold_us_58c5a514e4b0a797c1d39e3b>, last accessed 20 January 2019.
76. I was interested in reading about how the Paralympic movement is dealing with a range of low-sightedness in the dressage event by using the blindfold as a levelling device across all the participants' sightedness. 'Partially-sighted dressage rider fights new Paralympic blindfold rule', *Telegraph* (December 2015), <www.telegraph.co.uk/

news/uknews/12031519/Partially-sighted-dressage-rider-fights-new-Paralympic-blindfold-rule.html>, last accessed 20 January 2019.

77. Michaël Lévinas, 'The Final Meeting between Emmanuel Lévinas and Maurice Blanchot', trans. Sarah Hammerschlag, *Critical Inquiry,* vol. 36, no. 4 (Summer 2010), p. 651.

78. Alexandre Lefebvre, 'The Rights of Man and the Care of the Self', *Political Theory,* vol. 44, no. 4 (2016), pp. 518–40.

9 Claire Denis – The Intruder

1. 'So [the film] became for me strictly masculine and all the women characters became I would say like his crown of distant planets – Bambou, Beatrice, the little girl in the forest, the wild girl with the dog, his son's wife, of course Beatrice, and of course, important, the masseuse who is almost a magician in the film for me, she's making him alive with her hands.' Interview with Claire Denis, *L'Intrus* DVD, Tartan films Ltd, 2005.

2. Martine Beugnet, 'The Practice of Strangeness: *L'Intrus* – Claire Denis (2004) and Jean-Luc Nancy (2000)', *Film Philosophy*, vol. 12 no. 1 (2008), pp. 31–48.

3. The Dziga Vertov Group was established by Jean-Luc Godard, Anne-Marie Miéville and John-Pierre Gorin in 1968. It was a collaborative filmmaking group dedicated to politically motivated works, with Maoist ideologies. *Ici et ailleurs* used footage that the Group had shot of the Palestinian Liberation Army (PLO) used in an earlier film, *Jusqu'à la victoire* (*Until Victory / Palestine Will Win*) (1970). Shortly after the footage had been shot, the subjects were all killed. The 1974 film used this as the basis to critically reflect upon their earlier filmmaking methods. Altogether nine films were produced from the Group's inception until it wound up in 1972.

4. Deleuze, *Cinema II: The Time Image,* trans. Hugh Tomlinson and Robert Galeta, *Cinéma II, L'Image-Temps*, 1985 (Minneapolis: University of Minnesota Press, 1989), p. 180.

5. Ibid. p. 158.

6. Antonin Artaud, 'Cinema and Reality', in Susan Sontag (ed.), *Antonin Artaud: Selected Writings* (Berkeley and Los Angeles: University of California Press, 1988). Originally published in French as 'Cinéma et réalité' (1927), p. 150.

7. See Martine Beugnet's texts, 'Cinema and Sensation: French Film and Cinematic Corporeality', *Paragraph*, vol. 31, no. 2 (2008), p. 175, or her earlier book, *Claire Denis* (Manchester: Manchester University Press, 2004).

8. Antonin Artaud, 'Sorcellerie et Cinéma' [1927], in *Oeuvres complètes* (Paris: Gallimard, 1978), p. 257.

9. At this point in his argument, Deleuze is speaking through Maurice Blanchot. *Cinema II,* p. 168.

10. Deleuze notes, 'Artaud would stop believing in cinema when he considered that cinema was sidetracking and could produce only the abstract or the figurative or the dream.' *Cinema II,* p. 166.

11. Ibid. p. 165.
12. John Rajchman, *The Deleuze Connections* (Cambridge, MA and London: MIT Press, 2000), p. 127.
13. Gilles Deleuze, *Difference and Repetition*, trans. Paul Patton (London: Continuum, 2001), p. 144.
14. Ibid.
15. Ibid. pp. 144–5.
16. John Rajchman, *Connections,* p. 132.
17. 'I was not trying to break the narration. No, I was trying to follow it as surely as I could.' Interview with Claire Denis, *L'Intrus* DVD, Tartan films Ltd, 2005.
18. Claire Denis, Jean-Luc Nancy at European Graduate School 2007, <www.youtube.com/watch?v=CoTGowlhABk>, last accessed 29 January 2019.
19. Henri Lefebvre, *Introduction to Modernity: Twelve Preludes*, trans. John Moore (London: Verso, 1995), p. 54.
20. Jean-Luc Nancy, *L'Intrus*, trans. Susan Hanson (Paris: Éditions Galilée, 2000; East Lansing: Michigan State University Press, 2002).
21. Ibid. p. 3.
22. Ibid. p. 10.
23. Damon Smith, '*L'Intrus*: An Interview with Claire Denis', *Senses of Cinema*, no. 35 (2005), <www.sensesofcinema.com/contents/05/35/ claire_denis_interview.html>, last accessed 20 January 2019.
24. Nancy, p. 9.
25. Ibid. p. 3.
26. Claire Denis DVD Interview.
27. Walter Benjamin, 'On Semblance' [1919–20], trans. Rodney Livingstone, in Howard Eiland and Michael W. Jennings (eds), *Selected Writings, Volume 1, 1913–1926* (Cambridge, MA and London: Harvard University Press, 1996). Benjamin develops these ideas further his essay on Goethe, 'Elected Affinities' (1924–5).
28. Crossing the bridge that spans Lac Léman, restages an early scene from Godard's *Petit Soldat* (1963), also starring Michel Subor: 'The lake that divides two Genevas' is the way the narrator-protagonist, Subor, describes it in Jean-Luc Godard's film.
29. Walter Benjamin, 'On Semblance', p. 224
30. Gary Smith, 'A Genealogy of "Aura": Walter Benjamin's Idea of Beauty', in Carol C. Gould and Robert S. Cohen (eds), *Artifacts, Representations and Social Practice: Essays for Marx Wartofsky* (Dordrecht: Kluwer Academic Publishers, 1994), p. 107.
31. Ibid. p. 109.
32. Ibid.
33. Walter Benjamin, 'Goethe's Elective Affinities', p. 340.
34. Miriam Hansen's full quote reads: 'On that understanding, aura is defined in antithetical relation to the productive forces that have been rendering it socially obsolete: technological reproducibility, epitomised by film, and the masses, the violently contested subject/object of political and military mobilisation. Ibid. 'Benjamin's Aura', *Critical Inquiry*, vol. 34 (Winter 2008), p. 336.

35. Arthur Rimbaud, *Une saison en Infer* (A Season in Hell), 1872, originally self-published. This translation, *Rimbaud Complete*, trans. Wyatt Wilson (New York: Random House, 2003), p. 195.

36. Charles Taylor, 'Beau Travail', *Salon* (31 March 2000), <www.salon.com/2000/03/31/beau_travail>, last accessed 4 January 2019.

37. Eleanor Kaufman, 'Midnight, or the Inertia of Being', *Parallax*, vol. 12, no. 2 (2006), p. 100.

38. Nancy, *L'Intrus,* p. 9.

39. Denis interview, Tartan films.

40. Paul Gégauff's 1965 adventure film *Le Reflux,* was not finished or released.

41. Jacques Mandelbaum, 'Michel Subor, "Petit Soldat" pour Godard, n'a jamais pu se résoudre au mercenariat', *Le Monde* (3 May 2005), <www.lemonde.fr/cinema/article/2005/05/03/michel-subor-petit-soldat-pour-godard-n-a-jamais-pu-se resoudre-au-mercenariat_645691_3476.html>, last accessed 28 January 2019.

42. Denis interview, Tartan films.

43. Nancy, *L'Intrus,* 'What a Strange Self', p. 10.

44. Claire Denis interview, 'I think … it is funny because now Jean-Luc admits it. But at the beginning it was, "Where have you been? Are you sure this was in the book?" … now he is convinced too.'

45. Walter Benjamin, 'The Task of the Translator', in Howard Eiland and Michael W. Jennings (eds), *Selected Writings, Volume 1* (Cambridge, MA and London: Harvard University Press, 1996), pp. 258–9.

46. As Garrett W. Brown points out, 'The idea of a cosmopolitan law of hospitality based on our shared humanity is not new. In 1552, Bartolome de las Casas argued against the injustices imposed on the American natives by attempting to show that the natives were 'equal human beings' with a right to be treated with respect and mutual hospitality … through violence and force, the Spanish had acted in violation of a natural law of universal hospitality.' Garrett W. Brown 'The Laws of Hospitality, Asylum Seekers and Cosmopolitan Right: A Kantian Response to Jacques Derrida', *European Journal of Political Theory*, vol. 9, no. 3 (2010), pp. 308–27.

47. Jacques Derrida, *Of Hospitality*, trans. Rachel Bowlby (Stanford: Stanford University Press, 2000). This is Derrida's response to Kant's obligations to the 'cosmopolitan rights of man'. And if we are to acknowledge the debt to Jacques Derrida's writings on hospitality in Nancy's text, then nestled within Derrida's own thinking about hospitality we can find Emmanuel Levinas's *Totality and Infinity: An Essay on Exteriority*, trans. Alphonso Lingis (Pittsburgh: Duquesne University Press), p. 1969. Derrida notes that Levinas 'bequeaths us a vast treatise on hospitality', in which the stranger for Levinas remains a wholly unassimilable figure. From Jacques Derrida, *Adieu à Emmanuel Levinas*, trans. Pascale-Anne Brault and Michael Naas (Stanford: Stanford University Press, 1999), p. 21.

48. Nancy, *L'Intrus,* 'What a Strange Self', p. 8.

49. Jacques Derrida, 'Hospitality', trans. Barry Stocker and Forbes Morlock, *Angelaki,* vol. 5, no. 3 (2000), p. 3.

50. Derrida, *Of Hospitality,* p. 6.

51. Jacques Derrida, 'Foreigner Question: Coming from Abroad/From the Foreigner' 1996, *Of Hospitality*, p. 3.

52. Ibid. p. 5.

53. These figures of 'undocumented migration' provided by the European Union-funded research project *CLANDESTINO – Undocumented Migration: Counting the Uncountable* (Anon. 2007–9) are quoted in Andreas Oberprantacher, 'Breaking with the Law of Hospitality? The Emergence of Illegal Aliens in Europe Vis-à-vis Derrida's Deconstruction of the Conditions of Welcome', *Hospitality & Society*, vol. 3, no. 2 (2013), p. 152.

54. Jacques Derrida, 'Principles of Hospitality', trans. Ashley Thompson. This is a translation of an interview with Dominique Dhombres for *Le Monde* (2 December 1997), p. 8.

55. Ibid. 'With the limits officially in force, the promised procedures for regularisation seem slow and minimalist, in a gloomy, tense and irritated atmosphere' (p. 7).

56. Claire Denis and Jean-Luc Nancy, *L'Intrus*, 2007, European Graduate School <www.youtube.com/watch?v=CoTGowlhABk>, last accessed 20 January 2019.

10 The Politics of Painting

1. Walter Benjamin, 'Theses on a Philosophy of History', trans. Harry Zohn, *Illuminations* (London: Fontana Press, 1992), p. 245.

2. Walter Benjamin and Gretel Adorno, *Correspondence 1930–1940* (Cambridge and Malden, MA: Polity Press, 2008), p. 286.

3. Walter Benjamin, 'Theses on a Philosophy of History', p. 247.

4. Many platforms have sought to define contemporary art and, in response, others have moved to complicate and question such categorisation. See: 'Contemporary Art Issue', *e-Flux Journal*, no. 11 (December 2009), < www.e-flux.com/journal/11>; Dieter Roelstraete, 'What is Not Contemporary Art? The View from Jena', *e-Flux Journal,* <www.e-flux.com/journal/what-is-not-contemporary-art-the-view-from-jena>; John Rajchman, 'Thinking in Contemporary Art', *For Art Lecture* (2006), <http://forart.no/lectures/john-rajchman-thinking-contemporary-art>, last accessed 29 January 2019.

5. Maurice Blanchot, 'The Ease of Dying' [1969], *The Blanchot Reader*, ed. Michael Holland (Oxford and Cambridge, MA: Blackwell, 1995), p. 310.

6. Ibid. p. 301.

7. Jean Paulhan, *Of Chaff and Wheat: Writers, War, and Treason*, trans. Richard A. Rand (Urbana and Chicago: University of Illinois Press, 2004), pp. 3–4.

8. This essay was originally published as 'De la paille et du grain' as a protest against the blacklisting of writers who collaborated with the Vichy regime and the occupying Nazis. This was a brave move by Paulhan whose position was judged, as Richard Rand insists, as politically naïve. Rand claims this is one reason why Paulhan is not now known widely in the English-speaking world (see David A. Rand, translator's preface). In 1950, Francis J. Camody wrote about the prominent position Paulhan held in French studies. And yet, despite the enormous influence

upon other writers such as Maurice Blanchot, Roland Barthes and Jacques Derrida, Paulhan no longer enjoyed the position being exalted by Camody at the time. Jean Paulhan was 'considered by many writers as the most significant French man of letters of today. As so often in the intense intellectual atmosphere of Paris, his importance is by no means limited to his published works.' *The French Review*, vol. 23, no. 4 (February 1950), p. 269.

9. Richard Rand, 'Grave Site', *Yale French Studies*, no. 106, special issue, *The Power of Rhetoric, the Rhetoric of Power: Jean Paulhan's Fiction, Criticism, and Editorial Activity*, ed. Kirstin Ross (2004), p. 140.

10. Michael Syrotinski, 'Domesticated Reading: Paulhan, Derrida, and the Logic of Ancestry', in Julian Wolfreys, Ruth Robbins and John Brannigan (eds), *The French Connections of Jacques Derrida* (Albany: State University of New York Press, 1999), pp. 88–9.

11. Ibid. p. 89.

12. Paulhan's vacillation over taking sides and his subsequent disagreement with Blanchot over the events of the Algerian crisis of 13 May 1958, which also brought de Gaulle back into power, meant that he and Blanchot would not meet again for many years and then only at the point of Paulhan's death. Maurice Blanchot, *Friendship,* trans. Elizabeth Rottenberg (Stanford: Stanford University Press, 1997), p. 149.

13. As Michael Syrotinski notes, 'Derrida's focus on the radical ambivalence of *pharmakon,* as a disruption of the Platonic privileging of presence, points to a more generalised disruptiveness occasioned by writing. According to Derrida, however, it is precisely the strange, ambivalent logic of writing that opens up and makes possible the very distinction between language and presence. Paulhan's ambiguity – which is quite different from a simple semantic conflict – is, from a theoretical perspective, of a similar order to the ambiguity of a term such as *pharmakon*'. From 'Domesticated Reading: Paulhan, Derrida, and the Logic of Ancestry', in Julian Wolfreys, Ruth Robbins and John Brannigan (eds), *The French Connections of Jacques Derrida*, p. 91.

14. Ibid.

15. Jennifer Bajorek, 'Editor's Translation', *Yale French Studies*, p. 207.

16. Maurice Blanchot, Charlotte Mandell (trans.), *Faux Pas* (Stanford: Stanford University Press, 2001), p .81.

17. Michael Fried, 'Art and Objecthood', *Artforum*, no. 5 (June 1967), p. 12.

18. Donald Judd, 'Nationwide Reports, Hartford', *Arts Magazine* (March 1964), *Donald Judd Complete Writings 1959–75* (Halifax, Canada and New York: The Press of Nova Scotia Art and Design and New York University Press, 2005), p. 118.

19. Thomas E. Crow, *The Rise of the Sixties: American and European Art in the Era of Dissent* (London: Lawrence King Publishing, 1996), p. 140.

20. Gilles Deleuze, 'Painting Sets Writing Ablaze', Interview with Hervé Guibert for *Le Monde* (3 December 1981), reprinted in David Lapoujade (ed.), *Two Regimes of Madness: Texts and Interviews 1975–1995,* trans. Ames Hodges and Mike Taormina (New York and Los Angeles: Semiotext(e), 2007), p. 183.

21. Jean Paulhan, *The Flowers of Tarbes, or Terror in Literature*, trans. Michael Syrotinski (Urbana-Champaign: Board of Trustees of the University of Illinois, 2006), p. 19.
22. Ibid.
23. Ibid. p. 20.
24. Ibid.
25. Paulhan, *The Flowers of Tarbes,* p. 10.
26. Ibid. p. 69.
27. Michael Syrotinski, 'Introduction to *The Flowers of Tarbes*', p. xiv.
28. Ibid. p. xv.
29. Ibid.
30. Quoted in Michael Syrotinski, *Defying Gravity: Jean Paulhan's Interventions in Twentieth Century French Intellectual History* (New York: State University of New York Press, 1989), p. 85.
31. Maurice Blanchot, 'How is Literature Possible?', *Faux Pas,* trans. Charlotte Mandell (Stanford: Stanford University Press, 2001), p. 83.
32. Paulhan, *The Flowers of Tarbes*, Ibid. p. 21.
33. Ibid. p.11.
34. Syrotinski, 'Introduction to the *Flowers of Tarbes*', p. xvii.
35. Paulhan, *The Flowers of Tarbes*, p.13.
36. Ibid. p. 27.
37. Ibid. p. 12.
38. Maurice Blanchot, 'How is Literature Possible?' (1942), trans. Michael Syrotinski, *The Blanchot Reader,* ed. Michael Holland (London and Cambridge, MA: Blackwell Publishers), p. 53.
39. For access to images, go to: <http://whitneybedford.com/tagged/shipwreck>, last accessed 31 January 2019.
40. Paulhan, *The Flowers of Tarbes*, p. 93.
41. Whitney Bedford, quoted in Tema Celeste, 'Whitney Bedford: Self Portrait', republished on <www.saatchi-gallery.co.uk/artists/whitney_bedford_articles.htm>, last accessed 10 January 2019.
42. Ibid.
43. Gilles Lipovetsky, *The Empire of Fashion: Dressing Modern Democracy*, trans. Catherine Porter (Princeton: Princeton University Press, 1994), p. 25.
44. Perhaps the most vocal critics of fashion were the proponents of Purism, the architect, Le Corbusier and the painter, designer, Ozenfant. 'One could make an art of allusions, an art of fashion, based upon surprise and the conventions of the initiated. Purism strives for an art free of conventions which will utilise plastic constants and address itself above all to the universal properties of the senses and mind.' Le Corbusier and Amédéé Ozenfant, 'Purism', *L'Esprit Nouveau,* Paris (1920). Quoted in Mark Wigley, *White Walls, Designer Dresses: The Fashioning of Modern Architecture* (Cambridge, MA and London: MIT Press, 1995), p. 37.
45. In particular, the writings of Charles Baudelaire, Georg Simmel and Walter Benjamin. For Baudelaire's theory of modernism, for instance, 'the modern' was to be located in the 'fleeting beauty of fashion'. Baudelaire hoped to demonstrate,

contra the privileging of classicism by a rigid nineteenth century canon, that the art of modernity is just as beautiful, just as 'heroic' as the ancient. Each age possesses a beauty particular to itself and for Baudelaire, a modern style only comes into being once it harnesses the air of the 'contemporary'. Charles Baudelaire, 'The Salon of 1846: On Heroism of Modern Life', in P. E. Charvet (trans.), *Selected Writings on Art and Literature* (London: Penguin, 1992). See also Georg Simmel's thesis that fashion is vital to modern life, so much so that there can be no escaping its universal hold: in one's conscious rejection of fashion sits an inverse relation to it. 'Fashion', *On Individuality and Social Forms: Selected Writings* (Chicago: University of Chicago Press, 1971).

46. In Hal Foster, *Compulsive Beauty* (Cambridge. MA: MIT Press, 1997), p. 187.
47. Walter Benjamin, *Charles Baudelaire: A Lyric Poet in the Era of High Capitalism* (London and New York: Verso, 1997).
48. Louis Aragon, *Paris Peasant*, trans. Simon Watson Taylor (London: Jonathan Cape Ltd, 1971).
49. In Hal Foster, *Compulsive Beauty,* p. 187.
50. Walter Benjamin, *The Arcades Project*, trans. Howard Eiland and Kevin Mc Laughlin (Cambridge, MA and London: Belknap Press of Harvard University Press, 1999).
51. See Giorgio Agamben, 'What is the Contemporary', *Nudities,* trans. David Kishik and Stefan Pedatella (Stanford: Stanford University Press, 2011), pp. 15–16.
52. Ibid.
53. Giorgio Agamben, 'What is the Contemporary', p. 15.
54. Ibid. p. 11.
55. Ibid. p. 11, italics in the original.
56. Ibid. p. 13.
57. Robin Durie, 'Wandering Among Shadows: The Discordance of Time in Levinas and Bergson', *The Southern Journal of Philosophy,* vol. 48, no. 4 (December 2010), p. 371.
58. Terry Smith, *Thinking Contemporary Curating* (London: ICA, Independent Curators International, 2012), p. 49.
59. Agamben, 'What is the Contemporary', p. 18.
60. Georg Simmel, 'Fashion', *On Individuality and Social Forms,* p. 303.
61. For an analysis of Benjamin's concept of time, see Jürgen Habermas, 'Modernity's Consciousness of Time and its Need for Self-Reassurance', trans. Frederick Lawrence, *The Philosophical Discourse of Modernity: Twelve Lectures* (Cambridge and Malden, MA: Polity Press, 1987), and Peter Osborne, 'Small-scale Victories, Large-scale Defeats: Walter Benjamin's Politics of Time', in Andrew Benjamin and Peter Osborne (eds), *Walter Benjamin's Philosophy: Destruction and Experience* (London and New York: Routledge, 1994). However, for a closer analysis of Benjamin's notion of fashion, both in its relationship to time and to clothing (not dealt with here), see Andrew Benjamin, 'Being Roman Now: The Time of Fashion, A commentary on Walter Benjamin's 'Theses on the Philosophy of History' XIV,' *Thesis Eleven,* no. 75 (November 2003), pp. 39–55.

62. For a sustained discussion on Benjamin's use of the Cabalistic tradition, see Irving Wohlfarth, 'On Some Jewish Motifs in Benjamin', in Andrew Benjamin (ed.), *The Problems of Modernity: Adorno and Benjamin* (London and New York: Routledge, 1992).

63. Walter Benjamin, *Charles Baudelaire,* p. 172.

64. Jean-Luc Godard and Youssef Ishaghpour, *Cinema: The Archaeology of Film and the Memory of a Century* , trans. John Howe (Oxford and New York: Berg, 2005).

65. See for instance, David Joselit, 'Painting Beside Itself', *October*, no. 130 (Fall 2009), pp. 125–34.

66. 'Content is to be dissolved so completely into form that the work of art or literature cannot be reduced in whole or in part to anything not itself.' Clement Greenberg, 'Avant-Garde and Kitsch', originally published *Partisan Review,* vol. VI, no. 5 (Fall 1939).

67. This is a modified version of an essay published in *Angela Brennan: 19 Desires and One Belief* (Muckleford, Australia: 3-ply, 2019).

68. *Angel with Green Hands* (2016), crayon and pencil on paper, 24 x 34 cm, first exhibited at Knulp Gallery, Sydney, Australia in May 2016.

69. Jean-Luc Nancy, 'The Image – The Distinct', *The Ground of the Image*, trans. Jeff Fort (Bronx: Fordham University Press, 2005), p. 7, italics in the original.

70. Philippe Lacoue-Labarthe, *Typography: Mimesis, Philosophy, Politics* (Cambridge, MA and London: Harvard University Press, 1989), p. 102. At this point of his thesis, Lacoue-Labarthe is working out of René Girard's connections between mimesis, rivalry and desire; or what is termed 'mimetic desire'.

71. Ibid. p. 63.

72. Ibid. p. 115.

73. Ibid. p. 116.

74. *Flagellazione di Cristo* (c.1460), oil and tempura on panel, 58.4 × 81.5 cm, Galleria Nazionale della Marche, Urbino. For image, see: <http://en.wikipedia.org/wiki/Ducal_Palace,_Urbino#/media/File:Piero_della_Francesca_042_Flagellation.jpg>, last accessed 30 January 2019.

75. *The Erroneously Named Mistake* (2016), oil on canvas, 90 x 61 cm, Private Collection.

76. Jean-Luc Nancy, 'Distinct Oscillation', *The Ground of the Image*, p. 63.

77. John Alford, 'The Responsibility of The Artist in Contemporary Society: A Symposium', John Alford, Holcombe M. Austin, George M. Cohen and Helmut Hungerland, *College Art Journal*, vol. 15, no. 3 (Spring 1956), pp. 201–2.

78. In 2012, Hal Foster offered a potted summary of how attitudes to criticality had shifted in the second half of the twentieth century: 'How did we arrive at the point where critique is so broadly dismissed? Over the years, most of the charges have concerned the positioning of the critic. First, there was a rejection of judgement, of the moral right presumed in critical evaluation. Then, there was a refusal of authority, of the political privilege that allows the critic to speak abstractly on behalf of others. Finally, there was scepticism about distance, about the cultural separation from the very conditions that the critic purports to examine.' Hal Foster, 'Post-Critical', *October*, no. 139 (Winter 2012), p. 3.

79. Gilles Deleuze, 'To Have Done with Judgement', trans. Daniel W. Smith and Michael A. Greco, *Essays Critical and Clinical* (Minnesota: University of Minnesota Press, 1997), p. 129.

80. Gilles Deleuze, 'Plato the Greeks', trans. Daniel W. Smith and Michael A. Greco, *Essays Critical and Clinical* (Minnesota: University of Minnesota Press, 1997), p .137.

81. Gilles Deleuze, *Difference and Repetition,* trans. Paul Patton (New York: Columbia University Press, 1994), p. 60.

82. Gilles Deleuze, *Nietzsche and Philosophy,* trans. Hugh Tomlinson (New York: Columbia University Press, 1983), p. 28.

83. Gilles Deleuze, 'To Have Done with Judgement', p. 135.

84. Ibid. p. 136.

85. Todd May, 'Gilles Deleuze and the Politics of Time', *Man and World,* vol. 29, no. 3 (1996), p. 293

86. Keith Ansell-Pearson, 'Introduction', *Henri Bergson: Key Writings*, ed. Ansell-Pearson and John Mullarkey (London and New York: Bloomsbury, 2002), p. 26.

87. Deleuze, 'To Have Done with Judgement', p. 129. For an extended discussion by Deleuze on the importance of the Stoics to his philosophy, see *The Logic of Sense,* trans. Mark Lester (New York: Columbia University Press, 1990).

88. Ibid. p. 126.

89. 'The debt had to be owed to the gods; it had to be related, no longer to the forces of which we were the guardians, but to the gods who were supposed to have given us these forces', ibid.

90. Ibid. p. 129.

91. Gilles Deleuze, *Pure Immanence: Essays on Life,* trans. Anne Boyman (New York: Zone Books, 2001), p. 27.

92. Ibid. p. 135.

93. Gilles Deleuze, 'Spinoza and the Three "Ethics"', *Essays Critical and Clinical*, trans. Daniel Smith and Michael A. Greco (London and New York: Verso, 1998), p. 151.

94. Ibid.

95. Ibid. p. 145.

96. John Rajchman, 'Deleuze's Time, or How the Cinematic Changes Our Idea of Art', in D. N. Rodowick (ed.), *The Afterimages of Gilles Deleuze Film Philosophy* (Minneapolis and London: University of Minnesota Press, 2010), p. 285.

97. John Rajchman, *The Deleuze Connections,* p. 129.

98. Maurice Blanchot, *The Infinite Conversation,* trans. Susan Hanson (Minneapolis and London: University of Minnesota Press, 2003), p. 32.

99. Situationist International, 'All the King's Men', *Internationale Situationniste*, no. 8 (January 1963), trans. Ken Knabb, <www.bopsecrets.org/SI/8.kingsmen.htm>, last accessed 22 June 2016.

100. Ibid. italics in the original.

11 Alex Monteith – Na Trioblóidí and Decolonising Tactics

1. *Murihiku* is the Māori name for the tail end of the land, later renamed and replotted as Southland.

2. *The Globalising Wall,* curator, James Pinker, Mangere Arts Centre/Ngā Tohu o Uenuku, featuring work by Alex Monteith, Danae Stratou and Shahriar Asdollah-Zadeh (24 November 2012–7 February 2013).
3. The Good Friday Agreement had its twentieth Anniversary in April 2018. However, 'The Marching Season' persists as a potential provocation to continuing peace. In 2013 six hours of violence broke out as police tried to ban an Orange Order parade from marching through a republican district, resulting in many injuries and 500 extra police being deployed to Northern Ireland from Britain in an escalation of police presence. Source, 'Orange Order March Erupts into Violence', *Guardian* (13 July 2013), <www.theguardian.com/uk-news/video/2013/jul/13/belfast-orange-order-march-violence-video>, last accessed 19 January 2019. And there have been ongoing, sporadic episodes of violence in the years since the Agreement from dissident Republican factions (known as the New IRA or the Real IRA). At the time of writing, the most recent attack occurred in January 2019 when a bomb was exploded outside the Bishop Street Courthouse in Derry.
4. Royal Ulster Constabulary (RUC) was renamed in 2001 as the Police Service of Northern Ireland (PSNI).
5. Although freedom of speech is guaranteed under 'Fundamental Rights', Article 40.6.1, *Constitution of Ireland,* this right is qualified by a clause that states that such speech 'shall not be used to undermine public order or morality or the authority of the State', <www.constitution.org/cons/ireland/constitution_ireland-en.htm >, last accessed 29 January 2019.
6. Monteith has been living in New Zealand since she was eleven, but her family made annual trips back to Northern Ireland.
7. An example of how this still cuts deeply with Republicans; in July 2013, violence broke out between Republicans and Loyalists during a Republican demonstration to mark the forty years since internment without trial was introduced into Northern Ireland during The Troubles, resulting in many injuries, <www.theguardian.com/uk-news/video/2013/aug/11/belfast-violence-police-injured-video>, last accessed 29 January 2019.
8. A digital image of the VHS cassette with Police Labelling can be found at: <www.alexmonteith.com/work_detail.php?id=88>, last accessed 29 January 2019.
9. All footage was shot by Monteith.
10. Gilles Deleuze, *Cinema II: The Time Image,* trans. Hugh Tomlinson and Robert Galeta, *Cinéma II, L'Image-Temps,* 1985 (Minneapolis: University of Minnesota Press, 1989), p. 169.
11. Trinh T. Minh-hà, 'Documentary Is/Not a Name,' *October,* no. 52 (Spring 1990), p. 76.
12. Antonin Artaud, 'Cinéma et réalité' [1927], *Antonin Artaud: Selected Writings* (Berkeley and Los Angeles: University of California Press, 1988), p. 150.
13. Sorcha Pollak, 'Surfers Pounce as Prowlers Pounce Back to Life: Six lucky Surfers Take Their Lives into Their Hands to Catch Giant Swell off Coast of Sligo', *The Irish Times* (5 March 2014), <www.irishtimes.com/news/ireland/irish-news/

surfers-pounce-as-prowlers-roars-back-to-life-1.1713484>, last accessed 17 July 2019.

14. Imogen Calderwood, 'Irish Police Know Who Killed Mountbatten in 1979 Bombing, says Westminster Source – But Secret Amnesty Deal is Obstructing Justice', *Daily* Mail (17 May 2015), <www.dailymail.co.uk/news/article-3084858/Irish-police-know-killed-Earl-Mountbatten-1979-bombing-says-Westminster-source-IRA-attacks-secret-amnesty-deal-obstructing-justice.html>, last accessed 17 January 2019.

15. Exhibition first shown at Gow Langsford Gallery, Lorne Street, Auckland (15 June–2 July 2016).

16. From phone and email interviews with artist (June to August 2017).

17. 'It was clear that Ireland had become the new Hawaii of big-wave surfing, and that the international big-wave surfing map had been redrawn.' Fionola Meredith, 'Riding Irish Giants', *Irish Times* (29 May 2010), <www.irishtimes.com/culture/books/riding-irish-giants-1.671645>, last accessed 19 January 2019.

18. Sorcha Pollak, 'Surfers Pounce as Prowlers Pounce Back to Life'.

19. Richie Fitzgerald, 'This is What Surfing Mullaghmore Looks Like from the Water – Terrifying', *Behind the Lines*, Ep. 5, <www.youtube.com/watch?v=dvwNaXmz5u8&t=2s>, last accessed 19 January 2019.

20. Andrew Cotton, 'Chasing Big Wave BOMBS in Mullaghmore', <www.youtube.com/watch?v=4yLX9yw-Jhk&t=2s>, last accessed 19 January 2019. In November 2017, Cotton had a severe crash in Nazaré, Portugal, breaking his back, while filming a documentary. Luke Brown, 'Andrew Cotton shocking wipeout', *Independent* (9 November 2017), <www.independent.co.uk/sport/general/watch-surfing-wipeout-big-waves-crash-andrew-cotton-nazare-portugal-a8045436.html>, last accessed 19 January 2019.

21. 'For a ride to be deemed successful, the surfer must complete the meaningful portion of the wave while in control and under the power of only the wave and gravity. The wave height to be measured will be the distance from the lip to the trough of the wave at its highest moment during the ride as measured above and below the surfer.' Editorial, *Surfer Today* (9 March 2011), 'Big Wave Surfing Ignites the Billabong XXL 2011', <www.surfertoday.com/surfing/5166-big-wave-surfing-ignites-the-billabong-xxl-2011>, last accessed 29 January 2019.

22. Rosa Prince, 'Mournful Memories for Prince Charles Amid the Beauty of Sligo', *Telegraph* (19 May 2015), <www.telegraph.co.uk/news/uknews/northernireland/11616301/Mournful-memories-for-Prince-Charles-amid-the-beauty-of-Sligo.html>, last accessed 29 January 2019.

23. Ibid.

24. Simon Hoggart, 'Mountbatten: A Noble with a Common Touch', *Guardian* (28 August 1979), <http://static.guim.co.uk/sysimages/Guardian/Pix/pictures/2015/5/19/1432036419635/The-Guardian-28-August-19-001.jpg>, last accessed 29 January 2019.

25. Rosa Prince, 'Mournful Memories for Prince Charles Amid the Beauty of Sligo'.

26. Susan McKay, 'After Mountbatten: The Many Victims of the Mullaghmore Bombing', *Irish Times* (17 May 2015), <www.irishtimes.com/life-and-style/people/after-mountbatten-the-many-victims-of-the-mullaghmore-bombing-1.2214103>, last accessed 19 January 2019.

27. Mark Williams, *Ireland's Immortals: A History of the Gods of Irish Myth* (Princeton, NJ, and Oxford: Princeton University Press, 2016), p. 63.

28. Ibid. p. 64.

29. Ibid.

30. According to the Museum of Australia, half a million Irish people left Ireland for Australia between 1788 and 1921. 'Today, Australia is the most Irish country in the world outside Ireland.' They came as convicts, political prisoners, free settlers and soldiers working for the Crown, <www.nma.gov.au/exhibitions/irish_in_australia/family_history/irish_convicts>, last accessed 29 January 2019.

31. 'On 1 March 1863 Mrs M.C. lost a baby for the third time because of her narrow pelvis . . . and on 15 January 1964 Mrs M. O'C. was delivered of her sixth stillborn child; her pelvis deformed and heart-shaped. Both these women were born in Ireland and of an age to be entering adolescence as the potato blight brought starvation . . . at its worst, in 1860, one in fifteen of the patients born in Ireland had a contracted or deformed pelvis.' Janet McCalman, *Sex and Suffering: Women's Health and Women's Hospital: The Royal Women's Hospital, Melbourne 1856–1996* (Carlton South, Vic: Melbourne University Press, 1998), p. 23.

32. 'Racial and Ethnic Tensions', *Melbourne: The City Past and Present*, <www.emelbourne.net.au/biogs/EM01218b.htm>, last accessed 29 January 2019.

33. 'Riots in Melbourne', *Launceston Advertiser* (15 July 1846), <http://trove.nla.gov.au/newspaper/article/84769063>, last accessed 29 January 2019.

34. Joe McGowanm, quoted in Caroline Davies, 'Prince Charles Visits Scene Where Lord Mountbatten Was Killed by the IRA', *Guardian* (21 May 2015), <www.theguardian.com/world/2015/may/20/prince-charles-visits-scene-where-lord-mountbatten-was-killed-by-the-ira>, last accessed 17 August 2017.

35. See Nicholas Thomas and Mark Adams, *Cook's Sites: Revisiting History* (Dunedin, NZ: University of Otago Press and Centre for Cross-Cultural Research, Australian National University, 1999).

36. William Hodges, *Cascade Cove: Dusky Bay* (1775), oil on canvas, 1359 x 1930 mm (excluding frame), held at the National Maritime Museum, Greenwich, London, provenance, HM Admiralty.

37. George Forster, *A Voyage Round the World*, vol. 1, ed. Nicholas Thomas and Liver Berghof (Honolulu: University of Hawaii Press, 2000), pp. 91–2.

38. Forster, p. 92. It is noted by Nicholas Thomas that 'Forster's description made sense, though the 1773 visit must have been after heavier rain unless he exaggerated the drenching effect of the mist. In 1995, the fall certainly did create vapour, but we were not soaked to the skin; nor did we witness the unusual circular rainbow described in this passage.' He also notes that Hodges diminished the sublime effect of the rocks. Thomas and Adams, *Cook's Sites: Revisiting History*, p. 79.

39. From a close reading of Hodges' *Dusky Bay,* the genesis of Colin McCahon's waterfalls from the 1960s is clearly identifiable, with their darkly rendered landscapes and beams of glowing white water, abstracted to their barest and simplest forms.

40. Edmund Burke, *A Philosophical Inquiry into the Origin of Our Ideas of the Sublime and Beautiful* [1756], ed. J. T. Boulten (London: Routledge and Kegan Paul, 1958), p. 57.

41. See, for instance, Peter Brunt, 'Savagery and the Sublime: Two Paintings by William Hodges Based on an Encounter with Māori in Dusky Bay, New Zealand,' *The Eighteenth Century*, vol. 38, no. 3 (Fall 1997), pp. 266–86.

42. As Bernard Smith points out, one needs to be prudent when applying the adjective 'romantic' at this time, since an intellectual engagement with Romanticism is still many decades away, and yet, it is evident in Hodges' work that he is foreshadowing the popularity of this movement, perhaps, as Smith points out, under the influence of both the 'profound beauty of Dusky Bay', and the Forsters, in particular the elder, J. R. Forster (1729–89), who came from the region of Germany that is to become the source of Romanticism. Rüdiger Joppien and Bernard Smith, *The Art of Captain Cook's Voyages, Volumes 1–3, The Voyage of the* Resolution *and* Discovery *1776–1780* (Melbourne: Oxford University Press, 1987), pp. 22–3.

43. Bruce Pascoe, *Dark Emu: Black Seeds: Agriculture or Accident* (Broome, Western Australia: Magabala Books Aboriginal Corporation, 2014), p. 24.

44. Henry Reynolds, *Forgotten War* (Sydney: New South Press, University of New South Wales, 2014), p. 27.

45. Ibid.

46. Michaela Whitbourn, 'SBS Presenter Scott McIntyre Sacked Over "Inappropriate" Anzac Day Tweets', *Sydney Morning Herald* (26 April 2015), <www.smh.com.au/national/sbs-presenter-scott-mcintyre-sacked-over-inappropriate-anzac-day-tweets-20150426-1mtbx8.html>, last accessed 11 January 2019.

47. Editorial, 'Yassmin Abdel-Magied', Australian Broadcasting Commission, News Online (updated 26 April 2017), <www.abc.net.au/news/2017-04-26/yassmin-abdel-magied-under-fire-for-anzac-post/8472414>, last accessed 29 January 2019.

48. James Belich, *Replenishing the Earth: The Settler Revolution and the Rise of The Anglo-World, 1783–1939* (New York: Oxford University Press, 2009).

49. Belich is using the term 'Settlerism' to define the ideological dimension of his Settler Revolution (capitalisation, Belich), claiming it loomed as large in its time as 'socialism, evangelism and racism'. Ibid. p. 153.

50. Noel George Butlin, *Economics and the Dreamtime: A Hypothetical History* (Cambridge and Melbourne: Cambridge University Press, 1993), pp. 184–5.

51. While European settlement intensified through the nineteenth century, there was an attempt to form a Treaty with Māori. Known as the Treaty of Waitangi, it is the founding agreement between the British Government and 540 Māori *rangatira* (Chiefs), representing a majority but not all *ragatira*. It was signed in 1840,

incorporating Aotearoa/New Zealand into the Empire and opening it up to greater numbers of settlers. Stemming from problems of interpretation and translation, as of 2019, the Treaty is not fully resolved. 'The exclusive right to determine the meaning of the Treaty rests with the Waitangi Tribunal, a commission of inquiry created in 1975 to investigate alleged breaches of the Treaty by the Crown. More than 2000 claims have been lodged with the tribunal.' *New Zealand History,* <http://nzhistory. govt.nz/politics/treaty/the-treaty-in-brief>, last accessed 19 January 2019.

52. *Dark Emu, Black Seeds: Agriculture or Accident* (Broome, Western Australia: Magabala Books Aboriginal Corporation, 2014), p. 24.

53. Link to *The River Nile, Van Diemen's Land from Mr Glover's Farm* (1837), oil on canvas, 76.4 × 114.6 cm, National Gallery of Victoria, Felton Bequest, 1956. <www. ngv.vic.gov.au/explore/collection/work/5631>, last accessed 31 January 2019.

54. Jeanette Hoorn, *Australian Pastoral: The Making of a White Landscape,* (Fremantle, Western Australia: Fremantle Press, 2007), p. 80.

55. In Glover's own words written in a letter to Robinson (2 November 1835): 'under the wild woods of the country, to give an idea of the manner they enjoyed themselves before being disturbed by the White People'. Quoted in John McPhee, *The Art of John Glover* (South Melbourne: Macmillan Company of Australia Pty Ltd, 1980), p. 37; see also Jeanette Hoorn's research noting that this painting was to be a gift to Robinson for his efforts (*Australian Pastoral,* p. 84) which were clearly 'to see the Aboriginal people of Tasmania dispossessed and imprisoned' (pp. 80ff.).

56. It should be acknowledged that Glover's experience and competency lies in landscape painting and not in the figure, for which he is generally considered inept. See in particular Jeanette Hoorn, p. 88.

57. John McPhee, *The Art of John Glover,* p. 35. Along similar lines of defence, see David Hansen, 'The Life and Work of John Glover', *John Glover and the Colonial Picturesque* (Hobart: Tasmanian Museum and Art Gallery, 2003), pp. 88–9.

58. Ian McLean has written; '[Glover's] paintings were not just generalised representations of the Rousseauesque "noble savage", but pictures of people and things he had seen in Tasmania.' See Ian McLean, 'Figuring Nature: Painting the Indigenous Landscape', in David Hansen (ed.), *John Glover and the Colonial Picturesque,* p. 126. With reference to Glover's *River Nile,* McLean's view seems impossible to support, with its idealised subject matter and awkward and generalised representation of local Plindermairhemener people. It also provokes the question, after Edward Said, and following decades of decolonising activism, what processes could possibly continue to foster the separation of 'art' from the politics of its production?

59. There are several entries by George Forster about this family, who became the main Māori contact in this part of their voyage. See Peter Brunt, 'Savagery and the Sublime: Two Paintings by William Hodges', pp. 266–86.

60. The sympathetic rendering of the figures being noted, John Bonehill draws our attention to the similarities between Hodges' male figure in *Dusky Bay* and that of an engraving of an early Briton, *Habit of an Ancient Briton,* from Jeffreys (1772), held in the British Library, London. Bonehill argues that it is likely to be a reference to the discussions at the time of 'Artists, historians and social theorists

[who] all drew parallels between newly discovered cultures and earlier European societies, such as the early Britons, whose belligerence was taken to indicate their uncorrupted state.' See Bonehill, 'Catalogue Entries', in Geoff Quilley and John Bonehill (eds), *William Hodges, 1744–1797: The Art of Exploration* (New Haven, CT: Yale Center of British Art; London: National Maritime Museum, 2004), p. 112.

61. Rüdiger Joppien and Bernard Smith, *The Art of Captain Cook's Voyages, Volumes 1, The Voyage of the* Resolution *and* Discovery *1776–1780* (Melbourne: Oxford University Press, 1987), p. 28.

62. David Bindman, ''Philanthropy seems natural to mankind': Hodges and Captain Cook's Second Voyage to the South Seas', in Quilley and Bonehill (eds), *William Hodges 1744–1797,* p. 21.

63. Ibid. p. 22.

64. *Māori Bartering a Crayfish with an English Naval Officer* (1769) is held in the British Library and is now attributed to Tupaia. Shelfmark: Add MS 15508, f.12A. Full title: *Drawings Illustrative of Captain Cook's First Voyage, 1768–1770, Chiefly Relating to Otaheite and New Zealand, by A. Buchan, John F. Miller, and Others.* For image, see: <www.bl.uk/collection-items/maori-trading-a-crayfish-with-joseph-banks>, last accessed 30 January 2019.

65. Anne Salmond, *Two Worlds: First Meetings Between Māori and Europeans, 1642–1772* (Auckland: Viking, 1991).

66. The series was first exhibited in a two-person show, *Nature Unassisted by Art,* featuring the work of Sarah Munro and Frank Schwere. Page Blackie Gallery, Wellington, New Zealand (31 August–23 September 2018).

67. In his journal of 12 July 1769, Banks asks his reader why he may 'not keep him [Tupaia] as a curiosity, as well as some of my neighbours do lions and tygers at a larger expence', *The Endeavour Journal of Sir Joseph Banks by Sir Joseph Banks* (25 August 1768 to 12 July 177), <http://gutenberg.net.au/ebooks05/0501141h.html>, last accessed 29 January 2019.

68. Nicholas Thomas, *In Oceana: Visions, Artifacts, Histories* (Durham, NC and London: Duke University Press, 1997), p. 4.

69. Bruce Pascoe, *Dark Emu: Black Seeds: Agriculture or Accident* (Broome, Western Australia: Magabala Books Aboriginal Corporation, 2014).

70. Nicholas Thomas, *In Oceana,* p. 4.

71. Email exchange with artist (September 2017).

72. James O. Young, 'Cultures and the Ownership of Archaeological Finds', in Chris Scarre and Geoffrey Scarre (eds), *The Ethics of Archaeology: Philosophical Perspectives on Archaeological Practice* (Cambridge: Cambridge University Press, 2006), p. 15.

73. Young, p. 16.

74. Young offers the example of the State of Mexico that takes ownership over all pre-Columbian artefacts, despite Indigenous claims, Ibid. p. 17.

75. Ibid.

76. '*The* Kōiwi *Tangata/Human Remains Guidelines* provide advice for culturally responsible mechanisms for the management of *kōiwi* tangata/human remains

that have been either uncovered through accidental discovery or deliberately excavated/exhumed in emergency response situations, or as a result of natural processes e.g. coastal erosion. In the majority of cases it will be found that these koiwi tangata/human remains are Māori in origin, so these Guidelines have a deliberate focus in that direction, and recognize the kaitiaki role that Māori play in determining what happens in the management of the discovery of *kōiwi* tangata.' Heritage New Zealand Pouhere Taonga, *The Koiwi Tangata/Human Remains Guidelines* (25 August 2014).

77. The following information was gathered from interviews with archaeological colleagues of Coutts carried out in Melbourne throughout 2017. After his return to Australia, Coutts became an avowed 'expert' in Indigenous archaeological methodologies, and the first archaeologist to be employed for the Victorian Aboriginal Survey (1973–85), a State Government body established to enact the Archaeological and Aboriginal Relics Preservation Act of 1972. Coutts worked across locations predominately belonging to the Kulin and Kura Nations, alliances of Indigenous peoples whose traditional country includes the City of Melbourne and its surrounding regions. By the early 1980s, wider public sensitivities to Indigenous cultural meaning and practice led the State Labor Government of Victoria to sever a formal relationship with Coutts for his ongoing refusal to consult with Aboriginal stakeholders. Coutts sited the growing commercialisation of scholarship for the break, while the government accused Coutts of continuing his extensive archaeological digs without proper consultation with the bands of the Victorian Indigenous nations.

78. I want to thank Melissa Deerson for her help in clarifying the ideas in this passage.

79. An example of this are the debates initiated by Stan Grant, a Wiradjuri man and journalist, who suggested in the media on 25 August 2017 that inaccurate descriptions on a statue of Captain Cook should be amended to better reflect the history of all Australians, '247 years of British possession; 65,000 years of the first people.' It should not be controversial to say that Cook did not discover Australia in 1770, since he was not even the first European to land on Australian shores, and yet, it seemed to re-fire the ideologically riven History Wars that took place earlier in the century. Stan Grant 'Between Catastrophe and Survival: The Real Journey Captain Cook Set Us On.' The words 'Genocide' were sprayed on the statue on the following day. Australian Broadcasting Commission, News Online (updated 25 August 2017), <www.abc.net.au/news/2017-08-25/stan-grant-captain-cook-indigenous-culture-statues-history/8843172>, last accessed 26 August 2017.

80. Jacques Rancière, 'Interview for the English Edition', *The Politics of the Aesthetic: The Distribution of the Sensible,* trans. Gabriel Rockhill (New York and London: Continuum, 2004), p. 61.

81. Jacques Rancière, trans. Charlotte Mandell, *Flesh of the Words: The Politics of Writing* (Stanford: Stanford University Press, 2004).

82. Ibid. p. 185.

Conclusion

1. With utter drollness, Jan Verwoert asked, 'Why are conceptual artists painting again? Because they think it's a good idea.' See Jan Verwoert and Hugh Rorrison, article of the same title, *Afterall: A Journal of Art, Context and Enquiry,* no. 12 (Autumn/ Winter 2005), pp. 7–16.
2. Walter Benjamin, 'On the Concept of History', in Howard Eiland and Michael W. Jennings (eds), *Walter Benjamin: Selected Writings, Volume 4, 1938–1940* (Cambridge, MA and London: Belknap Press of Harvard University Press, 2003), p. 391.

Bibliography

Agamben, Giorgio, *Homo Sacer: Sovereign Power and Bare Life*, trans. Daniel Heller-Roazen (Stanford: Meridian, Stanford University Press, 1998).

Agamben, Giorgio, *Nudities*, trans. David Kishik and Stefan Pedatella (Stanford: Stanford University Press, 2011).

Agamben, Giorgio, 'The Power of Thought', *Critical Inquiry*, vol. 40, no. 2 (Winter 2014), pp. 480–91.

Agamben, Giorgio, *The Signature of All Things: On Method*, trans. Luca D'Isanto, with Kevin Attell (New York: Zone Books, 2009).

Agamben, Giorgio, *What is an Apparatus and Other Essays*, trans. David Kishik and Stefan Pedatella (Stanford: Stanford University Press, 2009).

Albright, Madeleine, *Fascism: A Warning* (New York: Harpers Collins UK Audio, 2018).

Alford, John, Holcombe M. Austin, George M. Cohen and Helmut Hungerland, 'The Responsibility of The Artist in Contemporary Society: A Symposium', *College Art Journal*, vol. 15, no. 3 (Spring 1956), pp. 197–227.

Alliez, Eric, Claire Colebrook, Peter Hallward, Nicholas Thoburn and Jeremy Gilbert (chair), 'Deleuzian Politics? A Roundtable Discussion', *New Formations*, no. 68 (Spring 2009), pp. 143–87, 206.

Ansell Pearson, Keith, and John Mullarkey (eds), *Henri Bergson: Key Writings* (London and New York: Bloomsbury, 2002).

Artaud, Antonin, 'Cinema and Reality', in Susan Sontag (ed.), *Antonin Artaud: Selected Writings* (Berkeley and Los Angeles: University of California Press, 1988). Originally published in French as 'Cinéma et réalité' (1927).

Artaud, Antonin, 'Sorcellerie et Cinéma' [1927], *Oeuvres complètes* (Paris: Gallimard, 1978).

Aragon, Louis, *Paris Peasant*, trans. Simon Watson Taylor (London: Jonathan Cape Ltd, 1971). Originally published in French as *Le Paysan de Paris* (1926).

Balibar, Étienne, *The Philosophy of Marx*, trans. Chris Turner (London: Verso, 2014). Originally published in French as *La philosophie de Marx* (1993).

Balibar, Étienne, *Spinoza and Politics*, trans. Peter Snowdon (London and New York: Verso, 2008).

Barthes, Roland, *Image, Music Text*, trans. Stephen Heath (London: Fontana Press, 1977).

Baudelaire, Charles, 'The Salon of 1846: On Heroism of Modern Life', in P. E. Charvet (trans.), *Selected Writings on Art and Literature* (London: Penguin, 1992).

Baudrillard, Jean, *America*, trans. Chris Turner (London and New York: Verso, 1988).

Baudrillard, Jean, *The Ecstasy of Communication*, trans. Bernard Schutze and Caroline Schutze (New York: Semiotext(e) Columbia University, 1987).

Baudrillard, Jean, 'An Interview with Judith Williamson', trans. Brand Thumim, *Block*, 15 (1989), pp. 17–19.

Baudrillard, Jean, *Mirror of Production*, trans. Mark Poster (St Louis: Telos Press, 1975).

Baudrillard, Jean, *Paroxysm: Interviews with Philippe Petite* (London and New York: Verso, 1998).

Baudrillard, Jean, *The Spirit of Terrorism and the Requiem of the Twin Towers*, trans. Chris Turner (New York and London: Verso Books, 2002).

Beausoleil, Emily, 'Responsibility as Responsiveness: Enacting a Dispositional Ethics of Encounter', *Political Theory*, vol. 45, no. 3 (2017), pp. 291–318.

Becker, Gary S., *Human Capital: A Theoretical and Empirical Analysis, with Special Reference to Education* (Chicago: University of Chicago Press, 1993).

Belich, James, *Replenishing the Earth: The Settler Revolution and the Rise of the Anglo-World, 1783–1939* (New York: Oxford University Press, 2009).

Benderly, Jill, and Evan Kraft, *Independent Slovenia: Origins, Movements, Prospects* (New York: St Martin's Press, 1995).

Benjamin, Andrew, *Art's Philosophical Work* (London and New York: Rowman & Littlefield International, 2015).

Benjamin, Andrew, 'Being Roman Now: The Time of Fashion, A Commentary on Walter Benjamin's "Theses on the Philosophy of History" XIV', *Thesis Eleven*, no. 75 (November 2003), pp. 39–55.

Benjamin, Andrew, *Present Hope: Philosophy Architecture, Judaism* (London: Routledge, 1997).

Benjamin, Andrew (ed.), *The Problems of Modernity: Adorno and Benjamin* (London and New York: Routledge, 1992).

Benjamin, Andrew, and Peter Osborne, *Walter Benjamin's Philosophy: Destruction and Experience* (London and New York: Routledge, 1994).

Benjamin, Walter, *Charles Baudelaire: A Lyric Poet in the Era of High Capitalism*, trans. Harry Zohn (London and New York: Verso, 1997).

Benjamin, Walter, *Illuminations*, trans. Harry Zone (London: Fontana, 1992).

Benjamin, Walter, 'Left Wing Melancholy', trans. Ben Brewster, in Howard Eiland and Michael W. Jennings (eds), *Walter Benjamin Selected Writings*, vol. 2 (Cambridge, MA and London: Harvard University Press, 1996).

Benjamin, Walter, *One-Way Street* (London and New York: Verso, 1997).

Benjamin, Walter, *Walter Benjamin: The Arcades Project* [1927–40], trans. Howard Eiland and Kevin McLaughlin (Cambridge, MA and London: Harvard University Press, 1999).

Benjamin, Walter, *Walter Benjamin Selected Writings, Volumes 2, 1927–1934; 4, 1938–1940*, trans. Rodney Livingstone and others, ed. Michael W. Jennings, Howard Eiland and Gary Smith (Cambridge, MA and London: Belknap Press of Harvard University, 2003).

Benjamin, Walter, and Gretel Adorno, *Correspondence 1930–1940*, trans. Wieland Hoban, ed. Henri Lonitz and Christoph Gödde (Cambridge, MA: Polity Press, 2008).

Benjamin, Walter, and Gershom Scholem, *Correspondence 1932–1940*, trans. Gary Smith and Andre Lefebvre (New York: Schocken Books, 1989).

Bennett, Christopher, *Yugoslavia's Bloody Collapse: Causes, Course and Consequences* (London: Hurst and Company, 1995).

Bergson, Henri, *Creative Evolution*, trans. Arthur Mitchell (Basingstoke: Palgrave Macmillan, 2007). Originally published in French as *L'évolution créatrice* (1907).

Bergson, Henri, *Matter and Memory*, trans. Nancy Margaret Paul and W. Scott Palmer (New York: Zone Books, 1991). Originally published in French as *Matière et mem-oire* (1896).

Best, Steven, 'The Commodification of Reality and the Reality of Commodification: Baudrillard, Debord and Postmodern Theory', in D. Kellner (ed.), *Baudrillard: A Critical Reader* (Cambridge, MA and Oxford: Blackwell, 1994).

Beugnet, Martine, 'Cinema and Sensation: French Film and Cinematic Corporeality', *Paragraph*, vol. 31, no. 2 (2008), pp. 173–88.

Beugnet, Martine, *Claire Denis* (Manchester: Manchester University Press, 2004).

Beugnet, Martine, 'The Practice of Strangeness: *L'Intrus* – Claire Denis (2004) and Jean-Luc Nancy (2000)', *Film Philosophy*, vol. 12, no. 1 (2008), pp. 31–48.

Bindman, David, '"Philanthropy seems natural to mankind": Hodges and Captain Cook's Second Voyage to the South Seas', in Geoff Quilley and John Bonehill (eds), *William Hodges 1744–1797: The Art of Exploration* (New Haven, CT and London: Yale University Press, 2004).

Birch, Kean, *A Research Agenda for Neoliberalism* (Cheltenham and Northampton, MA: Edward Elgar Publishing Ltd, 2017).

Blanchot, Maurice, *The Blanchot Reader*, ed. Michael Holland (Oxford and Cambridge, MA: Blackwell, 1995).

Blanchot, Maurice, 'Everyday Speech' [1959], trans. Susan Hanson, ed. Alice Kaplan and Kristin Ross, *Yale French Studies*, no. 73, special issue, *Everyday Life* (1987), p. 15.

Blanchot, Maurice, *Faux Pas*, trans. Charlotte Mandell (Stanford: Stanford University Press, 2001).

Blanchot, Maurice, *Friendship*, trans. Elizabeth Rottenberg (Stanford: Stanford University Press, 1997).

Blanchot, Maurice, *The Infinite Conversation*, trans. Susan Hanson (Minneapolis and London: University of Minnesota Press, 2003).

Blanchot, Maurice, *The Space of Literature*, trans. Anne Smock (Lincoln and London: University of Nebraska Press, 1989).

Block, Fred L., *Postindustrial Possibilities: A Critique of Economic Discourse* (Los Angeles: University of California Press, 1990).

Botta, Anna, 'Calvino and the Oulipo: An Italian Ghost in the Combinatory Machine? *MLN*, vol. 112, no. 1, Italian Issue (January 1997), pp. 81–9.

Bouchard, Donald F. (ed.), *Language, Counter-Memory, Practice: Selected Essays and Interviews by Michel Foucault* (Ithaca, NY: Cornell University Press, 1977).

Breton, André, *Nadja* [1928] (Paris: Éditions Gallimard, 1964).

Brown, Wendy, *Regulating Aversion: Tolerance in the Age of Identity and Empire* (Princeton: Princeton University Press, 2006).

Brown, Garrett W. 'The Laws of Hospitality, Asylum Seekers and Cosmopolitan Right: A Kantian Response to Jacques Derrida', *European Journal of Political Theory*, vol. 9, no. 3 (2010), pp. 308–27.

Brunt, Peter, 'Savagery and the Sublime: Two Paintings by William Hodges based on an Encounter with Māori in Dusky Bay, New Zealand', *Eighteenth Century*, vol. 38, no. 3 (Fall 1997), pp. 266–86.

Bryan-Wilson, Julia, *Art Workers: Radical Practice in the Vietnam Era* (Berkeley and Los Angeles: University of California Press, 2009).

Buchloh, Benjamin, 'Figures of Authority, Ciphers of Regression: Notes on the Return of Representation in European Painting', *October*, no. 16 (Spring 1981), pp. 39–68.

Burke, Edmund, *A Philosophical Inquiry into the Origin of Our Ideas of the Sublime and Beautiful* [1756], ed. J. T. Boulten (London: Routledge and Kegan Paul, 1958).

Burn, Ian, 'The Art Market: Affluence and Degradation', *Artforum*, vol. 13, no. 8 (1975), pp. 34–7.

Butler, Judith, *Parting Ways: Jewishness and the Critique of Zionism* (New York: Columbia University Press, 2012).

Butler, Judith, *Precarious Life: The Powers of Mourning, and Violence* (London and New York: Verso, 2006).

Butler, Judith, interview with Christian Salmon, trans. David Broder, Verso Blog, <www.versobooks.com/blogs/3025-trump-fascism-and-the-construction-of-the-people-an-interview-with-judith-butler>, last accessed 17 January 2019. Originally appeared in French as 'Pourquoi «Trump est un phénomène fasciste»', 18 December 2016, https://www.mediapart.fr/journal/international.

Butlin, Noel George, *Economics and the Dreamtime: A Hypothetical History* (Cambridge and Melbourne: Cambridge University Press, 1993), pp. 184–5.

Cacciari, Massimo, *Architecture and Nihilism: on the Philosophy of Modern Architecture*, trans. Stephen Sartarelli (New Haven, CT: Yale University Press, 1993).

Calvino, Italo, 'Finding One's Way as a Writer: A Sequence of Letters', trans. Martin McLaughlin, *New England Review*, vol. 34, no. 1 (2013), p. 57.

Calvino, Italo, *Invisible Cities (Le città invisibile)*, trans. William Weaver (Orlando: Harcourt Brace and Company, 1974).

Calvino, Italo, *Letters 1941–85*, trans. Martin McLaughlin (Princeton: Princeton University Press, 2013).

Carmody, Francis J, 'Jean Paulhan's Imaginative Writings', *The French Review*, vol. 23, no. 4 (February 1950), pp. 269–77.

Caygill, Howard, *On Resistance: A Philosophy of Defiance* (London: Bloomsbury, 2015).

Caygill, Howard, *Walter Benjamin: The Colour of Experience* (London and New York: Routledge, 1998).

Charles, Matthew, 'Secret Signals from Another World: Walter Benjamin's Theory of Innervation', *New German Critique*, vol. 45, no. 3 (135) (November 2018), pp. 39–40.

Clark, T. J., *The Painting of Modern Life: Manet and His Followers* (Princeton: Princeton University Press, 1984).

Clark, T. J., *The Sight of Death: An Experiment in Art Writing* (New Haven, CT and London: Yale University Press, 2006).

Clark, T. J., and Donald Nicholson-Smith, 'Why Art Can't Kill the Situationist International', *October*, no. 79 (Winter 1997), pp. 15–31.

Congressional Record of April 6 and 7, 1971, *The Winter Soldier Investigation: An Inquiry into American War Crimes* (Boston, MA: Beacon Press, 1972).

Connelly, William, 'The New Materialism and the Fragility of Things', *Millennium: Journal of International Studies*, vol. 41, no. 3 (2013), pp. 399–412.

Connelly, William, *The Fragility of Things: Self-Organizing Processes, Neoliberal Fantasies, and Democratic Activism* (Durham, NC: Duke University Press, 2013).

Critchley, Simon, *Infinitely Demanding: Ethics of Commitment, Politics of Resistance* (London and New York: Verso, 2007).

Crow, Thomas E., *The Rise of the Sixties: American and European Art in the Era of Dissent* (London: Lawrence King Publishing, 1996).

Culbert, John, 'Slow Progress: Jean Paulhan and Madagascar', *October*, no. 83 (Winter 1998), pp. 71–95.

Dabrowski, Magdalena, Leah Dickerman and Peter Galassi (eds), *Aleksandr Rodchenko* (New York: Museum of Modern Art, 1998).

de Certeau, Michel, 'Walking in the City', *Practices of Everyday Life* (Berkeley, Los Angeles and London: University of California Press, 1984).

de Peuter, Greig, and Nicole S. Cohen, 'Emerging Labour Politics in Creative Industries', in Kate Oakley and Justin O'Connor (eds), *The Routledge Companion to the Cultural Industries* (New York: Routledge, 2015).

Debord, Guy, *Panageric, Vols I & II*, trans. James Brook (London and New York: Verso, 2009).

Debord, Guy, *'Cette mauvaise reputation . . . '* (Paris: Gallimard, 1989).

Debord, Guy, *The Society of the Spectacle*, trans. Donald Nicholson-Smith (New York: Zone Books, 1995).

Debord, Guy, 'Préface à la quatrième edition Italienne de *La Société du Spectacle*', included in the French edition of *Commentaires sur la société du spectacle* (Paris: Èditions Gallimard, 1992).

Debord, Guy, *Comments on the Society of the Spectacle*, trans. Malcolm Imrie (London: Verso, 1988).

Debord, Guy, 'The State of Spectacle', in Hedi El Kholti, Sylvère Lotringer and Christian Marazzi (eds), *Autonomia: Post Political Studies* (Los Angeles: Semiotext(e), 1980).

Debord, Guy, *Le société du spectacle* (Paris: Buchet-Castel, 1967).

Deleuze, Gilles, *A 1000 Plateaus: Capitalism and Schizophrenia (Mille Plateaux*, vol. 2 *Capitalisme and schizophrénie)*, trans. Brian Massumi (London and New York: Continuum, 1988).

Deleuze, Gilles, *Bergsonism*, trans. Hugh Tomlinson (New York: Zone Books, 1991).

Deleuze, Gilles, *Cinema I: The Movement Image*, trans. Hugh Tomlinson and Robert Galeta (Minneapolis: University of Minnesota Press, 1989). Originally published in French as *Cinéma I: L'Image-Mouvement* (1983).

Deleuze, Gilles, *Cinema II: The Time Image*, trans. Hugh Tomlinson and Robert Galeta (Minneapolis: University of Minnesota Press, 1989). Originally published in French as *Cinéma II, L'Image-Temps* (1985).

Deleuze, Gilles, 'Control and Becoming', in discussion with Antonio Negri, trans. Martin Joughin, *Negotiations* (New York: Columbia University Press, 1995). Originally published in French in *Futur Antérieur* (Spring 1990).

Deleuze, Gilles, *Cours Vincennes*, trans. Timothy S. Murphy (24 January 1978), <www. webdeleuze.com/textes/14> last accessed 24 July 2017.

Deleuze, Gilles, *Difference and Repetition*, trans. Paul Patton (New York: Columbia University Press, 1994). Originally published in French as *Différence et Repetition* (1968).

Deleuze, Gilles, *Expressionism in Philosophy: Spinoza*, trans. Martin Joghin (New York: Zone Books, 2009).

Deleuze, Gilles, *Logic of Sense*, trans. Mark Lester with Charles Stivale (London: Athlone Press, 1969). Originally published in French as *Logique du sens* (1969).

Deleuze, Gilles, 'Michel Foucault's Main Concepts', in Nicolae Morar, Thomas Nail and Daniel W. Smith (eds), *Between Deleuze and Foucault* (Edinburgh: Edinburgh University Press, 2016).

Deleuze, Gilles, *Nietzsche and Philosophy*, trans. Hugh Tomlinson (London and New York: Continuum, 2005).

Deleuze, Gilles, 'Postscript to Societies of Control', trans. Martin Joughin, *October*, no. 59 (1992), pp. 3–7. Originally published in French as 'Post-scriptum sur les sociétés de contrôle', *L'autre* (May 1990).

Deleuze, Gilles, *Pure Immanence: Essays on Life*, trans. Anne Boyman (New York: Zone Books, 2001).

Deleuze, Gilles, *Spinoza*: *Practical Philosophy*, trans. Robert Hurley (San Francisco: City Lights Books, 1988).

Deleuze, Gilles, *Two Regimes of Madness: Texts and Interviews 1975–1995*, ed. David Lapoujade, trans. Ames Hodges and Mike Taormina (New York and Los Angeles: Semiotext(e), 2007).

Deleuze, Gilles, *What is Philosophy?* trans. Hugh Tomlinson and Graham Burchell (New York: Columbia University Press, 1994).

Deleuze, Gilles, and Felix Guattari, *Anti-Oedipus: Capitalism and Schizophrenia*, [1972], trans. Robert Hurley, Mark Seem and Helen R. Lane (Minneapolis: University of Minnesota Press, 1994).

Deleuze, Gilles, Daniel W. Smith and Michael A. Greco (trans.), *Essays Critical and Clinical* (Minnesota: University of Minnesota Press, 1997).

Denis, Claire, in dialogue with Eric Hynes, Walker Art Center (15 July 2013), <https://www.youtube.com/watch?v=onYtE01KmFE>, last accessed 20 January 2019.

Denis, Claire, and Jean-Luc Nancy, *L'Intrus*, European Graduate School (2017), <https://www.youtube.com/watch?v=CoTGowlhABk>, last accessed 20 January 2019.

Deranty, Jean-Philippe, 'Jacques Rancière's Contribution to the Ethics of Recognition', *Political Theory*, vol. 31, no. 1 (February 2003), pp. 136–56.

Deranty, Jean-Philippe, 'Rancière and Contemporary Political Ontology', *Theory and Event*, vol. 6, no. 4 (2003), pp. 1–28.

Deranty, Jean-Philippe (ed.), *Jacques Rancière: Key Concepts* (Oxford and New York: Routledge, 2014).

Derrida, Jacques, *Adieu à Emmanuel Levinas*, trans. Pascale-Anne Brault and Michael Naas (Stanford: Stanford University Press, 1999).

Derrida, Jacques, 'Hospitality', trans. Barry Stocker and Forbes Morlock, *Angelaki*, vol. 5, no. 3 (2000).

Derrida, Jacques, *Negotiations: Intervention and Interviews, 1971–2001*, trans. Peggy Kamuf (Stanford: Stanford University Press, 2002).

Derrida, Jacques, *Of Hospitality*, trans. Rachel Bowlby (Stanford: Stanford University Press, 2000).

Derrida, Jacques, 'Principles of Hospitality', Ashley Thompson translation of an interview with Dominique Dhombres for *Le Monde* (2 December 1997), p. 8.

Derrida, Jacques, *Specters of Marx*, trans. Peggy Kamuf (Oxford: Routledge, 1994).

Descombes, Vincent, *Modern French Philosophy*, trans. L. Scott-Fox and J. M. Harding (New York and Melbourne: Cambridge University Press, 1980).

Dews, Peter, 'The *Nouvelle Philosophie* and Foucault', *Economy and Society*, vol. 8, no. 2 (1979), pp. 127–71.

Didi-Huberman, Georges, *Confronting Images: Questioning the Ends of a Certain History of Art*, trans. John Goodman (University Park: Pennsylvania State University Press, 2005).

Doane, Mary Ann, *The Emergence of Cinematic Time: Modernity, Contingency, The Archive* (Cambridge, MA and London: Harvard University Press, 2002).

Durie, Robin, 'Wandering Among Shadows: The Discordance of Time in Levinas and Bergson', *The Southern Journal of Philosophy*, vol. 48, no. 4 (December 2010), pp. 371–92.

Durie, Robin (ed.), *Time and Instant: Essays in the Physics and Philosophy of Time* (Manchester: Clinamen, 2000).

Engels, Friedrich, *Condition of the Working Class in England* [1844], ed. David McLellan (Oxford: Oxford University Press, 1993).

Fisher, Dominique. 'Jean Paulhan: Toward a Poetic/Pictural Space', *The French Review*, vol. 61, no. 6 (May 1988), pp. 878–83.

Foster, Hal, 'Post-Critical', *October*, no. 139 (Winter 2012), pp. 3–8.

Foster, Hal, *Compulsive Beauty* (Cambridge, MA: MIT Press, 1997).

Forster, George, *A Voyage Round the World* [1777], vols I and II, ed. Nicholas Thomas and Liver Berghof (Honolulu: University of Hawaii Press. 2000).

Foucault, Michel, *Ethics: The Essential Works – 1955–1984*, vol. 1, Robert Hurley and others (trans.), (London: Allen Lane, The Penguin Press, 1997).

Foucault, Michel, *The Government of Self and Others: Lectures at the Collège de France, 1982–1983*, ed. Frédéric Gros, trans. Graham Burchell (Basingstoke: Palgrave Macmillan, 2011).

Foucault, Michel, *Discipline and Punish: The Birth of the Prison*, trans. Alan Sheridan (New York: Vintage Books, 1995). Originally published in French as *Surveiller et punir* (1975).

Foucault, Michel, *History of Sexuality*, vol. 1, trans. Robert Hurley (New York: Pantheon Books, 1978). Originally published in French as *Histoire de la sexualité* (1976–84).

Fried, Michael, 'Art and Objecthood', *Artforum*, vol. 5, no. 10 (Summer 1967), pp. 12–23.

Furet, François, *Passing of an Illusion: The Idea of Communism in the Twentieth Century*, trans. Deborah Furet (Chicago: University of Chicago Press, 1999).

Galassi, Jonathan, '*Poesia in forma di rosa (Poetry in the Form of a Rose*', 1964, *New York Review of Books* (20 June 2013). <www.nybooks.com/articles/archives/2013/jun/20/dreams-italo-calvino/>, last accessed 20 January 2019. Review of Calvino, *Letters, 1941–1985*.

Gardner, Anthony, *Politically Unbecoming: Postsocialist Art against Democracy* (Cambridge, MA: MIT Press, 2015).

Godard, Jean-Luc, and Youssef Ishaghpour, *Cinema: The Archaeology of Film and the Memory of a Century*, trans. John Howe (Oxford and New York: Berg, 2005).

Gorz, André, *Farewell to the Working Class: An Essay on Post-Industrial Socialism*, trans. Michael Sonenscher (London and Sydney: Pluto Press, 1982). Originally published in French as *Adieu au Proletariat* (Paris: Éditions Galilée, 1980).

Grace, Helen, *Artists Think: The Late Work of Ian Burn* (Sydney and Melbourne: Power Institute and Monash University Gallery of Art, 1996).

Grosz, Elizabeth, *The Incorporeal: Ontology, Ethics, and the Limits of Materialism* (New York: Columbia University Press, 2017).

Gržinić, Marina, 'Synthesis: Retro-avant-garde, or Mapping Post-Socialism in Ex-Yugoslavia', *ARTMargins* (September 2000), http://www.artmargins.com/index.php/8-archive/258-synthesis-retro-avant-garde-or-mapping-post-socialism-in-ex-yugoslavia-, last accessed 16 January 2019.

Gržinić, Marina, 'Total Despair', *Telepolis*, 19 June 1997, <www.heise.de/tp/english/speical/mud/6145/1.html>, last accessed 21 January 2009.

Habermas, Jürgen, 'Consciousness-Raising or Redemptive Criticism: The Contemporaneity of Walter Benjamin', *New German Critique*, no. 17, Special Walter Benjamin Issue (Spring 1979), pp. 30–59.

Habermas, Jürgen, 'Modernity's Consciousness of Time and its Need for Self-Reassurance,' trans. Frederick Lawrence, *The Philosophical Discourse of Modernity: Twelve Lectures* (Cambridge and Malden, MA: Polity Press, 1987).

Haider, Asad, *Mistaken Identity: Race and Class in the Age of Trump* (London and New York: Verso, 2018).

Hamacher, Werner, '"Now": Walter Benjamin on Historical Time', in Heidrun Friese (ed.), *The Moment: Time and Rupture in Modern Thought* (Liverpool: Liverpool University Press, 2001).

Hansen, David, *John Glover and the Colonial Picturesque* (Hobart: Tasmanian Museum and Art Gallery, 2003).

Hansen, Miriam, 'Benjamin's Aura', *Critical Inquiry*, vol. 34, no. 2 (Winter 2008), pp. 336–75.

Hardt, Michael and Antonio Negri, *Empire* (Cambridge, MA: Harvard University Press, 2000).

Hardt, Michael and Antonio Negri, *Multitude: War and Democracy in the Age of Empire* (London: Penguin, 2004).

Harvey, David, *A Brief History of Neoliberalism* (Oxford and New York: University of Oxford Press, 2005).

Hohendahl, Peter Uwe, 'Autonomy of Art: Looking Back at Adorno's Ästhetische Theorie', *The German Quarterly*, vol. 54, no. 2 (March 1981), pp. 133–48.

Hoorn, Jeanette, *Australian Pastoral: The Making of a White Landscape* (Fremantle, Western Australia: Fremantle Press, 2007).

Illich, Ivan, 'Hospitality and Pain' (paper presented in Chicago, 1987 to a theological seminary), www.davidtinapple.com/illich/1987hospitality_and_ pain.PDF, last accessed July 2014.

Illich, Ivan, *Gender* (New York: Pantheon Books, 1982).

Inglehart, Ronald F., *The Silent Revolution: Changing Values and Political Among Western Publics* (Princeton: Princeton University Press, 1977).

Inglehart, Ronald F., and Pippa Norris, 'Trump, Brexit, and the Rise of Populism: Economic Have-nots and Cultural Backlash', *Roundtable, Rage Against the Machine, Populist Politics in the U.S., Europe and Latin America* (Philadelphia: American Political Science Association, September 2016).

Irwin, and Eda Cufer, *Retroavantgarda: Mladen Stilinovic, Kasimir Malevic, Irwin* (Ljubljana: Visconti Fine Art Kolisej, 1994).

Jacobson, Eric, 'Understanding Walter Benjamin's Theological-Political Fragment', *Jewish Studies Quarterly*, vol. 8, no. 3 (2001), pp. 205–47.

Janoski, Thomas E, 'Challenging Dominant Market Theories in Five Ways', *DisClosure: Journal of Social Theory*, vol. 24 (2015), pp. 45–70.

Joppien, Rüdiger, and Bernard Smith, *The Art of Captain Cook's Voyages*, vols 1–3, *The Voyage of the Resolution and Discovery 1776–1780* (Melbourne: Oxford University Press, 1987).

Judd, Donald, *Complete Writings 1959–75* (Halifax, Canada, and New York: The Press of Novia Scotia Art and Design and New York University Press, 2005).

Kaufman, Eleanor, 'Midnight, or the Inertia of Being', *Parallax*, vol. 12, no. 2 (2006), pp. 98–111.

Houston, Kerr, 'The Decline of "Political Art"', *BMoreArt: Creative, Critical, Daily* (27 January 2016), <www.bmoreart.com/2016/01/the-decline-of-political-art. html,> last accessed 4 July 2018.

Keucheyan, Razmig, *The Left Hemisphere: Mapping Critical Theory Today* (London and New York: Verso, 2014).

Khosravi, Shahram, 'Stolen Time', *Radical Philosophy*, no. 2.03 (December 2018), pp. 38–41.

Knabb, Kenneth, *Situationist International Anthology* (Berkeley: Bureau of Public Secrets, 1981).

Laclau, Ernesto, 'Can Immanence Explain Social Struggles', in Paul A. Passavant and Jodi Dean (eds), *Empire's New Clothes: Reading Hardt and Negri* (New York and London: Routledge, 2004).

Lacoue-Labarthe, Philippe, *Typography: Mimesis, Philosophy, Politics* (Cambridge, MA and London: Harvard University Press, 1989).

Lefebvre, Alexandre, 'The Rights of Man and the Care of the Self', *Political Theory*, vol. 44, no. 4 (2016), pp. 518–40.

Lefebvre, Henri, *Introduction to Modernity: Twelve Preludes*, trans. John Moore (London: Verso, 1995).

Lefebvre, Henri, *Critique of Everyday Life Vol. 1*, trans. John Moore (London and New York: Verso, 1991). Originally published in French as *Critique de la vie quotidienne, Vol. I* (1947).

Lefebvre, Henri, *Critique of Everyday Life Vol. II*, trans. John Moore (London and New York: Verso, 1991). Originally published in French as *Critique de la vie quotidienne, Vol. II* (1961).

Lefebvre, Henri, *Everyday Life in the Modern World*, trans. Sacha Rabinovitch (New York: Harpers Torchwood, 1971).

Levinas, Emmanuel, *Totality and Infinity: An Essay on Exteriority*, trans. Alphonso Lingis (Pittsburgh: Duquesne University Press, 1969).

Lévinas, Michaël, 'The Final Meeting between Emmanuel Lévinas and Maurice Blanchot', trans. Sarah Hammerschlag, *Critical Inquiry*, vol. 36, no. 4 (Summer 2010), pp. 649–51.

Lippard, Lucy, *Six Years: The Dematerialization of the Art Object from 1966 to 1972: A Cross-Reference Book of Information on Some Aesthetic Boundaries* (London: Studio Vista, 1973).

Lipotevsky, Gilles, *The Empire of Fashion: Dressing Modern Democracy*, trans. Catherine Porter (Princeton: Princeton University Press, 1994).

Livingston, Paisley, 'Review: *Pasolini* by Maria Antoinetta Macciocchi', *MLN*, vol. 96, no. 4 (1981), pp. 913–15.

Loewenstein, Antony, *Disaster Capitalism: Making a Killing out of Catastrophe* (London and New York: Verso, 2017).

Lordon, Frédéric, *The Willing Slaves of Capital: Spinoza and Marx on Desire*, trans. Gabriel Ash (London and New York: Verso, 2014), p. 11. Originally published in French as *Capitalisme, désir et servitude* (Paris: La Fabrique éditions, 2010).

Lukács, György, 'The Phenomenon of Reification', *History and Class Consciousness* [1923], trans. Rodney Livingstone (London: Merlin Press, 1971).

McCalman, Janet, *Sex and Suffering: Women's Health and Women's Hospital: The Royal Women's Hospital, Melbourne 1856–1996* (Carlton South: Melbourne University Press, 1998)

McLaughlin, Martin, 'Finding One's Way as a Writer: A Sequence of Letters', *New England Review*, vol. 34, no. 1 (2013), p. 57.

McLean, Ian, *John Glover and the Colonial Picturesque*, ed. David Hansen (Hobart: Tasmanian Museum and Art Gallery, 2003).

McNeill, Isabelle, *Memory and the Moving Image: French Film in the Digital Era* (Edinburgh: Edinburgh University Press, 2010).

McPhee, John, *The Art of John Glover* (South Melbourne: The Macmillan Company of Australia Pty Ltd, 1980).

Malabou, Catherine, 'Before and Above: Spinoza and Symbolic Necessity', *Critical Inquiry*, vol. 43 (Autumn 2016), pp. 84–139.

Malabou, Catherine, *Ontology of the Accident: An Essay on Destructive Plasticity*, trans. Caroline Shread (Cambridge, MA: Polity Press, 2012).

Malabou, Catherine, *What Should We Do With Our Brains?* trans. Sebastian Rand (New York: Fordham University Press, 2008).

Marchart, Oliver, *Post-foundational Political Thought: Political Difference in Nancy, Lefort, Badiou and Laclau* (Edinburgh: Edinburgh University Press, 2007).

Marx, Karl, *Early Writings*, Rodney Livingstone and Gregor Benton (London: Penguin Classics, 1992).

Marx, Karl, *Capital: A Critique of Political Economy, Volume* 1 (Moscow: Progress Publishers, 1978).

Marx, Karl, *Grundrisse*, trans. Martin Nicolaus (London: Penguin and New Left Review, 1973).

Marx, Karl, and Friedrich Engels, *The German Ideology*, Part I, intro. C. J. Arthur (London: Lawrence & Wishart, 1974).

Mastnak, Tomaz, 'From Social Movements to National Sovereignty', in Jill Benderly and Evan Kraft (eds), *Independent Slovenia: Origins, Movements, Prospects* (New York: St Martin's Press, 1995).

May, Todd, 'Gilles Deleuze and the Politics of Time', *Man and World*, vol. 29, no. 3 (1996), pp. 293–304.

Milana, Fabio, '*Gender*: Notes to the Text', *The International Journal of Illich Studies*, vol. 5, no. 1 (2016), pp. 69–94.

Minh-hà, Trinh T, 'Documentary Is/Not a Name,' *October*, no. 52 (Spring 1990), pp. 76–98.

Monroe, Alexei, 'Twenty Years of Laibach. Twenty Years of . . . ? Slovenia's Provocative Musical Innovators', *Central Europe Review*, <http://www.ce-review.org/00/31/monroe31.html>, last accessed 20 January 2019.

Morin, Edgar, 'The Anti-Totalitarian Revolution', in P. Beilharz, Gillian Robinson and John Rundell (eds), *Between Totalitarianism and Postmodernity* (Cambridge, MA: MIT Press, 1992).

Murphy, Carol J., 'Re-Presenting the Real: Jean Paulhan and Jean Fautrier', *Yale French Studies*, no. 106 (2004), pp. 71–86.

Musil, Robert, *The Man Without Qualities* [1930–43], trans. Sophie Wilkins (London: Picador, 2017).

Nancy, Jean-Luc, *The Ground of the Image*, trans. Jeff Fort (Bronx: Fordham University Press, 2005).

Nancy, Jean-Luc, *L'Intrus*, trans. Susan Hanson (Paris: Éditions Galilée, 2000; East Lansing: Michigan State University Press, 2002).

Nancy, Jean-Luc, 'Art Today', trans. Charlotte Mandell, *Journal of Visual Culture*, vol. 9, no. 2 (2000), pp. 91–9.

Nancy, Jean-Luc, *The Inoperative Community*, trans. Peter Connor and Lisa Garbus (Minneapolis and Oxford: University of Minnesota Press, 1991).

Negri, Antonio, 'Starting Again with Marx', trans. Arianna Bove, *Radical Philosophy*, no. 2.03 (December 2018), pp. 1–9.

Negri, Antonio, 'When and How I Read Foucault', trans. Kris Klotz, in Nicolae Morar, Thomas Nail and Daniel W. Smith (eds), *Between Deleuze and Foucault* (Edinburgh: Edinburgh University Press, 2016).

Néray, Katalin, Zdenka Badovinac, Dušan Mandič et al., 'Irwin in Budapest', *Irwin: Interior of the Planit* (Ljubljana: Moderna galerlja, Budapest and Ludwig Museum, 1996), unpaginated.

Nietzsche, Friedrich, *The Birth of Tragedy: Out of the Spirit of Music*, trans. Shaun Whiteside (London: Penguin Classics, 2003).

Nietzsche, Friedrich, *On the Genealogy of Morality* [1887], trans. Carol Diethe (Cambridge: Cambridge University Press, 2006).

Nietzsche, Friedrich, *Thus Spoke Zarathustra*, trans. R. J. Hollingdale (London: Penguin Classics, 2003).

Oberprantacher, Andreas, 'Breaking with the Law of Hospitality? The Emergence of Illegal Aliens in Europe Vis-à-vis Derrida's Deconstruction of the Conditions of Welcome', *Hospitality & Society*, vol. 3, no. 2 (2013), pp. 151–68.

Osborne, Peter, *Anywhere or Not at All: Philosophy of Contemporary Art* (London and New York: Verso, 2013).

Pascoe, Bruce, *Dark Emu: Black Seeds: Agriculture or Accident* (Broome, Western Australia: Magabala Books Aboriginal Corporation, 2014).

Pasolini, Pier Paolo, *Poems*, ed. Norman MacAfee (New York: Farrar, Straus, and Giroux, 1996).

Pasolini, Pier Paolo, *In Danger: A Pasolini Anthology*, ed. Jack Hirschman (San Francisco: City Lights Books, 2010).

Pasolini, Pier Paolo, *Pasolini*, ed. Maria Antonietta Macciocchi (Paris: Grasset, 1980).

Paulhan, Jean, *The Flowers of Tarbes, or Terror in Literature*, trans. Michael Syrotinski (Urbana–Champaign: Board of Trustees of the University of Illinois, 2006). Originally published in French as *Fleurs de tarbe: Terreur dans les letters* (1936).

Paulhan, Jean, *La peinture cubiste* (Paris: Folio, Gallimard, 1990).

Paulhan, Jean, *L'art informel: Éloge* (Paris: Gallimard, 1962).

Paulhan, Jean, *Œuvres completes*, vol. 1 (Paris: Gallimard, 2006).

Paulhan, Jean, *Of Chaff and Wheat: Writers, War, and Treason*, trans. Richard A. Rand (Urbana and Chicago: University of Illinois Press, 2004).

Poster, Mark, *Existential Marxism in Postwar France: From Sartre to Althusser* (Princeton: Princeton University Press, 1975).

Pouilloux, Jean-Yves, and Michael Syrotinski, 'Fault Lines: Literature and the Experience of the Impossible', *Yale French Studies*, no. 106 (2004), pp. 159–72.

Poulantzas, Nicos, *State, Power, Socialism*, trans. Patrick Camiller (London: Verso, 2014).

Poulantzas, Nicos, *Fascism and Dictatorship: The Third International and the Problem of Fascism*, trans. Judith White (London: Verso, 1979). Originally published in French as *Fascisme et dictature* (1970).

Quattrocchi, Angelo, and Tom Nairn, *The Beginning of the End* (London and New York: Verso, 1998).

Quilley, Geoff, and John Bonehill (eds), *William Hodges, 1744–1797: The Art of Exploration* (New Haven, CT and London: National Maritime Museum, Greenwich and the Yale Center of British Art, 2014).

Rabinbach, Anson, 'Between Enlightenment and Apocalypse: Benjamin, Bloch and Modern German Jewish Messianism', *New German Critique*, no. 34 (Winter 1985), pp. 78–124.

Rajchman, John, *Constructions* (Cambridge, MA: MIT Press, 1998).

Rajchman, John, *The Deleuze Connections* (Cambridge, MA and London: MIT Press, 2000).

Rajchman, John, 'Deleuze's Time, or How the Cinematic Changes Our Idea of Art', in Tania Leighton (ed.), *Art and Moving Image: A Critical Reader* (London: Tate Publishing, 2008).

Rajchman, John, 'Thinking in Contemporary Art', *For Art Lecture* (2006), <http://forart.no/lectures/john-rajchman-thinking-contemporary-art>, last accessed 29 January 2019.

Rancière, Jacques, 'The Aesthetic Revolution: Emplotments of Autonomy and Heteronomy', *New Left Review* (March/April 2002), pp. 133–51.

Rancière, Jacques, *Aisthesis: Scenes from the Aesthetic Regime of Art*, trans. Zakir Paul (London and New York: Verso, 2013).

Rancière, Jacques, *Althusser's Lessons* [1974], trans. Emiliano Battista (London and New York: Continuum, 2011).

Rancière, Jacques, *Béla Tarr, the Time After*, trans. Erik Beranek (Minneapolis: Univocal Publishing, 2014).

Rancière, Jacques, *Chronicles of Consensual Time*, trans. Steve Corcoran (New York and London: Continuum, 2010).

Rancière, Jacques, *Dissensus on Politics and Aesthetics*, trans. Steve Corcoran (London and New York: Continuum, 2010)

Rancière, Jacques, 'The Emancipated Spectator', *Artforum*, vol. 45, no. 7, March 2007.

Rancière, Jacques, *The Emancipated Spectator*, trans. Gregory Elliot (London and New York: Verso, 2011).

Rancière, Jacques, 'The Ethical Turn in Art and Politics', trans. Jean-Philippe Deranty, *Critical Horizons*, vol. 7, no. 1 (2006), pp. 1–20.

Rancière, Jacques, 'A few remarks on the method of Jacques Rancière', *Parallax*, vol. 15, no. 3 (2000), pp. 114–23.

Rancière, Jacques, *Film Fables*, trans. Emiliano Battista (Oxford and New York: Berg, 2006).

Rancière, Jacques, *Flesh of the Words: The Politics of Writing*, trans. Charlotte Mandell (Stanford: Stanford University Press, 2004).

Rancière, Jacques, *The Future of the Image* (London and New York: Verso, 2007).

Rancière, Jacques, *The Ignorant Schoolmaster: Five Lessons in Intellectual Emancipation*, trans. Kristen Ross (Stanford: Stanford University Press, 1991).

Rancière, Jacques, 'On the Theory of Ideology: The Politics of Althusser' [1969], *Radical Philosophy*, no. 7 (Spring 1974), pp. 2–15.

Rancière, Jacques, *The Politics of the Aesthetic: The Distribution of the Sensible*, trans. Gabriel Rockhill (New York and London: Continuum, 2004).

Rancière, Jacques, 'The Thinking of the Dissensus: Politics and Aesthetics', in Paul Bowman and Richard Stamp (eds), *Reading Rancière* (London and New York: Continuum, 2011).

Rancière, Jacques, with Fulvia Canevale and John Kelsey, 'Art of the Possible', in Emiliano Battista (ed. and trans.), *Dissenting Words: Interviews with Jacques Rancière* (London: Bloomsbury, 2017).

Rancière, Jacques, Beth Hinderliter, William Kaizen et al. (eds), *Communities of Sense: Rethinking Aesthetics and Politics* (Durham, NC and London: Duke University Press, 2009).

Rand, Richard, 'Grave Site', *Yale French Studies*, no. 106, special issue, *The Power of Rhetoric, the Rhetoric of Power: Jean Paulhan's Fiction, Criticism, and Editorial Activity*, ed. Kirstin Ross (2004).

Reader, Keith A., with Khursheed Wadia, *The May 1968 Events in France: Reproductions and Interpretations* (Basingstoke: Macmillan, 1993).

Rebentisch, Juliane, 'The Contemporaneity of Contemporary Art', *New German Critique*, vol. 42, no. 1 (124) (February 2015), pp. 223–37.

Reynolds, Henry, *Forgotten War* (Sydney: New South Press, University of New South Wales, 2014).

Ricciardi, Alessia, *After* La Dolce Vita*: A Cultural Pre-History of Berlusconi's Italy* (Stanford: Stanford University of Press, 2012)

Richter, Gerhard, 'The Work of Art and Its Formal and Genealogical Determinations', *Grey Room* no. 39 (Spring 2010), pp. 95–113.

Rimbaud, Arthur, *Complete Works*, trans. Paul Schmidt (New York: Harper and Row Publishers, 1976).

Rodowick, D. N. (ed.), *The Afterimages of Gilles Deleuze's Film Philosophy* (Minneapolis and London: University of Minnesota Press, 2010).

Ross, Kristin, *Communal Luxury: The Political Imaginary of the Paris Commune* (London and Brooklyn: Verso, 2015).

Ross, Kristin, 'Lefebvre on the Situationists: An Interview,' *October*, no. 79 (Winter 1997), pp. 69–83.

Rothwell, Phillip, 'Unfinished Revolutions: Gaps and Conjunctions', *Signs*, vol. 32, no. 2 (Winter 2012), pp. 271–4.

Salmond, Anne, *Two Worlds: First Meetings Between Māori and Europeans, 1642–1772* (Auckland: Viking, 1991).

Schmitt, Carl, *The Concept of the Political* [1927] (Chicago and London: University of Chicago Press, 1996).

Scholem, Gershom, *Kabbalah* (Jerusalem, Israel, and Toronto: Keter Publishing and Quadrangle, the New York Times Book Company, 1974).

Schönher, Mathias, 'Deleuze, a Split with Foucault', *Le foucaldien*, vol. 1, no. 1, (2015), pp. 2–12.

Schultz, Theodore William, *Investing in People: The Economics of Population Quality* (Berkeley and Los Angeles: University of California Press, 1981).

Sholette, Gregory, *Delirium and Resistance: Activist Art and the Crisis of Capitalism* (London: Pluto Press, 2017).

Sholette, Gregory, 'Dark Matter, Activist Art and the Counter-Public Sphere', in Matthew Beaumont, Andrew Hemingway, Esther Leslie and John Roberts (eds), *As Radical as Reality Itself: Essays on Marxism and Art for the 21st Century* (Bern: Peter Lang, 2007).

Simmel, Georg, 'Fashion', *On Individuality and Social Forms: Selected Writings* (Chicago: University of Chicago Press, 1971).

Simons, Maarten, and Jan Masschelein, 'Governmental, Political and Pedagogic Subjectivation: Foucault with Rancière', *Educational Philosophy and Theory*, vol. 42, nos 5–6 (2010), pp. 588–605.

Smith, Bernard (1989), *European Vision and the South Pacific* (Melbourne: Oxford University Press).

Smith, Damon, '*L'Intrus: An Interview with Claire Denis*', *Senses of Cinema*, no. 35 (2005), <www.sensesofcinema.com/contents/05/35/ claire_denis_interview.html>, last accessed January 2019.

Smith, Gary, 'A Genealogy of "Aura": Walter Benjamin's Idea of Beauty', in Carol C. Gould and Robert S. Cohen (eds), *Artifacts, Representations and Social Practice: Essays for Marx Wartofsky* (Dordrecht: Kluwer Academic Publishers, 1994).

Smith, Gary (ed.) *Benjamin: Philosophy, Aesthetics, History* (Chicago: University of Chicago Press, 1989).

Smith, Gary (ed.) *On Walter Benjamin: Critical Essays and Recollections* (Cambridge, MA: MIT Press, 1988).

Smith, Terry, *Thinking Contemporary Curating* (London: ICA, Independent Curators International, 2012).

Spinoza, *The Ethics*, trans. Edwin Curley (London: Penguin Classics, 1996).

Syrotinski, Michael, 'Domesticated Reading: Paulhan, Derrida, and the Logic of Ancestry', in Julian Wolfreys, John Brannigan and Ruth Robbins (eds), *The French Connections of Jacques Derrida* (New York: State University of New York Press, 1999).

Syrotinski, Michael, *Defying Gravity: Jean Paulhan's Interventions in Twentieth-Century French Intellectual History* (New York: State University of New York Press, 1989).

Szondi, Peter, 'Hope in the Past', in Howard Eiland (ed.), *Berlin Childhood Around 1900* (Cambridge, MA and London: Belknap Press of Harvard University Press, 2006).

Tiedemann, Rolf, 'Dialectics at a Standstill', in Howard Eiland and Kevin McLaughlin (trans.), *The Arcades Project: Walter Benjamin* (Cambridge, MA and London: Belknap Press of Harvard University Press, 1999).

Tiedemann, Rolf, 'Historical Materialism or Political Messianism? An Interpretation of The Theses "On the Concept of History"', *The Philosophical Forum*, vol. XV, nos 1–2 (Fall–Winter 1983–84), pp. 71–105.

Thomajan, Dale, 'Handheld Heaven, Agitprop Purgatory', *Film Comment*, vol. 31, no. 2 (1995), pp. 87–8.

Thomas, Nicholas, *In Oceana: Visions, Artifacts, Histories* (Durham, NC and London: Duke University Press, 1997).

Tønder, Lars, *Tolerance: A Sensorial Orientation to Politics* (New York: Oxford University Press, 2013).

Touraine, Alain, *The May Movement; Revolt And Reform: May 1968 – The Student Rebellion and Workers' Strikes – The Birth of a Social Movement* [1968], trans. Leonard F. X. Mayhew (New York: Random House, 1971).

Vernon, Richard, 'Pascalian Ethics? Bergson, Levinas, Derrida', *European Journal of Political Theory*, vol. 9, no. 2 (2010), pp. 167–82.

Valverde, Mariana, '"Despotism" and Ethical Liberal Governance', *International Journal of Human Resource Management*, vol. 25, no. 3 (1996), pp. 357–72.

West, Dennis, '*I am Cuba* by Mikhail Kalatozov', *Cinéaste*, vol. 22, no. 2 (1996), p. 52.

Wigley, Mark, *White Walls, Designer Dresses: The Fashioning of Modern Architecture* (Cambridge, MA and London: MIT Press, 1995).

Williams, Mark, *Ireland's Immortals: A History of the Gods of Irish Myth* (Princeton and Oxford: Princeton University Press, 2016).

Wilke, Tobias, 'Tacti(ca)lity Reclaimed: Benjamin's Medium, the Avant-Garde, and the Politics of the Senses', *Grey Room*, no. 39 (Spring 2010), pp. 39–55.

Wohlfarth, Irving, '"Männer aus der Fremde": Walter Benjamin and the "German-Jewish Parnassus"', *New German Critique*, no. 70 (Winter 1997), pp. 3–85.

Wohlfarth, Irving, 'On the Messianic Structure of Walter Benjamin's Last Reflections', *Glyph 3* (Baltimore and London: Johns Hopkins University Press, 1978).

Wohlfarth, Irving, 'On Some Jewish Motifs in Benjamin', in Andrew Benjamin (ed.), *The Problems of Modernity: Adorno and Benjamin* (London and New York: Routledge, 1992).

Young, James O., 'Cultures and the Ownership of Archaeological Finds', in Chris Scarre and Geoffrey Scarre (eds), *The Ethics of Archaeology: Philosophical Perspectives on Archaeological Practice* (Cambridge: Cambridge University Press, 2006).

Young, Robert, *White Mythologies: Writing, History and the West* (London: Routledge, 1990).

Zamora, Daniel, and Michael C. Behrent (eds), *Foucault and Neoliberalism* (London: Polity Press, 2015).

Filmography

I Am Cuba (USSR), dir. Mikhail Kalatozov, 1964, black and white, 35 mm, 143 mins (original edit).

Beau Travail (France), dir. Claire Denis, 1999, colour, 35 mm, 92 mins.

Certain Women (USA), dir. Kelly Reichardt, 2017, colour, 16 mm, 107 mins.

L'Intrus (The Intruder) (France), dir. Claire Denis, 2004, colour, 35 mm, 130 mins.

Jeanne Dielman, 23 Commerce Quay, 1080 Brussels (Belgium), dir. Chantal Akerman, 1975, colour, 35 mm, 201 mins.

Prerokbe ognja (Predictions of Fire) (Slovenia/USA), dir. Michael Benson, 1996, colour, 90 mins.

The Turin Horse (Hungary), dir. Béla Tarr, 2011, 35 mm, black and white, 186 mins.

Winter Soldier (USA), Collaboration between Winterfilm (a collective of 18 filmmakers) and the Vietnam Veterans Against the War (VVAW), 1972, black and white, colour, 16 mm, 96 mins.

Websites referenced

Aljazeera, editorial, 'Why Australia's Detention Centres on Nauru and Manus Island are Still Open', <www.aljazeera.com/blogs/asia/2017/08/australia-detention-centres-nauru-manus-island-open-170813142449181.html>, last accessed 20 August 2018.

Arns, Inke, *Continued: Mobile States . . . / (NSK)*, East European Institute at the Free University of Berlin (December 1995), <www.backspace.org/everything/e/hard/texts2/cnsk.html>, last accessed 16 January 2019.

Australian Broadcasting Commission (ABC), News Online, editorial, 'Yassmin Abdel-Magied' (updated 26 April 2017), <www.abc.net.au/news/2017-04-26/yassmin-abdel-magied-under-fire-for-anzac-post/8472414>, last accessed 29 January 2019.

BBC News, editorial, 'Laibach and North Korea's First Western Concert' (Asia) (20 August 2015), <www.bbc.com/news/world-asia-33995268>, last accessed 2 August 2017.

Brown, Luke, 'Andrew Cotton shocking wipeout', *Independent* (9 November 2017), <www.independent.co.uk/sport/general/watch-surfing-wipeout-big-waves-crash-andrew-cotton-nazare-portugal-a8045436.html>, last accessed 19 January 2019.

Calderwood, Imogen, 'Irish Police Know Who Killed Mountbatten in 1979 Bombing, Says Westminster Source – But Secret Amnesty Deal is Obstructing Justice', *Daily Mail*, 17 May 2015, <www.dailymail.co.uk/news/article-3084858/Irish-police-know-killed-Earl-Mountbatten-1979-bombing-says-Westminster-source-IRA-attacks-secret-amnesty-deal-obstructing-justice.html>, last accessed 17 January 2019.

Cathcart, Michael, and Sarah Kanowski, 'Former Biennale Head Hits Back at Critics', *Arts and Books*, ABC Radio, <www.abc.net.au/radionational/programs/booksandarts/5312000>, last accessed 20 May 2018.

Claire Denis in dialogue with Eric Hynes, <https://www.youtube.com/watch?v=onYtE01KmFE>, last accessed 20 January 2019.

Cotton, Andrew, 'Chasing Big Waves BOMBS in Mullaghmore', <www.youtube.com/watch?v=4yLX9yw-Jhk&t=2s>, last accessed 19 January 2019.

Crikey, editorial, 'Full List of Casualties from Brandis' Arts Bloodbath Revealed' (13 May 2016), <www.crikey.com.au/2016/05/13/brandis-arts-bloodbath>, last accessed 22 May 2018.

Cumming, Laura, 'More of a Glum Trudge Than an Exhilarating Adventure', *Guardian* (15 May 2015), <www.theguardian.com/artanddesign/2015/may/10/venice-biennale-2015-review-56th-sarah-lucas-xu-bing-chiharu-shiota>, last accessed 28 January 2015.

Diaz, George, 'How the Nazis Ruined Erich Kästner's Career', *Der Spiegel* (18 April 2013), <www.spiegel.de/international/zeitgeist/nazi-book-burning-anniversary-erich-kaestner-and-the-nazis-a-894845.html>, last accessed 21 April 2018.

Editorial, solidarity.net.au (May 2018), <www.solidarity.net.au/mag/current/ 114/ may-1968-worker-student-revolt-stopped-france>, last accessed 20 January 2010.

Fitzgerald, Richie, 'This is What Surfing Mullaghmore Looks Like from the Water — Terrifying', *Behind the Lines*, Ep. 5, <https://www.youtube.com/watch?v=dvw NaXmz5u8>, last accessed 13 August 2019.

Galassi, Jonathan, 'The Dreams of Italo Calvino', *New York Review of Books* (20 June 2013), <www.nybooks.com/articles/archives/2013/jun/20/dreams-italo-calvino>, last accessed 28 January 2019.

Gheith, Jenny, 'Exhibiting Politics: Palestinian-American Artist Emily Jacir Talks about Her Work', *The Electronic Intifada* (4 November 2004), <electronicintifada.net/ content/exhibiting-politics-palestinian-american-artist-emily-jacir-talks-about-her-work/5295>, last accessed 28 January 2019.

Grant, Stan, 'Between Catastrophe and Survival: The Real Journey Captain Cook Set Us On' (updated 25 August 2017), <www.abc.net.au/news/2017-08-25/stan-grant-captain-cook-indigenous-culture-statues-history/8843172>, last accessed 31 January 2019.

Gržinić, Marina, 'Synthesis: Retro-avant-garde, or Mapping Post-Socialism in Ex-Yugoslavia', *ARTMargins* (September 2000), <http://www.artmargins.com/index. php/8-archive/258-synthesis-retro-avant-garde-or-mapping-post-socialism-in-ex-yugoslavia->, last accessed 16 January 2019.

Gržinić, Marina, 'Total Despair', *Telepolis* (19 June 1997), <https://www.heise.de/ tp/autoren/?autor=Marina%20Grzinic>, last accessed 13 August 2019.

The Guardian, editorial, Australian edition (14 August 2017), <www.theguardian.com/australia-news/2017/aug/14/dutton-retreats-on-offshore-detention-secrecy-rules-that-threaten-workers-with-jail>, last accessed 9 May 2018.

The Guardian, editorial, 'Orange Order March Erupts into Violence', <www.theguardian. com/uk-news/video/2013/jul/13/belfast-orange-order-march-violence-video>, last accessed 19 January 2019.

Helgesen, Sally, 'Scenes', *The Village Voice* (27 January 1972), <http://www.wintersol-dierfilm.com/reviews_012772_voice.htm>, last accessed 31 January 2019.

Heath, Joanna, 'Turnbull Accuses Biennale Artists of "Vicious Ingratitude"' *Australian Financial Review* (11 March 2014), <www.afr.com/lifestyle/arts-and-entertain-ment/turnbull-accuses-biennale-artists-of-vicious-ingratitude-20140311-ixlsu>, last accessed 10 May 2018.

Hoggart, Simon, 'Mountbatten: A Noble with a Common Touch', *Guardian* (28 August 1979), p. 2, < www.theguardian.com/uk-news/from-the-archive-blog/2015/ may/19/mountbatten-lord-prince-charles-ira-1979>, last accessed 31 January 2019.

Houston, Kerr, 'The Decline of "Political Art"', *BMoreArt: Creative, Critical, Daily* (27 January 2016), <www.bmoreart.com/2016/01/the-decline-of-political-art. html>, last accessed 4 July 2018.

Jacir, Emily, *Made in Palestine*, The Station Museum, Houston TX, <www.stationmuseum. com/Made_in_Palestine-Emily_Jacir/jacir.html>, last accessed 28 January 2019.

Launceston Advertiser, 'Riots in Melbourne' (15 July 1846), <https://trove.nla.gov.au/ newspaper/article/84769063>, last accessed 13 August 2019.

Lentin, Alana and Javed de Costa, 'Sydney Biennale Boycott Victory Shows that Divestment Works', *Guardian* (11 March 2014) <www.theguardian.com/ commentisfree/2014/mar/11/sydney-biennale-boycott-victory-shows-that-divestment-works>, last accessed 20 May 2018.

McKay, Susan, 'After Mountbatten: The Many Victims of the Mullaghmore Bombing', *Irish Times* (17 May 2015), <www.irishtimes.com/life-and-style/people/after-mountbatten-the-many-victims-of-the-mullaghmore-bombing-1.2214103>, last accessed 19 January 2019.

McCarthy, Jake, 'A Film You Shouldn't See: A Personal Opinion' *St. Louis Post-Dispatch* (23 October 1972), <www.wintersoldierfilm.com/reviews_102372_stlouis.htm>, last accessed 31 January 2019.

McGowan, Joe, quoted in Caroline Davies, 'Prince Charles visits scene where Lord Mountbatten was killed by the IRA', *Guardian* (21 May 2015), <www.theguardian.com/world/2015/may/20/prince-charles-visits-scene-where-lord-mountbatten-was-killed-by-the-ira>, last accessed 17 August 2017.

Mandelbaum, Jacques, 'Michel Subor, "Petit Soldat" pour Godard, n'a jamais pu se résoudre au mercenariat', *Le Monde* (3 May 2005), <www.lemonde.fr/cinema/article/2005/05/03/michel-subor-petit-soldat-pour-godard-n-a-jamais-pu-se resoudre-au-mercenariat_645691_3476.html>, last accessed 28 January 2019.

Melbourne: The City Past and Present, 'Racial and Ethnic Tensions', <www.emelbourne. net.au/biogs/EM01218b.htm>, last accessed 29 January 2019.

Meredith, Fionola, 'Riding Irish Giants', *Irish Times* (29 May 2010), <www.irishtimes. com/culture/books/riding-irish-giants-1.671645>, last accessed 19 January 2019.

Monroe, Alexei, 'Twenty Years of Laibach. Twenty Years of . . . ? Slovenia's Provocative Musical Innovators', *Central Europe Review*, vol. 2, no. 3 (2000), <www.ce-review. org/00/31/monroe31.html>, last accessed 28 January 2019.

National Public Radio (NPR) '*Winter Soldier*, A Remembrance of Vietnam Atrocities', broadcast in August 2005. <www.npr.org/templates/story/story. php?storyId=4800067>, last accessed 28 January 2019.

New Zealand History, 'The Treaty' <https://nzhistory.govt.nz/politics/treaty/the-treaty-in-brief>, last accessed 19 January 2019.

Pollak, Sorcha, 'Surfers Pounce as Prowlers Pounce Back to Life: Six Lucky Surfers Take Their Lives into Their Hands to Catch Giant Swell Off Coast of Sligo', *The Irish Times* (5 March 2014), <www.irishtimes.com/news/ireland/irish-news/surfers-pounce-as-prowlers-roars-back-to-life-1.1713484>, last accessed 3 July 2019.

Rosa Prince, 'Mournful Memories for Prince Charles Amid the Beauty of Sligo', *Telegraph* (19 May 2015), <www.telegraph.co.uk/news/uknews/northernireland/11616301/Mournful-memories-for-Prince-Charles-amid-the-beauty-of-Sligo.html>, last accessed 29 January 2019.

Ruggiero, Gregory, 'Latin American Debt Crisis', <www.angelfire.com/nj/Gregory Ruggiero/latinamericancrisis.html>, last accessed 10 June 2018.

Scorsese, Martin, Introduction to the Milestone Film and Video release of of *Soy Cuba* in 1995.

Scott, Blake, 'I Am Cuba, For Sale, 1964', *Not Even the Past*, <http://notevenpast. org/i-am-cuba-sale/>, last accessed 28 January 2019.

Skodo, Admir, 'How Immigration Detention Compares Around the World', *The Conversation* (19 April 2017), <theconversation.com/how-immigration-deten-tion-compares-around-the-world-76067>, last accessed 5 June 2018.

Stiglitz, Joseph, 'Of the 1%, by the 1%, for the 1%', *Vanity Fair* (31 March 2011), <www.vanityfair.com/news/2011/05/top-one-percent-201105>, last accessed 20 June 2018.

Surfer Today, editorial (9 March 2011), 'Big Wave Surfing Ignites the Billabong XXL 2011', <www.surfertoday.com/surfing/5166-big-wave-surfing-ignites-the-billa-bong-xxl-2011>, last accessed 29 January 2019.

Tarr, Belá, 'Interview' and Vladan Perkovic, *Cineuropa* (1 March 2011), <http://cineu-ropa.org/it.aspx?t=interview&lang=en&documentID=198131>, last accessed 24 January 2018.

Tarr, Belá, with Virginie Sélavy, '*The Turin Horse*: Interview with Belá Tarr', *Electric Sheep: A Deviant View of Cinema* (4 June 2012), <www.electricsheepmagazine. co.uk/features/2012/06/04/the-turin-horse-interview-with-bela-tarr>, last accessed 24 January 2018.

Tait, Melanie, 'Biennale Boycott', Radio National Archive (15 March 2014), <www.abc. net.au/radionational/programs/archived/weekendarts/biennaleboycott/5323094>, last accessed 20 May 2018.

Taylor, Charles, 'Beau Travail', *Salon* (31 March 2000), <www.salon.com/2000/03/31/ beau_travail>, last accessed 4 January 2019.

Telegraph Agency, 'Partially-sighted Dressage Rider Fights New Paralympic Blindfold Rule', *Telegraph* (3 December 2015), <www.telegraph.co.uk/news/ uknews/12031519/Partially-sighted-dressage-rider-fights-new-Paralympic-blindfold-rule.html>, last accessed 20 January 2019.

Tema, Celeste, 'Whitney Bedford: Self Portrait', republished on <www.saatchigallery. com/artists/whitney_bedford_articles.htm>, last accessed 10 January 2019.

Westwood, Matthew, *The Australian* (2 August 2016), <www.theaustralian.com.au/ arts/coalition-punished-artists-for-biennale-boycott-by-cutting-funding/news story/6ebf1792902f887c60fb93c1c722bc76>, last accessed 20 May 2018.

Whitbourn, Michaela, 'SBS Presenter Scott McIntyre Sacked Over "Inappropriate" Anzac Day Tweets', *The Sydney Morning Herald* (26 April 2015), <www.smh.com. au/national/sbs-presenter-scott-mcintyre-sacked-over-inappropriate-anzac-day-tweets-20150426-1mtbx8.html>, last accessed 11 January 2019.

Williams, Bruce, 'Winter Soldier Review', *Playboy* (May 1972), <www.wintersoldier-film.com/reviews_0572_playboy.htm>, last accessed 31 January 2019.

Withers, Rachael, 'Venice Biennale 2015: The Arsenale Stuffed With Guns, Stripped of Hope', *The Conversation* (12 May 2015), <http://theconversation.com/

venice-biennale-2015-the-arsenale-stuffed-with-guns-stripped-of-hope-40856>, last accessed 20 July 2015.

Zilak, Alejandra, 'The Racism Blindfold', *Huffington Post* (22 June 2017), <https://www.huffingtonpost.com/entry/the-racism blindfold_us_58c5a514e4b0a797c1d39e3b <www.huffingtonpost.com/entry/the-racism blindfold_us_58c5a514e4b0a797c1d39e3b>, last accessed 20 January 2019.

Zwi, Karen, 'Detained Children Risk Life-long Physical and Mental Harm', *The Conversation* (19 February 2015), <http://theconversation.com/detained-children-risk-life-long-physical-and-mental-harm-37510>, last accessed 5 June 2018.

Index